THE AFTERLIFE OF DISCARDED OBJECTS

VISUAL RHETORIC
Series Editor: Marguerite Helmers

The Visual Rhetoric series publishes work by scholars in a wide variety of disciplines, including art theory, anthropology, rhetoric, cultural studies, psychology, and media studies.

Books in the Series

The Afterlife of Discarded Objects: Memory and Forgetting in a Culture of Waste by Andrei Guruianu and Natalia Andrievskikh (2019)

Type Matters: The Rhetoricity of Letterforms, ed. by Christopher Scott Wyatt and Dànielle Nicole DeVoss (2018)

Inventing Comics: A New Translation of Rodolphe Töpffer's Reflections on Graphic Storytelling, Media Rhetorics, and Aesthetic Practice, ed. and trans. by Sergio C. Figueiredo (2017)

Haptic Visions: Rhetorics of the Digital Image, Information, and Nanotechnology by Valerie L. Hanson (2015)

Locating Visual-Material Rhetorics: The Map, the Mill, and the GPS by Amy D. Propen (2012)

Visual Rhetoric and the Eloquence of Design, ed. by Leslie Atzmon (2011)

Writing the Visual: A Practical Guide for Teachers of Composition and Communication, ed. by Carol David and Anne R. Richards (2008)

Ways of Seeing, Ways of Speaking: The Integration of Rhetoric and Vision in Constructing the Real, ed. by Kristie S. Fleckenstein, Sue Hum, and Linda T. Calendrillo (2007)

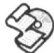

THE AFTERLIFE OF DISCARDED OBJECTS

MEMORY AND FORGETTING IN A CULTURE OF WASTE

Andrei Guruianu and Natalia Andrievskikh

Parlor Press
Anderson, South Carolina
www.parlorpress.com

Parlor Press LLC, Anderson, South Carolina, USA
© 2019 by Parlor Press
All rights reserved.
Printed in the United States of America on acid-free paper.

S A N: 2 5 4 - 8 8 7 9

Cataloging-in-Publication Data on File

978-1-64317-049-7 (paperback)
978-1-64317-050-3 (hardcover)
978-1-64317-051-0 (PDF)
978-1-64317-052-7 (ePub)

1 2 3 4 5

Visual Rhetoric
Series Editor: Marguerite Helmers

Cover image: "Workshirt." © Andrei Guruianu. Used by permission
Book Design: David Blakesley

Parlor Press, LLC is an independent publisher of scholarly and trade titles in print and multimedia formats. This book is available in paper, cloth and eBook formats from Parlor Press on the World Wide Web at http://www.parlorpress.com or through online and brick-and-mortar bookstores. For submission information or to find out about Parlor Press publications, write to Parlor Press, 3015 Brackenberry Drive, Anderson, South Carolina, 29621, or email editor@parlorpress.com.

Contents

Acknowledgments vii

To The Reader 3

1 Leopard Print Pumps and Other Instruments of Memory 18

2 Between Here and Then: A Material Understanding of Time and Space 34

3 Discarded Memory: History and Forgetting 53

4 Unbecoming Garbage: The Spectacle of the Archive 75

5 The Abject and Fear of Social Contamination 96

6 Recycling: Guilt, Fetish, or Necessity? 122

7 The Ludic Potential of Found Artifacts 147

8 Transgressive Art: The Aesthetics of Decay 168

9 Digital Erasures: New Media and Re-Enchantment With the Material World 193

10 A Guided Tour Through the Museum of Imminent Catastrophe 216

11 Personal Narratives: Selected Contributions to ***The Afterlife of Discarded Objects*** 246

Illustrations 274

Works Cited 281

Index 291

About the Authors 293

Acknowledgments

We would like to thank first and foremost David Blakesley for his patience and guidance in making this book possible, and for making the whole process easy to navigate from start to finish. We are also thankful to Marguerite Helmers for her suggestions during the revision process that led to a significantly stronger manuscript, and to Jared Jameson for his incredible copyediting skills and attention to the smallest detail.

We would also like to note that much of *The Afterlife of Discarded Objects* contains and is indebted to contributions from others who shared our vision. We extend our gratitude to the numerous artists who gave us permission to use their work as illustrations through the book: Peg Johnson, Wendy Stewart, Brent Williamson, Ruby Silvious, Dianne Hoffman, Alexandra Davis, Christopher Hynes, Olga Bakhareva, and Sandra Hopkins. Along with the artists featured in the book, there are also numerous others who've contributed to the online project, www.theafterlifeofdiscardedobjects.com, with their works helping to create an archive of both written and visual engagement with objects.

And, of course, we cannot forget the dozens of contributions of personal narratives without which this project would not have gotten off the ground, and which form the foundation for several of the chapters that follow. Whether as short as a paragraph, an entire essay, story, or poem, the stories that we've received over the past four years served as inspiration for the book and encouragement that the project touched upon something not only relevant to contemporary discourse on matter, but more importantly also highlighted how simple everyday objects point to the things that truly unite us.

With gratitude,
Andrei & Natalia

THE AFTERLIFE OF
DISCARDED OBJECTS

To The Reader

> *Storytelling is a form of recollection and a way of reconciling ourselves to the past—a way of knowing who and what we are in relation to the world. Hence story and history imbricate each other. The world we understand is a written world—a plurality, a multiplicity of narratives. Between the particularity of one's natality and of the world lies the story: the mastering of a moment of the past, for a moment.*
>
> —Niran Abbas, *Mapping Michel Serres*

While we live in a world that produces material goods at an overwhelming rate, one thing that has not changed throughout history is the complexity of human relationship to the material world. In our increasingly consumerist and digitized culture, we still assign value beyond the immediate function of objects, an act that plays a crucial role in constituting memory and identity. The moment we decide to keep a used train ticket or a postcard instead of throwing it away, or an old favorite chipped plate reimagined as a coin dish, we invest it with sentimental value that replaces its expired functionality. As such, preserved and repurposed objects become vessels for projections of childhood fantasies or the nostalgic longing of adults.

The above premise is the broad foundation for this book and the guiding principle for the digital storytelling and archival project *The Afterlife of Discarded Objects* (www.theafterlifeofdiscardedobjects.com). Both the book and the digital project emerged from our conversations about our shared post-communist past in Russia and Romania, abound with recollections of how the abrupt turn to consumerism during the 1990s after decades of poverty and repression changed people's perception of the material world around them. Inspired by these conversations, in 2014 we launched *The Afterlife of Discarded Objects*, where we solicited and subsequently archived contributors' memories about playing with, preserving, or making art from what we might broadly label as trash, waste, or unwanted, discarded items. Over the past two years, the responses from participants all over the world have provided rich ethnographic material for analysis; simultaneously, the themes that emerged from the submitted stories and the diversity of cultural perspectives gave us inspiration to probe some of the same territory in the following chapters. *The Afterlife of Discarded Objects* is an ongoing project, one that we hope will continue to grow and develop into a living archive alongside its print counterpart (a selection of contributors' stories collected to date is available at the back of this book).

Whether our contributors came from Italy, Kuwait, the United States, Russia, or India, and whether they submitted poems, brief recol-

lections or well-developed nonfiction narratives, one aspect of their shared memories stood out as common ground. While writing about their interaction and relationship with objects they seemed to reveal at the same time something about themselves: their own personal views toward material objects, the way value is constructed and attributed to things, and their particular society's attitudes toward waste. In other words, through recalling discarded objects they were telling more than the story of a thing—they were reconstructing from memory moments of the past that were in some fundamental ways indicative and representative of themselves and larger social, political, and economic contexts behind their stories. The rhetorical function of such wide-ranging narratives is to create a more inclusive historical perspective, one that highlights the agency of ordinary objects as they serve as important cultural artifacts as well as the agency of those whose voices are otherwise excluded from an official accounting of history. As Abbas puts it above, story and history overlap, and the multiplicity of our personal stories told through image, text, and works of art create an intricate web of relations that we can seek to understand by addressing the role of material objects and artifacts in our lives.

* * *

Junk, trash, garbage, rubbish, detritus, or the all-encompassing *stuff*, are some other terms often invoked in discussions on the effects of waste on our world. And while this book is not only about *waste* per se but specifically concerns itself more with discarded and subsequently recovered objects, the terms—by proximity and by association—often go together; their connotations therefore offer fertile ground for thinking through both physical and emotional entanglements that arise in our encounters with such items. Regardless of the choice of terminology, the referent is *matter*, or the *material nature* of our world. As such, we take as a point of departure for our work the primacy of physical objects in establishing and securing personal identities and more generally a sense of who we are as a people. In his book *Genesis*, Michel Serres writes that,

> The only assignable difference between animal societies and our own resides [. . .] in the emergence of the object. Our relationships, social bonds would have been airy as clouds were there only contracts between subjects. In fact, the object, specific to the Hominidae, stabilizes our relationships, it slows down the time of our revolutions. For an unstable band of baboons, social changes are flaring up every minute. One could characterize their history as unbound, insanely so. The object, for us, makes history slow. (87)

To the Reader

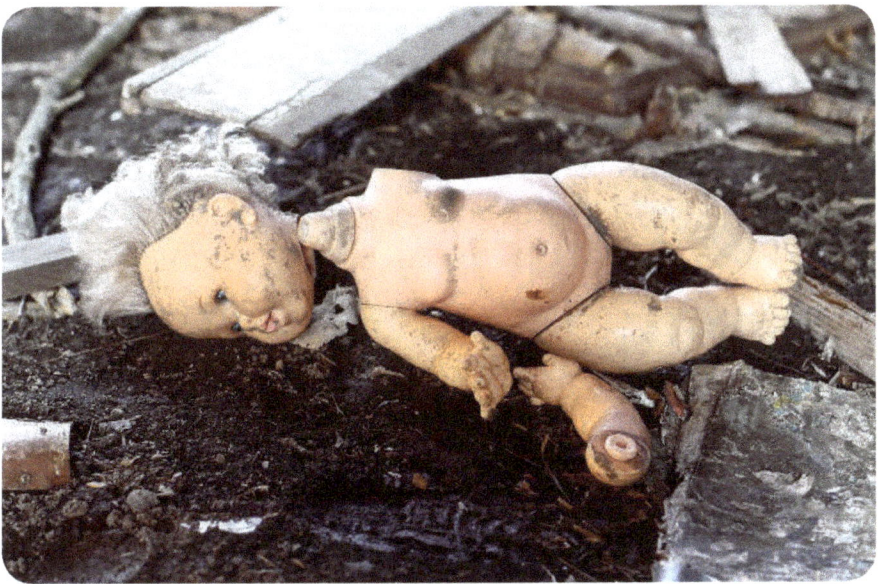

Figure 1: Dismembered doll found in abandoned farmhouse, Naperville, Illinois (Photo by the authors)

The relationship between objects (and their narratives) and time is clear in terms of a traditional chronological approach to history. Because objects decay, decompose, and disappear (though never entirely), their passage through time helps us envision the trajectory of our lives and function as mirror images of our own mortality. But more than the nature of objects as symbolic of the passing of time, sociomaterial relations allow us to glimpse into the intricate workings of memory and forgetting, abstractions that we might hope to bring into focus by examining their grounding in objects. Serres's use above of the term *stabilizes* hits at this crucial function of objects. Objects do the heavy lifting; they are the load-bearing columns in the house of memory. Without them we would live without concrete coordinates for navigating our environments—from something as small as a room to a crowded city square.

Conceiving of memory in terms of "structure" (as having individual organizational components) is nothing new. "An enduring idea of memory," writes Barbara L. Craig for *The American Archivist*, "likens it to a box or storage area or some like structure, which corresponds to the idea of a special container located in a place. According to this view, memory has a location in the mind, one that occupies a space and is the site of the memorial process." Craig goes on to note that for Plato in Theaetetus (368 B.C.) memory is analogous to a wax tablet onto which our thoughts and experiences imprint

images of themselves and which are archived or stored for later access; and for St. Augustine in his *Confessions* memory was a "vast landscape whose endless fields and deep caves he could neither visit nor catalogue." In Book X of *Confessions* he writes,

> And I come to the fields and spacious palaces of my memory, where are the treasures of innumerable images, brought into it from things of all sorts perceived by the senses. There is stored up, whatsoever besides we think, either by enlarging or diminishing, or any other way varying those things which the sense hath come to; and whatever else hath been committed and laid up, which forgetfulness hath not yet swallowed up and buried. (188)

For St. Augustine the spacious palaces of memory are inhabited by innumerable images of things perceived by the senses, which are always in danger of being annihilated by the act of forgetting. Objects act then as a kind of spatial and temporal landmark on our memoryscape, whereby we can locate specific events, people, places, and even ideas. Without objects, or when an object is erased from memory, the stable infrastructure of memory begins to collapse; we feel out of sorts and endure an irreparable sense of loss, a rupture in our spatial and temporal perception, which affects both psychological and physical wellbeing.

This is what Serres meant when he said, "the object [. . .] stabilizes our relationships," but he also hints at a larger sociocultural impact of the subject-object relationship when he says, "The object, for us, makes history slow." Objects, more than mere points of referral within a house of memory, *insert* and *embed* us in history. Because both memory and forgetting are retrospective, directed at the past, adding the material dimension makes it possible to bring particular moments into the present where they are made manifest by the physical embodiment of objects. In other words, our sense of the present can only be facilitated through engagement with the materiality of the past. In "Reclaiming Things: An Archaeology of Matter," Bjornar Olsen explains:

> The past endures, it accumulates in every corner and crevasse of existence becoming "now," making these presents chronological hybrids by definition and thus objecting to the common conception of time (and history) as the succession of instants. The past is made manifest as duration—as sediments constantly piling up (and gradually eroding) [. . .] This layering of the past as the present is hardly conceivable without those durable qualities of things. Habit memory, is thus also *material memory*; the past is made manifest, "stored up," through the

presences and practices. To live with this past, and to exact the habit of memory it facilitates, is an inescapable part of our existence shared by all people throughout history. (182)

Because objects have the inherent ability to change through time, we can understand how the past extends itself not only into the present but also the future. Walter Benjamin's Angel of History being propelled into the future while staring at the rubble at his feet perfectly captures this simultaneous movement backward and forward in time, facilitated by the accumulations of objects. Discussion of the future, therefore, only exists within the discourse on materiality.

In the narratives submitted to *The Afterlife of Discarded Objects* we encountered a wide range of experiences that highlighted the various functions of material objects in terms of memory and forgetting; the stories also provided historical perspectives, especially when experiences of the older and younger generations were compared. In each case, the object transcended its intended functional limitations to become *something more*. At the same time, we also noticed that a certain tension arose when the delineation between *things* and *waste* was not clear. In one story from Iran, we are told of plastic bag kites. In another story from New York, we follow the trail of a family heirloom from Italy to America, to its possible afterlife of being handed down even further. Is there a difference then between the significance for memory of a thing someone has salvaged that is now kept and cherished, and that fragment of broken pottery a child uses to scratch her name into the dirt? In other words, do all objects function similarly in terms of memory and forgetting and historical significance? Or, simply put, does all matter matter?

* * *

In an essay titled "Kipple and Things: How to Hoard and Why Not to Mean," delivered in 2011 at the Birkbeck/London Consortium "Rubbish Symposium," Daniel Rourke explores Phillip K. Dick's 1968 sci-fi novel *Do Androids Dream of Electric Sheep?* and provides possible insight into how and why matter matters to us. The novel is set on Earth in the midst of a nuclear winter and introduces readers to several dystopian views of the world, one of which is the existence of something to which Dick gave the name of *kipple*. The book defines kipple as "useless objects, like junk mail or match folders after you use the last match or gum wrappers or yesterday's homeopape. When nobody's around, kipple reproduces itself. For instance, if you go to bed leaving any kipple around your apartment, when you wake up the next morning there's twice as much of it. It always gets more and more."

Kipple's even more insidious nature is that it "drives out nonkipple," and while one might try to fight back, eventually "No one can win against kipple [. . .] except temporarily and maybe in one spot, [. . .] a stasis between the pressure of kipple and nonkipple, for the time being. But [. . .] the kipple will again take over. It's a universal principle operating throughout the universe; the entire universe is moving toward a final state of total, absolute kippleization."

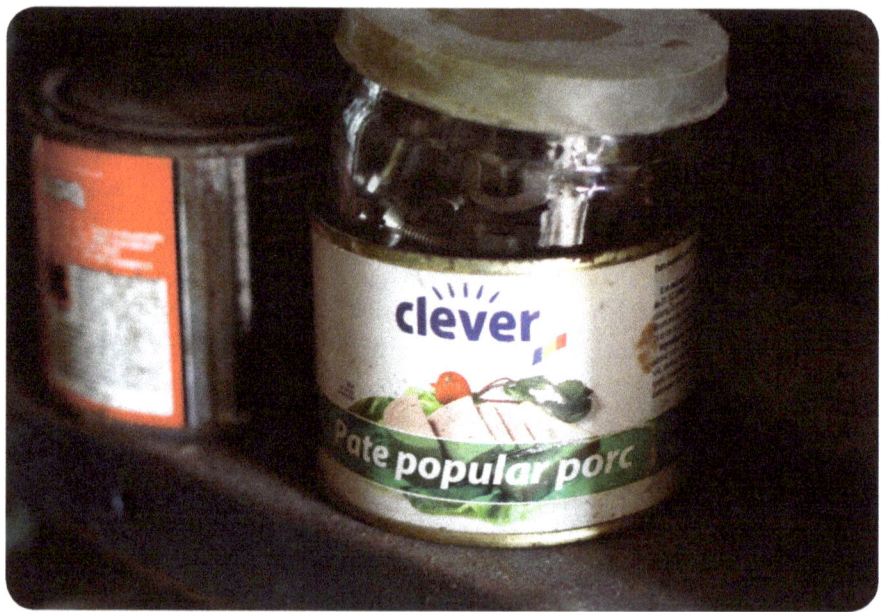

Figure 2: Processed meat tin can and glass jar repurposed as storage container for nuts and bolts (Photo by the authors)

We expect that as you come to the end of the above passage most readers would nod their heads in recognition, followed by a twinge of guilt. We might not call it kipple, but many of us certainly have experienced the seemingly unexplainable accumulation of stuff in our closets, junk drawers, basements, attics, etc. Spring cleaning becomes part of a yearly ritual of tossing out kipple just to make room for the next year's kipple. Indeed, it's a battle we wage throughout a lifetime, making little progress. There's that odd souvenir from a family vacation years ago that somehow survives year after year in a box at the back of the closet and simply will not be tossed out with the rest. And at the next garage sale that we stop for by the side of the road, there will be a well-worn sometimes-working sometimes-accurate wooden clock that simply wants to come home with us. Whatever worth such objects have, however, is elusive, abstract at best, but most of all symbolic,

To the Reader

dependent on a myriad of unique traits that point to personal or cultural significance. Our understanding of how such items work is indebted in part to Roland Barthes's classic text of semiotics, "The Rhetoric of the Image," where he dissects an Italian Panzani pasta advertisement, an object whose function is also that of a "sign," and argues that, "the knowledge on which this sign depends is heavily cultural"; in this case the image is that of a half-open bag, bags of pasta, a can of sauce, and a bag of parmesan, which according to Barthes all add up to say *Italianicity* (33). More importantly, what Barthes observed in the Panzani advertisement is that images, and by extension the things they portray, are read both at a denotative and connotative level; that is, paying attention to both direct, literal meaning and what is implied or suggested, what we can cull together from various conscious and unconscious associations. When images are read connotatively, it inevitably becomes a rhetorical act inseparable from socio-cultural functions. Depending on our backgrounds and culturally-determined assumptions, we read the images around us making judgments about them. An old broken toy truck that a child plays with on the side of the road might signal poverty; a 1970s John Lennon concert poster found on eBay can be interpreted as a sign of love and peace; an original glass Coca Cola bottle can be symbolic of Americana. An image or object always communicates something, our ability to read it makes our interaction with the object a rhetorical act.

And that is another aspect of our infatuation with kipple: we assign meaning to the things in our lives based on criteria that we have learned and inherited or otherwise devised for ourselves. We label and order things according to their hierarchy of importance to better understand their role in our lives and to have a sense of control over the material world. At least that's what we'd like to believe. "Our apparent mastery over creation comes from one simple quirk of our being: the tendency we exhibit to categorise, to cleave through the fabric of creation," Rourke explains. Humans "can take kipple and distinguish it from itself, endlessly, through categorization and classification. Far from using things until they run down, humans build new relations, new meanings, carefully and slowly from the mush. New categories produce new things, produce *newness*. At least, that's what Dick—a Platonic idealist—believed."

What Dick did not address entirely is the mechanism for this categorization, the method by which we know what to preserve and catalogue, what things will make for meaningful new relations and meanings, and which are destined for the landfill. *Value* as a term in itself is not sufficient and accurate enough to indicate the afterlife of any given object, as evident from the vast amount of personal narratives that recall objects of little or no monetary value. Barthes partially addresses this insufficiency by providing

a framework for understanding how things *mean* by way of symbolic associations that human subjectivity assigns to them by turning objects into signs. However, this still leaves us with several questions: Is there a reason why kipple might be trash and treasure simultaneously? Is our inclination toward certain things and not others simply arbitrary, or is there something in a *thing* that explains its staying power? In other words, can a thing and its image still mean something even if not intentionally presented as a means of communicating with an audience?

<p style="text-align:center">* * *</p>

The generative, almost life-like qualities of matter as depicted in the image of kipple are brought to the forefront of critical attention in new materialism, a school of thought that seeks to place the primacy of matter in human lives into the limelight. Diane Coole and Samantha Frost, editors of *New Materialisms: Ontology, Agency, and Politics*, point out that the problem with studying matter lies in apparent human inability to separate matter itself from our emotional projections and the processes of meaning-making and assigning value to the world around us. Such failure, Coole and Frost explain, stems from placing human subjectivity over everything else based on a dualist thinking that separates human and non-human. Recent studies in new materialism disturb such binaries and "often discern emergent, generative powers (or agentic capacities) even within inorganic matter, and they generally eschew distinction between organic and inorganic, or animate and inanimate, at the ontological level" (Coole and Frost 9). What if, new materialism suggests, instead of striving to categorize and describe things, to weigh them against one another and determine their worth, we pay attention to the productive chaos of things and the intricate ways in which they do not yield easy categorization? What if we pay attention to the power with which things insert themselves in our lives, albeit unintentionally, for "intention" is, above all, just another concept from the realm of subjectivity? And, perhaps most importantly, can this new insight into the power of things work together with existing epistemologies, without perpetuating the very binary thinking that new materialism cautions against?

The Afterlife of Discarded Objects seeks to find a productive intersection between new materialism and more traditional studies of culture and memory, paying attention to how human subjectivity and agency of matter work together to make things happen. Taking the cue from Coole and Frost, we regard materiality as "always something more than 'mere' matter: an excess, force, vitality, relationality, or difference that renders matter active, self-creative, productive, unpredictable" (9), while at the same time remaining mindful of what stories about objects can tell us about ourselves.

To the Reader

As Bruno Latour says (and Bill Brown quotes in his seminal *Thing Theory*), "Things do not exist without being full of people." Similarly, the stories that our participants have shared with us speak powerfully about how our relationship with things reflects our backgrounds—gender, class, cultural, and ethnic identities—providing much food for thought. In the chapters that follow, we will reflect on how the diverse ways in which we bond with and discard things reveal who we are individually and collectively, personally and culturally.

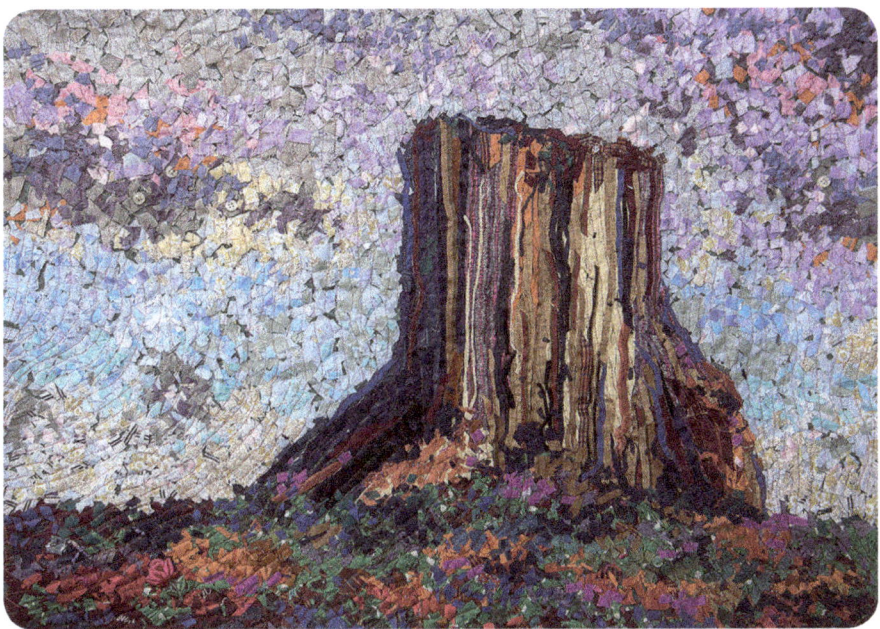

Figure 3: *Aloft on a Rock*: Fiber art by Sandra Hopkins made using scraps and remnants of fabric sewn together to tell a Native legend about a group of children and an abused woman fleeing a bear. According to the legend, in their fear the children prayed to the Great Spirit to save them. Hearing their prayers, the Great Spirit made the ground rise up to the heavens and they were protected, high out of reach, from the bear. The marking on the tower walls are said to be the claw marks, but the bear could never reach them again. The name of this tower in Wyoming was mistranslated as "Devil's Tower," but the Kiowa call it "Aloft on a Rock." (Artwork (c) 2014 by Sandra Hopkins. Photographed by Beth Bruno. Used by permission.)

The images invoked by voices from the cultural and economic margins have valuable insights to share with the reader about the power of things and the different ways in which humans engage with matter around the

world. In a story by one of our contributors named Meera, set in the 1960s in South India, a ribbon braided in a child's hair saved her life. A woman was washing her laundry in the pond when she noticed a bright red ribbon floating on the surface of the water: "Thinking that she would help herself to the bright colored ribbon she tried to grab it when she realized that she was holding a drowning child's head." While this happened entirely by a lucky accident, the ribbon's role in the girl's rescue is hard to overestimate, as is the overall context of the importance that material objects could boast in rural India during that time. "Village life necessitates reuse and recycle," Meera explains, "and since lives are connected intimately in rural India one person's garbage is somebody else's treasure."

Adding on to many of our participants' stories coming from developing countries, throughout the chapters we share our own experiences and recollections informed by our respective backgrounds in Russia and Romania. Because Eastern Europe and Russia experienced a sharp break with the communist past, the rapid injection of consumerist sentiment through a free-market economy led to a radically different experience of material goods, one where what was bought, cherished, and preserved always bore the mark of past habits and mindsets instilled through decades of oppression. In this book, we seek to bring this distinctly Eastern European and Russian sensibility to the ongoing conversation about materiality, one that has been predominantly concerned with and conducted from the Western perspective. It is our hope that these considerations will prove useful to the reader, providing insights into non-Western and immigrant perspectives.

When we discuss memories shared by our contributors from outside of the West, we try to tread carefully, conscious of the dangers of generalizing or stereotyping. In her often-cited TED talk titled "The Danger of a Single Story," author Chimamanda Ngozi Adichie recalls how her mother only ever told her one thing about their house boy, Fide, and his family: how poor they were. Then one day she saw a beautiful basket that Fide's mother had made and was taken by surprise: "It had not occurred to me," Adichie says, "that anybody in his family could actually make something. All I had heard about them was how poor they were, so that it had become impossible for me to see them as anything else but poor. Their poverty was my single story of them." The danger of a single story lies in replacing reality with a one-dimensional, flat representation that erases any possibility of diverse meanings and experiences. "The problem with stereotypes," Adichie reminds us, "is not that they are untrue, but that they are incomplete." Hegemonic Western rhetoric has too often constructed an incomplete, one-sided representation of experiences of others to offer a single story and a single identity. The best antidote for such cultural flattening of perspectives is to provide a venue for the expression of diverse experiences, to allow for al-

ternative forms of rhetoric that decentralize and fragment the mainstream narrative. Told in diverse voices, stories place the storytellers in the position of authority. Similarly, the works of photographers and artists included in the book are placed in the position of having authority over the objects and events that they set to chronicle, claiming agency in the construction of identity. No longer is there a single story or version of reality, but instead multiple means by which reality and meaning are constructed, none of which are necessarily subservient or less legitimate than another.

In many cases, the collected visual and written memories challenge our perspective of the geographic divides, reminding us that issues that we would prefer to overlook are closer to home than one would think, and that our shared struggles are just as universal as they are culturally-specific. Even when the shared memories reflect upon experiences of poverty and struggle, these accounts do not invite feelings of pity, disgust, or revulsion—all possible reactions one might have to an encounter with waste. Instead, the stories and artworks actively seek out different rhetorical strategies of meaning-making, resulting in constructions of narratives of hope and inspiration, nostalgia for shared past and appreciation for beauty of objects, messages of defiance and perseverance. By highlighting the stories of ordinary individuals told in their own voices, including those from a marginalized cultural position, we hope to highlight the legitimacy of perspectives that stand outside of mainstream narratives.

* * *

As the book navigates varied locations, cultural perspectives, and storylines we return time and again to the crucial role of materiality in our lives. Ultimately matter does matter more than one would initially imagine. Yet, while our work finds its footing in and is guided by an appreciation of the material world, the book nonetheless acknowledges that we are facing an increasingly digital future, a paradigm shift in how material culture is experienced, shared, and talked about. The rhetorical strategies employed in the construction of this book are both a result of and a response to this cultural watershed. "In the digital world there is no turning back," says American poet Kenneth Goldsmith during a 2014 CNN interview for the segment *Reading for Leading*. Goldsmith was discussing what he claimed to be his favorite book, Walter Benjamin's *The Arcades Project*, which in many ways informs the writing of *The Afterlife of Discarded Objects* and the way in which we hope it functions as a finished product. A description of Benjamin's project from the Harvard University Press reads:

> Focusing on the arcades of nineteenth-century Paris—glass-roofed rows of shops that were early centers of consumerism—Benjamin

presents a montage of quotations from, and reflections on, hundreds of published sources, arranging them in 36 categories with descriptive rubrics such as "Fashion," "Boredom," "Dream City," "Photography," "Catacombs," "Advertising," "Prostitution," "Baudelaire," and "Theory of Progress." His central preoccupation is what he calls the commodification of things—a process in which he locates the decisive shift to the modern age.

Goldsmith, who admits to no longer consuming books cover to cover in the digital age, says he likes the book (in all of its "unfinished" 1090 pages), because as a "collection of scribbles" it conforms to the way we consume information today. We skim, click, browse, scroll, flip, thumb through, bookmark, but seldom indulge in hour-long marathon reading sessions. Simply put, "We're reading differently today," says Goldsmith, but we're also reading more than ever, and a wider variety of things than ever before. But what exactly is it that we're reading? "Most of what I think I read in a day is quite frankly rubbish," interjects Goldsmith's interviewer. One only need to glance at a Facebook feed or link-hop for thirty seconds across the Internet to know what that means. Goldsmith, however, is not easily dissuaded: "This is important stuff. It's not all garbage, and a lot of the garbage that we think is garbage, the detritus, the flotsam and jetsam of our daily lives is actually what makes our daily lives as rich as they are."

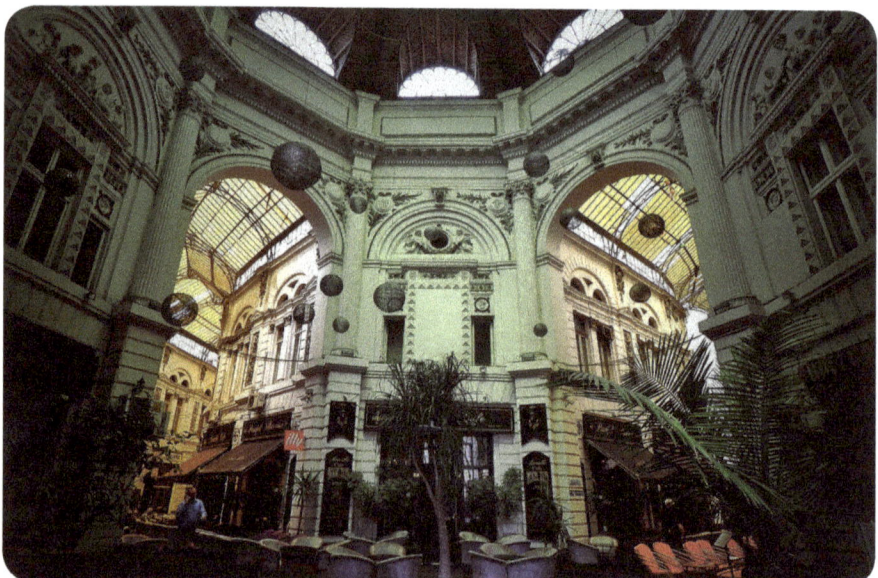

Figure 4: Macca-Villacrosse passage/arcade, Bucharest, Romania (Photo by Ștefan Jurcă / CC BY 2.0, via Wikimedia Commons)

To the Reader

The way Goldsmith views the information that we ingest and process via the Internet and social media closely echoes the content and methodology behind *The Afterlife of Discarded Objects*. The dividing line between waste and valuable object is porous, flimsy, often arbitrary, subjective at best. Benjamin's *The Arcades Project* took the detritus of our culture of consumption and turned it into a poetics of fragments, a philosophy of our fascination with the physical manifestations of habits, passions, needs, and desires. According to Martin Heidegger, this is possible because of the innate quality, the essence of material objects: "But how does the thing essence?" he asks. "The thing things. Thinging gathers." And what it gathers about it is what Benjamin experienced in early-twentieth-century Paris. Thus, in *The Arcades Project* meaning gathers, accumulates, literally out of the iron, glass, and streets of Paris; it is both rooted in the concreteness of things encountered and in Benjamin's associative flights of imagination. "In the dusty, cluttered corridors of the arcades," write Benjamin's translators Howard Eiland and Kevin McLaughlin, "where street and interior are one, historical time is broken up into kaleidoscopic distractions and momentary come-ons, myriad displays of ephemera, thresholds for the passage of what Gerard de Nerval (in *Aurelia*) calls 'the ghosts of material things.' Hence, at a distance from what is normally meant by 'progress,' is the *ur*-historical, collective redemption of lost time, of the times embedded in the space of things" (xii). The line "Where street and interior are one" (echoed later in the *Arcades*, "Streets are the dwelling place of the collective") calls attention to the way the arcades blur the lines between private and public, between the individual and the collective, in a similar way to how objects serve as both personal talismans and societal symbols (visual metaphors whose connotations we decode as a means of positioning ourselves vis-à-vis our respective cultures). The individual is always cultural, and the space between is bridged by things themselves. While Benjamin did not intend the book to serve as an overture to "stuff," it nevertheless reads at times as a gesture of acknowledgment for the invisible work that material objects do for us, and without which, we argue, we run the risk of losing something fundamental of our humanity, about who we are.

As a poet and conceptual artist, Goldsmith intuits this relationship. Explaining the contents and function of *Arcades* and its echoes in today's digital culture, he says, "There's just a lot of stuff about what it was like to live in Paris in the nineteenth century. If you take the Internet to be the greatest book, the greatest poem ever written, the Facebook page is the great collective autobiography of our culture. You're going to find out what it was like to be here, and I don't think that's any small task." Similarly, in the stories we tell about discarded objects and in the objects themselves we sense an

accumulation of meaning and value. This might not be obvious at first, and it might not be clear even to us, but over time the fragments on the mantelpiece of the imagination begin to coalesce and cohere, and a clearer picture begins to emerge. It is not surprising that Benjamin describes the *Arcades* as his attempt to use collage technique in literature, stringing together bits and pieces of observations, analysis, quotes, passages from books he was reading, etc. What is important is that the pieces, the stories, are there to be recalled, that the objects remain as bookmarks in the unfinished tome of memory to be recalled when needed. "These proliferating individual passages, extracted from their original context like collectibles," write Eiland and McLaughlin, "were eventually set up to communicate among themselves [. . .]. The organized masses of historical objects—the particular items of Benjamin's display (drafts and excerpts)—together give rise to 'a world of secret affinities'; and each separate article in the collection, each entry, was to constitute a 'magic encyclopedia' of the epoch from which it derived." When writing *The Afterlife of Discarded Objects*, we went about the task with a similar mindset, that of *assembling* meaning from disparate parts, and always with an eye on what the different parts had to say, how they constructed their own rhetorical logic, and how they dictated the ways by which they established their own value and rationale for existence. To that end, the book is composed of excerpts of multiple stories, quotes from texts that range from seminal works in the field of waste and material studies to current events and television. Similarly, it is illustrated primarily with the work of amateur photographers (many found through another alternative archive, the Creative Commons) and artists who've contributed over the years to the digital project. While at times the images correspond quite literally to the subject matter of a given chapter or passage, the chosen illustrations often serve also as pictorial echoes of the conceptual framework that holds the different chapters together, resonating across themes and topics and calling attention to one another. In that sense, they and the narratives function as a glue holding the book together, allowing for anchor points within individual chapters, while also performing a broader rhetorical function where readers are allowed the room for and invited to draw connections and come to meaning through their own intertextual analysis—recognizing how stories, ideas, and ordinary objects overlap and speak to one another across cultures and backgrounds. By including these "everyday chroniclers"—whether narrative or pictorial—alongside the works of what typically are referred to as "voices of authority," the picture that develops is rich and complex, not unlike Goldsmith's "autobiography of our culture."

 In an Amazon.com review for *The Arcades Project*, Ralph Beliveau wrote on June 15, 2000: "In the fifth of his 'Theses on History' Benjamin mentions that, 'every image of the past that is not recognized by the present

To the Reader

as one of its own concerns threatens to disappear irretrievably.' This work represents a significant way of not forgetting. In its fragmentary nature it reminds us that the texts we read are all fragmentary and we assemble and contextualize them as we read them." One need not look far or long to discover that indeed this observation reflects much of what we consume on a daily basis, from images to music to books. On NPR's Morning Edition segment "Something Old, Something New: Public Service Broadcasting on History and Storytelling," Jacob Pinter interviews J. Willgoose, Esq., the founder of Public Service Broadcasting—a musical band as well as historical project—who reveals that "[i]t started off as a kind of tongue-in-cheek thing where we claimed to be 'teaching the lessons of the past through the music of the future.'" According to Pinter, the band "uses archival material, whether it be film footage or radio broadcasts, to write new songs," but Willgoose explains that it's more than simply a gimmick: "It's not an exercise in nostalgia, it's actually about reframing the past." We would like to think that the stories and images of things in *The Afterlife of Discarded Objects* also address Benjamin's concerns and, in each instance, represent unique ways of not forgetting, of reframing the past (the images quite literally doing so as they parallel official accounts of events), and of signaling possibilities for the future. If there is a difference it is that for Benjamin time was embedded in the space of things, and for us, increasingly, the stories of things come with digital embodiments, often fragmentary, incomplete, nonlinear. But the possibilities of rich relationships exist all the same for collectors who take the time to rummage through a box of junk at a yard sale as well as the curious reader-observer who can navigate the physical and digital landscape littered with the ghosts of our culture. The Arcades themselves are considered by some nothing more than "a monumental fragment or ruin"—a perfect place we say to begin looking.

In *Arcades* Benjamin recorded fragments of the zeitgeist embedded in the materiality of his world. Our own love of things, *resophilia* if you will, is made manifest in the things we choose to hold on to and the things we choose to discard, but still remember. At times there is a logic to it, and at times it takes a leap of imagination to understand. And because we believe that both reason and imagination are necessary, that so far neither scholars nor poets have made their peace with the material world, in *The Afterlife of Discarded Objects* the theory of waste meets a poetics of waste, the philosophical overlaps with the spiritual, the critical with the lyrical impulse. This is fertile ground, yet to be fully explored, and thus is it our hope that this opens up new possibilities for critical and creative discourse on our infatuation with things. As *flaneurs* of the modern wastescape, we invite you to navigate with us through a mash-up of history, philosophy, pop-culture criticism, memoir, and ethnography—begin anywhere and wander about the ruins.

1 Leopard Print Pumps and Other Instruments of Memory

Andrei

Not everyone is willing to call the *stuff* lurking in their drawers and closets junk, much less waste or garbage. Whether that's a matter of semantics or personal taste, the incontrovertible fact remains that stuff—those objects that have outlived their original purpose, that we no longer need or want for immediate use—takes up space. And when we run out of space, we design and build clever ways to store even more stuff.

Individually and collectively, our appetite for material objects has made The Container Store not only a reality but also a necessity. A quick informal poll of anyone around you at this moment will typically reveal that no one hates The Container Store. Everyone, in fact, loves The Container Store. And in certain circles one might even call the zealous affinity for it a Container Store fetish, the name itself upon utterance having quasi-religious appeal. Where else can you find under one giant roof zebra striped boxes, boxes with lids and without lids, boxes within boxes, boxes that fold, boxes that expand, boxes that you can personalize to your individual taste, and of course oversized containers to organize your containers? If you're into that sort of thing. And apparently many of us are very much into that sort of thing. It makes us happy to see our stuff organized, neatly secured and tucked away, even if we might never see it again for days, months, even years. We know it is there, and something about that is reassuring—it soothes the anxious, it gives the cluttered life a sense of order and creates an illusion of control over our material world.

Our stuff takes up so much space these days that entire multi-story buildings, entire city blocks, are now dedicated to storing it away, presumably to make more room for other stuff. In New York City some of the more clever advertisements adorning subway cars are for storage units. One might even say they glorify them. "I like my wife and kids, but I love my storage unit" is one that pretty much says it all, showing a man in drag smiling in front of a space crammed with various wigs, furs, and leopard print pumps. The implied alternative lifestyle and secret identity aside, a more accurate interpretation of the slogan might read, "I like my wife and kids, but I love things even more."

Leopard Print Pumps and Other Instruments of Memory

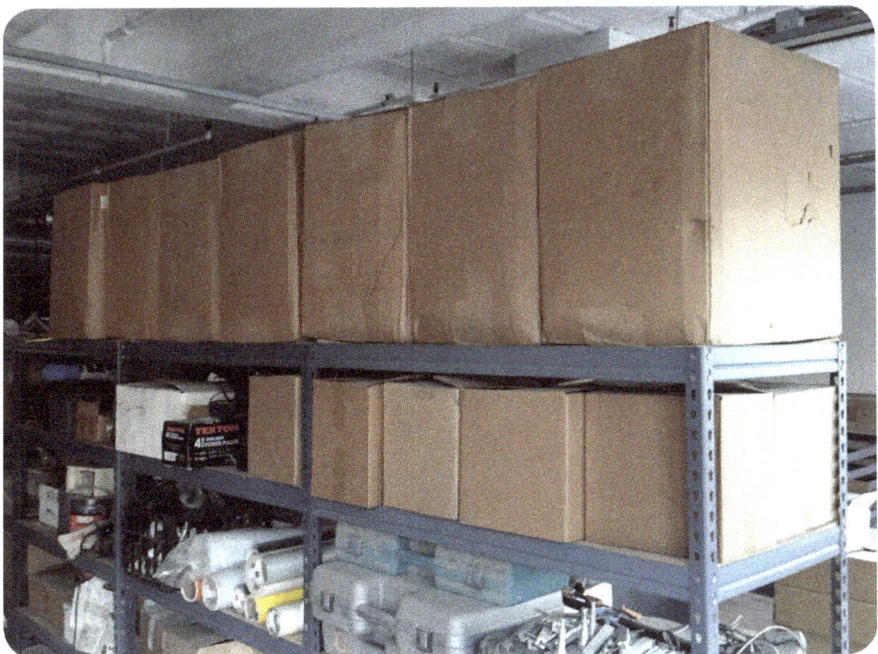

Figure 5: Cardboard storage boxes during renovation of an art gallery in upstate New York. (Photo by the authors)

That man is certainly not alone in his adoration for material objects. In fact, he might just be the norm rather than the exception, and he's willing to pay to satisfy his pleasures. How much is it worth to store your bust of fat Elvis or that glass jar of sand and shells you brought back (without declaring it to customs) from the beaches of Rio? Or that lamp you bargained for at a garage sale, declaring it a "real find," only to find out that your roommate has declared it the epitome of kitsch? The cost depends, of course, on whether you're renting a climate-controlled unit in Brooklyn or a budget-conscious rusty 4x6 on the outskirts of Queens, NY. Or how much you value keeping your leather fetish a secret.

※ ※ ※

By all accounts The Container Store is a little late to the game. As Thomas Hine argued in his 1995 book *The Total Package: The Secret History and Hidden Meanings of Boxes, Bottles, Cans and Other Persuasive Containers*, nature got there way before us. From pea pods to peanut shells, to eggs, oranges, and just about any seed, all around nature comes in neat packages that are designed to secure and preserve. Our inclination to design and use containers of various sorts

could then be seen as a natural extension of what has always worked. But where nature left off, man has picked up and added dizzyingly new varieties, the most conspicuous of these being the box, a human invention and a shape that does not exist in nature, yet one that has been used to structure all spheres of material lives from architecture, to storage, to cemeteries. The box appears throughout history, mythology, and art, revealing that our fascination with it—whether intended to organize, preserve, display, or conceal—is nothing new. While The Container Store, which bills itself as "The Original Storage and Organization Store," has only been around since 1978, the allure of containers dates back millennia. It is no surprise that Pandora's box (a mistranslation of the Greek *pithos*, or jar) holds a perverse sort of appeal in classical academic discourse as well as popular culture. It is this single box or jar that contained arguably all of the elements of our modern condition, with consumerism and waste likely tucked in there in one of the dusty corners. But Pandora's box was just the beginning. From ancient myth to modern day, history has seen man invent a seemingly endless array of containers of various sizes and functions: from snuff boxes, musical boxes, jewelry boxes, and wedding chests to tombs, crypts, pyramids, and vaults. Most of the time, they functioned as receptacles for other things we considered important, valuable, or fragile. If we possessed a thing, we wanted to make sure we had it for as long as possible; we wanted to safeguard and preserve.

But this original compulsion, what might even be considered an evolutionary impulse, stretches beyond utility and the containment of objects to the preservation of memory and the construction and reinforcement of identity. As Pierre Nora writes in "Between Memory and History: *Les Lieux de Mémoire*," "Memory takes root in the concrete, in spaces, gestures, images, and objects; history binds itself strictly to temporal continuities, to progressions and to relations between things. Memory is absolute, while history can only conceive the relative" (9). In other words, our ability to remember (and the ease or difficulty with which we forget) is indelibly linked to material objects. Nora's phrase "takes root in" therefore gestures towards the object itself as not only a unit of containment, as the receptacle for our memories, but as their very genesis.

Many stories contributed to *The Afterlife of Discarded Objects* refer specifically to containers of various design and function and their role in shaping memory—individual history, family history, and cultural history. One such example comes from Priya Sarukkai Chabria (Pune, India), who in a poem titled *Blue Vase* recalls a family heirloom that she had converted over the years from a vase to a lamp stand by drilling a hole in the base to accommodate an electrical cord. Today the object might be considered discarded, no longer

used as either vase or lamp, but simply put somewhere *out of the way*. Its turquoise presence, however, in the corner of a closet, glimpsed occasionally by the owner, allows Priya to travel back in time to "the phosphorescent dreams / of [her] childhood and those of a family fragmenting." Priya's memories of childhood are rooted partially in this object, and the history of her family's fragmenting and her movement into adulthood bound to the progression of the object's identity and her shifting relationship to it. Nora would call an item such as the blue vase a *liue de memoire*, a site of memory, which has replaced the *milieu de memoire*, or the real environment of memory. Because the family environment Priya was raised in as a child no longer exists, the memory of those years is activated and made tangible by the repurposed vase.

The power and potential of objects to house memories, to borrow from Gaston Bachelard's *The Poetics of Space*, is revealed once again through a story by Janice Bisset (New Mexico, USA) that recalls one Mrs. Jaramillo, who in the 1960s had offered to teach her mother, Joyce, how to make tortillas. The trick, according to the story and to Mrs. Jaramillo's inexact orders, was to fill a particular bowl with flour "to here, where this crack is." Those were Mrs. Jaramillo's baffling instructions. The bowl in question was one of Mrs. Jaramillo's dishes, one that we would imagine she'd used countless times throughout her life in the preparation of tortillas and possibly other goodies. A young Joyce asked her teacher what most curious students would ask in that case: "But what if I don't have a bowl with a crack in it?" A reasonable question most of us would agree, assuming that one is not in the habit of collecting broken or nearly broken dishes, and especially not for cooking. The response was anything but expected; Mrs. Jaramillo simply refused to continue the lesson, and Joyce left the befuddled woman's kitchen and home and never did learn to make tortillas.

The story, of course, has more to do with how to live—with an *experience* and a *relationship*—than with culinary expertise or with a single cracked bowl. And it has to do with something that does not even involve the object itself. Prior to beginning the cooking lesson, Janice recalls that her mother tried to tell Mrs. Jarammillo a story of her own, about a grasshopper that waved to her and her daughter when they were gathering leftover peanuts from a farmer's field: "I'm telling you the truth! It waved at us! We got down in the dirt and stared real close and it waved one little arm at us and we said 'Hello' to it." By the end of the story about Mrs. Jaramillo, Janice reveals the real function of that day and the bowl, when she writes that, "We treasure that story because it makes us laugh, because we don't know what to do with it. We hold on to it because it reminds us of a time when grasshoppers enchanted us while we gleaned the fields." That ephemeral moment, real or imagined, when mother and daughter bent down in the field to greet a small

grasshopper, is now forever linked to and anchored in a bowl with a crack in it, whose image once recalled allows a mundane object to take on a vital role in the transmission of memory.

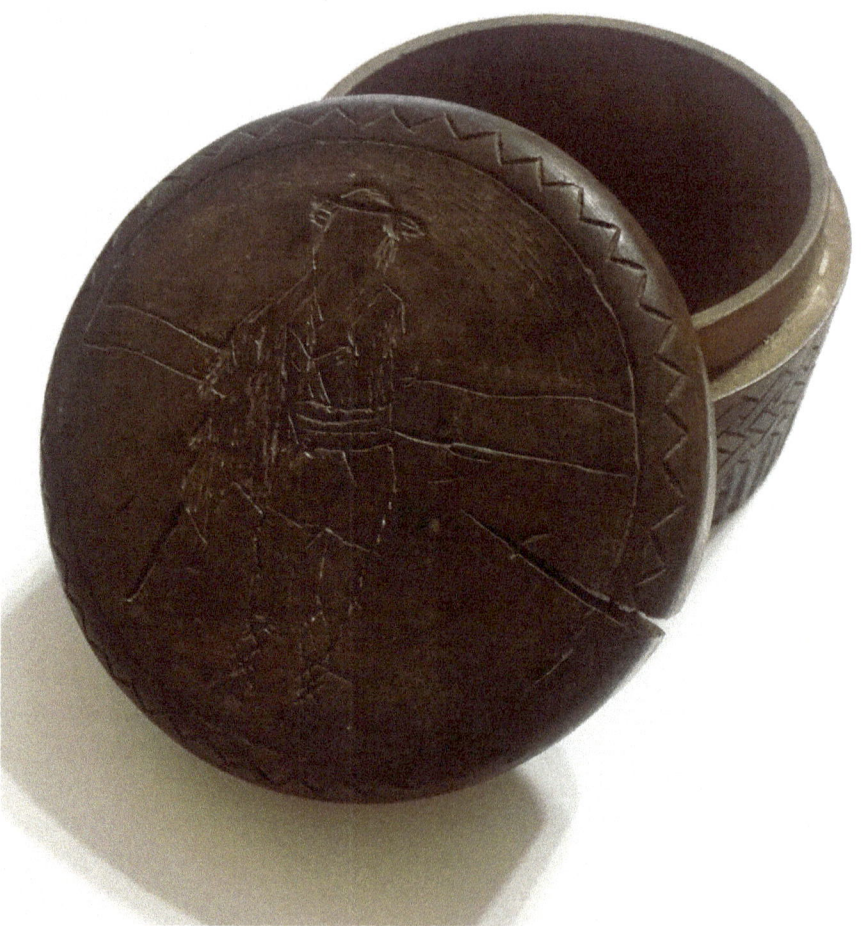

Figure 6: Wooden jewelry/trinket box with traditional Romanian etching. (Photo by the authors)

In *The System of Objects* French cultural theorist Jean Baudrillard makes the distinction between objects such as the cracked bowl and what he defines merely as objects of consumption (i.e., objects consumed primarily to meet the desire for status—brand names, for example, which offer no real relationship to the individual except that of signs manipulated to provide the illusion of satisfaction). "Traditional symbolic objects (tools, furniture, the house itself)," writes Baudrillard, "were the mediators of a real relationship

or a directly experienced situation, and their substance and form bore the clear imprint of the conscious or unconscious dynamic of that relationship" (218). According to Baudrillard, today real human relationships (to one another and to objects) have been transformed into relationships of consumption. The relationship is not with the materiality of the object but with what it signifies. In contrast, when we preserve and hold on to discarded items what we hold on to and by extension foreground first and foremost is the materiality of the object—any subsequent relationship and symbolic meaning is forged and solidified through that materiality. Yet, while we might concede and agree with Baudrillard that increasingly our interactions are mediated through objects of consumption—the smart phone we swap out every two years, the car we drive because it symbolizes our support for clean energy, etc.—we cannot overlook stories such as Janice's that can still reveal a genuine human relationship. Here it should be pointed out once again that the state of the object that made it happen—fractured, imperfect, in many instances suitable for the landfill—renders it anything but a status symbol. It was precisely that flaw in the bowl that "bore the clear imprint" of "human actions, whether collective or individual," and it was that symbolic imprint that for a young girl turned an experience with a "living object" into a living memory (Baudrillard 218). Priya and Janice's stories remind us that memories and the relationships that define us often lie in the most ordinary of objects, but they also remind us how delicate memory can be, dependent as it is in both cases on the "substance and form" of things that bear aspects of *brokenness*. The reality we are presented with in both cases is that objects do not last forever, that they perish, disappear, become lost, and with them a part of us might be lost as well. This is what we want to hold on to, why we are compelled to save and box away and keep things from vanishing forever. Even now, Priya says that she would like to patch up the hole in the base, turning it again into a vase, reminiscent of the time when the entire family was still together. But she doesn't want to erase that imprint, and with it so many memories along the way. She wants the hole in the vase to remain the conduit of memory. "I remember kintsugi or golden joinery," Priya writes, "the Japanese art of repairing broken pottery that highlights breakage by filling the cracks with gold or silver dust so that neither its past as shards nor its mending is disguised; rather fragility and resilience are simultaneously on display." And perhaps it is this simultaneity of fragility and resilience that best captures our fascination with containers of all stripes—faced daily with the delicate nature of life and aware of our own mortality and transience (after all we know that imprints, over time, can be rubbed out), we construct the best we can our own personal strategies to mitigate that sobering fact.

Pierre Nora wrote his essay "Between Memory and History: *Les Lieux de Mémoire*" in 1989, two years after Andy Warhol's death, a man obsessed with his image, how he was perceived, and how he would be remembered. And here he might have been influenced by another artist consumed by image, the rock band Queen's front man Freddie Mercury, who is known to have told his manager, "You can do whatever you want with my music just don't make me boring." Warhol did not want to take that chance. Born in 1928 in Pittsburgh, Pennsylvania to former Hungarian immigrant parents, Andrej Varhole created a version of himself as Andy Warhol that endured over time and ensured that he would be thought of as anything but boring. Part of that effort consists of his *Time Capsules*. According to *Warhol.org*, "This serial work, spanning a thirty-year period from the early 1960s to his death in 1987, consists of 610 containers (mainly standard-sized cardboard boxes), which Warhol, beginning in 1974, filled, sealed and sent to storage." In the boxes Warhol put in photographs, newspapers and magazines, invitations, phone messages, objects and ephemera such as nail clippings, dead bees, acne medication, shampoo bottles, stamps, and much more. *Warhol.org* reveals that the collection of Warhol's ephemera consists of over 8,000 cubic feet of material and perhaps half a million objects.

In the NPR article "Dead Bees, Nail Clippings And Priceless Art In Warhol's 'Time Capsules,'" writer Lauren Over quotes Matt Wrbican, the Warhol Museum's chief archivist: "There's an interview Warhol gave pretty early in his days as a pop artist where he said that pop art is liking things," Wrbican says. "I can't think of a better expression of that idea than the *Time Capsules*. I mean, Warhol loved stuff." One might argue that Warhol's obsession with stuff reveals his obsession with himself, or more accurately with the preservation of his identity through the curation of memory. Pierre Nora likely would nod his head. "Modern memory is, above all, archival," he writes. "It relies on the materiality of the trace, the immediacy of the recordings, the visibility of the image. [. . .] it exists only through its exterior scaffolding and outward signs—hence the obsession with the archive that marks our age, attempting at once the complete conservation of the present as well as the total preservation of the past." He goes on to call memory nothing but a "gigantic and breathtaking storehouse of a material stock of what it would be impossible for us to remember, an unlimited repertoire of what might need to be recalled." In other words, because we simply do not know what will be important in the future, what we might need or want later, what might be necessary to call up from the recesses of remembrance, we

feel obligated and compelled not to destroy, but to collect, preserve "every indicator of memory" as a bulwark against forgetting.

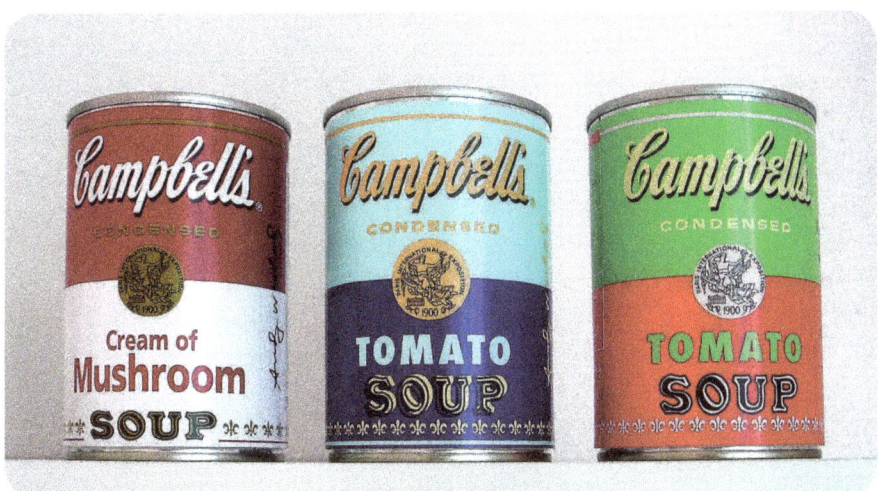

Figure 7: Special edition Campbell's soup cans with Andy Warhol's autograph. (Photo by Jonn Leffmann / CC BY 3.0, via Wikimedia Commons)

Warhol's preoccupation with "image" and with not being forgotten is not far from our own. His desire to remain "in memory" was part of the search for and active *construction* of his own identity, bound up as it is in a carefully curated world of material objects and their representation. Arguably, he succeeded in his efforts. For example, for many people Warhol *is* the image of the iconic Campbell's soup can he painted. The two, in popular consciousness, are nearly synonymous and inseparable. Even those who know nothing else about Warhol and his life's work are able to connect his name to a common pantry item and object of Americana.

But Warhol's project of "becoming Warhol" addresses more than identity's and memory's attachment to physical objects. Warhol did not desire simply to be an *individual remembered*; he wanted to be a *memory-individual*, something less susceptible to forgetting through the active and continued reconstitution of its own history. Nora explains it this way:

> Memory and history, far from being synonymous, appear now to be in fundamental opposition. Memory is life, borne by living societies founded in its name. It remains in permanent evolution, open to the dialectic of remembering and forgetting, unconscious of its successive deformations, vulnerable to manipulation and appropriation, susceptible to being long dormant and periodically revived.

History, on the other hand, is the reconstruction, always problematic and incomplete, of what is no longer. Memory is a perpetually actual phenomenon, a bond tying us to the eternal present; history is a representation of the past. [. . .] History, because it is an intellectual and secular production, calls for analysis and criticism. (8)

Under the influence of this new modern dynamic that has pitted history against collective, social memory, we also (albeit on a different scale and magnitude than Warhol) turn to the preservation of personal memories, making each of us our own personal historian. "The less memory is experienced collectively, the more it will require individuals to undertake to become themselves memory-individuals. With the careful curation of how he would be remembered and by manipulating the "mechanics of memory" through the accumulation of discarded objects that now must be sorted, catalogued, and analyzed, Warhol became such a memory-individual, himself a *lieu de memoire*.

* * *

The story of Warhol's *Time Capsules* has a less-than-remarkable beginning. It begins with a whole lot of stuff lying about. Tasked with having to "clean up the mess," writes Lauren Over for NPR, one of Warhol's assistants suggested that he instead put everything in cardboard boxes, call them *time capsules*, and continue working on them as works of art. And as Warhol is famously known to have said "I can simply be an artist without doing any art: I am the art," the 610 containers of ephemera seem to have proven him right.

And this sobering fact, that through discarded objects, scraps and literal trash Warhol solidified his place in history, gives the rest of us a bit of solace and redeems our preoccupation with material objects, those invaluable instruments of memory. Maybe those things we decide to stash away in our own cardboard boxes—that ill-advised purchase of a longhorn from a trip to Texas, the Barbie doll and the green or pink glass collection, or the always puzzling rack of souvenir spoons—stacking them inside storage units across urban and suburban America, know us better than we know ourselves, are how we really want to be remembered. Maybe their importance beyond ourselves has been overlooked. More than personal archives, they are cultural markers, with their own identities and stories that at the very least deserve a box or two from The Container Store.

Natalia

In the middle of season 9 of the popular TV show *The Big Bang Theory*, Sheldon Cooper, the show's quirky protagonist, reveals to his girlfriend his most hidden secret. He rents a storage space on the outskirts of the city where he keeps literally everything that he has ever owned, from a bag of used toothbrushes to a ping pong ball that hit him on the head many years ago. What would compel him to undertake the monumental task of preserving what amounts to trash? For an average person objects can function as mnemonic devices, anchors to a particular moment that we want to remember, offering a partial explanation of the reason we hold on to material possessions. But that is not the case for Sheldon, who in the show possesses eidetic memory, similar to photographic memory, meaning that he cannot forget anything. The objects he holds on to are not necessary for him to recall exact moments in time, be they connected to places or people. Instead, Sheldon's reason to never throw things away is his compulsion to control his surroundings, including material possessions. By keeping his things sorted out, neatly packed into bags and boxes and tucked away from outside intervention, he hopes to make sure that his belongings—and by extension, his world—is under control.

This hope is, of course, illusory, and yet Sheldon would be surprised at how many people share his delusion of the possibility to assert complete control over the material world. From Warhol's mania to catalogue physical traces of his existence to someone who is unwilling to let go of a non-functioning blue vase, we have placed ourselves at the center of the act of shaping our surroundings. In *Vibrant Matter: A Political Ecology of Things*, Jane Bennett takes to task the human fantasy to subordinate things, suggesting that to prioritize mind over matter is not only dangerous—leading to a utilitarian, colonizing appropriation of the material world by humans—but also profoundly errant. Together with Bruno Latour, Bill Brown, Ian Bogost, and other theorists of new materialism who are skeptical of the traditional subject-centered ontology, Bennett asserts existence of "active powers issuing from nonsubjects . . . the material agency or effectivity of nonhuman and not-quite-human things" (ix). In other words, things exist both within our subjective perception as well as outside of it. Human subjectivity certainly casts objects as icons, signs, or metaphors, mnemonic devices or recipients of emotional projection. And yet, this is not all there is to our relationship with the material. Without a consideration of an independent life of things outside of the process of signification, our understanding of human interactions with the world of objects would be incomplete. As Ian Bogost reminds us, "We humans are elements, but not the sole elements,

of philosophical interest. Object-Oriented Ontology contends that nothing has special status, but everything exists equally—plumbers, cotton, bonobos, DVD players, and sandstone, for example" (6). To believe that human will can take the upper hand over the rest of various actants in the universe is presumptuous at the very least.

What if someone like Sheldon did not have as much control over his world as he would like to believe? What if, in some way, objects had the ability to control their own fate, asserting themselves in the process of selection, calling attention to their properties, refusing to be discarded? Or, better yet, what if objects did not care whether we decide to keep or discard them, living their separate, independent lives irrespective of our intervention? What, then, happens to the objects that we do discard? The short answer is: they still continue to exist elsewhere, albeit possibly in a different shape or form; their removal from our limited experience does not signal that things simply cease to be.

One of my earliest memories is that of playing with little plastic animals in my grandparents' house in rural Russia. One of the architectural quirks of old Russian village houses is a special hole in the floor that leads to the basement, made specifically for cats to go in and out of the room without waiting for somebody to let them out. Cats were the main inhabitants of the basement of my grandparents' house, making sure there were no mice; most of the basement was unfinished and not accessible for people, with the exception of a small area where my grandmother kept jars of pickles and preserves. This design made it impossible to retrieve any objects should they fall down the cat hole to the basement. As a young child, I cared little about such details; my game, which I remember being entirely fascinated with, was to line little toys around the hole and knock them down one by one, watching them disappear in the dark abyss of the basement. One moment, the toys were there; the other, they were gone forever. When told that the toys were now trapped in the basement because of my game, I did not believe; in my imagination, they no longer were anywhere—they did not exist.

I was obviously wrong. What a profoundly humbling and alarming lesson: things do not disappear all that easily, even after they are removed out of sight. Matter defies human will. What is threatening about *stuff* is precisely its potential to accumulate, its resistance to annihilation. Numerous dump fills crammed with trash and storage units tightly packed with our belongings are not only a testament to the consumerist nature of the society that we live in, but also manifestations of the agency of matter, the excess of *thingness* that disrupts the ordered human world. Even as things decay and fall apart, their going out of existence is slow, and their very decomposition

asserts itself in a most aggressive, intrusive manner, getting in the way of our intention.

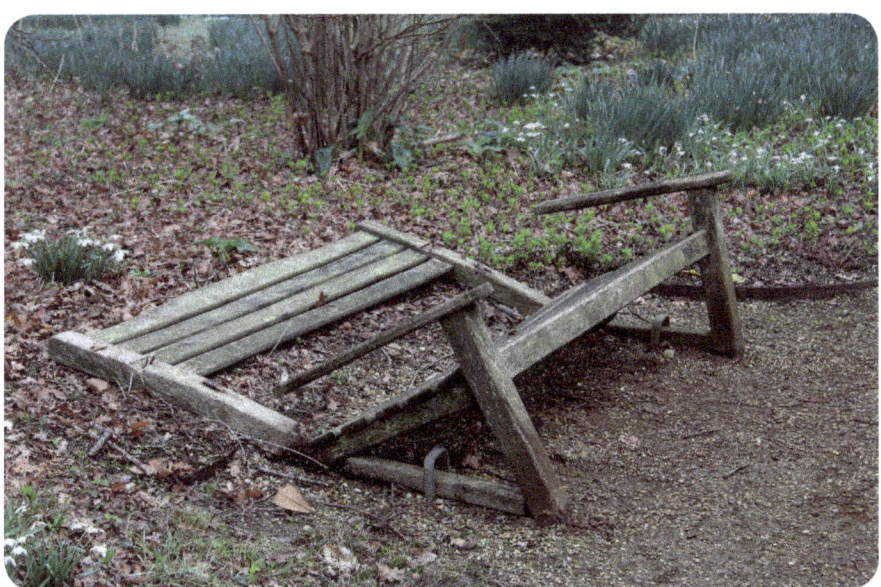

Figure 8: A broken and rotting park bench at Ickworth Park, Suffolk, England (Photo by Karen Roe / CC BY 2.0, via Wikimedia Commons)

One can even say that the intrusive agency of matter becomes most obvious when objects break. Once an object stops fulfilling its primary function and becomes useless from a strictly utilitarian perspective, it becomes a thing, explains the founder of thing theory Bill Brown: "We begin to confront the thingness of objects when they stop working for us: when the drill breaks, when the car stalls, when the windows get filthy, when their flow within the circuits of production and distribution, consumption and exhibition, has been arrested, however momentarily" (*Thing Theory*, 4). The distinction between an object and a thing is central to thing theory, whose aim is to better understand the mechanisms of the impact that things have on us. While the definition of objects is more or less clear, or at least predictable, things can be loosely described as "what is excessive in objects, . . . what exceeds their mere materialization as objects or their mere utilization as objects—their force as a sensuous presence or as a metaphysical presence, the magic by which objects become values, fetishes, items, and totems" (Brown, *Thing Theory*, 5). Bennett in *Vibrant Matter* echoes this definition when theorizing thing-power: "Thing-power gestures towards the strange ability of ordinary, man-made items to exceed their status as objects and

to manifest traces of independence or aliveness, constituting the outside of our own experience" (xvi). Both accounts emphasize the excess of meaning, excess of power that things hold over our imagination, their ability to leave an imprint on our lives, bodies, and minds.

Taking a closer look at the thingness of objects, their potential to be more than they already are, might reveal something about human connection with the material world beyond the one-way relationship of subordination. After all, our attraction to things is not always rational or even accidental. We are drawn to certain items and not to others, or we might say that some things speak louder to us than others. Bennett, for example, recalls a moment during a walk on the seashore when she froze in disgust, having stumbled upon a heap of trash: a plastic glove, a dead rat, a lump of oak pollen, a bottle cap, and a stick. At the same time, she says, she was struck by a realization of a unique singularity of each of these items, however banal they seem; a realization perhaps caused by the randomness of her encounter with these things, torn out of context. Especially revealing is her remark on the dual role of the items she spotted on the ground: "at one moment disclosing themselves as dead stuff and at the next as live presence: junk, then claimant; inert nature, then live wire" (Bennett, *Vibrant Matter*, 5). In the analysis that follows, she wonders whether her reaction to seeing the garbage was conditioned by the cultural meanings that we assign to waste or somehow caused by the properties of the things themselves. Do things stir our imagination simply because we want them to? Or is there perhaps *a thing* about certain things that arrests our attention due to some inherent qualities that cannot be reduced to functionality, be these qualities aesthetically pleasing or repelling, threatening or complying, inviting for collaboration? In other words, is the vibrancy of matter, the hidden thing-power that Bennett speaks of, a real factor or is it a yet another projection of our wishful thinking?

I say that the two are not necessarily mutually exclusive. Thinking in rigid absolutes is counter-productive, and to quickly dismiss the belief in the vibrancy of the material would mean to forbid any promise of a broader shift in the popular attitude to the ways in which we produce, consume, and otherwise engage with the material environment. Bennett believes that, "The figure of an intrinsically inanimate matter may be one of the impediments to the emergence of more ecological and more materially sustainable modes of production and consumption" (ix). Why not then entertain the possibility that two mutually complementing processes are happening simultaneously, or that, at the very least, there is a degree of unresolved tension between them? On the one hand, we endow things with meaning, inscribe, project, and impose our agency on objects, interpret them, use

them as instruments of memory, justify, rationalize, or romanticize our interactions with things. On the other hand, though infinitely outside of human perception, things exist on their own, age, move or remain immobile depending on various physical processes that impact them, get in the way of people or stay out of sight, resist or enable our agency, dictate through their various qualities our reactions to them. It is exciting to consider the affordances of a combined approach that focuses first and foremost on the *encounter* between the human and the material, acknowledging a potentially equal exchange of affects and meanings.

Certainly, much of the language used to describe the agency of things is anthropomorphic: agency, will, power, impact, resistance, etc, are undeniably words derived from the discourse on subjectivity. We can accept it as a limitation that is almost necessarily dictated by language as a tool of human expression and perception, a concession of impossibility to describe the experience of the Other. For W. J. T. Mitchell, otherness is the defining feature of a thing, "the moment when an object becomes the Other" (qtd. in Bennett, *Vibrant Matter*, 2). From a strictly phenomenological point of view, to recognize things as Others, alien to our experience, means to accept the futility of any attempt to know the experience of things from within, or, "what it's like to be a thing," to borrow from Ian Bogost, author of *Alien Phenomenology*. From a politically conscious perspective, this also means learning to treat the multiple Others in our lives with respect—be that things, people, or nature. "Accepting the otherness of things," Brown speculates, "is the condition for accepting otherness as such" (*Alien Phenomenology*, 12); in other words, a crucial prerequisite for a more egalitarian approach to the human–nonhuman relationship.

The encounter with the "alien" matter is a deeply poetic one. It forces you to do a double take, to look again at the object, this time attuned to its difference, the air of mystery around it, its unfamiliar features. Such an encounter more readily stays in memory, for we much better remember (even though we don't necessarily better *understand*) what is new and different, breaking the habitual patterns of our engagement with what surrounds us. As Lindsey Freeman, Benjamin Nienass, and Rachel Daniell point out in a recent issue of *Memory Studies*, there is a "surplus of meaning" in our encounters with objects, "including those objects that were not necessarily imbued with a memory value from their very beginning," ensuring "the involuntary and poetic effects of the material world on our experiences with the past and consequently a sense of agency imbued in materiality itself" (Freeman 7).

It is the alien in objects—their otherness—that inscribes itself in memory, because it forces the mind to reckon with the unfamiliar thing's

place among all that is known, typical, and expected, to re-adjust our mental picture of the world and see where the thing fits in our understanding. We don't remember objects—we remember things. When I visited my father in Russia during the summer of 2015 and we sat down to dinner as usual, catching up on the months between, I know we must have used spoons, forks, and knifes—but I do not *remember* them. They were merely objects fulfilling a role in the routine ritual of dining. I do, however, remember quite vividly the sight of my father eating his soup with a large wooden spoon that had originally been intended as a souvenir. With chipped lacquer, darkened wood exposed, the spoon called for my attention, similar to the way Andre Breton's attention was arrested by a peculiar wooden spoon that he purchased at a Parisian flea market.

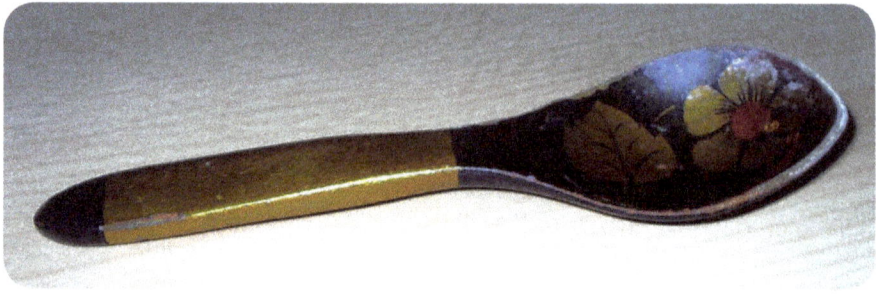

Figure 9: Decorative wooden spoon (Photo by Skyline at Russian Wikipedia / Public domain, via Wikimedia Commons)

Similar, but also different: Breton recalls having an image of a shoe, Cinderella's slipper, to be exact, on his mind for days around the time he bought that spoon. When he was suddenly struck by the likeness of the spoon's design to a shoe, then, the spoon stood out to him at least partially because it lent itself perfectly to being a projection of his imagination. The item's very oddity had made it impossible to dismiss as yet another ordinary object. The spoon in my father's kitchen, on the contrary, did not fill any slot premeditated for it by my imagination. Instead, it cut out a spot for itself, lodged itself in my memory. Whether because the spoon was re-purposed, used outside of the intended context of a souvenir on display, or because it stood in stark contrast to the other utensils that we used that day, or, maybe, because it made me wonder what it was like to sip hot soup from a wooden spoon, holding it at a certain, slightly awkward angle due to its size—whatever the reason, the thingness, the Otherness of that particular object made an imprint on my mind. I am wondering if the spoon will still be there when I visit my father again; and yet it almost does not matter: it will still occupy my memory even after it is gone, just like I still remember

vividly the plastic toys from my childhood disappearing game. Those, too, were alien things that initiated an encounter between subject and object. Ghostly things.

Out of sight, out of mind, as the popular saying goes. To discard something means to forget, to free oneself of the almost physical weight of memory. But how much agency do we really have in selecting what to forget? Even in their absence, things keep a powerful hold on us, and their physical presence, too, is defiantly persistent. *Mad Men*'s Don Draper, that charming manipulator of minds, faces the omnipresence of things on more than one occasion—and each time, he finds himself conquered, or at least confounded. Things don't simply disobey him; they come back to haunt him, reminding him of what he is so desperately trying to forget. One remarkable instance of this is the box of photos depicting his previous life, one he had led before the Korean War under a different name, before he stole another officer's identity. The box is mailed to him, but another person receives it and attempts to blackmail Don with the knowledge that the photos reveal. A human mistake, of course; but the material manifestation of memory, the box of photos that Don did not even realize existed, is what interrupts his present and powerfully brings back a distant past. Later, his wife, who knows nothing about Don's secret, discovers that same box in his study, and their world is once again shattered by the presence of a thing—material evidence—embodiment of a memory that everyone would prefer to ignore.

One more, very telling, example from the show is from Season 6, when Don throws away a lighter that again reminds him of the war and of his previous identity. His wife spots it in the garbage can and, thinking that the object is too valuable and probably ended up in the trash by mistake, rescues the lighter and puts it on Don's bedside table. Needless to say, his reaction upon seeing the lighter is one of dismay: the stubborn thing refuses to let go, uncannily inserting itself back into his life. He can throw things away in the garbage, but it does not guarantee freedom from memory. Things do not disappear: they come back to haunt us. In a culture of waste it is the waste itself that becomes an agent of memory and forgetting.

We attempt to control our possessions, reaching various degrees of mastery over them. We sort and categorize things compulsively, like Sheldon, in order to discipline the material world. We store things for future use or for representation, like Warhol. We sequester things in boxes, from our own and others' sight, like the man with his leopard print pumps in the NYC storage ad, in order to compartmentalize and keep separate the different parts of ourselves. We may even try to get rid of them for good, hoping to once and for all erase them from memory. In response, things remain, silently smirking back.

2 Between Here and Then: A Material Understanding of Time and Space

Andrei

In April 1959, at the age of thirteen, Eva Hoffman sailed from Poland with her family and immigrated to Canada. In her 1990 book *Lost in Translation: A Life in a New Language*, she writes: "Looking ahead, I came across an enormous, cold blankness—a darkening, an erasure, of the imagination, as if a camera eye has snapped shut, or as if a heavy curtain has been pulled over the future. Of the place where we're going—Canada—I know nothing. There are vague outlines of half a continent, a sense of vast spaces and little habitation" (4). Hoffman's disorientation is common among immigrants and exiles, with terms such as uprooted, disconnected, and dispossessed dominating the discourse on their condition.

Yet, this sense of feeling disconnected, *lost* and *disoriented*, is one precipitated as much by the disassociation, voluntary or otherwise, from a place of origin as it is by the separation from the ordinary objects that govern daily relations—be it our actions, habits, and exchanges, both with one another as well as with the objects themselves. I can't help but imagine the scene as a young Hoffman and her even younger sister make their way about the ship that would take them away from everything they had previously known, all that had made up their world—real and imaginary. What cherished toy did the two girls bring along with them for the long journey ahead? I imagine a doll, maybe somewhat sentimental I realize, or a stuffed toy, possibly a favorite book. Even more, what things were they forced to leave behind?

Later on in *Lost in Translation*, Hoffman recalls moments of her childhood, when still in Cracow, in her own room, she was filled with a sense of belonging, familiarity and comfort. "Occasionally," she writes, "a few blocks away I hear the hum of the tramway, and I'm filled by a sense of utter contentment. I love riding the tramway, with its bracing but not overly fast swaying, and I love knowing, from my bed, the street over which it is moving" (5). In that room, the space that she abandoned without choice, one also imagines the accumulation of childhood playthings, those less-than-crucial possessions that did not make the cut when choosing what to carry across the Atlantic: maybe wooden blocks that had not been played with for some time, a few plastic figurines, miniatures of domestic objects, and of course treasures such as bits of string, a rock or two, glass marbles and the like, whose value is difficult to calculate except in the mind of a child whose

world at times revolves around collecting and cherishing the mundane, the easily overlooked. Hoffman's nostalgia, or *tesknota* as she calls it (with an added emphasis on sadness and longing), is palpable in the way she describes feeling inside her room. It is precipitated by the severed connection to that childhood world—one that consists of place and all of the material trappings that come with that particular environment. It is no wonder then that she felt untethered, might feel so still, why immigrants might claim *lost* as their perennial condition and permanent place of residence. The tram in the distance, its sounds tracing the outline of familiar streets, the toy box protecting her material possessions close by, all of those things were embodiments of a familiar world, it made concrete and shaped Hoffman's relationship to Cracow; further, that relationship helped to shape her, conferring an identity that upon immigrating was irreparably torn apart, made *immaterial* in the sense that it no longer had the same recognizable body, a set of physical demarcations: city, building, street, room, bed, toy, etc.

That room that I'm imagining, somewhere in a Cracow that no longer exists, might as well have been my own in a pre-revolutionary 1980s Bucharest, Romania. There I lined up my die-cast cars, staged imaginary battles—though I can assure you they were a very serious matter to a six-year-old—using an army of toy soldiers and wooden block fortifications, which scattered across the room from make-believe explosions with an alarming rate. There I also remember watching at night scenes from favorite fairy tales projected on the wall, my father reading out the lines in a soothing voice. But most of all I remember that projector, the film rolls that we had to insert just so into the slot so that it would catch and turn courtesy of a black dial. And the smell—the head from the projector's lamp combined with the plastic of the film to create a smell that is still embedded in the imagination. And of course, there were sundry other objects such as shelves full of books, dolls, and the entire back of the bedroom door that I had, over several years, covered with stickers and magazine cut-outs to transform it into a giant collage.

Figure 10: A diorama by Stewart that uses dollhouse furniture from the artist's childhood, toys from Christmas crackers and gum machines, candy box letters, magazine titles, and more to bring to life an old American lullaby, "Hush, Little Baby." (Diorama © 2017 by Wendy Stewart. Photo by Kally Schoenfeldt, used by permission.)

When my parents chose to immigrate to America in 1991 following the Romanian revolution that had overthrown the Ceaușescus, we left everything behind. We left with one suitcase each, if that, and the clothes on our backs. I do not remember brining with me a single toy, though I very much wish it weren't true. Immigrants always talk of "starting over," "a clean slate," "new beginnings," "a new life," which in many ways is not only desired but also impossible to avoid. Strange and new become facts of life, intertwined, as the immigrant experiences himself in unpredictable relationships to both time and space. What is required of the immigrant is the abandonment of a certain identity associated with a specific time in history (memory of *how* it was *then*), as well as a sense of self curated over that period of time and which is depended on what we might call material building blocks of memory (*what* it was *then*).

It is exactly this spatial/temporal existence that is disrupted when one leaves one place for another in ways that lead to radical disorientation, a disturbance in the network of associations that had until that moment served as an entire infrastructure of being. Since our relationship to place is often enabled and mediated through things—buildings, streets,

monuments, works of art, household objects, furniture, toys, etc.—an immigrant's sense of place, and how to navigate that space in time, creates a (sometimes irreparable) dissociation between self and environment (not to mention within the self).

That is not to say that such an individual is no longer defined by an association with objects, but that the new objects and structures he encounters do not, and cannot, activate the same network of associations that he had come to rely on as familiar tools and points of navigation. Such an individual is without a recognizable place either at the hub of these associations or at points on the periphery.

Hoffman had referred to a Canada of the imagination as the "vague outlines of half a continent, a sense of vast spaces and little habitation." For many who have been uprooted, the feeling of existing within a vague delineation of space and time never goes away entirely. The space, with its new objects that communicate a new language and a new function, remains for the most part always at a distance. And time, quite literally a change in time zones but also the time it takes to readjust, is felt acutely as separate from the self and especially indicative of one's place outside of it. Such a condition—a warping of one's spatial/temporal existence—might be likened to a virtual condition, life in the abstract if you will. This is, after all, how one encounters life online—a space virtually without end and infinite. We've all had moments (days?) when going down the rabbit hole of the Internet has led to exclamations such as "I lost track of time" and "I have no idea how I got here"; and still, with the machine's digital clock always reminding us of the time, the Web's abundance of signs and easy to follow instructions, the Internet is one of the most disorienting experiences. We might be digital natives, but rarely are we at home. We live in the abstract, much the way the displaced experience their own lives—separated from the objects and places that had given their life meaning, and the time whose passing was recognized in the very relationship to those things.

Clearly memory persists in some sense into the present. Once lived, the past does not temporally expire, even though the event itself may have ceased to exist. Instead, it stretches out into the present, resonating in such a way that personal identity and collective identity become reinforced. This gesture of reinforcement does not mean that memory is solely the province of mental content, however. Memory is not simply confined to our heads, as it were. While it is true that without our brains, recognition of the past would crumble, it is nonetheless the interaction be-

tween persons and world that provides the genesis for remembering. Things in the world activate our brains, directing us in different paths accordingly.

—Dylan Trigg, "Scene and Surrounding," *The Memory of Place*

Dylan Trigg reminds us in *The Memory of Place: A Phenomenology of the Uncanny* that things reflect the ways by which an individual knows and constructs his reality, and this process requires being inserted, implanted in time. Something once lived extends into the present, and into the future. This insertion into time and the means by which we connect our past to our present is facilitated through the objects associated with that particular period.

I left Romania in 1991, and fourteen years passed before the first time I returned to the country. I expected to remember little and to encounter even less of what remained of my childhood. But much of what I had assumed would be long gone had been preserved by my grandparents—everything from toys to clothing to books. My elementary school uniform with its badges and insignias was still there, as was my collection of toy cars, an old rusty bicycle, my sled, and much more. It was an overwhelming feeling facing the past as if time had stood still. Part of me wondered why they bothered keeping all of that stuff when I would never use it again; part of me was grateful that I could look at those things one more time. As Trigg would put it, those things activated something in my brain—nostalgia, regret, appreciation, maybe even pride. Most of all those things gave me a sense that I was still in some way connected to that place. Through their very presence they transported me back to the days when I first encountered them, forging a connection between the two time periods. And because so many years had elapsed between those moments, they were invaluable tools in my attempt to reconcile who I was with who I had become. Where once there had been a rupture, an insurmountable gap of time, these objects were inserted and served literally as pieces of an identity puzzle.

But there was still the issue that while starting over in America we had accumulated an entirely new set of "American" objects. We had acquired new lives through the acquisition of new stuff, which dictates the "interactions between persons and world" (Trigg). We therefore understood our world, and each other, as always double, as split between *here* and *there*, *now* and *then*. When I returned to America after that first trip, and during subsequent ones, I brought back little by little some of the trappings of the old life. My parents' outdated and now irrelevant books on electrical engineering from the 1970s, some old shirts that my father would never fit in again, mementos from the revolution, a sea shell, some cut glass dishes. Most of the stuff is useless, has no real monetary exchange value, except that they now serve as reminders, anchors in time for the psychologically unmoored.

Between Here and Then

Figure 11: Handmade International Women's Day plaque (Photo by the authors)

I especially remember one item I brought back with me, an approximately 5"x9" piece of thin plywood, decorated by me using pyrography in a shop class when I was about eight or nine years old. The design is a simple flower, with the lettering "March 8" in a corner and a border reminiscent of lace. The plaque, which is what it most resembles, was meant as a gift for my mother on March 8, recognized as Women's Day internationally. It is not, however, a common holiday celebrated in America, instead replaced by Mother's Day in May, a holiday that we did not celebrate in Romania. And since my parents had opted for complete integration as soon as possible in America, we no longer celebrated Women's Day and instead followed the Mother's Day traditions. That particular day had essentially been torn from memory, had been eliminated from the way time was experienced in the new place we called home. When I brought back the plaque it was a small way of reinserting that day back into our consciousness, of making it again part of our identity. By bringing it back and giving it a new life, the object, a child's

simple school project, was reinserted back into time and gave us a sense of connection—to the past, tradition, to ourselves—but also created a fuller sense of place and time (a more complete spatial/temporal orientation) instead of the "vague" outlines that were created by the original dislocation.

<p style="text-align:center">* * *</p>

For my parents, as I imagine it must also have been the case for Hoffman's parents, the dislocation is much more violent, much more extreme. Certain objects over time become so embedded into the fabric of consciousness that they become inseparable from who you are, resurfacing as specters in the narrative of your life every chance they get. For my parents, one such object has an uncanny ability to come up in conversation more than any other. This "object" is a horse's tail, more specifically the tail of a statue of a horse and rider somewhere in the vicinity of the college they both attended. As my parents' friendship and courtship developed, the story goes that they would ask one another to meet on a specific day and time "at the horse's tail." That particular feature of the statue, but more importantly the location of the statue within the city of Bucharest, provided the coordinates for orientation in both time and space: we will meet *there* and *then*.

Such physical points of referral serve to *shape* space and time. Without such markers it is easy to understand the immigrant's sense of estrangement and disorientation. All of the *theres* he has known are no longer relevant, and because of that neither is his sense of time—how long does it take to get from place X to place Z? But one need not be an immigrant or exile to understand the role that material objects play in how we orient ourselves in space.

Let's start with the obvious claim that "things take up space." Let's imagine a new piece of furniture, say a TV stand, being brought into the household. That single item, by the virtue of the size and shape of its body, will take up a specified amount of space, displacing or rearranging anything else that happened to be in the space where it will now reside. Even if that space had been empty, the presence of this new object will dictate the placement and arrangement of all subsequent objects in the vicinity of that space. It will also, whether we are conscious of it or not, affect our own movement in and around that space. It will become a point of reference: the remote is next to the TV stand; the TV stand is too close to the wall; the TV stand needs to be moved in order to clean the floor; etc.

In the domestic sphere, we know by heart the placement of most of our material objects. With eyes closed we might even be able to make our way around a room by gauging the distance between things. When we travel and arrive in a new place, a hotel room, or while visiting a friend's house,

we endure periods of discomfort, we feel "out of place." What might be a more accurate statement is that we feel "disconnected from familiar things." It is for that reason young children often travel with a favorite (ragged, old, dirty) blanket, or a cherished toy. It brings comfort, it transports them to the place where they feel at home. We grant them this indulgence because we recognize the power that objects have to affect our emotions, even our physical wellbeing.

 I like to imagine Hoffman having such an object with her that transported her back to her room in Cracow, among all of the other objects that had to be discarded. I think of my parents and the statue that has probably long been removed to make way for new developments at the heart of the city and hope they will keep remembering that horse's tail—and through it the time and the place.

Natalia

"How can secret rooms, rooms that have disappeared, become abodes for an unforgettable past?" asks Gaston Bachelard in the introduction to *The Poetics of Space* (xxxvi). This classic work of phenomenology has long fascinated various audiences, from lovers of architecture to lovers of poetry. "Lovers" is a key word here, for the book is saturated with nostalgia and passion. To answer the question that he poses for himself, Bachelard closely analyses the example of the house of one's childhood, introducing two new terms instrumental to his methodology: *topoanalysis* (a "systematic psychological study of the sites of our intimate lives") and *topophilia* (a love of places). Through an attentive look at the places that we inhabit, this methodology suggests, we achieve an unprecedented understanding of ourselves, for places and people share a history of intimacy. Places shape us every bit as much as we shape them, if not more so.

From the very beginning, our perception of space is facilitated by objects: they demarcate the boundaries of a place, fill a place, divide and contour the spatial arrangement and direction of a place, mark its identity, and so on. Things are such a crucial component to our interactions with places that they are necessarily brought under scrutiny as part of topoanalysis. In fact, humans and things have forged such a strong bond that perhaps the term *resophilia*, a love for things, would be appropriate to express our attachment to things and appreciation of the work that material objects accomplish in furnishing not only our external landscapes, but also the interiors of memory. The connotation of "love" as a word to describe a sincere affection as opposed to a mere desire to possess is conceptually productive because it emphasizes the appreciation that we are able to experience for things regardless of their monetary value. As a concept, *resophilia* echoes what Martin Heidegger calls "staying with things," which means to spare, to preserve, to partake in the metaphysical oneness of the fourfold (the sky, the earth, the divinities, and the mortals). Such engagement with things consists of at least two separate components: one is curatorial, aimed at preserving and attending to the various objects that make up our lives, and the other relational, being attuned to the affects that things produce in us and the various ways in which we, in turn, affect things.

* * *

We can begin this multifold analysis with a simple statement: things make up a space. We know little about the enormity of the space around us, but we do know the room, the apartment, the yard, the street leading to school. When I think about this, I always recall a strategy computer game that I once

played that strikes me as an excellent metaphor for our exploration of space. It starts with a black screen, a sort of black fog covering the landscape from sight. The character you play is at the center of the screen; by moving the cursor, you make him walk around, moving away from the center, uncovering the parts of the land where he walks. As the character ventures farther away, more and more details that comprise this fictional world become visible: not only forests, rivers, and villages, but also tools, carts, stones, coins, wooden logs, and other objects, as well as people and animals. The goal and rules of the game escape me now as unimportant: it is the way you uncover the things around you and move more freely from one thing to another in the unraveling material world that rang the bell for me.

My narrow room, where the world started, was definitely the center around which things situated themselves and from which places unfolded in all directions. I can still vividly remember all the furniture in the room and how it was arranged. A desk with a reading lamp on a tall, bendable leg that looked like a heron. A pullout sofa. My teddy bears and dolls sitting in a row on the yellow, ribbed radiator. A wardrobe in the corner. Next to the wardrobe, a bookshelf that my grandfather had made for my mother's books when she was young, still admirably serving its purpose. My grandfather's left hand was paralyzed because of an injury suffered in WWII, so the bookshelf that he made was no masterpiece of craftsmanship, a little crooked, stained by the years, but still sturdy. I remember how looking at the shelf always made me think about the various *befores* and *afters*: grandfather had built the shelf after the war, but long before I was born; my mother had used it to keep her journals and books before she had me, and, after I was born, the shelf was assigned to house my books and toys, and so on. All those moments blended together to simultaneously exist in the wooden bookshelf.

Figure 12: Wall clock made from discarded vinyl record, St. Petersburg, Russia (Photo by the authors)

The tendency to ground memory in the material world can be explained through the way we perceive (or don't) the passing of time. "At times we think we know ourselves in time," Bachelard says, "when all we know is a sequence of fixations in the spaces of the being's stability [. . .]. In its countless alveoli space contains compressed time. That is what space is for." Memory, Bachelard goes on to explain, "does not record concrete duration . . . Memories are motionless, and the more securely they are fixed in space, the sounder they are . . . For a knowledge of intimacy, localization in the spaces of our intimacy is more urgent than determination of dates" (8–9). By asserting that memory is motionless, Bachelard inverts and challenges our conventional understanding of the relationship between memory and time. In memory we often say that *we recall*, by which we mean to bring something back, to summon back to presence, to officially order a thing or per-

son to return to a place. Temporality, indeed, seems to be less central to this definition than presence, situatedness, and spatial orientation. *Here* I recall *it*. The work of memory is to bring the past in alignment with the present, to make the two seemingly incompatible temporal layers be simultaneously in attendance—in other words, to materialize and manifest the past here and now.

But that is easier said than done. Because we are only capable of experiencing the present; the future and the past remain but abstract constructs that we are constantly, and vainly, trying to grasp. We are therefore in need of something that would serve as a measure, a tool instrumental to our perception of time, as we can only experience the past through something external to ourselves, such as cycles of the natural world or the perceived wearing down of the material environment. While both the object and the person co-exist in the same moment, the object is often perceived as if it were capable of simultaneously existing in the past, present, and the immediate future: *This object that I treasure as a keepsake belongs to the past, and it belongs to this moment, and it will still be here tomorrow.* By imagining the ability of objects to exist simultaneously as the embodiment of past, present, and future, we acknowledge their potential to function as the perpetual embodiment of memory.

Our ability to imagine the life of objects prior to and beyond the moment, however, is a double-edged sword. Because they have lasted they are endowed with excess symbolic value, and we continue to cherish them in part because we know that nothing lasts forever. Therefore, seeing how material objects have changed and anticipating how they might change through time allows us to situate ourselves in relation to time. When this change is insignificant, such as when we see objects or places that have remained unaltered for a number of years before we encounter them again, we have the uncanny feeling of how no time seems to have passed: *Everything looks as if [the remote event] happened no earlier than yesterday*. Conversely, when we do notice a change, we are able to witness the passing of time and, consequently, the instability of matter, including the body. Vulnerability of material objects to decay and decomposition serves as a powerful reminder of our own corporeality and our inevitable mortality.

* * *

If material objects function as anchors to the past, then loss of such objects effectively interrupts this connection. The moment of rupture between the body and the cherished material object redefines the self and finalizes our separation from the past. As a result, a gap forms between self and the world in which the markers of the familiar are no longer present. Since familiar things can serve as comfort objects orienting us in space,

their removal from our experience is capable of creating severe unease. Heidegger points at the direct correlation between our psychic state and how attuned we are to our material surroundings: depression can be described as a "loss of rapport with things" in which things "*fail* to speak to us, *fail* to concern us any longer" (102). While depression is an extreme example, a discord between the self and things can account for many cases of emotional discomfort.

Telling a story of a thing, then, is reuniting with it through narrative representation, which can have a therapeutic effect. When memory is narrated through things in their absence, however, the resulting account is one more degree removed from the actual experience that is being recollected. It is precisely at the moment of recollection that a remembered item firmly assumes the status of a historical artifact. In the stories from *The Afterlife of Discarded Objects*, absence of the remembered items further fuels the narrative drive to re-imagine the past, to invest new meaning in the narrated experience. This retrospective standpoint allows for double reconstitution of discarded items in the shared stories: first, from a worthless object to a cherished one, and then to an artifact of a specific historical time period represented through memory. In both cases, discarded objects are re-imagined through projection and cultural conceptualization. Shaped by nostalgia and wishful thinking, discarded items become representations of what is wasted, longed for, and aestheticized. Longing for an imagined past, we are eager to mold it from even the most unremarkable scraps. And, whether we realize it or not, together with a representation of the past, we are constructing a bridge to the future informed by our interaction with things, the single stable beacon unifying our experience and stabilizing it in time.

Perhaps, the significance of these recollections becomes more pronounced when personal and collective histories conflate, when the items that we remember are recognized to be uniquely created by a certain historical era or event. In one story, contributor Marina from Tomsk, Russia remembers building a staircase from the full collection of works by Lenin, "bright, red volumes" that nobody ever read: "they just stood there, collecting dust." The memory belongs to the late 1980s, shortly before nearly every household in post-Soviet Russia unburdened itself from these collections, giving them away to libraries, or, more frequently, simply dumping them in the trash. The collection, which could literally be found in every home, is no average item that transcends times and cultures; it is an artifact of the era that created it, engraved in the collective memory of a whole nation. I, too, have a somewhat similar recollection from just several years later, when Soviet-era memorabilia was being thrown away left and right: I remember finding on the street a set of intricate cheating sheets for an exam on the history of the communist party. They were folded accordion-style, with tiny

beaded letters neatly covering the paper from one edge to the other—a work of art, really; it is hard to imagine how many hours were spent crafting the now useless device. I kept the paper accordions for some time in a box, together with some Soviet-era star-shaped lapel pins; at some point, I got rid of the box's contents, not seeing any value in holding on to them.

Many years later, when traveling abroad, I saw pins just like the ones I had discarded at an antique shop, selling for what seemed like a fortune. How ironic. Michael Shanks, David Platt, and William L. Rathje call such reassessment of the meaning and value of things "a process of archaeological metamorphosis: mundane things come to carry the baggage of history; they become allegorical" (64). To facilitate such metamorphosis, time is essential: a certain time has to go by to provide the necessary distance from the events, to recognize objects as artifacts of the past, belonging to a different time, and subsequently, to deem them valuable. In archeology, which concerns itself with constructing knowledge of the past through studying the material remains of history, there actually exists a so called fifty-year rule used to determine relevance of material for study. According to the rule, any site that is older than fifty years can be evaluated for eligibility to be officially declared as historically significant. The rule is admittedly controversial, as it gives archaeologists a rather unreliable criterion to determine and justify value, as well as presents the public officials with added difficulties in managing the ever-growing sites of the history of modernity. What it demonstrates without failure, though, is the respect that the human mind has for the past, along with our clouded judgment with regards to the value of everyday objects. The very "stuff" of archaeology, Shanks, Platt, and Rathje remind us, is garbage: that which was once discarded.

* * *

Certainly, the discarded objects from our childhood games have not always had the symbolic status as representations of history. It is an acquired value, an afterthought, a trick that our memory performs as it attempts to provide an uninterrupted narrative of our lives. What memory singles out from the past is contingent, if not altogether accidental; and the objects we remember become invested with symbolic meaning merely by virtue of being randomly and unpredictably preserved in our recollections. Even adults do not often have the foresight to recognize an object as a potential historical artifact that will be of interest to scholars or collectors a number of years in the future; much less children who pick up playthings indiscriminately and lose them, in most cases, just as easily.

But narratives, especially historical ones, are in no hurry to admit their own randomness. More than anything else, archiving memories especially is an exercise in storytelling, in which the narrative drive necessitates

imposition of logic and meaning on the represented past. The impulse to tell a story of an item starts the chain of decisions: exactly what seemingly unimportant details can be deemed important? To compensate for the random nature of their recollections, our respondents construct a beginning and an end to frame the experience that they are sharing, provide reasons or comment on how unreasonable it was for them to invent games with the objects discarded by adults, and generally attempt to rationalize their experiences. One narrator, for example, speaking of her memories of a broken plate with a popular cartoon character pictured on it, wonders: "I still cannot understand why I liked that plate so much: I am not even a fan of that cartoon! I guess its image was ingrained in my imagination though, for each epoch stamps people's subconscious with different visual images and characters" (Sara, Yerevan, Armenia). According to the unspoken popular convention of storytelling, most narrators explicitly state the "moral of the story," be that the tragic loss of innocent pleasures of childhood or, quite often, a superior experience of the world before the imposition of technology: "I had a great childhood, without computers or cell phones" (Alexander, Yemanzhelinsk, Russia). Almost without exception, the contributors emphasize their appreciation for the lavishly imaginative perspective of childhood, unmarred by grown-up prejudices and boring concerns: "Before long, the illusions faded and the real world began to set in. . . . My creative and visionary past self evolved into what I have always dreaded to become—a dull, unimaginative adult" (C.B., Atlanta, GA). As evident from these examples, accounts of the past are consciously self-reflective, dependent on the different perception of the self *now* and *back then*. Temporal distance from the experience and a focalization in the adult perspective dictate the need to reassess the past, making sense of the otherwise fragmented recollections. In a sense, discarded items in these stories function as a McGuffin: a narrative device whose primary and sometimes sole purpose is to further the plot. A recollection of playing with an object is an excuse to tell a story of the Self, to explain oneself to oneself, to take stock of how we are and who we are now.

This realization, however, only reinforces our sense of resophilia, the idea of human dependence on material objects as intricately connected to our sense of identity: objects are the necessary props of both memory and self-expression. We surround ourselves with objects that are meant to serve as markers of our social standing, fashion taste, music preferences, cultural likes and dislikes, religious and ethnic affiliation, and numerous other tenets of identity. In our desire to communicate our beliefs and philosophical manifestos through material objects, we use them as signs of ourselves, as metonymical extensions of our own bodies and minds. We also, in turn, make our bodies into signs: we discipline the body through diets and physical exercise, style and groom the body, literally make inscriptions on the

skin with tattoo art, carefully control body language and the body's relation to space, equip the body with clothes and accessories, etc. These and other techniques objectify the physical body by shaping and modifying it to reflect a certain message. This two-way process goes beyond merely bonding with the physical world: we collate with material objects, designing a complex hybrid self that is firmly embedded outside of the biological body.

Figure 13: Old car and truck tires used to line a well used to draw water for a traditional Russian banya, Yurgamysh, Russia. (Photo by the authors)

Things that surround us in our daily lives eventually take our shape, molding around our bodies like a memory foam mattress. The older such objects are, the more pronounced is their role as material manifestations of memory, a function that Shanks, Platt, and Rathje describe as "material correlates for intimate personal experiences" (62–63). Eventually, while the physical body of the object deteriorates and its value as a functional commodity declines, its value as a memento most likely increases. Examples abound in anecdotal evidence, popular culture, or literature—you name it. The protagonist of the Showtime series *Shameless*, Fiona Gallagher (Emmy Rossum), who is being evicted from her childhood home, returns to it one more time before the house is taken over by the new owners. While the viewers see the house as falling apart and barely fit for living, for Fiona, every wall and corner partake in the personal history that the house embodies. To rescue at least some of the memories, she tears off a closet door that has pencil notches marking the height of her siblings as they were growing up. The door keeps traces of her family's story; a more effective account of the past than any diary, this piece of wood is an extension of their physical bodies, an embodied version of their selves in time ("NSFW").

* * *

In yet another example of embodied memory that Freeman et al. refer to in the opening of "Memory, Materiality, Sensuality," essayist Peter Stallybrass recalls how he was able to feel his departed friend's presence through wearing his jacket. Where memory as approached through language failed, memory embodied in the physicality of an object effectively worked to provide a connection with the lost person, a palpable, though illusory, bridge to the past: "He was there in the wrinkles of the elbows, wrinkles which in the technical jargon of sewing are called 'memory'; he was there in the stains at the very bottom of the jacket; he was there in the smell of the armpits" (Stallybrass 36). Remembering, Freeman explains, cannot be reduced to mere recounting; it is bringing to presence the moment that we are trying to remember; it is visceral, sensual memory that appeals to our bodily experiences and reflexes to recreate the past. Such remembering, *felt presence*, is most readily facilitated by things, since it is through things that we experience our connection with both place and time to begin with.

The relation between human beings and their things, then, is more than a simple metonymical association by proximity. To return once again to the childhood home as an example, Bachelard demonstrates how the material world impresses itself on our bodies by conditioning our responses to it:

> But over and beyond our memories, the house we were born in is physically inscribed in us. It is a group of organic habits. After twenty years of all the other anonymous stairways, we would recapture the reflexes of the "first stairway," we would not stumble on that rather high step. . . . We would push the door that creaks with the same gesture, we would find our way in the dark to the distant attic. The feel of the tiniest latch has remained in our hands. (Bachelard 15)

The affective capacities of our material surroundings shape our bodies' reactions and, consequently, participate in creating memory. This process can be partially accounted for by repetition, or formation of rote memory through regularly performing a habitual task. Invoking Heidegger, who writes that "dwelling itself is always staying with things," (353) William Viney in *Waste: A Philosophy of Things*, explains that "dwelling maintains this place through repetition; indeed the sense of location that we attach to a building is secured by repeated use and utilization of material objects" (132). The dwelling, the house, is an object solidified in memory and subsequently recalled through the force of repeated encounters. However, repetition per se is not sufficient; both Heidegger and Bachelard imply a feeling of singularity that accompanies the repetitive engagement with the house/dwelling, a unique intimacy that we forge with matter that is bound to stay in memory.

To Fiona, who grew up in the house that she is now forced to leave, the closet door is not an object: it exceeds its function as a door, just like the house itself is a home, which is much more than a mere architectural construction. "A house that has been experienced is not an inert box," Bachelard says, "Inhabited space transcends geometrical space." Inhabited—lived in, cared for, and purposefully readjusted—space interacts with its inhabitants repeatedly, and through that repetition, in its turn, comes to bear marks of their presence. The repeated action of marking the children's height on the door literally inscribed their bodies' changing in time into the materiality of the house itself. One can imagine the paint peeling off a windowsill from too much contact with elbows; a couch back showing an imprint of the owner's head, doorknobs polished to shine unevenly by the hands that touch it day after day. Through daily interaction with its inhabitants, the house records memory of their bodies, habits, likes and dislikes; it performs a diaristic, archival function of their lives. No wonder, then, that leaving one's house behind is so often experienced as being torn apart from oneself.

To some extent, leaving a place, especially the place that has become intimately familiar through a routine interaction, is necessary to be able to recognize one's connection with it. Parting with a familiar place and

the things that comprise it brings our intimacy with matter to the level of metacognition, makes what the body has known all along a part of subjective, cerebral knowledge. This epiphany effectively solidifies the function of matter to concretize time: things and places become anchors to the past, agents of memory, while simultaneously stretching into the future, claiming it with the sheer physicality of matter that persists and lasts. It is entirely understandable that humanity cannot conceive of the time machine other than a vehicle: a device of spatial navigation.

* * *

The bookshelf that my grandfather built years ago no longer exists; one day my parents got rid of it in a fit of remodeling. The refurnished room does look much better with the new matching bookcase and desk set, more spacious, filled with light. But when I think of my childhood room, I always see the old arrangement in my mind's eye; I see it from down up, as a young four-foot-tall child would. I am sitting on the floor next to the bookshelf; the touch of the rough, unfinished wood is warm under my palm. The smell of books. Their worn jackets with white tousled edges. I pick out a book and hold it open; a dried leaf from a walk in the woods the summer before looks back at me from between the pages.

3 Discarded Memory: History and Forgetting

Andrei

> *It is frightening to think how many things are made and unmade with words; they are so far removed from us, trapped in their eternal imprecision, indifferent with regard to our most urgent needs; they recoil at the moment when we seize them; they have their life and we have ours.*
>
> —Rainer Maria Rilke, Letters on Life

The twentieth century might not have seen the construction and eventual decline of its own Machu Picchu, Colosseum, or Acropolis, but it certainly has left behind a trail of disaster and decay, its own testament to the process of ruination that every building or monument must endure. Enter ruin photography, more commonly referred to as ruin porn—our modern fascination with visiting, recording, and sharing images of urban decay, abandoned industrial sites, and crumbling structures in desolate environments. Beyond mere fascination and leisure activity, proponents of ruin porn argue that it draws attention to issues of preservation and renewal. Some, however, don't buy that, which has lead ruin porn to acquire a bad rap, or at least a *tsk tsk* from certain critics. And that's understandable—the very term suggests objectification and exploitation, with an entire industry of images, websites, books, and disaster tourism dedicated to the glorification of contemporary ruins.

The problem with ruin porn, however, begins not with the word *porn*, as some might believe, but with the taken-for-granted wholesale application of the term *ruin* on all aging structures—buildings or monuments—that have fallen into various states of disrepair, decay, and general neglect. What if, I would like to suggest, a ruin is not always a *ruin*?

* * *

Edited by Ian Bogost and Christopher Schaberg, *Object Lessons* is billed as "A book series about the hidden lives of ordinary things." One book in the series is Brian Thill's *Waste*, which, according to the book description, "focuses on those waste objects that most fundamentally shape our lives and attempts to understand our complicated emotional and intellectual connections to our own refuse." Thill's book attempts to address the ordinary and not so ordinary things that shape our lives, but admits that, "Among [. . .] scattered objects, I am less interested in the decayed remnants of grandiose ancient

monuments than with some of the other classes of waste that have supplanted them in our age: buried video games; the slow leak of decaying plutonium miles below ground; the plastic bag caught in the tree; the accumulated wreckage in our attics, barns, and living room; the satellite debris hurling through space" (6). While his avowed interest in a litany of discarded items and accumulations of trash is understandable and certainly significant in its own right, the wholesale dismissal of ruins, ancient or otherwise, poses a problem when considering the crucial role they play in collective memory. Thill does raise the concept of *ruin porn* later in his book, but again I sense the approach is somewhat limited and provides a skewed perspective on the function of monuments and ruins with respect to the history of the communities they call home. Thill comments,

> No one actually living through the decimation and the end of all things, no one dying from pollution or surviving in a community choked with filth, would look upon the decay of the world and find beauty in it; but a sufficiently comfortable subject-citizen, on tour among the necropolises of old, indulging in a daytrip to the past, can allow himself to find something majestic and noble in the demise of peoples and communities and civilizations that are not his. (76)

Despite the admirable self-flagellation Thill engages in here as a Western academic "comfortable subject-citizen" aware of his and others' position in relation to "ruin porn," what is clear is that he looks at the concept solely through the lens of an outsider, as if no other perspective were possible, only that of an outsider looking in and seeing the beauty in destruction. As if all that the "native" or "local" can see is a world of filth and degradation.

Such perspective aligns with Jean Baudrillard's assessment of "The Object Destructured: Perversion" (*The System of Objects*). Baudrillard presents us with a relationship between possession and perversion, which Thill hints at, though I sense unintentionally, when he refers to "the demise of peoples and communities and communities that are *not* his" (italics mine). Certainly, the subject does not actually possess the objects of interest, but through the exploitative gaze, capturing it on film, video, etc., he takes symbolic possession of it and subsequently distorts/perverts it for his own needs. Baudrillard writes that,

Discarded Memory

Figure 14: Abandoned factory, England. (Photo by Copta / CC BY 3.0, via Wikimedia Commons)

> The effectiveness of the system of possession is directly linked to its regressive character. And this regression in turn is linked to the very *modus operandi* of perversion. If perversion as it concerns objects is most clearly discernable in the crystalized form of fetishism, we are perfectly justified in noting how throughout the system [. . .] the possession of objects and the passion for them is, shall we say, a *tempered mode of sexual perversion*. (107)

The possessed ruin "thus becomes a constituent 'object' in a series whose different terms are gazette by desire, and whose real referent is by no means the loved [object] but, rather, the subject himself, collecting and eroticizing himself and turning the relationship of love into a discourse directed toward him alone" (107–8). Baudrillard aims to explain his argument by drawing a distinction between how such a relationship plays about between people and between people and objects. While the tendency to "break the object down into discrete details" is slowed somewhat by the "unity" of a person, "When it comes to material objects, however, and especially to manufactured ob-

jects complex enough to lend themselves to mental dismantling, this tendency has free rein" (108–9).

Such has arguably been the predominant approach to vis-à-vis ruin porn, or to our fascination with ruins in general. They, like so many material objects, lend themselves to fantasy, projection, and reinvention. They lend themselves to dismantling and reconstitution. Baudrillard comes to this conclusion time and again: "The possibility of a destructuring is ever imminent"; "Such a structure is vulnerable to the human mind"; and "The object is discontinuous already—and certainly easy for thought to disassemble" (110–11). I place modern ruins among complex manufactured objects, susceptible to the possession-perversion dynamic, which, unlike everyday objects that we might possess outright, reveal our inability to control and fully understand them. They fascinate and frustrate, like a coquette who seems to dangle promises before our very eyes before abandoning us to the cold, naked stare. In our frustration with the convulsive nature of our relationship to ruins and in an attempt to come to terms with it, it has lead solely to a subject-oriented ontology, one that unconsciously privileges the *looking at* versus the things itself.

In this chapter, I argue that to get a better understanding of the role of modern ruins we must look at them not only through the lens of a camera-toting tourist on a drive-by site excursion, but through the eyes of someone whose daily commute or walk to the grocery store takes them past such structures. In other words, we must try and look at them not through a purely aesthetic perspective, typically afforded of the outsider, but through the frame of reference that pits the existence of such ruins against the daily tasks of picking up a child from school and deciding what's for dinner. I offer in exchange for criticism of ruinscapes a lyrical approach to *the thingscape*, one that foregrounds the *thing itself*, which has outlived its function, literally or symbolically, but nonetheless retains its singular qualities and remains inconspicuous, remarkably ordinary but for the fact that it has a life and we have ours.

To begin, we must acknowledge and honor a debt to much of the scholarship surrounding both ancient and modern ruins, the "ruin-gaze" and "present-day ruinophilia," as Svetlana Boym puts it. However, while adding valuable insight to our relationship with ruins in terms of the construction of social knowledge and shifts in political ideology, it nevertheless seems to be always oriented from the outside in, a vantage point that fails to consider fully that for a significant number of the population what we might call ruin is seldom seen as *ruin*. A matter of semantics, to be sure, but to name is to define and to erase simultaneously, and the term *ruin* is no ex-

ception to the rule. In this chapter, therefore, I propose that we think about memory and forgetting with and through the lens of ruin, with all of its attendant discourse vocabulary and politics, while acknowledging that any such approach threatens to exclude the vantage point of those actually living *with* and *in* what we have termed as ruins. Do such peoples and communities have no other recourse but to see their world as decimated and choked in filth, as Thill suggests, or does their encounter with the materiality of crumbling national architectures tell us something else entirely?

In "Beauty and the East: Allure and Exploitation in Post-Soviet Ruin Photography," Jamie Rann, for *The Calvert Journal*, explains the difference between a European attitude to ruins and that found in modern Russia. Quoting Andreas Schonle, author of *Architecture of Oblivion*, he writes that "The ruin is a trope of reflexivity, the reflexivity of a culture that contemplates its own becoming." Rann then explains that the recent popularity of Russian ruin photography could be "understood as a symptom of the absence of any grand outward-looking project; instead, contemporary Russia's big project is to try to understand itself," which takes on the appearance of an "introspective journey into the past and its ruined present." What Rann establishes here is the function of monuments and ruins as mirrors to the past and gateways to the future. The images certainly combine "beauty and destruction, worship and shaming," but in the encounter with such complexity is where the work of memory and forgetting truly lies.

Rann wrote his article partially as a critique of the book *Soviet Ghosts*, a photography book of post-Soviet ruins by Rebecca Litchfield. His critique certainly lands a few well-founded barbs such as the fact that in our fascination with ruin-porn photography, especially in the post-Soviet ruinscape, we run the risk of "glorification of design friendly fragments" and "emptying the Soviet period of actual ideology." But again it is a critique aimed at *us*, at the outsider-consumer who might have the leisure and specific intent to look upon such derelict objects with an "eye to design." "The twentieth-century ruin has become the preserve of countless urban explorers and enthusiasts of decaying concrete: the evidence of their obsession is spreading across hundreds of websites devoted to haunted asylums, silent foundries, vacant bunkers, and amputated subway stations," writes Brian Dillon for the *Cabinet* magazine. But there are too many rural areas in Russia and Romania, as a limited regional example among many, where the hardship and monotony of daily living makes the presence of such architectural elements (long by now in their ignominious decline) anything but a passing thought, if it gets a thought at all.

Figure 15: Unfinished and abandoned building in a field, Yurgamysh, Russia (Photo by the authors)

How, then, can we understand the role such structures play in the quotidian lives of a sheepherder or retiree or the unemployed whose favorite spot on a park bench puts him face to face with a crumbling statue of Lenin? Dillon again offers what seems to be a conflicting but promising approach: "The ruin, still with us after six centuries of obsession, is no longer the im-

age of a lost knowledge, nor of the inevitable return of repressed nature, nor even of a simple nostalgia for modernity. Instead, it seems almost a means of mourning the loss of the aesthetic itself." That assessment, aimed at the outsider perspective, rings true to a ruinophile. To the I-could-care-less-about-socialist-realism individual, the ring is somewhat hollow. However, Dillon offers another possibility, that such ruins create "a melancholy world in which, as Adorno put it, 'no recollection is possible any more, save by way of perdition; eternity appears, not as such, but diffracted through the most perishable.'"

The word *diffracted* in Adorno's quote seems crucial for me in understanding the function of modern ruins from the inside out as it were. To diffract means roughly to bend, diffuse, deflect, divert—the effect being anything but direct and predictable. The unpredictability here, however, comes not from what might be expected (though it is a factor), the idiosyncratic manner of decay, but instead results because individual responses to the encounter with modern ruins is as varied as each man or woman who sets eyes on it. And because such an individual looks upon the slow decay of his world not with a ruin-gaze nor with an obsession to understand but with the learned indifference of familiarity, the ruin is not perceived as a symbol of the past-present-future narrative with all of its attendant and delineated temporal dimensions. There is no sense of rupture or dislocation associated with the encounter—no explicit outpouring of nostalgia for an imagined past or a romanticized future ideal. Instead, the simultaneity of quotidian life with its plodding, natural forward momentum, experienced alongside decay and disrepair, results in a no man's land between memory and forgetting, eternity in suspended animation as you wait for your line at a bus stop built in the shape of a giant octopus.

Soviet Bus Stops, by Canadian photographer Christopher Herwig, is a collection of photographs of bus stops from across former Soviet territories, including Kazakhstan, Armenia, Lithuania, and more. From constructions featuring pyramids, arches, domes, vaults, mosaics, and shapes such as a fish, shell, a kalpak hat, and a concertina-like halo, the bus stops are anything but what you would expect. Yet, hundreds of such designs could be found mostly in rural areas now, along seldom-traveled roads, claimed by the weeds and the ravages of time. In a time of censorship of all arts, bus stop architecture seemed to enjoy an unusual amount of freedom. The aim for such structures, according to Oliver Wainwright for *The Guardian*, was to "emphasize the local" aesthetic. Today they are labeled as ruins, oddities of the landscape. "The ruin is hermeneutically 'elsewhere,'" writes William Viney, "composed of decomposing things, giving us locations by establishing relationships between dislocated objects" (128). And because

of both their alien shapes and their placement being often in nature, it is certainly understandable that one would take notice; that their presence would provoke a reaction, especially when their very materiality, their presence as elements in a *thingscape* interrupts our expectations. In a series of postcard-sized *Advertisements for Architecture* 1976–77, Bernhard Tschumi locates the ability of architecture to interrupt expectations and calls it an act of transgression. Referring to an image of Le Corbusier's Villa Savoye (as photographed in 1965)—crumbling façade, the whitewash peeling and dirty—he writes that, "The most architectural thing about this building is the state of decay in which it is," and continues below the photograph: "Architecture only survives where it negates the form that society expects of it. Where it negates itself by transgressing the limits that history has set for it" (qtd. in Heynen, 25–26).

Certainly, the notion of transgression in the face of history is clearly applicable to something such as *Soviet Bus Stops*. While we cannot separate politics from such a project, Boym also writes that our "fascination for ruins is not merely intellectual, but also sensual. Ruins give us a shock of vanishing materiality. Suddenly our critical lens changes, and instead of marveling at grand projects and utopian designs, we begin to notice weeds and dandelions in the crevices of the stones, cracks on modern transparencies, rust on withered 'Blackberries' in our ever-shrinking closets" ("Ruinophilia: Appreciation of Ruins"). In Boym's poetic rendering of the ruin encountered I see once again the use of "shock," and "we begin to notice weeds and dandelions in the crevices of stones" as indicative of a perspective that privileges the encounter as "new," as the first time the condition of decay had made itself conscious. For the daily commuter there is no "sudden" change of perspective, as if one day out of all others the existence of dandelions triggers an existential moment upon the realization that one is standing among relics of the past.

It could very well be the case, and I do not dismiss that possibility. But instead of a sudden coming into view of the ruin's material nature and its insertion into consciousness as a wedge between past and present, such ruins are instead fully integrated components into the daily negotiation of "memory events." We have incorporated them to the point that they seem organic to us, aware of their singularity only on rare occasions when something out of the ordinary prompts us to pay attention. When we experience ruins as components of history, however, argues French writer Eric Mechoulan, it is always "an experience of a caesura, of a rupture between past and present; it is structured by the loss of the past as present" (148). This, he explains, is an experience *of* ruins (much like a tourist taking a tour *of* the Parthenon). Such an experience unfortunately, however illumi-

nating, short-circuits reality. It is an experience *of* memory, rather than an experience embedded *in* the construction of memory itself (*in* ruins so to speak). While walking the dirt road home, two schoolboys kicking a ball back and forth alongside a crumbling larger-than-life-size patriotic mural experience the monument *in* ruin. They encounter the object as itself, another cog in the continuity of the eternal home-to-school-to-home drudgery of childhood; no caesura, no rupture by the experience *of* ruin. Yet, their experience is nonetheless just as important, if not more so, to our understanding of how discarded objects play a role in shaping memory.

Figure 16: A crumbling tile mosaic mural on the side of a former sports complex, Yurgamysh, Russia. (Photo by the authors)

I refer to the experience of the boys above as a "memory event" specifically to differentiate it from purely historical events, the chronological foundation of collective history. The memory *of* ruins, which sees itself as a part *of* history, seeks to bring experience into the fold of collective memory, a process that, according to John Gillis is full of "intense contest, struggle, and, in some instances, annihilation" (qtd. in Mechoulan). Yet, such a collective memory, Mechoulan adds, "we must beware, is not the same as traditional memory; it rests on the bedrock of history and its inscription on monuments" (150). In our expanding love affair with ruins over the past century or so, the struggle between object and space, object and environment, object and object, history often trumps memory.

We understand and we cite what we know from the engravings on the pedestals of statues, remarking on how it must have been and what things could have been like; seldom how it is. In quoting Walter Benjamin, Mechoulan sums up our critical blind spot in ruinophilia: "[to] write history thus means to *cite* history. It belongs to the concept of citation, however, that the historical concept in each case is torn from context" (147–48). This act of tearing is reminiscent of Baudrillard's notions of destructuring, disassemblage, and discontinuity, and to Tschumi's transgressing the limits of history. "[T]he task," Baudrillard argues, "is all the easier now that the object—especially the technical object—is no longer lent unity by a set of human gestures and by human energy" (111). Without the context of a lived reality, we can only cite, photograph, and discuss fragments of history—we keep them always at a distance, at bay, the *thing* desired a perverse sort of fetish because it seems less human, less alive.

When we talk *ruins*, we inhabit by virtue of our critical positioning a space outside of the ruin space. When we romanticize ruination, we tear the object out of its context, out of its quotidian now, both momentary and eternal in its indifference to history. And so, what we must keep in mind is that not everyone gets to write history, nor do they cite it as a habit. Many of us simply live *in* history, *with* and *in* memory—and that, much like the hundreds of thousands of obsolete or crumbling monuments to progress, seems to be too easily forgotten.

* * *

In the foreword to Bruce C. Swaffield's in *Rising from the Ruins: Roman Antiquities in Neoclassic Literature*, John Paul Russo recalls the work of Georg Simmel, who claimed that a ruin represents a balance and tension of opposing forces, with nature usually claiming victory over the human spirit and its material creations. "Although victorious nature takes its revenge on the spirit," writes Russo, "the ruin nonetheless conveys a sense of peacefulness to the extent that the opposing forces 'are working serenely together'" (x).

I am reminded by this quote of a scenario that I encounter each time I pass through certain parts of rural Romania. After making the half-hour drive from Henry Coanda Airport in Bucharest to the village of Hagiești, one must veer off the main highway onto a smaller road that winds through vast corn and wheat fields to the village itself. In these fields you are greeted by the sight of the crops but also by the sight of tall, concrete pillars, evenly spaced, whose sole purpose seems to be to point out that the sky still exists. During the 1980s those pillars were strung with electrical cables, carrying electricity from the center to remote, rural areas. In the chaos and lawless-

ness of the 1990s following the revolution, all of the wires were taken down by Roma gangs and stripped of their copper to be sold for a profit.

What remains of the communist government's attempt to modernize the country are empty pillars to progress, rising upward in futility. These modern thingscapes are present throughout much of the country (and I have yet to figure out what replaced their original function). But what I am also struck by now in retrospect is another common sight among those fields, mainly farmers with herds of sheep or cows bringing their animals there daily to pasture. I realize that my moment of recognition and shock when faced with the pillars is due in large part to the distance I have from them—both in space and in time. I see them as an outsider would, and I pick apart their history, connect it to that of the country, to its past and present, and I imagine each time the components of the act—someone climbing to the top of the pillar, pliers in hand, risking life, in order to cut down the wire; an act followed by someone else disassembling the thick rubber to access the copper, which was then collected, coiled, melted down, re-formed. I build in my head and reconstruct this story each time. I am a voyeur of a moment of destruction and its lingering decay.

Figure 17: Row of concrete electrical poles stripped of cables, Hagiești, Romania (Photo by the authors)

"Absolute lyricism is the lyricism of last moments," writes the Romanian philosopher Emil Cioran in *On the Heights of Despair*.

> In it, expression becomes reality, ceasing to be a partial, minor, and unrevealing objectification. Not only your intelligence and your sensitivity, but your entire being, your life, and your body participate in

it. [. . .] Such lyricism will never take an objective and separate form, for it is your own flesh and blood. It only emerges at those crucial moments when experience is expression. (57)

I crave that lyricism; in reality I'm still a critic. My iPhone is clogged with the ruin porn of my homeland. Meanwhile, the farmer is still tending to his flock. For him ruin and nature have merged into one; he does not see ruin any more than he has to think about the path he must take. So, he pauses in the punishing heat of August to take off his hat, wipe his brow, and lean for a while against the stone. After some time he leaves—the pillar damp from his sweat—and follows the same trail he followed the day before, and the day before that. The stone keeps doing what a stone does best.

Natalia

Wolfgang Becker's 2003 film *Goodbye, Lenin!* tells the story of Alex Kerner and his mother, Christiane, as they navigate the turbulent times of German unification. Alex's father left the family for West Berlin in 1978 when Alex was still a child, and in his absence Christiane, as a means to provide a sense of stability and purpose for herself and her family, became an ardent supporter of the Socialist Unity Party of Germany. In 1989, during an anti-government demonstration, Alex is arrested, an event inadvertently witnessed by Christiane. The shock gives her a near-fatal heart attack and sends her into an eight-month-long coma.

During Christiane's stay in the hospital and in the wake of the unification, her entire world changes as Western companies, products, and advertisements replace all that was familiar. As Alex readies to take his mother home from the hospital, doctors warn him that she is still in a very fragile state and she should avoid anything that might shock her again. To protect his mother's health, Alex devises an elaborate plan to recreate the world as she knew it prior to unification, down to individual household objects.

Unfortunately, Alex soon realizes that the things Christiane grew up with and which she remembered as a citizen of East Berlin are no longer readily available. In the rush to Westernize, the East Berliners have tossed out old furniture and replaced it with new Western items. Even familiar foods and brands have been replaced with new ones. To recreate a world that now only existed in Christiane's memory, Alex's project takes him to the neighborhood curbs and garbage bins where he must salvage and reuse what others had discarded without a second thought. It would not be enough simply to tell his mother that the world was the same—he needed to prove it through the material identity of that world, the signs that defined and gave shape to its existence. In one scene, Alex digs through the trash to find old jars of Spreewald pickles, popular in East Germany but no longer so, replaced by Western brands. Washed and filled with the new Dutch pickles, Alex presents the jar to his mother as if it were the original thing.

Lauren Shockey, writing for *The Atlantic* in her essay "In Former East Germany, A Search for Lost Foods," recalls a similar experience looking for the hard-to-find goods she remembered as a child. "But I didn't want the Vita Cola because I expected it to be a superior product," she recalls. "Coca-Cola has succeeded worldwide for a reason: it tastes really good. I wanted to buy Vita Cola because it is a vestige of a time that no longer exists. More so than any other commodity, food locates us, both spatially and temporally." She continues to say that often when the nostalgia for certain foods hits us "it is rarely the taste of the food itself that we crave. We are looking for the

moment, the locus. When Proust writes of his madeleine, he does not write of its sumptuous, buttery flavor or of the sweet, lemon-hued crumbs. I bet his madeleine probably didn't even taste all that good. He had to moisten it in tea, after all. At the end of the day, it doesn't matter how foods actually taste, because our memories will always tell us otherwise."

In one of the film's most iconic scenes, Christiane has regained some strength and ventures outside while Alex is asleep. She sees the old furniture discarded on the sidewalk to be taken to the dumb, as well as advertisement for Western companies. Yet, in what might have been Becker's most poignant depiction of the upheavals in identity during unification, Christiane sees a helicopter carrying away an old gargantuan statue of Lenin, his hand extended, as if reaching out to her.

Today in many Eastern European countries and satellites of the former Soviet Union, you would be hard pressed, as Alex Kerner and Lauren Shockey were, to find the same products that helped shape one's memories of life pre-1989. But what does remain, as prominent features of the landscape, and just as conspicuous as a flying Lenin statue, are the ruins and reminders of former Soviet-era monuments whose purpose had been to glorify the ruling party. When public attitudes shifted from glorification or even forced tolerance to open resentment, most monuments were dismantled and destroyed; those that were left intact—mostly in remote areas away from population traffic—slowly deteriorated. They might not be considered ancient ruins in the classical term—no Parthenon or Colosseum here—but they are nonetheless relics of a time past, ones that in many ways still inform individual and national identities to this day.

For Christiane her own identity was indelibly linked with that of the German Democratic Republic (GDR) to the point that any interruption in that connection—Lenin torn from his pedestal—was a traumatic experience. It is difficult to disentangle the personal and the social, as each of our individual recollections is inevitably informed by and constructed as part of what is referred to as collective memory—that of a community, a country, an era. Maurice Halbwachs points out that collective memory requires a negotiation of several narrative frames that would align personal recollections with what the teller of the story knows about the historical events that form the background of the story:

Discarded Memory

Figure 18: Statue of Lenin in central square, Yurgamysh, Russia (Photo by the authors)

[. . .] It is necessary to show that [. . .] in reality the past does not recur as such, that everything seems to indicate that the past is not preserved, but is reconstructed on the basis of the present. It is necessary to show, besides, that the collective frameworks of memory are not constructed after the fact by the combination of individual recollections; nor are they empty forms where recollections coming from elsewhere would insert themselves. Collective frameworks are, to the contrary, precisely the instruments used by the collective memory to reconstruct an image from the past which is in accord, in each epoch, with the predominant forms of the society. (Halbwachs 39–40)

According to this definition, memory of the past is shaped by the dominant ideology of the present, whether political or socio-economic. By implication, a change in the dominant ideology entails renewal of the collective frameworks of memory accompanied by disposal of the previously dominant ones. We can talk, therefore, of discarded ideologies and deterioration of collective memory. Interestingly, discourses of memory and knowledge often rely on metaphors of garbage and decay to underscore unreliability of memory. We speak about eroding memory; for example, the so-called decay theory in psychology claims that memory deteriorates with the passage of time due to the weakening of neurochemical connections in

the brain. Whether or not this theory is correct and there is, indeed, a direct correlation between accuracy of memory and passage of time, memory is also subject to other corrupting influences that are capable of altering our recollections. One can, for example, choose to forget certain details as a subconscious defense mechanism; make up fictional memories as wishful thinking, or confuse one's own recollections with somebody else's. The metaphors of decay, disposal, and waste underscore replaceability and impermanence of systems of knowledge, both personal and collective.

In the social construction of history, what we forget is just as important—if not more so—than what we remember. Forgetting, both intentional and involuntary, relates to disposal of the material manifestations of memory. While it might seem relatively easy to throw away old photographs and burn diaries in an attempt to forget a personal past, a whole nation's past is more difficult to erase due to the monumental scale of its investment in the material environments. When institutionalized ideologies compete with and replace each other, they leave behind what George Bataille would refer to as expenditure: the detritus of the ideological systems' material infrastructure, both utilitarian and symbolic (*Visions of Excess*). As one epoch is replaced by another, its material backdrop, predictably, also becomes obsolete. The stage props change with the change of ideology, forcing sites and objects of memory into oblivion. In a series of documentary images portraying the once iconic communist memorials in Bulgaria, now abandoned, photographer Nikola Mihov explores the paradoxical connection between memory and forgetting. On his website *nikolamihov.com* this is how Mihov introduces his project that bears a rather fitting title *Forget Your Past*:

> The title of the series is borrowed from graffiti writing over the entrance of the Bulgarian Communist Party Memorial at Mount Buzludja that poignantly illustrates the fate of the communist-era monuments in Bulgaria. Constructed at enormous expense as expressions of national pride, today most of them are looted and neglected. Whether they commemorate the feats of the Soviet Army or the April Uprising against the Ottoman rule, they all share a common fate—to be silent symbols of the forgotten past.

As Mihov points out, archival documentation that described the history of these monuments has been mostly eradicated. However, the monuments themselves serve as reminders of the past, difficult to erase because of the sheer size of their material presence. Ousted from the public's attention and neglected, the sites are in a liminal state, both resilient to oblivion and vulnerable to decay. What is perhaps most intriguing is that the ruins embody the lingering significance of the past, whose socio-econom-

ic and political consequences have ultimately proven challenging to ignore (as "sites and objects of memory" one is reminded of Confederate monuments in the American South, whose presence and subsequent removal in recent years has forced a necessary, and sometimes violent, reckoning with the past). By its very presence, decay calls attention to itself and in effect monumentalizes—for better or worse—the very memory that it is supposedly destroying. How individuals and nations attend to this memory (by placing them in appropriate historical context in museums or storing them out of sight) remains a contentious and controversial issue.

Figure 19: Robert E. Lee statue at Lee Circle New Orleans removed. Block party festive atmosphere of people waiting on Howard Avenue. (Photo by Infrogmation of New Orleans, 19 May, 2017 / CC BY 2.0, via Flickr)

The Afterlife of Discarded Objects

* * *

"Looking for Lenin: Hunting down Banned Soviet Statues in Ukraine," an essay by Liza Premiyak for *The Calvert Journal*, tells a fascinating story of a Swiss photographer-and-journalist duo in a similar search of remains of the Soviet past. The escalation of the Russian-Ukrainian conflict in 2013–2014 started a massive demolition of monuments to Lenin across Ukraine, a phenomenon that was playfully nicknamed Lenin-fall (*Leninopad*). According to the essay, over nine hundred monuments were brought down across the country; I imagine this number has since increased and is still rising as we speak. When caught up in the spectacle of history in the making, Premiyak says, it is "easy to forget about the physical debris left after such a symbolic gesture as the razing of a monument." Niels Ackermann and Sebastien Gobert set on a journey to trace the fate of the fallen Lenins, hoping to find out exactly what happens to the monuments after they are knocked down, when the crowd's attention has turned elsewhere.

As it turns out, the fate of these particular monuments is rather amusing. Ironically enough, these statues, while now officially banned in Ukraine, still cannot be legally destroyed without official permission: as state property, they are protected by law. Jumping through the bureaucratic hoops to receive such permission, however, is usually too much trouble. Consequently, the downed Lenins were moved to neighborhood dumps or outside of cities, albeit, probably, in a less dramatic manner compared to the helicopter ride accorded to the statue from *Good-bye, Lenin!*. In the most interesting scenario of all, the statues were disassembled, with small fragments of the statues leaving in different directions. Ackermann and Gobert document chasing various Lenin-parts, finding them in museums, private collections, art galleries, dumps, business offices—the list gets curioser and curioser. "We heard about someone who had the ear of the statue," Ackermann and Gobert recall about the search for the largest Lenin yet, the one from the central square in Kiev, "then we found someone else who was supposed to have the nose." The photo series features falling apart Lenin-heads scattered across the country: one tucked under a table in a museum storage room; another lying face down in some bushes; yet another facing the fence in what looks like somebody's backyard, next to Mayakovsky, Engels, and a couple of less recognizable Soviet figures to keep it company. Discarded, but not easily destroyed, they continue to live their curious lives in most unexpected places.

Other countries of the Eastern bloc faced with the same dilemma of whether to preserve or to dispose of monuments of the past have dealt with it in a variety of ways, both similar to and radically different from the

Lenin-fall in Ukraine. In Budapest, Hungary, Soviet-era monuments are gathered together in the Memento Park in the outskirts of the capital. Perhaps, the most famous exhibit in the park is the statue featuring dispossessed boots: back in 1956, in an outrage against the oppressive regime, citizens of Budapest blew up the statue of Stalin, with only his boots left standing on the podium. The pair of boots in the Memento Park, though, are not the original but a replica; ironically, it is now a monument to a monument once destroyed, and to the defiant spirit of the nation. Similar monument parks—depositories for the great discarded—can be found in Lithuania (Grūtas Park in Vilnius, also known unofficially as Stalin's World) and Russia (Muzeon in Moscow, usually translated into English as Park of the Fallen Heroes). The parks seek to isolate the statues while preserving them. Once triumphant figures looming over public places, they are now prisoners rotting in seclusion, yet still attracting onlookers lured by the grandiosity of their fall.

Poland, too, is set to demolish five hundred communist monuments as of 2016, planning to transfer them to museums where they will serve as "a witness of hard times," according to Lukasz Kaminsky, head of the Institute of National Remembrance. Monuments to Lenin, once again, become the most obvious target. In a controversial gesture aimed to attract tourists, the Polish town of Nowa Huta erected a newly built fluorescent green statue that depicts Lenin relieving himself. The statue, which was created as a part of the 2014 Grolsch Artboom Festival, is called "Fountain of the Future," but it is first and foremost a commentary on the country and the city's turbulent past. The peeing Lenin replaces the now discarded bronze statue of the communist leader solemnly looking over the city. Whether intended as merely a joke as the artists claim, or as subversive ridicule and a political statement about nationalism, the new statue is impossible to read without a reference to the previous one, and by extension, to the memory of the past that still refuses to be forgotten.

The Afterlife of Discarded Objects

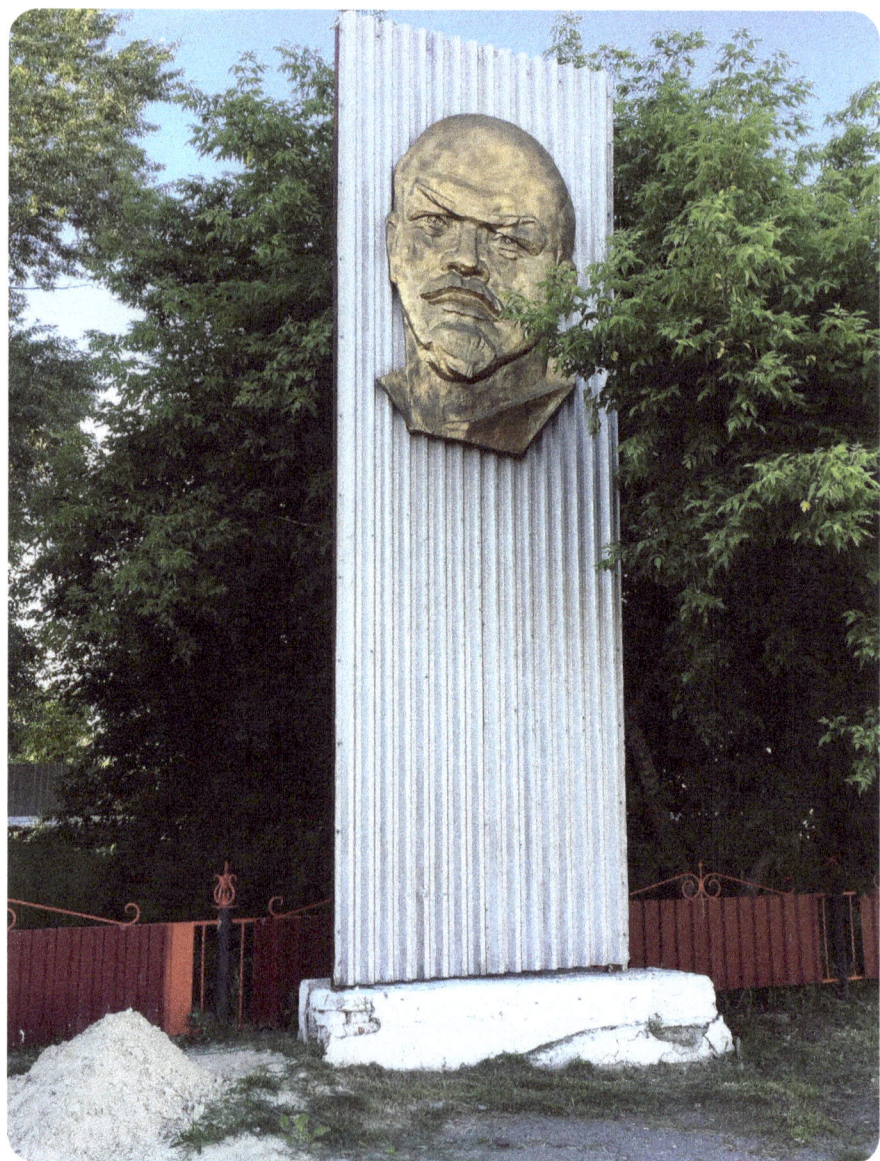

Figure 20: A pile of sand next to a bas-relief of Lenin, presumably to be used to repair the crumbling base, Yurgamysh, Russia. (Photo by the authors)

In Russia, once home to Lenin et al., public attitude toward the old monuments is much more ambiguous. For one, Lenins across the country still remain standing, hovering over central squares, even though they are not getting much attention from the crowd. Teenagers gather there to lis-

ten to hip-hop and practice parkour moves on the steps leading up to the ex-leader's figure, mostly oblivious of what he represents. At times, though rarely, monuments become sites of protest, stirring controversy and making the news. In April 2015, the city of Chelyabinsk, Russia, woke up to see a bust of Lenin in the center of the city painted in the colors of the Ukrainian flag. The authorities promptly covered the bust with a black garbage bag until it was possible to erase the recent artistic addition to the sculpture. I am not sure how long Lenin spent with his head wrapped in a garbage bag, but the image is both grotesque and uncanny, a vivid piece of evidence to the power that monuments—their afterlives and metamorphoses—have over human imagination.

Far more often, however, the sight of Soviet monuments merely invokes sadness or, more commonly, indifference on the part of Russians passing by the granite figures on the way to work. The statue of Lenin in the village of Yurgamysh, Kurgan region, where my parents live, has stayed untouched and, for the most part, invisible throughout the past decades. Slowly deteriorating and surrounded by weeds, he barely gets a second glance from passersby. I believe that the most attention he has received since the fall of the Soviet Union is when locals joke about his pose: with a pathos-filled gesture, Lenin is pointing in the direction of the local cemetery. "That's the right way to go, comrades!" they say and chuckle, and, as far as I can tell, this is an existential statement more than anything else, not a political opinion, not a critical judgment or call for action, but an ironic reflection. Ideologies come and go, granite crumbles, and people take a moment in their day to ponder the significance, or lack thereof, of this all in the grand scheme of things.

In 2015, in preparation to celebrate the seventieth victory over fascism, the village authorities restored the Memorial to the Unknown Soldier situated in the same square and gave Lenin a coat of fresh paint at the same time. I sort of liked him weatherworn and sun-bleached, though. The monument looked truer to itself, somehow, before it was painted white again. Sometimes, it seems, leaving traces of decay untouched accomplishes more than painting them over. I would like to ask the monument's opinion on this, but he keeps busily looking away into some future invisible to everybody else but him.

From Galatea to the Stone Guest and the Bronze Horseman, to the animated Lincoln Memorial from the second part of the film *Night at the Museum*, humanity has always played with the dream of statues coming alive. Perhaps, the anthropomorphic features that we endow statues with are the main reason for this sustained fantasy, but I suggest that the thingness of the stone figures, their powerful material presence, have something to do

with it as well. As a somewhat sinister joke, I imagine the discarded monuments across the world coming to life, stretching their limbs numb after the long immobility, flexing their shoulder muscles, rolling their necks. The cubist-inspired figures of Marx and Engels in the Memento Park are holding hands. Stalin's boots are performing a tap dance. Best of all, numerous Lenins with missing ears and noses join the carnivalesque nightmare gesturing to each other, while the one with his head wrapped in a garbage bag is still trying to point in the right direction: "That's the right way to go, comrades, the right way."

4 Unbecoming Garbage: The Spectacle of the Archive

Andrei

Jacques Derrida in his groundbreaking *Archive Fever* employs terms from Freudian psychoanalytic theory to explain our fascination, even obsession, with preservation of memory through archives. The archive desire, he suggests, compels us to save memory from annihilation, to resist the effects of what Freud interchangeably called death drive, destruction drive, or aggression drive. The death drive is constantly at work to eradicate every trace of memory—and therefore of life, its pleasures and traumas, its events that are reflected in archive-able materials and records. While it can manifest in physical destruction of archives, more generally it is also a disregard for artifacts and overall resistance to memory. In other words, it is the drive to erase the significance of events and recollections and ultimately reduce them to silence. Conversely, the archive desire ensures representation of the past, assembling a collection of items that ultimately serve as signs that can be put together into a coherent narrative.

According to this logic, the process of assigning value to objects—and preserving them either physically or through narration—is an on-going negotiation between memory and forgetting, presence and decay, life and death. To engage with discarded objects, then—via play, preservation or reuse—achieves no less than to keep them alive, creating meaning and purpose. Later, memory remediates these objects through a narrative, retrospectively projecting a multitude of possible other meanings and emotions upon one's experience of the object, and by extension, upon the object itself. Admittedly, what part of the original experience survives through memory is arbitrary; no more arbitrary, however, than any archivist's decision on what constitutes a collection of records or artifacts.

Once we acknowledge the contingent nature of the archive, it becomes clear that archival work implies a series of deliberate acts of inclusion and exclusion. This process is essentially a racing game against time; a negotiation of what parts of our experience will receive a chance to escape annihilation. Paradoxically, the more memories are included in the record, the more palpable is our awareness of what is left out due to the limited resources of memory, archival technologies, and the mere existential impossibility to fully embrace—and express—any human experience. What remains unaccounted for will eventually escape all recollection and perish. With this in mind, an archive of memories about trash serves as a meta-commentary

on the unstable status of both memory and the material world, their troubled existence on the edge between creation and corrosion.

Ironically, it is the danger of annihilation that ignites the archive desire in the first place: the two contradicting drives to preserve and to destroy are linked together and are prerequisites of each other's existence. Together, they constitute the archive fever. Clearly, the desire to record memories and preserve objects that represent events comes from a place of uneasiness; indeed, from a feverish unrest. Hence the term *mal d'archive*, which in French has connotations of sickness, but also obsession or passion. To have archive fever, Derrida explains, is to be "in need of archives:"

> It is to burn with passion. It is never to rest, interminably, from searching for the archive right where it slips away. It is to run after the archive, even if there's too much of it, right where something in it anarchives itself. It is to have a compulsive, repetitive, and nostalgic desire for the archive, an irresistible desire to return to the origin, homesickness, a nostalgia for the return to the most archaic place of absolute commencement. (*Archive Fever* 57)

No matter how powerful the drive to return to the origin, however, the archive is only able of constructing a representation of the origin. Memory of a thing does not equal the thing itself; it is nothing more than a medium to indirectly connect with the desired experience. The frustration of falling short of the ideal prototype is embedded in the archiving process. The archive is ever-so-conscious of its inherent failure to recreate the past, instead offering a version of the past that can never fully approach the lost truth of the "absolute commencement."

* * *

In the late twentieth and early twenty-first centuries, archive fever has quite literally caught on fire. On January 31, 2015, a fire at a *CitiStorage* warehouse in Brooklyn, NY destroyed decades of medical records, court transcripts, financial documents, and more. As the fire tore through the 1.1 million cubic feet of storage space, hundreds of thousands of files were subsequently scattered by the wind along the waterfront and the neighboring streets of Williamsburg. In "Fire at a Brooklyn Warehouse Puts Private Lives on Display," Vivian Yee for *The New York Times* writes that the fire "revealed a scattering of records stamped 'confidential,' a health insurance form with a person's Social Security number, a urinalysis report complete with a patient's name and copies of checks featuring bank account numbers."

Unbecoming Garbage

Among the photographs accompanying the article is that of a mound of debris on top of which sit a couple of black and white images of the same man in an open shirt with a large tattoo of Jesus emblazoned in the middle of his chest. Although the caption does not specify, given the large number of criminal court records that were damaged in the fire, the likelihood that the man could have been a convict is quite strong. The image is jarring for multiple reasons: the man's languid, easy stare into the camera that gives it the appearance of a candid photo, and the way we become engaged in the construction of a narrative out of mere scraps of information. To encounter this image is to partake in the work of archive, assembling from an accumulation of various signs a sense of story, an irresistible desire to pick up the pieces in order to remember, to know.

Figure 21: Damaged book and papers following a flood, Binghamton, NY (Photo by the authors)

The story told by those two photographs of a single man is only one of thousands that had been crammed into cardboard boxes and stacked on endless rows of shelves. When the fire gutted the storage space it was an event that epitomized and embodied the death drive and archive fever meeting in a head-on collision, a push-and-pull between life and death. Even as the fire attempted to destroy what had been saved for years, to eradicate from memory and render them silent forever, the kept records exhibited the ultimate form of self-preservation, refusing to disappear. We could ar-

gue that in its resistance to annihilation the archive possessed and affirmed a "metaphysical will," what Arthur Schopenhauer called in *The World as Will and Representation* a "will to live." It took days for firefighters to put out the fire completely, the flames and the files engaged quite literally in a battle of survival. In the end, the fire consumed nearly everything, but the face of one man, now preserved in yet another archive, still looks at us up from the ashes and says "I existed," "I still exist," "I had a life."

The Williamsburg warehouse fire is an example of the tortured and dynamic relationship between the death drive and archive fever, but it is also a small glimpse into the scope and magnitude of the *state archive* apparatus and its relationship to the lives it affects.

According to Shayla Jacobs for the *New York Daily News*, the lost *Citi-Storage* records included:

- 85,387 boxes from the New York State Office of Court Administration (mostly closed cases from all five boroughs)
- 19,108 boxes from the criminal division of the Manhattan Supreme Court (case files and court transcripts from felony matters between 1940 and 1998)
- 34,187 boxes of family court files (dating from 1954 50 2006)
- 1,213 boxes of Manhattan Supreme Court Civil Records (dated 1911 to 1954 and 1985 to 1997).
- 18,721 boxes from the Brooklyn Supreme Court (civil) (dated 1873 to 1941)
- 7,668 boxes from the Bronx Supreme Court (dated 1983 to 1995)

One can only begin to guess at the total number of individual files, names, cases, and lives crammed into those boxes—the sordid stories, the tragedies, all that was once deemed confidential and secret. And it bears pointing out that the above figures reflect only a *small fraction* of archival material for the city of New York, the bulk of which is scattered throughout numerous other storage facilities in and around the city. But those numbers, however mind-boggling they might appear, pale in comparison to the maniacal archiving impulse exhibited by some of twentieth century's political regimes. In *Archive Fever*, Derrida writes that, "[T]here is no political power without control of the archive, if not memory. Effective democratization can always be measured by this essential criterion: the participation in and access to the archive, its constitution, and its interpretation" (11). And nowhere is this clearer in the twentieth century than in communist, authoritarian states that literally sought to destroy their opposition, to erase entire portions of their citizenry, while simultaneously putting in place a surveillance mechanism that would record and preserve every detail of a person's

conversations, whereabouts, correspondence, even their trash. Repressive totalitarian regimes turned archiving—a combination of written texts and visual records with their own internal logic and system of signs used to catalogue and categorize—into a macabre kind of art form as a means to and expression of power.

In *Paper Cadavers: The Archives of Dictatorship in Guatemala*, Kirsten Weld reveals that during the country's 36-year-long civil war from 1960 to 1996 the archives of the National Police contained seventy-five million pages worth of secret state records, the largest ever to be discovered in Latin America. The book's cover is telling in itself—bound parcels of paper documents tied together with plastic cord or twine, the handwriting still visible and giving them the appearance of personal, intimate correspondence. One such file shows a set of fingerprints, while on another one the face of a man looks back at us, much like the man captured in *The New York Times* photograph.

I find it apt that both the cover of *Paper Cadavers* and the lead image of "Fire at a Brooklyn Warehouse Puts Private Lives on Display" feature a person, the human face behind the archive. *Paper Cadavers* reminds me of the saying "Dead men tell no tales," and how far from true it is, especially when in this case the archives speak as it were from beyond the grave. I am also reminded of a story I have kept coming back to over the years, almost compulsively against will and reason, of my own grandfather's fate in Romania under the communist dictatorship. As much as I could piece together from second hand narratives, my grandfather on my father's side, Ionel Guruianu, held a job where he was required to keep records on the distance traveled and gasoline used by vehicles in the city's transportation systems. As he made his way up the ranks he was put in charge of other files, the ones that kept detailed records of what people said when they thought no one was listening. He might not have been an informant himself, but when asked rather convincingly by those who have the means to make your life a living hell to help them for the good of the party, there is little recourse. He did not like his job, nor what he saw written in those files, but turning down the position was not an option. And it was, after all, a position of power.

One day a colleague asked for a favor. The man had spoken up once, likely something that was deemed a threat to the party, and someone had overheard, told someone else, and the event had been permanently inscribed in his file. He was marked from then on, that paper trail haunting his life and his career. The man asked my grandfather to help make his file disappear. Grandfather said he would; he destroyed the file. They were friends. Then someone heard about it, or saw, or it could even have been that same friend-turned-spy with a different agenda. Grandfather was tried and found guilty. He did time in jail for burning the papers (fire and

archives indeed have a long tortuous history), which meant that he would have from then on a file dedicated to him, to his daily routines, to his conversations, and to his interactions with family and friends. That file would have grown until his death, and in it there are likely details about him, and possibly ourselves, that our family will never know.

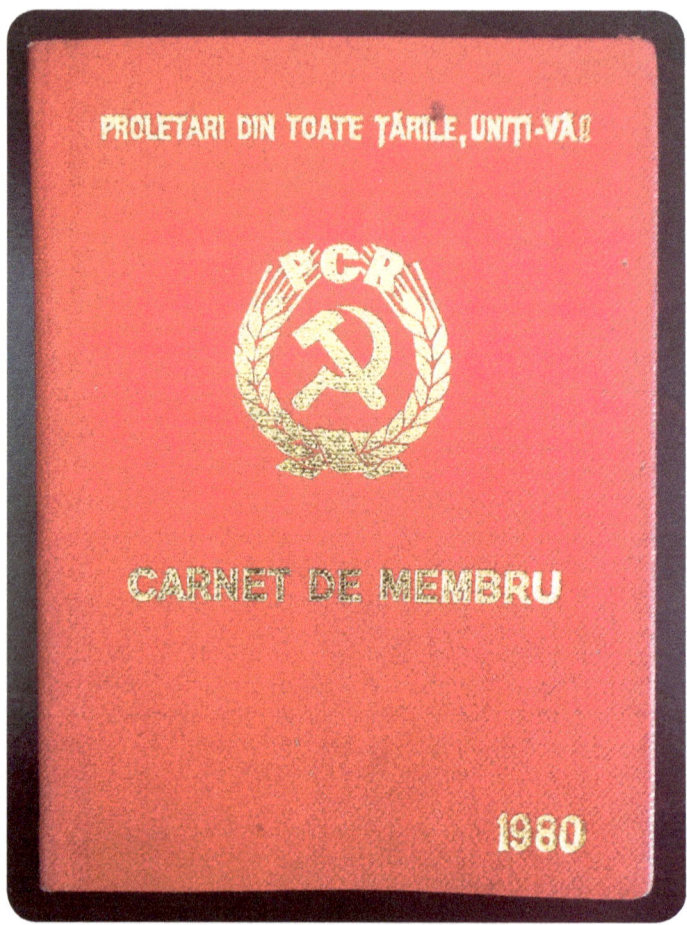

Figure 22: Former Communist party membership card (outside cover), circa 1980s, Romania (Photo by the authors)

Figure 23: Former Communist party membership card (inside pages), circa 1980s, Romania (Photo by the authors)

My grandfather's story is one among millions caught up in the web of the Securitate, the Romanian communist secret political police (similar to the East German Stasi), a repressive apparatus involved in the harassment, manipulation, and surveillance of the country's citizens. According to Lavinia Stan writing for the Wilson Center in her comprehensive article "Inside the Securitate Archives," "The political police employed some 14,000 full-time agents and 400,000–700,000 part-time informers selected from all walks of life. Official figures suggest that on 22 December 1989 the Securitate had 13,275 officers and 984 civilian personnel . . ." After the fall of the communist regime it was revealed that the Securitate archive contained 35 kilometers of documents, of which 25 kilometers were victim files, 4 kilometers were informer files, and 6 kilometers were attached folders. Every meter of archive contains some five thousand documents, and every file is on average two hundred pages in length. However, according to Stan those numbers are disputed by some and assumed to be much higher, considering the fact that the Stasi archive totaled 188 kilometers for a population of 14.5 million (compared to Romania's 23 million inhabitants).

It is not known how much of the archive has already been destroyed, either during the revolution or in the years after. Stan recounts the story

of the head of the Argeș Securitate office, Colonel Gheorghe Dița, who in December 1989 tried to destroy trucks full of archival material by burning them. While the fire lasted for days, he was only partially successful in his attempt. In the early 1990s, former Securitate officers now working for the newly created Information Service similarly tried to destroy thousands of files from the archive, but having learned their lesson from Dița's failed attempt, they decided instead to bury them. But, Stan writes, due to mistakes made by the agents in charge, nearby villagers soon discovered the burial site and began to rescue the Securitate documents, leaking them to the media who subsequently published them in Bucharest newspapers.

* * *

In the first chapter of *Waste*, titled "The Beach That Speaks," Brian Thill recalls Paul Valery's *Eupalinos* (The Architect). In it Socrates stumbles across an object while walking on the beach, and later tells Phaedrus that "the seashore is a special kind of wasteland, a place of derelict things, a gathering-zone for all the detritus of a great and eternal struggle." Faced with the unknown object—its origins, purpose, and meaning a mystery—Socrates tosses it back into the sea.

This image, an attempt to send something back to its primordial origins, recurs whenever the death drive and archive fever meet head on, as they did in 2015 along the Brooklyn waterfront. Part of what the sea and shore reveal at that meeting point of the "eternal struggle" Socrates calls "ignoble treasures." In the NYT article a 24-year-old Brooklyn resident is quoted as saying of the charred remains of the city's archives, "They're like treasure maps, but with people's personal information all over them." And maybe it is no coincidence that many of the destroyed documents ended up in the water, nothing more than charred muck, waste destined for the landfill that had to be fished out by the cleanup crew using fishing nets.

Faced with the madness of such archives—kilometers of material, the millions of files meticulously written, copied, and microfiched, one would not be faulted for exclaiming, "What a waste!" Indeed it is, in many ways, a waste of time, manpower, intelligence, resources; by their very constitution and the methods employed in their keeping they are also producers of waste, so much in fact that we need to think of it in terms of distance, a visual representation that the mind can wrap itself around. And, of course, they are a waste of space. But the relationship between archives and waste is more common and immediate to our lives than state repositories. One look at your computer desktop will reveal a garbage can; your email has a trash and a junk mail folder; we use terms such digital detritus, data dumps, leaks, and the Internet and TV talk shows are full of celebrities and others airing out their dirty laundry. Our lives are a constant negotiation between

what to keep and what to throw away, what we consider valuable and what is merely trash, a waste of our time and energy.

* * *

According to Freud, the death drive is "an urge in organic life to restore an earlier state of things." If archive fever is the imposition of an artificial order and logic on the living, material world, then paradoxically the archive itself exhibits the tendency to want to return to a state of natural disorder, or as Derrida put it, "something in it anarchives itself" (*Archive Fever* 57). The Brooklyn archives were hurled by the wind into the water in the same way that Socrates's tossed object ended up at the bottom of the ocean. The Williamsburg archives had become garbage, "ignoble treasures," ones likely, just as Socrates's mystery object, to resurface again in the future.

That is the uncanny nature of archives—they simultaneously preserve, categorize, and order, while harboring the impulse to destruction. Halbwach's concept of historical memory is also at play here in the function of official state archives, especially when thought of in terms of Derrida's assertion that, "[T]here is no political power without control of the archive, if not memory" (*Archive Fever* 11). Totalitarian regimes effectively shape historical memory through the selectivity of that which is preserved and made available for common consumption, but also through what it represses, destroys, erases and denies. Such archives might be said to be living embodiments of the death drive; the death drive thwarted, or the death drive held in indefinite suspension until it might return once more to the place of absolute commencement.

Indeed, it seems that archives exist in a type of buffer zone between life and death, compulsively reenacting versions of their own demise. When the former Romanian Securitate officers attempted to bury part of the archives, the archive resisted being silenced. By erasing that part of the past, the agents hoped to shape historical memory in their image, yet the documents were given new life by the villagers, everyday Romanians who had suffered for years under the same repressive regime these men represented. By turning over the documents to the media (analog precursors to Edward Snowden and Julian Assange), the villagers engaged in an act of counter memory, salvaging items that would subsequently serve as a counter archive to what was officially admitted by the governing apparatus. In his book *War Crimes, Atrocity and Justice*, Michael J. Shapiro quotes South African Verne Harris, the archivist for the papers of Nelson Mandela since 2004, who acknowledges that, "the shape (and the shaping) of record making is determined by relations of power." Yet, Verne also adds that, "The record is always in the process of being made. And all of us who narrate its meanings

and significances, whether we do it in a togetherness of hospitality or in a separateness of insularity, are record makers" (155). The organizations that reprinted and made available the Securitate documents functioned then as parallel archives, of which there are many: in television, newspapers, scholarly articles, books, websites.

For French theorist Guy Debord, the archival loop is nothing more than a manifestation of the *spectacle*, a self-sustaining and self-perpetuating mechanism of representations. In his seminal work *The Society of the Spectacle*, a series of theses on modernity and everyday life in the twentieth century, Debord writes that, "The spectacle is essentially tautological, for the simple reason that its means and its ends are identical" (15). He continues by arguing that, "For the spectacle, as the perfect image of the ruling economic order, ends are nothing and development is all—although the only thing into which the spectacle plans to develop is itself" (15–16). Therefore, anything that threatens its autonomy, specifically individual autonomy, is eliminated. Even when constituted in counter archives and memory, the very nature of the new/different/other material calls attention to the original as a kind of specter guiding the means/process of the alternate archive. The archive-as-spectacle can then be understood as a perpetual cycle of affirmation and denial—its means of existence motivated by gathering and preserving, its end expressed through its anarchiving and subsequent narrative or material recomposition subject to the same operative logic. It is in this way that through all of the alternate media channels the Securitate archive continues to speak, even when buried, even in the form of waste, demanding that we involve ourselves in the disposal or preservation of its material remains.

* * *

Charles Simic, a poet of disaster, as Hellen Vendler calls him in *The New York Review of Books* essay "The Voice at 3AM" (her 1999 review of his book *Jackstraws*), takes us back to the beach where Paul Valery also imagined a voice and Jane Bennett stumbled across a heap of garbage:

> Head of a Doll
> Whose demon are you,
> Whose god? I asked
> Of the painted mouth
> Half buried in the sand.

That half-buried mouth is the archival impulse made manifest: discarded, half dead, mute, hidden; it is impossible to ignore, clamoring to be listened to. And, the voyeurs that we are, we look it in the eye and we listen. We might even write poems, books, make it into something altogether new.

Natalia

After Derrida brought to light the privileged position of the authority in legitimizing official archives such as state and national archives, museums, and libraries, much work has been done to debunk the myth of an impartial archive and question the authorial intention behind recorded information. Archival studies have validated the interest in informal archives, as opposed to institutionalized inventories that serve as gatekeepers of knowledge who get to decide what information is worth recording. Unlike national collections of historical records, informal archives allow for multiple perspectives, preserving records of people's experiences and memories that might differ significantly from the official version of history. However, opening up the definition of what constitutes an archive brings significant difficulties in both conceptualization and management of archival data. For example, it is not immediately clear whether any collection of records or items can be considered an archive, or whether there should be an organizing principle discriminating between what is included and excluded from the collection and why. What about the process of storing records and providing public access to archived information? Does an archive necessarily have to be systematized in a certain way, or can it be simply a repository of random artifacts and records? Where do such inventories fit alongside (or inside) other official archival methods? The politics, aesthetics, functions, and approaches to archives are widely debated.

In "Beyond the Archive," Aleida Assman discusses what she calls "reverse affinity" of archives with rubbish dumps: archives aim to preserve the past, while dumps are sites of erasure and forgetting. She then immediately complicates the analogy by demonstrating that the distinction between archives and dumps can be easily transgressed in both directions: "Objects that are not confined to archives end up on the rubbish dump, and objects occasionally cast out of archives, due to shortages of space, likewise end up there," Assman explains. "Furthermore, as Kryzstof Pomian has pointed out, certain objects stored in archives today were at some stage classified as garbage" (71). Indeed, the rubbish dump is often referred to as an archive or an archaeological trove that serves as a source of our knowledge about the past. The history of the world is best told by garbage; the refuse of our everyday lives tells the most sincere story of our routines, values, habits, and interactions. In "The Perfume of Garbage: Modernity and the Archaeological," Michael Shanks, David Platt, and William Ratjhe perfectly sum up the archaeological function of the garbage pile:

> [. . .] the archaeological refers to ruin and responses to it, to the mundane and quotidian articulated with grand historical scenarios,

to materializations of the experience of history, material aura, senses of place and history, choices of what to keep and what to let go (remember/forget), the material artifact as allegorical, collections and their systems, the city and its material cultural capitalizations (investments in pasts and futures), the intimate connection between all this and a utopian frame of mind (archaeology is not just about the past, but about desired futures too). And the stuff of it all is garbage. (64)

Treating rubbish as an archive of the past is an intriguing, even if controversial, proposition. At the very least, this approach offers one highly desirable affordance: an inquiry into the histories of waste, of all things, is yet another step toward de-centralizing and deconstructing the ways in which official knowledge is created. The locale of trash "from below," as Kenneth W. Harrow theorizes in his work on the imagery of trash in African cinema, offers a unique epistemological standpoint, a lens that enables a radical, denunciatory perspective on the global society. Assman, too, demonstrates the ability of material waste to function as agent of cultural counter-memory. She prefaces her analysis with an excursion into the semantics of the German word *Abfall* (waste, rubbish). In its original meaning, Assman points out, the word denotes the Original Sin—fall from the Garden of Eden. This metaphysical connotation intensifies the concept of hierarchy inherent in the image of garbage. What's more, interpretation of waste as transgression is extremely productive, as it allows us to conceive of collection of trash as resistance to cultural and political hierarchies.

In her analysis of rubbish as counter-memory, Assman draws on creative installations by Ilya Kabakov, a Russian avant-garde artist of the 1970s–1980s. Living in Soviet Moscow, Kabakov accumulated a personal archive of everyday rubbish, in particular, paper waste. Later, as he articulated the conceptual significance of his collection, he put together installations comprised of "life books"—a paper trail of everyday experiences that indiscriminately included everything that would otherwise have been thrown away. Assman explains that the artist's presentation of these collections of items—meticulously labeled and arranged as inventory—creates allusions to state control and bureaucracy. Only in his work, what are being preserved are details that the official archives would likely deem irrelevant. In Kabakov's installations, the driving force behind memory conservation is not the omnipresent agency of the state, but personal agency, affirmation of resilience of each individual life within the totalitarian system.

Kabakov's rubbish collections are profoundly transgressive, contradicting, and even mocking the power of official authorities:

> In the totalitarian context, the dump becomes an emblem of a subversive counter-memory that cannot be controlled by the institutions of political power, figuring as a perpetual resource of creative energy. Thus through their waste archives, authors and artists have created various forms of cultural counter-memory, their refuge for the forgotten and rejected. Their memorial art resembles the *ars memorativa*, whose methods it faithfully copies in the neat archival systems of collecting, ordering, and arranging its materials. But it also includes *ars oblivionalis*, since it is constructed on the paradoxical act of remembering what is forgotten. (Assman 81)

As Assman shows, the discovery of meaningfulness of human life under a totalitarian state is achieved "under the pressure of its negation" (80). In Kabakov's ouvre, counter-memory works to reclaim the value of individual existence, fighting against the assumed dominance of collective over individual experience. The preserved rubbish undergoes a redemptive transformation from insignificant to noteworthy, affirming relevance of individual experience in the face of the colossus of the State.

* * *

Such expanded definition of the archive and its function allows us to look at the seemingly mundane and personal in a new light. What does it mean when every one of us is an archivist in her own way, with her own idiosyncratic method and purpose? What can and cannot be considered as an archive, and what value do archives of the mundane offer us outside of a context of resisting the power of the State? In a piece of video scholarship entitled "The Things They Left Behind: The Estate Sale as an Archive," Jody Shipka makes a case for the critical and creative potential of nontraditional archival materials, "treating flea markets, antique stores, and estate, yard, and church sales, as a kind of archive." As Shipka reminds us, "feminist scholars such as Cheryl Glenn, Jessica Enoch, Nan Johnson, Wendy B. Sharer, Gesa Kirsch, and Liz Rohan (among others), have urged moving beyond established archives to explore the potentials of "alternative" or "nontraditional" archives such as small community archives or boxes of materials found in offices, garages, or a relative's attic." In her work with discarded—and subsequently found—material objects, or what Ayisha Abraham refers to as "orphaned artifacts," Shipka highlights how the material accessories and backdrops that furnish our lives serve as embodiment of lived experience. Scrapbooks, photographs, notes to self and shopping lists, medical records and official documents, as well as various household objects and other items comprise a record of the everyday life as experienced by

The Afterlife of Discarded Objects

somebody, *some body*, through its senses, through direct contact with these and other objects. Such items are not simply building blocks for construction of memory: they themselves are memory, material traces of a life before it has been narrativized through a verbal record—and, arguably, no less effective than an (auto)biographic account would be.

The moment we decide to keep a used train ticket or a postcard instead of throwing it away we invest it with sentimental value to replace the expired functionality. One only need visit any of the thousands of yard sales across suburban America to notice the sheer volume of boxes containing old black and white photographs or postcards that have been kept in some damp, dark basement or stuffy attic by someone who simply couldn't let go. This is not to mention the countless Barbie dolls in various states of dismemberment, sprawled out on a blanket, begging to be put together again. Saving something from the discard pile as a keepsake follows an impulse to preserve, to elevate, to make meaningful. It is an act of love, really, or at least that is what we want to believe; labor of imagination that gives a new, arguably better, life to an otherwise useless item. The kept object becomes a vessel for projections, be that childhood fantasies or the nostalgic longing of adults. The object stretches beyond itself; as a magic portal, it provides a passage to reconnect with a moment from the past that we treasure or a person whom we want to remember.

Figure 24: Train tickets on a page from the journal of artist Brent Williamson, 2015, New York (Photo by Brent Williamson)

This certainly makes the already tiresome process of management and disposal of things even more chaotic and unpredictable. What do we keep? What do we discard? What do we rescue from the refuse pile? Suddenly, the very definition of "trash" seems uncertain, the difference between valuable things and junk blurred. The agglomeration of personal and household objects that any of us accumulates through a lifetime, papers and documents, the various paraphernalia that structures our daily lives—all of it is essentially in the process of turning into garbage since the moment of acquisition.

But garbage, if I learned anything from our contributors' stories, is not synonymous with "meaningless." In fact, contemporary Western imagination shows an unprecedented obsession with other people's leftovers. For example, among the celebrity items auctioned off to fans on eBay, one can reportedly find Justin Timberlake's half-eaten French toast sold for $3,154; Britney Spears's used chewing gum acquired by an ardent fan for $14,000; and a tissue that Scarlett Johansson used to blow her nose, apparently worth $5,300. Similarly, in an institutionalized attempt to preserve what the famous leave behind, museums diligently collect, archive, and exhibit renowned people's possessions, as if proximity to these items can somehow transport museum visitors into the presence of genius. We remember Nabokov by his round glasses; Freud by his smoking pipe; Twain by his hat. Items like these, solemnly exhibited in museums under thick glass, become our best chance to establish a connection, albeit illusory, with their long gone owners. Subconsciously, we must still believe in the law of contagious magic that stipulates that things which have at some point been in direct contact with each other will always stay connected. An extreme example of this illusion at work—indeed the epitome of the desire to get a hold of a person through his belongings—is Graceland, the estate museum of Elvis Presley. The so-called Trophy Building in the estate houses a collection of Elvis memorabilia such as records, movie posters, his notes and autographs, clothes and accessories, and personal items that used to belong to his family members. The estate boasts an almost sacred significance, as countless fans come here on pilgrimage every year to feel the touch of the legend.

But what, Shipka asks, "becomes of the experiences, written texts, and other material artifacts associated with the not quite so famous?" What remains of the "ordinary" lives also makes its way, even though anonymously, to antique shops and flea markets frequented by visitors for business and for viewing pleasure. According to statisticbrain.com, approximately 690,000 people purchase something at a yard or garage sale each week in the US, which amounts to an estimated total of 4,967,500 items. Part of the attraction, of course, is the scavenger hunters' hope to find treasures

that were discarded unknowingly by the previous owners; lucky finds that will instantly bring a fortune. Yet, fortune-making is not the main reason we are attracted to the junk that others leave behind. Paradoxically, it is our desire to live that makes us interested in items that used to belong to the dead. It is the drive to imagine a life, to project a personality onto the ghost lurking behind a found item, or to recreate an era. Those items whose previous owners are probably alive and well also carry a promise of a history, more enticing in the absence of any known factual details. Preserving objects—taking inventory of somebody's belongings—preserves a story of a life, if not the life itself.

Kenneth Goldsmith claims that "by inventorying the mundane—what we eat and what we read—we leave a trail that can say as much about ourselves as a more traditional diaristic approach, leaving room enough for the reader to connect the dots and construct narratives in a plethora of ways" (188). Inventory of one's possessions performs a diaristic function by simply listing the objects that one has been in touch with. In her NeMLA 2016 presentation on aesthetics of the listing technique, Elise Takehana mentions Peter Menzel's photo series "Material World: A Global Family Portrait" in which the artist relies on things to reveal and describe their owners. The series features families from around the world in front of their houses, posing with all of their possessions. "Objects in portraits are more than symbolic markers," Takehana believes, "Objects act as an inventory of material facts and a direct way of knowing a person. [. . .] Over a false personality or a public image, the material artifacts are more revealing."

What is revealed when looking at photos from developed and developing countries side-by-side is, of course, the contrast in the number of things these families rely on in their everyday lives. But something else is equally striking in these pictures, namely, how drastically different the depicted worlds are from one another; how dwellings and places (composed of smaller things such as household items, tools, and toys) must inevitably shape individual lives and characters in unique ways. Menzel's images invite the viewer to play a Bachelardian game of inhabiting a space in one's imagination, placing oneself in a surrounding to see what it might feel like. It is a rhetorical sleight of hand, whereby witnessing from a distance we nonetheless become implicated through the affective power of the image and its contents. A photo of a round Mongolian ger, put together on the outskirts of a city and surrounded by domestic animals, juxtaposed to an image of a seaside house in Iceland, with boats and fisherman supplies in the background: one can only imagine the vastly differing affects produced by the

spatial, temporal, and material dimensions of each location featured in the series, acknowledging in this way how objects not only simply describe us, but also build and shape our bodies and identities.

"Material World" can be read as an archive of people's experiences, insofar as the project catalogues a collection of items. Cataloguing things often takes precedence over plot in literature and cinema: from Walt Whitman's famous lists, to Dziga Vertov's fast flickering sequences of images in *The Man with a Movie Camera*, the world is reachable through its composite elements. This, however, does not mean that a world depicted through a list lacks a specific narrative, especially since it often makes use of a definite and recognizable physical structure. Rather, the narrative is implicit: readers are invited to take a more active role in putting together the separate components that might make up a story and fill in the communicative gaps, the *whys* and *hows* that human inclination to storytelling insists on. Ian Bogost in *Alien Phenomenology* talks about lists in computer science terms, treating them as data: a database of logged entries might present a disconnected list of items, yet nevertheless, "a tiny part of the expanding universe is revealed through cataloguing" (Bogost 41). Even though databases such as these might include items indiscriminately, without a process of selection or without applying any specific principles of categorization, we approach a set of data from the position of interpreter, thus turning a list into a narrative. We are attracted to such catalogues as a way to get closer to experiencing the same part of the universe as another person before us did, breaching the never-yielding gap between self and other. Similarly, the flea markets and yard sales that are so popular in today's society indulge our voyeuristic impulses, allowing us to play out in our heads the untold stories behind objects. Found objects recreate an experience that another person had, and in doing so give us the gift of becoming somebody else for a little while. Shipka's *Inhabiting Dorothy* project accomplishes just that by inviting participants to imagine the woman, Dorothy, beyond her family archive that Shipka purchased at an estate sale. Through creatively engaging with items from the six boxes of stuff that constitute the archive—making art with, remediating, framing, and variously curating the items—participants imagine experiencing life as Dorothy, while honoring uniqueness of individual existence.

Figure 25: Envelopes of black and white film and photographs circa 1970s-1980s, Romania (Photo by the authors)

 The ability to capture the fragility of the moment is something that all archives, whether official or otherwise, have in common. Photography, perhaps, is the best medium to freeze a moment in time, giving it a material manifestation that endures, capturing what is elusive and spontaneous. Found photos, as opposed to ones that picture ourselves and people we know, offer the added allure of mystery, appealing once again to our voyeuristic inclinations. In 2007, a Chicago real estate owner named John Maloof purchased a box of negatives at a local thrift auction house. The negatives used to belong to one Vivian Maier, a lonely, secretive woman who worked all her life as a nanny and, unbeknownst to anybody, did street photography in her spare time. Upon a closer look, the found photos turned out to be visually striking, which inspired Maloof to search for the rest of images by Maier that were sold to other people at that auction. Over time, he recovered "a hundred thousand negatives, seven hundred rolls of undeveloped color film, eight millimeter and sixteen millimeter movies" taken by Maier, and promoted and publicized her work, filming a documentary about his stunning discovery.

Posthumously recognized by *The New York Times* as "one of America's more insightful street photographers," the creator of these artifacts herself is still a mystery. We can only know her through the photos that she took, which, some may argue, is not enough information: after all, these images alone do not provide us any insight into Vivian's thoughts, hopes and dreams, likes and dislikes. She herself is featured in several shots, but most of the photographs depict whatever she saw on her walks in the city: close-ups of people, streets, buildings, and cars, moments from a busy everyday life.

Yet, that record of what she saw might offer us hints into Maier's identity, small glimpses into the woman behind the lens. It is tempting, then, in the absence of sufficient information about the photographer, to read these photographs as visual messages purposefully composed by Maier to serve as a record about herself, a kind of autobiographical identity construction against the odds of time. One can attempt to imagine the artist as a person through reflecting on her deliberate choice of frame and focus, the particular mood created by the images, what is included and what is left out. What audience did she think of when taking these photos? What were the purpose and rationale behind her artistic choices? While we will never have precise answers to these and other related questions, we can nevertheless engage in reconstruction of her identity from the pieces she left behind. The resulting account of Vivian Maier, the person, might be incomplete and inaccurate, but without the films that she left behind—the discarded and salvaged belongings—we wouldn't even have that.

The places, people, and objects that Maier captured on film are enough to provide us with a clue of what it might have felt to be her, to see through her eyes, to approach things in the uncanny moment when they reveal their ordinary, yet simultaneously outstanding beauty. Vivian Maier's archive is a record of moments that once were and still remain thanks to her efforts in cataloguing everything that she saw, rescuing the everyday things from being forgotten. The record runs parallel to the official history, to what we know, offering us a glimpse into life as encountered by one person who secretly, invisibly to anyone else, persisted in preserving herself through archiving her experience.

<center>* * *</center>

But what would have happened if Maier's archive had never been discovered and made visible? It is not enough to simply create a record of one's experience: a major challenge in archival practices is to ensure the discoverability of archives. The technological advances of the Internet era have certainly played their part in the democratization and outreach of archives, far be-

yond what Derrida could have imagined. Delivering his *Archive Fever* lecture in 1994, Derrida already had insights about the role of new communication technologies, email in particular, in shaping knowledge and memory. "What is no longer archived in the same way is no longer lived in the same way," he observed, anticipating the drastic changes that the evolved nature of communication would bring along. One of these changes, especially evident with the development of online social media, has been the rise of public participation in crowdsourcing archival content. The term *crowdsourcing* was coined in 2006, shortly after Derrida's death (Alsever). While it started as a process of obtaining services at low prices from a large group of volunteer providers, crowdsourcing soon spread to not-for-profit spheres, enabling anyone with access to the Internet to participate in the creation of knowledge. Not surprisingly, easy access to online venues of the production and sharing of discourse had a number of unintended consequences, such as the unreliability of sources. However, the newly found digital democracy also achieved an unprecedented level of public agency in recording, assessing, and making visible the experiences and voices that hitherto had remained unheard. Crowdsourcing archival entries and especially inviting anonymous contributors to share their experiences effectively disrupt the established expectations of what constitutes legitimate memory and what kind of stories are worth telling. When the hyperawareness of self-representation that comes with signing your name is alleviated, the utmost motivation for storytelling is that of preservation of knowledge about the past, especially when it comes to knowledge that cannot be accessed through perusing official records.

Stories shared by the participants of *The Afterlife of Discarded Objects* offer us history told from the margins: not only is the focus seemingly insignificant and unlikely to inspire any deep contemplation on the part of the reader, but the subject positions of the narrators themselves are, more often than not, marked by their struggle with economic inequality. These are truly stories from the bottom: from junkyards and backyards, abandoned construction sites and run-down factory warehouses, medical and industrial dumps, in addition to household rubbish bins. Intuitively, without necessarily having recourse to critical theory, our contributors knew the rebellious nature of their stories. What they remember about history may get silently erased from national textbooks at the whim of a new ideology; what they have to share about their personal histories would not otherwise be of interest to anyone but themselves. Subsequently, their desire to contribute to the archive of memory is simultaneously selfish and noble, serving both political and individual agendas.

At the very least, these stories serve as records of personal lives that would otherwise be slowly forgotten, stories told by the objects that themselves serve as archival artifacts represented by memory. As one of the contributors puts it, these discarded items are a well of memory and imagination that "tell stories of how we lived" and therefore, help immortalize personal history:

> My grandparents lived in a remote area next to a highway. Behind their house was a big garden, with a little patch of trees next to it. In that tiny forest were trashed items by former residents of the house. Old shoes, pots and pans. I loved it there. I imagined a different world hiding between those trees, and just roaming between them would be wonderful. Today I have made one corner of my garden into something like this little forest. It makes me happy to see rusty tools, pieces of wood, old toys, a discarded watering can lying around there. They tell stories of how we lived here.
>
> —Babygenie, Berkel-Enschot, the Netherlands, 1970s

5 The Abject and Fear of Social Contamination

Andrei

> "[A] person is, among all else, a material thing, easily torn and not easily mended."
>
> —Ian McEwan, *Atonement*

My grandmother's final years in Romania were spent being transported back and forth to a hospital three days a week where she was hooked up to a dialysis machine. When the kidneys are no longer functioning properly, dialysis helps to clean the unwanted waste from your blood. Dirty blood is circulated through the machine outside of the body before it is returned to you without the harmful contaminants. The process is time-consuming and exhausting, leaving the patient weak, though still functioning.

I visit Romania about once a year, usually during summer, and in 2014, on my last visit before my grandmother's death, I remember accompanying her to the hospital along with my aunt. At this point in her life she needed to be carried from the car to the building in a wheelchair, but the hospital did not have a wheelchair accessible ramp. Nurses and other visitors like us were carrying patients up and down stairs in wheelchairs, so we did the same. A couple of nurses were standing in the doorway smoking, drinking instant coffee from plastic cups. They shifted out of the way just enough to let us pass. At the front desk we were told which room to go to, and once inside we helped my grandmother onto a thin cot, next to a couple of other patients. It had the feeling of a self-serve operation, and in many ways it was, though it was not likely something anyone would want to partake in voluntarily. My aunt went away for a few minutes to find a nurse for the requisite tip (bribe, let's call it what it really is) so that she would come and begin the procedure. That's not unusual in Romania. And neither is it unusual to have to go down the street to the pharmacy to buy your own medicine and then bring it back to the hospital just to pay a nurse once gain to administer it. Tips make things move, and no one really thinks twice about it, because, well, things have to get done.

The Abject and Fear of Social Contamination

Figure 26: Broken and disassembled refrigerator and empty water bottles in an occupied hospital room, Bucharest, Romania. (Photo by the authors)

While my aunt was looking for the nurse, I took stock of the room. In nearly 40-degrees Celsius without air condition, the air was heavy, overpowering, infected. There were a couple of mismatched plates and spoons on a windowsill, a Disney-themed ceramic cup on a nearly table, 1-liter *Dorna* plastic bottles of water on the floor next to the beds. In some hospitals, though not all, because of lack of funding and supplies patients are encouraged (no other choice offered) to bring their own china and silverware. This happened to be one of them. Here, paint was peeling off the walls, off the iron bed legs, off the equipment, off of everything it seemed. Death looks like that and it smells like that, I thought, and somehow my mind drifted to images of bombed out war zones where hospitals function more like morgues, collecting zones for soon-to-be corpses and dismembered bodies. I went back to scanning the room. Immediately to the left of the entrance—something I had not noticed previously while concentrating on navigating the room with grandmother in a wheelchair—was an old, rusty, and useless refrigerator. Its door had been taken off the hinges and lay against the wall like a broken wing. It had "trash heap" written all over it, but no one seemed to have bothered or cared enough to read the inscription. Up until then, little about the hospital had instilled in me a sense of hygiene, health, safety, or dignity. The sight of a dismantled refrigerator rusting in place did

little to fix that. William Viney writes that our narratives of objects are what gives them (and us) a temporal dimension—we imagine how they came to be, what happened, who was involved, what will happen later. Such narratives inscribe the objects with a sense of movement through time, our narratives caught up alongside their own. The narrative I built up in my head goes like this: I imagine that someone, while upgrading appliances in their house or flat, instead of discarding the aging (or it could have been broken even then) refrigerator with the trash, they (could have been a patient or relative) brought the old fridge to the hospital to be used by others to store various foods, even medicines. That seems like the logical storyline, but if I know anything about Romania it's that the absurd is a national pastime, Dadaism a kind of religion (the absurdity that this was an object meant to *save* and *conserve* yet could do neither, found inside a hospital, could not be overstated). That refrigerator had long ago stopped functioning, had come apart, yet was allowed to remain in a state of ongoing decay alongside the ill and the dying—just one, among many, symbols of neglect.

* * *

Ever since leaving the country in 1991, Romania has been for me a source of nostalgic sentiment, and I admit at times to falling into the trap of over-romanticizing the homeland as much as anyone else. But at the same time, the place always carries with it a sense of the terminal, the destructive and disastrous. The two conflicting feelings are inseparable. A love affair—with person or place—is often filled with contradictions. There I began and there I ended in a way. Whenever I find myself there it feels like I exist at or on a fault line, both personal and cultural, always shifting at the whims of time and memory, while having to reckon with a kind of foundational instinct. It is at best a shaky foundation, one that is unsettled and shaken by encounters when, as Julia Kristeva explains in *Powers of Horror*, "meaning collapses" (2).

Kristeva's concept of the abject and its function has for me many parallels in the way I experience Romania, both from a personal and more general cultural perspective. Kristeva defines the abject as "the jettisoned object," the "radically excluded," that which "lies outside." In reality, it could broadly be construed as anything that opposes the "I," that stands against the self and the lines of demarcation it has established for itself. Yet, Kristeva says, "from its place of banishment, the abject does not cease challenging its master. [. . .] it beseeches a discharge, a convulsion, a crying out" (2). Purdue University's Professor Dino Franco Felluga, writing about Kristeva's work, explains that,

the abject refers to the human reaction (horror, vomit) to a threatened breakdown in meaning caused by the loss of distinction between subject and object or between self and other. The primary example for what causes such a reaction is the corpse (which traumatically reminds us of our own materiality); however, other items can elicit the same reaction: the open would, shit, sewage, even the skin that forms on the surface of a warm glass of milk.

Meaning collapses in such instances and leads to visceral, often violent bodily reactions to the abject because it upsets established modes of behavior, knowledge, belief. Abjection is caused by all that "disturbs identity, system, order. What does not respect borders, positions, rules" (Kristeva 4). We have established in earlier chapters that to (re)collect, organize, and preserve what otherwise might be called garbage or waste is an act of ordering one's environment, or giving it a sense of structure and meaning. In her seminal work *Purity and Danger* (1966), published nearly two decades prior to *Powers of Horror*, Mary Douglas also argued that discussions of what could be construed as dirt, defilement, hygiene, and cleanliness require "reflection on the relation of order to disorder, being to non-being, form to formlessness, life to death" (6). For Douglas, social order is built against filth and defilement. That sense of something terminal and catastrophic that I referred to earlier could then be understood as reactions to encounters with the abject, that which disturbed social expectations and resulted in the collapse of order. "Dirt offends order," argues Douglas, and "Sometimes words trigger off cataclysms, sometimes acts, sometimes physical conditions" (2, 4). The odor in that hospital room, the cracked and peeling paint, and the discarded refrigerator were symbolic of a breakdown in how I envisioned a hospital functioning, as a unit whose goal is to preserve life, whose very name conjures up images of cleanliness and sterility. In this instance, it was anything but that. Doctors and nurses, those who "fix" and save lives while adorned in their pristine white uniforms, are not imagined in such an environment. And their presence, for me at least, was not enough to overpower the confusion and incongruity in the scene. My grandmother had come to have her blood cleaned of waste in a place that was bounded by it on all sides. The place that was supposed to keep her alive had an overwhelming air of death about it, and it was present and magnified by all of the objects in the room, all of the *garbage* that did not make sense in what was supposed to be a clean and sterile environment. When there is no longer "any distinction between ourselves and the world of dead material objects," Felluga explains, such a condition gives rise to fear, anxiety, repulsion.

For Kristeva, this is exactly the power of the abject, to throw us into emotional and physical spasms. She writes,

> A wound with blood and pus, or the sickly, acrid smell of sweat, of decay, does not *signify* death. In the presence of signified death—a flat encephalograph, for instance—I would understand, react, accept. No, as in true theater, without makeup or masks, refuse and corpses *show me* what I permanently thrust aside in order to live. These body fluids, this defilement, this shit are what life withstands, hardly and with difficulty, on the part of death. There, I am at the border of my condition as a living being. My body extricates itself, as being alive, from that border (3).

As Felluga put it, this is the trauma of facing your own materiality when confronting the "real" (the material), of your own death made "palpably real." In the face of death and decay, the body abjects in acknowledgment of its impermanence. Once in that hospital room I knew that I wanted to leave as soon as possible. Although it was my grandmother who was, clinically speaking, on the border of her condition as a living being and facing the very defilement and rejection of her body, it was I who felt the need to extricate myself from there—no, I did not face a corpse exactly, but I'd seen the skeleton and it had rusty arms and legs and an open belly that no longer held or preserved anything and it had been enough.

*　*　*

I mentioned earlier that Romania has for me a sense of the terminal, the destructive and disastrous. But since we've established that the personal is always cultural, the individual linked with the collective, I argue that my singular experience with the abject is symptomatic of a general condition that could be expanded to the city of Bucharest itself and the country at large—a consideration of how the relationships present between people and places/things actually mirror those between people themselves. As Kenneth Harrow explains in "Trash and a New Approach to Cinema Engagé," "theorizing around trash moves from the material to the psychological, sociological, and political, with regimes of trash recycling discarded objects from one order to another: discarded, worthless people from one community to another; [. . .] A range of theories of history that entail forgetting in the forging of rule and national identity and in the creation of archives, order, and disorder, converge around the tropes of trash" (2–3). Trash belongs to the individual as much as to the society into which it is discarded, and which subsequently must engage with it—either by acknowledging it, engaging with it, or pushing it to the side, away from view.

Here, I would like to introduce a new term (to which I will return later), *imminent catastrophe*, which I believe resonates with our current twenty-first century mentality, but that also reflects the state of Romanian society (and as we will see, and as Harrow argues, is not limited geographically or ethnically). In Bucharest, the ability of the abject to make one face their own mortality and materiality is present in its houses and apartment buildings, in the very structures that give it life and shape. That's because Bucharest has a very distinct honor, even if it is one it would readily cede to any willing takers. "Welcome to Europe's most earthquake-prone city," says Stephen McGrath writing for CityMetric, "where tremors are commonplace and the next big earthquake looms large for its residents—but where many lack the financial or logistical means of moving out to safer accommodation." What this means, quite simply, is that Bucharestians face daily iterations of imminent catastrophe, reminders lurking on each city block and around every street corner that "today might be the day." The gaping maws of crumbling 150-year-old buildings, collectors of pigeon shit, graffiti, and stray dogs, seem to say to passersby, "This is what the future looks like. Or worse." According to CityMetric, earthquakes of magnitude 7.0 or higher struck three times in just over one hundred years, specifically in 1908, 1940, and 1977. With an average of about thirty-five years between major quakes, in 2019 the city is just about due for another big one. If that does not give one a sense of imminent doom I don't know what will.

Figure 27: Crumbling building under renovation (circa 2014–2015) in Old Town, Bucharest, Romania. (Photo by the authors)

Nowhere is that more apparent than in the area known to most residents as *Lipscani*. It is also called Bucharest's *new* Old Town, a neighborhood of contradictions. It sounds like an oxymoron because that's really the best way to describe it. What Bucharest also deals in, maybe even more so than it does in architectural eyesores, is a distinctly contemporary appeal, growth and development, enthusiasm for everything new. Along a dozen or so winding cobblestone streets, nineteenth-century derelicts and the condemned buildings stand side by side with modern, renovated chic cafes, restaurants, and nightclubs. In 2013 the BBC's Mark Baker sells it to potential tourists this way: "A decade of refurbishment has resulted in a charming, walkable quarter with enough sights to keep you occupied for the day and enough bars and clubs to ensure you never have to sleep." He's mostly right about that. It is the place in Bucharest that seems to be always alive, an energy about it that is both charming and uncanny. Bucharest has been called the Paris of the East or Little Paris for a reason, its architecture—Renaissance, Baroque, and Neo Classic—is reminiscent of its more famous namesake, though at times its shabbier regions seem to be cloaked in beggar's clothes. What Baker doesn't mention are the holes and tears in the façade of glitz and glamour.

The Old Town emerged around the sixteenth century and developed through the eighteenth and nineteenth centuries as a district of artisans and merchants selling their wares. During that time, it survived earthquakes and fires, and during WWII it saw severe damage from both Allied and Axis bombings, each time emerging from the brink of destruction as a phoenix from the ashes. The 7.2 magnitude earthquake of 1977 once again devastated large parts of the city, including the Old Town, which was largely left in disrepair during the 1980s under Ceaușescu, who did not care much for the historical value of the place and planned to have it torn down for good. As Ceaușescu ordered large parts of the city to be razed to make room for modern roads, building blocks, and the Palace of Parliament, he had focused at first on developing the northern parts of the city and the Old Town was miraculously spared its fate when he was finally overthrown and executed in 1989—the destructive instinct and the will to live are palpable in the city. However, due to the lack of attention, for decades it continued to slide into disrepair, and because the crumbling district came to be inhabited primarily by the ethnic minority Roma population (more commonly known by the exonym "gypsies"), the Old Town developed a reputation as a slum. For Ceaușescu, it had been like a stain on his otherwise perfect vision of a modern European city (the fact that he allowed it to decay and housed the Roma there is no coincidence, as we will see later), a heap of ancient rubbish among the solid concrete of Socialist realist architecture, and it re-

tained its reputation as a no-go zone for many residents of the city up until the early part of the twenty first century.

In the past decade or so, under a renewed effort to revitalize the Old Town, the Roma, who are often discriminated against in much of Romanian society, were largely pushed out and resettled; it didn't take long after that for business opportunities to present themselves and for the forgotten quarter to limp back to life. Investors swept in and built clubs and cafes on the first floors of the buildings, often with minimal repairs, ignoring the larger structural damage around them. Ritzy restaurants and upscale trendy bars opened up inside buildings that looked on the edge of collapse. While a major push for renovation took place between 2007 and 2011 and the Old Town has now become a tourist destination in Bucharest, it is still common to see the renovations side by side with the ruins and the rubble. On a street where H&M and Adidas have set up shop, buildings carry red circular plaques announcing that the particular structure is classified as a Class I seismic risk and in danger of collapse in the case of an earthquake magnitude 7 or higher. According to *The Guardian*, to date 374 buildings in the Old Town have been red-dotted. By my guess and by the looks of some of those buildings, it would take much less than that to cause serious damage; as it is, even without outside intervention the facades crumble and can cause injury to those passing by.

These contradictions are part of the charm of the Old City, but with a closer look through the lens of the abject we can get a better idea of the manner in which waste and decay, the discarded and forgotten, have a way of imposing themselves and collapsing distinctions in spatial and temporal perspective. Kristeva wrote that the abject calls out and challenges "from its place of banishment," and what's more, we cannot help but listen to it as we are inexplicably drawn and attracted by it. "One does not know it, one does not desire it, one joys in it [*on enjouit*]," she explains. "Violently and painfully. A passion. [. . .] One thus understands why so many victims of the abject are its fascinated victims—if not its submissive and willing ones" (9). It is on this border between the repulsive and the desired, along a fluid axis of ambiguity that the abject lies and where it most affects us. Think here of the morbid curiosity we sometimes get out of gawking at a car wreck, at decapitation videos, or the simple pleasure of picking at a scab until it bleeds. Some*thing* at the site of contradiction interjected and warped any sense of distinction. Thus, repulsion and desire were felt simultaneously and in the same place, leading to an erasure of temporal and spatial dimensions of the moment.

Figure 28: Section of crumbling building in Old Town, Bucharest, Romania (Photo by the authors)

Only in this way can we understand how both life and death could be embodied in the broken refrigerator and the squalid conditions of the hospital. Only in this way can we understand how one willingly enters into a labyrinth of condemned buildings to sip cappuccinos and cocktails. It takes a kind of willful amnesia in the face of the abject where we allow ourselves to forget and ignore (nurses chain smoking at the entrance to the hospital, waiters putting on a happy face in the Old Town). Catastrophe is imminent, history and the red dots tell us so, but as the writers for *Last Week Tonight with John Oliver* put it in a skit spoofing the Apple corporation's attempt to keep our data safe and secure: "Join us while we dance madly on the lip of the volcano." In the Old Town, the dancing takes place in barely standing build-

ings, their first floors spruced up with new paint, fixtures, and furniture, the bright lights and colors of advertisements. Out on the sidewalk, sprawling umbrellas block out the upper floors, whose windows resemble hollowed eyes looking down at the spectacle. And maybe it's appropriate that much of the foot traffic in the Old Town happens after sunset—then the abject does not have to be encountered directly, it can be secreted away in the dark; catastrophe can be temporarily ignored and swept under the rug of night.

* * *

But not everything can be swept away or buried, or at least not forever. During the renovation of the Old Town, workers dug down and unearthed traces of centuries-old city streets. In an effort at preservation and to celebrate the history of the neighborhood, along one section the city has laid down a giant rectangular glass window over the hole in the ground. While you can't walk over it, you can lean over to catch a glimpse of the ruins. Similar remains presumably underlie much of the neighborhood, running below the current pedestrian walkways and under houses. For centuries, one Old Town has been built over the ruins of another Old Town built over the ruins of another, and so on. Just trying to imagine it, one senses the precariousness of the present, the distinct feeling that today is just another layer of sediment in the grand scheme of civilization. What would it be like if every street were paved over with glass so that while having lunch you were always reminded of what was underneath and what came before? What would it mean to walk today with one eye to the past below while gawking at the architecture of the future going up alongside the ruins? It would not only be a tremendous feat of engineering, but a feat of curiosity as well; technically possible, but the mind staggers at the vertigo that would be induced and the loss of appetite that would ensue. When it comes to dredging up the past, there just doesn't seem to be sufficient interest in it unless that's the business you're in. Most people would prefer the discarded to remain that way, the forgotten to keep quiet and remain hidden from view.

For generations, this has been the general attitude in Romania toward the Roma population—out of sight, out of mind. Figures vary widely and wildly with anywhere from about 630,000 to as many as one million or more Roma thought to be living in Romania today (Marica). Up until the middle of the nineteenth century many were held in slavery, though after abolition there was an attempt to integrate the Roma into Romanian society, which was met with only limited success. To this day, the vast majority live in abject poverty on the fringes of society, and virulent anti-Roma sentiment is not something many Romanians would be ashamed to admit (without much prodding). General opinion is that they steal, are unclean,

and refuse to comply with civic rule and authority. Max Daly's *VICE News* article, "Bucharest's Drug-Addicted Roma are Being Left to Rot," exposes in vivid detail the plight of the Roma. With the exception of a few successful Roma entrepreneurs and self-proclaimed Roma royalty, "the overwhelming majority have low-paid, unadmirable jobs, such as recycling discarded scrap metal, cans, bottles, and clothes. On every level—housing, education, employment, and health—they are severely disadvantaged" and subject to "widespread discrimination" with many Roma "simply locked out of mainstream society."

To say that they not only live on the fringes of society but beneath would not be an overstatement. In 2014, a series of news articles and TV segments unearthed the hidden life of Bucharest's sewer people. In 1966, Ceaușescu's Decree 770 made abortion and contraception illegal, and Romania saw a sharp rise in births. Over the next several decades a significant number of children would end up in orphanages, whose horrific and inhumane conditions came to light in the West only after 1990. Many of those abandoned in the orphanages were Roma, and according to an ABC's *Nightline* report by Bob Woodruff in 2014, when the communist regime fell in 1989 and some of the orphanages were closed, thousands of children were essentially released into the streets to fend for themselves. With nowhere to go, these once-abandoned children found shelter inside Bucharest's sewer and underground tunnel system. Those who have sought out stories about the sewer people who seek out an existence below the streets inevitably have come across an enigmatic figure known as Bruce Lee. According to *Nightline*, Lee had lived in the sewers for twenty-four years and served as protector for the younger inhabitants and the most vulnerable. Almost all who live in the tunnels are orphans and junkies, who have contracted HIV or TB and survive day to day on a steady stream of drugs and whatever they can get by begging and scavenging the streets. "We take it from the city. . . . Everything we have we have collected from the garbage," Lee said when interviewed by *Nightline*. "This is how we can live. If not, we would die out on the streets." He added that the tunnel he lives in runs about two kilometers and is inhabited by many children, who "During the day, [. . .] go and search in the trash for food or whatever they need."

In 2015 Romanian authorities raided the sewers and tunnels, arrested Bruce Lee and "evicted" the inhabitants in what they stated was an operation to break up a drug trafficking ring. However, few expect that this will be the end of the tunnels. With nowhere else to go, those who have fallen through the cracks of society will likely continue to be swept away and aside. The stigma associated with the Roma and ingrained cultural attitudes will persist for much longer—whether those attitudes are aimed at objects

or individuals. According to Mary Douglas, "Culture, in the sense of the public, standardized values of a community, mediates the experience of individuals. It provides in advance some basic categories, a positive pattern in which ideas and values are tidily ordered." Douglas adds that, "A private person may revise his pattern of assumptions or not. It is a private matter. But cultural categories are public matters. They cannot so easily be subject to revision. Yet they cannot neglect the challenge of aberrant forms. Any given system of classification must give rise to anomalies, and any given culture must confront events which seem to defy its assumptions" (39–40). In Romania attitudes toward the Roma are very much "cultural" in nature, with Roma never quite being considered fully Romanian. They are "other," different; they are the abject and the aberrant forms, invoking at times disgust and outright hatred. The confrontation between established cultural norms and the anomalous is seldom easy, and it's one that either seeks to meet difference and fear head on, or it could further deny and marginalize. "As time goes on and experiences pile up, we make greater and greater investment in our system of labels," writes Douglas. "So a conservative bias is built in. It gives us confidence. At any time we may have to modify our structure of assumptions to accommodate new experience, but the more consistent experience is with the past, the more confidence we can have in our assumptions. Uncomfortable facts which refuse to be fitted in, we find ourselves ignoring or distorting" (37–38).

The Romani people in many ways challenge the ideas and values of Romanian culture at large—not unlike the inhabitants of Brazil's favelas or India's garbage pickers—disposable people in disposable buildings. Either through discrimination or refusal to integrate into mainstream society, they continually challenge and defy from the margins—in this case not an object discarded or a building in decay forcing us to face mortality, but a people whose very presence calls attention to a past that many would like to never remember, and to the state of affairs in a country that would very much like to disassociate itself from images of poverty and trash.

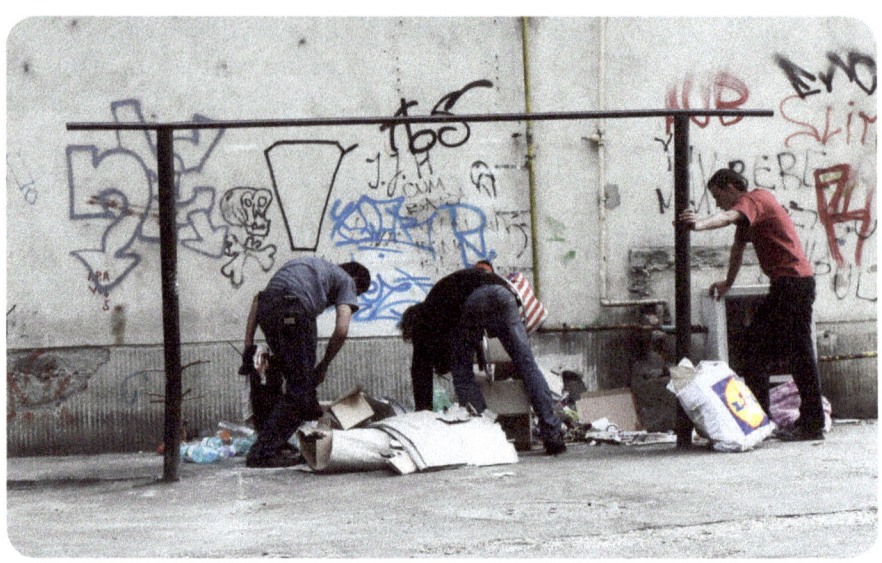

Figure 29: Men scavenging through trash for recyclable materials, Bucharest, Romania (Photo by the authors)

In "Bucharest's Drug-Addicted Roma are Being Left to Rot," Daly visits the ghetto of Ferentari and describes the dilapidated 1970s-era apartment blocks: "The basements have been flooded for years and are home to huge rats. The stench is amazing. Dirty needles are everywhere, in stairwells, on the pavements, and in the huge, open rubbish dumps [. . .]." Daly mentions that according to the book *Hidden Communities*, which focuses on Ferentari,

> the drug dealers and injectors here maintain these piles of waste on purpose as a kind of 'filth preservation policy' that creates a 'no go area where the drug culture can survive.' What is for sure is that most people throw their refuse out the window because the garbage trucks do not come and haven't done so for years because the local politicians simply do not care. This area is 70 percent Roma. So the trash is left to fester along with the people.

The stigma of being Roma and a drug user relegates the inhabitants of such places to almost non-human status alongside other objects that "rot" and decay. Daly interviews one 35-year-old drug user named Daniela, who was seen holding on to a box of clean needles donated by NGOs, a kind of lifeline and currency among junkies. "These needles are a beautiful thing," she

says. "But we are treated like garbage. Living here is like living on an island forgotten by the world."

Daniela's words are not hyperbole. In 2013 the UK's *Daily Mail* published a story about the Craica neighborhood of Baia Mare in northwestern Romania where approximately five hundred Roma families make their home in a shantytown and dilapidated communist-era apartment blocks. Keith Gladdis reported that in 2012, the city's mayor Catalin Chereches ordered a six-foot-tall wall to be built around the Roma settlement, sealing them off from the rest of the population, creating little more than an island of garbage. Inside the enclosure "Craica has no sewage, indoor water or power supplies, and ramshackle huts lie between heaps of rubbish." The dividing line between person and trash is one that few outside the slum are willing to draw, making the mayor's decision a popular one and earning him 86 percent of the vote in the local election following the construction of the wall.

Not to be outdone, in 2014 a mayor in Transylvania forcibly evicted and moved the Roma in his town to a former chemical waste dump. A story for *The Telegraph* revealed that, "Seventy six families were evicted from their homes in the centre of Romania's dynamic second city Cluj and relocated to one-room structures on the Pata Rat dump." It is not a stretch to say that the mayor wanted to "throw them away," to dump the Roma in a place where so much waste had been dumped previously. As Douglas argues, "[. . .] if uncleanness is a matter out of place, we must approach it through order. Uncleanness or dirt is that which must not be included if a pattern is to be maintained" (41). Yet, we've learned long ago that waste—chemical, industrial, radioactive—has a way of coming back to haunt us. We bury it and it returns, resurfaces in many unpredictable ways. The sarcophagus over Chernobyl seeks to enclose it, though only temporarily. We bury barrels of nuclear waste and pray that we outlive the plan. While looking to discard all that is unwanted, all that challenges our notions of what is good and clean, we run up against the refusal of such anomalies to be subdued.

The notion that objects do not remain buried for long, even when we believe their lives have been terminated, finds strong correlation for Kenneth Harrow in the ways marginalized peoples, communities, and countries assert agency within discourses of waste and decay. Harrow also quotes Robert Stam in "Beyond Third Cinema: The Aesthetics of Hybridity," who writes:

> Garbage, like death and excrement, is a great social leveler, the trysting point of the funky and the shi shi. It is the terminus for what Mary Douglas calls matter out of place. In social terms, it is a truth-teller.

> As the lower stratus of the socius, the symbolic bottom or *cloaca maxima* of the body politic, garbage signals the return of the repressed; it is the place where used condoms, bloody tampons, infected needles and unwanted babies are left, the ultimate resting place of all that society both produces and represses, secretes and makes secret. (Stam 41)

In Bucharest's Old Town, this certainly was the case as the neighborhood fell in decline and became populated by the Roma, who were otherwise banished from the rest of the city. Subsequently, the Roma were driven out even from there, only to return and be found once again today along the repaired streets either begging or selling flowers (and some would add outright stealing). Among the $10 cocktails and well-dressed tourists is a barefoot boy carrying a rose, his shirt dirty, his face smudged. And as *The Telegraph* revealed using drone footage of the families living on the chemical waste dump, we are never too far away from images where the abject forces us to face the contrast between order and disorder, life and death. In front of one of the dwellings, someone had arranged stones in the shape of the letters S.O.S., the international Morse Code distress signal—a plea for help. Which, if we might put fear aside the way we can when faced with imminent catastrophe, might be a good place to start. "Thus, fear having been bracketed, discourse will seem tenable only if it ceaselessly confront that otherness," writes Julia Kristeva, "a burden both repellent and repelled, a deep well of memory that is unapproachable and intimate: the abject" (6).

Natalia

Kazuo Ishiguro's 2005 science fiction dystopian novel *Never Let Me Go* introduces readers to an eerie alternate reality in which humanity has developed a system to farm clones for organ donation. Cloned children are brought up in a special boarding school named Hailsham, isolated from the rest of the world, where they are slowly indoctrinated to embrace their sole purpose in life. Once they reach their adult years, they start a cycle of donations and "complete"—a euphemism for death—around the fourth donation or sometimes earlier. Oddly, knowledge of their grim fate does not seem to disturb Hailsham students: never do they try to rebel against the unspoken rules of the school or the system in general, instead going about their daily routines, which include but a few exciting events. One such event that interrupts the monotony of school life and causes much eager anticipation is a monthly Sale of all kinds of things brought in from the outside world. "That's where we got our clothes, our toys," the narrator remembers, "we'd all of us in the past found something at a Sale, something that had become special: a jacket, a watch, a pair of craft scissors never used but kept proudly next to a bed" (Ishiguro 41). It might seem hyperbolic how much objects like these mean to Hailsham students: each of the children has a treasured collection of items, some acquired at the Sales, some coming from the regular exchanges of student artwork. On several occasions items bought at a Sale become central to the development of the plot, most notably when Kathy, the narrator, loses her favorite cassette tape with a recording of the song that gives title to the novel; and once again several years later, when Kathy and her friend find the exact same tape at a second-hand shop. In their bleak world, the children find solace and meaning in material objects; they rely on things to provide them with a sense of identity that they are otherwise missing and a tangible link connecting them to others and to Hailsham, the only place they can call home.

While Ishiguro's novel already consciously foregrounds materiality as one of its most prominent themes, the 2010 screen adaptation of the same name directed by Mark Romanek goes even further in its treatment of objects as a trope. In the movie, the Sales portrayed are significantly different from those of the novel in that all of the things offered to the students for purchase are second-hand, not-so-gently-used items, often outright trash. The implication is that new, and therefore more expensive, things would be too good for the clones, whose emotions and spiritual wellbeing are irrelevant as long as their bodies—valuable biological material—are kept healthy. As Robert Martin Adams writes in his 1976 essay on rags and garbage, "Second-hand clothing bears the implication that it wasn't good enough for

someone else, but for the unfortunate without any self-respect it may, even as contaminated by the first owner, still be good enough" (55). The parallel between the broken items and the bodies of Hailsham students tucked away from the mainstream society is all too obvious; like these objects, the donors will be discarded as soon as they have been used up, disassembled for spare parts. Considered sub-human, clones are placed far below "normal" people on the hierarchy of value and rendered replaceable—and disposable.

Unlike a typical science fiction novel that would describe a remote future, *Never Let Me Go* is set in the late 1990s, and uses a real place in England to provide setting for the events. This is understandable, for the novel is more of an allegory rather than a futuristic dystopia. Ishiguro offers a commentary on the hypocrisy of the society that we already live in, one where whole social groups find themselves pushed away to the margins. "We all know it," says Ruth, one of the protagonists, in a fit of despair, "We're modeled from trash. Junkies, prostitutes, winos, tramps. Convicts, maybe, just so long as they aren't psychos. That's what we come from" (Ishiguro 166). Trash here is a metaphor denoting negative value, pitted against normative conceptions of the social and the corporeal. Such idealized conceptions necessitate an artificial regulatory scale on which "human trash" scores lower than "the norm," while nonhuman and material bodies enjoy an even less significant status.

Figure 30: Overflowing trash on a sidewalk, Bucharest, Romania (Photo by the authors)

As such, trash—both trashed people and material and organic refuse—is relegated to the margins of society's consciousness, abjected from plain view. To abject literally means "to cast out," in other words, to discard. Mary Douglas and Julia Kristeva both explain that abjection functions to sustain the subject's (or a society's) idea of self as clean, orderly, and *whole*, emphasizing the significance of one's perception of bodily borders to one's identity. Decay and material decomposition trouble the sense of wholeness of human embodiment, and by extension the clarity and purity of the self. Clones' bodies in *Never Let Me Go* are produced specifically to be dismantled, and it is this very "brokenness" that threatens the notion of a body's autonomous, self-sufficient borders. Similarly, bodies that are different from the idealized norm threaten the self and are therefore abjected. This includes disabled bodies, homosexual and transsexual bodies, and various Others who, by the very fact of their physical difference, threaten society's sense of order and sameness.

As Judith Butler points out in *Bodies That Matter*, the process of normalization involves discursive powers that establish "[B]oundaries of bodily life where abjected or delegitimated bodies fail to count" (15). Butler argues that such discursive powers, in addition to their normative role, also perform the formative function, influencing materiality of bodies through available technologies of production and reproduction. In the age of applied genetics, when biomedical technologies of power have surfaced as a significant factor in societal formation, it is high time to revisit the binary thinking (*deviation vs. the norm*) that enables abjection. The notion of the abject poses an ethic dilemma that disability studies, gender, queer, and race studies, as well as animal, posthuman, and new materialist studies all concern themselves with: human responsibility to deconstruct dichotomies of value that form the basis of our ontology.

* * *

Gender is among the categories where abjection serves as a defense mechanism aiming to perpetuate clear distinctions between self and other. As Douglas explains, "it is only by exaggerating the difference between within and without, about and below, male and female, with and against, that a semblance of order is created" (4). Douglas and Kristeva both sketch the definition of the abject to include the female body associated in the cultural imaginary with pollution and defilement. Both theorists analyze examples from across cultures that cast the female gender as "unclean" due to its biologically-determined links to bodily fluids: sexual secretions, menstruation, and childbirth, and cite taboos and purification rituals aimed as protection against women as the source of defilement. In many cultures, menstruating

women cannot partake in religious ceremonies, attend sacred spaces, or be in public because they are considered unclean. They sometimes have to be isolated in a separate room for three days and use separate plates and cutlery. Such drastic measures are an attempt to isolate and contain the abject, stripping it of its power to disturb order. Since bodily fluids, and especially blood, signify transgression of the boundaries of a body, the female body poses a threat of dissolution of boundaries within and between bodies. The cultural imaginary, then, seeks to control the abject through various ritualistic and normalizing practices.

Kristeva argues that purification rituals are "accompanied by a strong concern for separating the sexes, and this means giving men rights over women" (1980:70). While patriarchal societies might directly claim men's rights to women's bodies, where a woman is often considered "property" of her father, husband, or a male relative, capitalist societies more generally exercise subordinating women indirectly, through public consumption of representations of sexualized female bodies. The language we use to speak of "objectification" of women's bodies is in itself a testament to how women are imagined not simply as subordinate to men and therefore of secondary significance, but as directly relegated to the world of objects. Woman bears the sin and seduction of flesh; the physicality of her body severs the distinction between the human and the material. According to this logic, first articulated in Sherry Ortner's now-famous 1974 article "Is Female to Male as Nature is to Culture?" women are considered closer to nature and the material realm than men, whose territory is language, culture, and reason:

> [women's] pan-cultural second-class status could be accounted for, quite simply, by postulating that women are being identified or symbolically associated with nature, as opposed to men, who are identified with culture. Since it is always culture's project to subsume and transcend nature, if women were considered part of nature, then culture would find it "natural" to subordinate, not to say oppress, them. (73)

The socio-economic position of women reinforced by the cultural imaginary often leads to gender-specific ways to engage with the natural and material world. Women, who in many societies are in charge of the processes of household consumption and disposal of refuse, arguably have unique insights into what constitutes garbage. The Global Development Research Center has a section on its Urban Environmental Management webpage that specifically addresses the issue of gender in waste management. According to a report by Maria Muller and Anne Schienberg from GDRC, "the fre-

quently subordinate status of women may affect their general access to and control of resources, so that the "waste" materials or waste-related activities may be the only ones which are available to them. . . . These activities might concern buying and selling household garbage, re-using and recycling waste materials, collecting and disposing of human and solid wastes in a safe manner, and keeping the streets clean."

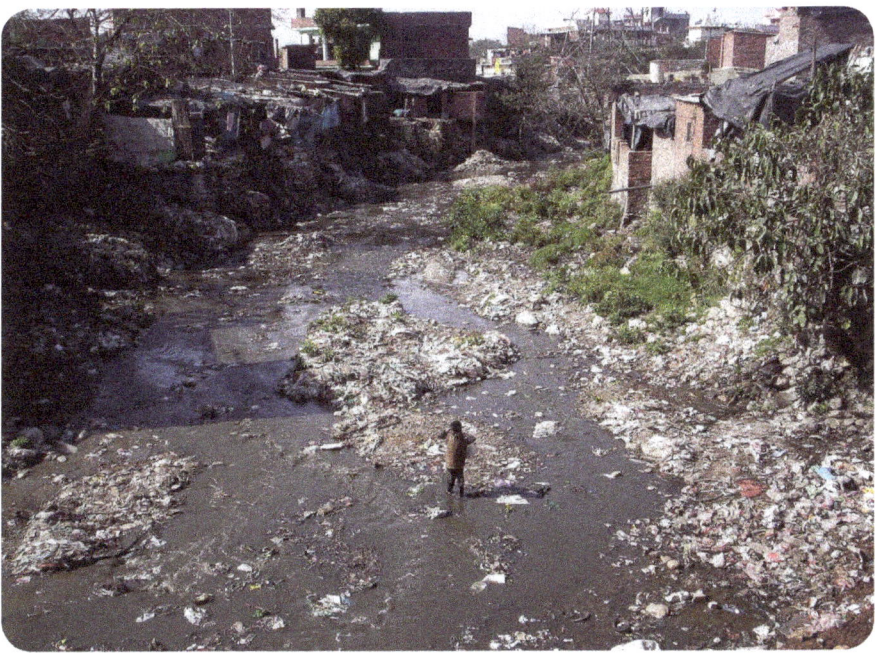

Figure 31: Slum shacks and a rubbish-laden river with a child in the middle, Indian Himalayas. (Photo by meg and rahul (Flickr) / CC BY 2.0, via Wikimedia Commons)

Muller and Schienberg go on to explicate the dangers, both psychological and physical, associated with the work of waste management: "Both men and women waste workers face the disrespect and outright scorn of fellow-citizens, as handling untreated waste materials is considered demeaning." The ambiguity of our attitude to the abject manifests itself in the meaning that we assign to waste as well as to the people whose job it is to handle it. Those who deal with garbage and refuse often by association become devalued. It is not uncommon throughout different cultures and epochs to see one's identity determined by occupation: many family names, for example, can be traced back to the profession that the family was known for, such as Smith, Fisher, or Miller. Identities fuse with the objects that

people handle, solidifying one's social status in the public realm. Robert Adams explains that, "Scavengers of all sorts are [. . .] stigmatized as unclean. "Dog" and "pig" become terms of ultimate insult, and garbage-men, who simply carry the stuff away, are objects of avoidance; in India, they find themselves segregated into a pariah caste" (55). Junkmen, garbage workers, the homeless looking for discarded items and food, children picking up empty bottles on the side of the road, men collecting scrap metal to trade in, and many other various kinds of scavengers find themselves ostracized and avoided. The fear of contamination that waste sites usually instill in us becomes, by extension, a fear of cross-contamination between different social groups, as if belonging to a lower social class were an infectious disease.

It might be this fear of metaphorical contamination that makes the teachers and supervisors of Hailsham students in *Never Let Me Go* maintain a safe distance from the clones in their care: they watch the children with eerie fascination, but are careful not to get too close. In a notable instance when Madame, a supervisor who visits the school from time to time, is surrounded by the children, she lets her feelings of disgust show, which endlessly bewilders and scares the children who are not fully aware of their own otherness: "I can still see it now," the narrator tells us, "the shudder she seemed to be suppressing, the real dread that one of us would accidentally brush against her . . . she was afraid of us in the same way someone might be afraid of spiders" (Ishiguro 35). Proximity to the abject reinforces the negative feelings associated with it, prompting the subject to maintain its distance from the abjected body. Madame's reaction that Kathy describes as "shudder," "dread," and being "afraid" might not be exactly fear, but is nonetheless a complex emotional response that the self experiences when faced with the abject. It seems to encompass a deeply suppressed guilt, the kind that we feel when passing by a homeless person on a busy sidewalk. It is a mixture of feeling responsible—a sentiment that, among other things, affirms our superior position over the abjected body—and simultaneously, a feeling of recognition, however suppressed, that we are not that different from the beggar we are trying to ignore. The latter feeling is much more powerful, for it threatens our stable position and turns on defense mechanisms that shelter the self from being contaminated by the Other.

Fear of contamination, literal and metaphorical, is a consistent motif in many of our contributors' stories that feature memories about playing with discarded objects as a child. Their recollections often serve as testimonies to the stark division between social classes: after all, the subject matter of these recollections often necessitates reflection on poverty, hardship,

and adversity. The authors often acknowledge the economic hardships and other contextual circumstances that serve as background to their stories, and speak of the fear of social contamination between classes that effectively isolated their families from those who were better off. For example, Lauros from Rome, Italy, remembers how, through dealing with objects, he came to realize his family's social standing and its consequences:

> I was six years old at that time, maybe five. My parents had financial problems. In fact, saying "financial problems" is a euphemism. Many times my father came back late at night, drunk, while mother remained at home with us (four children). My mom was a cleaning lady; she had no education and came from the extreme south of Italy. Her dream was to become a secretary, but she could not. His father told her that only bitches aspired to be a secretary. The 1960s . . . in Italy. We children had no toys. My parents could not even buy a new TV since the old one had been confiscated by the bailiff. My dad did not pay his debts, nor taxes, so they came and took the TV and other stuff. So toys . . . I remember when one day my mom came back from job. As I said I was six or seven years old. She came back with a big bag packed with old toys (and other stuff) recycled by the sons of the rich family she worked for. I did not realize that those were second hand toys. I did not care, I was simply happy because I got them. After more than 25 years I can still remember many of them. Some years later I did understand where I came from. I understood my social class. We were poor, that's why I did not have new toys like the others had. It helped me to know that, and thinking about it probably changed my whole life. It pushed me to know more about social justice, inequalities, and so on. However, some second-hand toys and other stuff recycled by "the rich" made my happiness, which lasted, at least, for a few days. (Lauros, Rome [suburbs], Italy, 1980s)

As the story testifies, the narrator's mother was denied access to education as a woman from a poor family, so the most readily available occupation for her was a cleaning job. The family's lower economic status determined their dependence on second-hand objects and reusing other people's things. Even as Lauros emphasizes the joy that the hand-me-down toys brought him as a child, he is very conscious of the societal stigma associated with second-hand things. What this story reveals is differences and divisions between social groups, while simultaneously forcing us to reconsider our own culturally-formed assumptions about poverty, childhood, and even something as abstract as happiness. In the face of cultural normative mechanisms of value formation that condition us to treat poverty with shame and

disdain, this testimony allows the author to take narrative agency in reframing his past: the story does not victimize, call for pity, or otherwise diminish the experience. Instead, this recollection serves as an alternative historiographic account of socio-economic inequality, and thus becomes potentially empowering to the reader as well, allowing us to identify possible similar experiences in our own past as something valuable and worth discussion and reflection.

Similarly, the following recollection from the Rosebud Sioux Indian reservation reframes a childhood experience of growing up in poor conditions by casting the memory across the larger geo-political context. The narrator makes a point of emphasizing that the children "never felt deprived," even when playing with discards:

> While we sent boys off to Vietnam, a place we'd never heard of, we reservation children played happily with discarded things. An old chicken coop furnished with empty cans and bottles became a store. A shelled car with the backseat intact became our house. We swam in mucky stock tanks and ponds, drug old tires and empty boxes into the brush to build castles and forts. In winter we warmed ourselves around neighborhood burning barrels after playing long games of tag in the snow. We burned newspapers, catalogs, cereal boxes, school papers and rags, and only when our families decided there was no use left in them.
>
> I never felt deprived. (CL Prater, rural South Dakota, 1960–70s)

The rhetorical power of this story lies in forcing readers to insert themselves in the experience that might be alien to many of them. What's more, it is alien by design: for a large part of the mainstream American population, reservations do not constitute a part of public consciousness, but exist separately, on a different plane of experience, in a different world that never collides with mainstream "reality." By their very nature, reservations were a way for the American government to isolate Native Americans: essentially, a segregationist practice to marginalize and separate an entire group of people from the rest of the country. As a result, experiences of life on a reservation are invisible to every day Americans until such stories are told and come to light, taking narrative agency over the experience.

Another story by Omnidoll from California demonstrates the author's awareness of her family's lower economic status. Omnidoll remembers her working class childhood in the 1970s, when she played with leftover flooring and tiles from a factory where her stepfather worked:

> I made that soft, rubbery tile last a long time as doll food and accessories. Sweets and doughy pretend food were important in my play world because food didn't often taste good to me. Cheap canned food, unflavored boiled cabbage, and hard, damaged apples and potatoes, unless your mother is a cooking genius, and she wasn't, means a child dreams of sweet, better-tasting food. (Omnidoll, Garden Grove, USA, 1970)

Her mother, Omnidoll remembers, was not much fond of her games with discarded items: "I had to be quick to intercept a throwaway item, because once in the garbage, my mother generally wouldn't let me use it. We were low income, but she had a fear of germs and contaminants." In addition to the reasonable fear of germs, the mother's attitude to her daughter's games also gives away a degree of resentment, self-resentment even, as a reaction to the family's economic situation. Eventually, the narrator tells us, her mother threw away all of her pretend toys so patiently crafted from the household cast-offs: "The little world was my solace as a child. The world 'ended' when my mother, who somehow resented this retreat of mine, destroyed the town, threw away everything [. . .]. I wanted to weep, but her one warning look meant I could not. I mourned the loss of the town silently for a long time." Perhaps discarding her daughter's simple playthings meant getting rid of the constant reminder of her inability to afford "real" toys. What the child saw as a small world full of wonders was a heap of garbage to her mother, the abject that signified poverty and contamination. By throwing away old things, we often attempt to get rid of an unwanted part of ourselves. Refuse, then, provides alienation from our own experience: we turn away with disgust from waste as if it were an extension of ourselves.

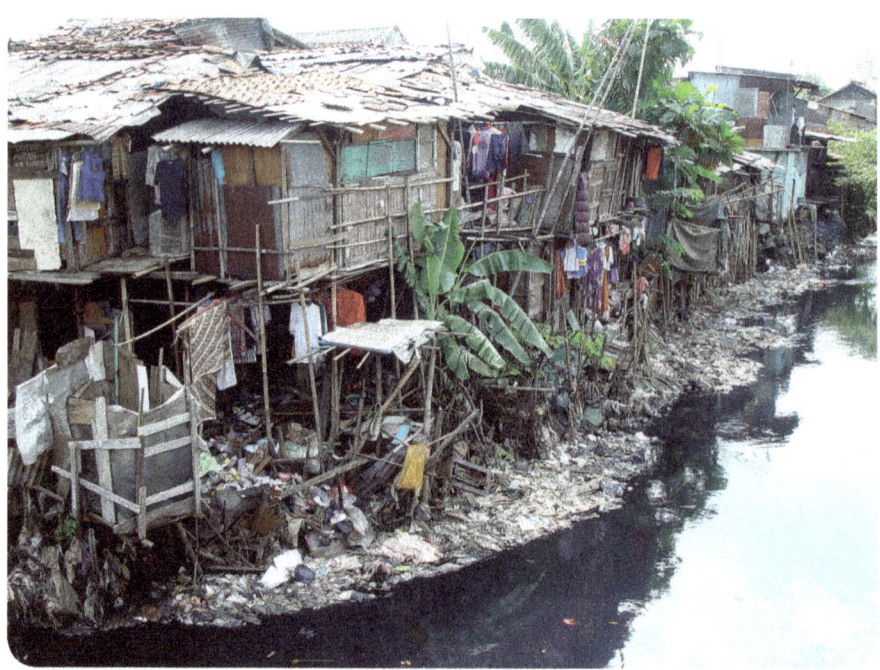

Figure 32: Slums built on swampland near a garbage dump in East Cipinang, Jakarta Indonesia. (Photo by Jonathan McIntosh/ CC BY-SA 3.0, via Wikimedia Commons)

Many cultures share a disparaging view of poverty, doing everything within their means to make it less visible in public spaces. For example, a controversial urban design trend known as hostile architecture, or defensive architecture, is a way to construct public spaces that prevents homeless people from settling down in plain view. Writing for Gizmodo.com, Chris Mills in "How 'Defensive Architecture' is Ruining Our Cities" enumerates representative architectural elements that are used most often to ensure that the homeless are kept away from the streets: "studs in the ground that prevent people from sleeping rough are the most obvious example, but [hostile architecture] can include things like slanting windowsills to stop people sitting, benches with armrests that make it impossible to lie down, or sprinklers that intermittently come on but aren't really watering anything." Mills and many other critics of hostile architecture point out the escapist mentality behind the trend: ultimately, by driving the homeless out of sight, we are avoiding the problem of socio-economic inequality instead of attempting to solve it. Similar to the anti-utopian world created by Ishiguro where clones are isolated from the society to save humans from pangs of conscience, keeping poverty off the radar allows us to go about out daily routines, undisturbed by moral dilemmas.

The Abject and Fear of Social Contamination

* * *

The final scene of Ishiguro's *Never Let Me Go* shows Kathy, the narrator, towards the end of her short clone life, looking back at her past and the friends she has lost. Hailsham, the boarding school where she spent her childhood, no longer exists; Kathy does not even know where its location used to be. She finds herself thinking about it often, though, and once, while driving out in the country, she spots a place that attracts her attention:

> All along the fence, especially along the lower line of wire, all sorts of rubbish had caught and tangled. It was like the debris you get on a seashore: the wind must have carried some of it for miles before coming up against these trees and these two lines of wire. Up in the branches of the trees, too, I could see, flapping about, torn plastic sheeting and bits of old carrier bags. [. . .] I was thinking about the rubbish, the flapping plastic in the branches, the shore-line of odd stuff caught along the fencing, and I half-closed my eyes and imagined this was the spot where everything I'd ever lost since my childhood had washed up . . . (Ishiguro 287)

As Kathy is getting ready for organ donations and eventual death, she can't help but feel a deep affinity to old discarded things that no longer have a future. Like these things, her mind is rooted in the past, in what used to be; now amorphous and shattered, they still preserve a memory of a better past and therefore provide Kathy a sense of tranquility and connection to where she came from and the people she loved and lost. They are trash, nothing more, but gathered together they can easily resemble a life. And perhaps, the resilience of rubbish in the face of decay, its defiant presence despite its apparent fate provides Kathy with a sense of dignity, if not hope.

6 Recycling: Guilt, Fetish, or Necessity?

Andrei

In chapter one we introduced briefly Thomas Hine's *The Total Package: The Secret History and Hidden Meanings of Boxes, Bottles, Cans and Other Persuasive Containers*, which argues that "packaging" is originally a natural phenomenon, found nearly everywhere we look in nature. Hine then traces the evolution of packaging to man-made containers of all sorts, and in his arguments is less interested with their contents than with the containers themselves. "We share our homes with hundreds of packages, mostly in the bathroom and kitchen, the most intimate, body-centered rooms of the house," he writes. "Some packages—a perfume flacon, a ketchup bottle, a candy wrapper, a beer can—serve as permanent landmarks in people's lives that outlast homes, careers or spouses." What we will concern ourselves with in this chapter is what Hine calls the "multiple lives" of packages, and beyond that the *living object* as exerting its own gravitational pull over the course of its existence into which it draws and subsequently alters aspects of our lives—everything from morning routines to divorce settlements.

Hine's observations about the function of packages help us realize that while "[p]ackages are an inescapable part of modern life," we seldom are fully conscious of their presence (ironically this happens even as they are being handled—a box of detergent or pancake mix, a jar of coffee, etc.). Yet they are always *working* to draw our attention, beckoning from supermarket shelves, next to the checkout counters, and from their designated storage places in our own homes. Probably the most inconspicuous of all containers is the ubiquitous, necessary, yet seldom appreciated cardboard box, something of an unsung hero as far as packages are concerned. Without the cardboard box Warhol's *Time Capsules* would not be what they are (and it bears pointing out that one of the things Warhol is most famous for, the Campbell soup cans, is also primarily a package). There is one place, however, where

Recycling

Figure 33: Paper-cardboard box containing 4 oz. of Plasmon, "pure, soluble, digestible milk protein powder," a tonic drink, made by Plasmon Ltd. of London, 1900–1950. "The great nerve and brain food." (Photo by Science Museum, London. Wellcome Images / CC BY 4.0, via Wikimedia Commons)

the cardboard box has gotten (belatedly) its due, and that is the National Toy Hall of Fame in Rochester, NY. In 2005 the cardboard box was officially inducted alongside notables such as the Frisbee, Lego blocks, and the bicycle. For anyone who's ever had a kid or remembers being a kid themselves and at times coveting boxes more than the items that came inside, this honor is certainly long overdue. ToyHallofFame.org's dedication addresses both the history and the modern lives of cardboard boxes:

> The Chinese invented cardboard in the 1600s. The English played off that invention and created the first commercial cardboard box in 1817. Pleated paper, an early form of corrugated board, initially served as lining for men's hats. By the 1870s, corrugated cardboard

cushioned delicate glassware during shipment. Stronger, lined corrugated cardboard soon followed. American Robert Gair produced the first really efficient cardboard box in 1879. His die-cut and scored box could be stored flat and then easily folded for use. Refinements followed, enabling cardboard cartons to substitute for labor-intensive, space-consuming, and weighty wooden boxes and crates. Since then, cardboard boxes have been widely appreciated for being strong, light, inexpensive, and recyclable.

Over the years, children sensed the possibilities inherent in cardboard boxes, recycling them into innumerable playthings. The strength, light weight, and easy availability that make cardboard boxes successful with industry have made them endlessly adaptable by children for creative play. Shoe boxes serve as ideal settings for scenes and dioramas. Small boxes take on alternate roles as dollhouse furniture. Wheels drawn on the side turn a box into a car. Really large boxes—from washers, stoves, big-screen televisions, or refrigerators—can offer children even greater opportunity for creativity. With nothing more than a little imagination, those boxes can be transformed into forts or houses, spaceships or submarines, castles or caves. Inside a big cardboard box, a child is transported to a world of his or her own, one where anything is possible.

Stories of recycled boxes abound in contributors' submissions to *The Afterlife of Discarded Objects*. Devon Brake from Rockville, MD shares this anecdote:

My brothers and I always had a curious imagination and when we moved back from California to Maryland the basement storage room was covered with cardboard boxes. We would sit in the basement with our markers and create cars to race, spaceships to travel to the moon with, and secret agent headquarters. For weeks on end we would use our creations for games and competitions. For big projects the three of us would combine boxes to create more exquisite things, like underground tunnels. Along with the boxes covered in marker colorations there were boxes without color that could be interchanged. Although the similarities in boxes, we could always tell the difference between them and remembered, which box, was which that we had played with the day before. The boxes taught us valuable lessons like heartache, when our parents decided to recycle one of our beloved boxes, and that day tended to be when the truck came, thus there was no way to rescue the box. Nevertheless, that only enforced our creativity as we moved to different boxes, now they were tree houses, animals, and planes. When we played together with our creations

there was an unsaid rule that at the beginning of playing everyone says what their box is and then they are not allowed to change it because that was cheating.

Figure 34: Grey and white cat in a large cardboard box. (Photo by CelloPics / CC BY 2.0, via Wikimedia Commons)

With stories such as this one and the implied ability of a repurposed object to continue affecting us, it is at least a little bit ironic that the things that are meant to preserve and contain are the things that we discard most often. There are boxes we keep and boxes that we toss away, but nonetheless our relationship with such objects revolves around ideas of containment; yet as we have seen in previous chapters what is often contained might not be other objects themselves but memories and experiences. One anonymous submission from Winchester, VA titled "The Cardboard Construction Worker" gives us this insight:

I moved a lot as a child, and it taught me a lot about making friends and learning to adjust to my environments. One thing that remained a constant through all the different cities, climates, and accents, was the fact that we always lived in a house. As a child I used to draw my dream house, or simply daydream about what my house would be like when I grew up. The week I moved to Winchester, Virginia was a hard one for me, I guess because I was old enough to understand what was happening. One day me, my little brother, and my little sister got tired of unpacking but hadn't unpacked our toys yet. We walked outside and soon found a pile of old cardboard boxes that we used to move our things. We proceeded to tear apart the boxes and build our own house. We used duct tape to hold it together and we kept it in the garage for years, pulling it out whenever the urge to play 'house' came upon us. It's funny how a piece of garbage, like a cardboard box, can mean so much to a child.

What these stories share in common is the child's unbound imagination when it comes to finding alternate uses for mundane objects, but they also give us a look into the subsequent stages of use that an object passes (or is cycled) through. Interestingly, the time that many of us—children and adults alike—become aware of the box, or the package itself and its many roles or lives, is when it has lost or run out of its contents, when it has become a thing-in-itself and not merely a container of something else. "[O]nce the product has been used up, and the package is empty, it becomes suddenly visible once more," writes Hine. "This time, though, it is trash that must be discarded or recycled. This instant of disposal is the time when people are most aware of packages. It is a negative moment, like an end of a love affair, and what's left seems to be a horrid waste." Hine is right, of course, but only partially in his final claim. Not all that has reached the moment of disposal is necessarily waste, and not all waste is horrid. The reference to *recycling* the cardboard box's *recyclable* qualities by the National Toy Hall of Fame is significant, as it addresses the possibilities and *continuity* of the object—what any child will attest to—as opposed to only its terminal stage once its original function has expired.

* * *

When we mention the term *recycling*, fundamentally we are invoking the physical and temporal continuity (as well as the limitations) of objects that places them simultaneously into categories of trash/waste and *something else*. Even the "natural packages" Hine had referred to and that we can easily recall—peanut shells, eggs shells, and pea pods for example—are destined to reach a

moment of *end use* and be discarded. But far from "horrid," we might imagine their continuing impact as compost or animal feed. End use—when the product or contents have been used up by us—is not necessarily the end. The same goes for material objects, and the ambiguous *something else* that defines their afterlife is just as crucial, since we can rarely predict or envision what that will be. Much in the same way that for a child a recycled cardboard box might become a racecar or a castle, an object's multiple lives makes it increasingly difficult to rely on a single definition such as *waste* to designate anything that has reached end use.

In *Waste: A Philosophy of Things*, William Viney takes issue in the section titled "Archaeologies of Waste" with the work of Michael Shanks, David Platt, and William L. Ratje and their essay "The Perfume of Garbage: Modernity and the Archaeological." Specifically, Viney argues against the authors' claims that waste is the end point of all objects and that junkyards are an example of the locus of such an end point. Viney quotes Shanks et al., who write that junkyards "compress space and time into a single point—artifacts from different times and places are brought into one location, to be (re)discovered" (62). The argument that follows suggests that, "For Shanks et al., waste seems to be reducible to these sites of spatial and temporal termini, or, put another way, as things that have no future" (62). Viney believes this is not the case and uses artist Mark Dion's mixed-media cabinet of curiosities *Tate Thames Dig* (1999) as proof that they are wrong. For *Tate Thames Dig*, Dion invited collaborators to help comb two sites on either bank of the river Thames, and the materials gathered, such as "bottles, shards of glass, plastic and iron, buttons, teeth, bones, identification and credit cards, clay pipes, toys and pottery," were then arranged within a large wooden cabinet and presented at the Tate Modern (61). Viney points to one of the objects in the cabinet in particular, a glass bottle, as an example that arguably disproves Shanks et al.,: "The places and times that it associates do not cohere to a particular point, whether construed as the site of excavation or the cabinet itself; instead, the bottle's significance through space and time depends upon a continuity of movement. This is a crucial aspect of waste, its structure of contradiction; the collection of waste does not necessarily make smooth its irregularities or make sequential the ruptures of its temporality." He adds that "the dubious continuity of waste extends into Dion's archive. As remains that are not guaranteed to remain" (63).

The point here is that all objects undergo a process of decay, of breaking down, so that even as waste they continue to change. The work of art itself contains objects that could degrade over time, and even the cabinet itself (which was allowed to be handled by visitors) shows signs of wear and tear with pieces having come loose. "The cabinet evolves continuously,"

writes Viney, and for its most recent exhibition new drawer runners were needed and new fabrics to line them to replace the old ones that had been damaged by corroding objects (72). Because of this "evolution" of the objects and the work of art itself, Viney believes that Shanks et al., have got it wrong and "waste is not the familiar fate of all things" (62).

Viney's argument hinges, I believe, upon a limited definition of waste but also of recycling, what we mean when an object enters that particular stage of its life. When Shanks et al., write that junkyards "compress space and time into a single point," Viney takes it to mean the end of the object in absolute terms, that it has now simply become waste, that its journey and connected narrative has concluded. Yet, throughout this particular section of the book, he never addresses the last word of the authors' claims, that the objects end their journey to a point where they await to be "(re)discovered." An object (re)discovered does by no means have "a sense of closure and resolution," as Viney claims Shanks et al., are implying. In fact, by using the term *(re)discovered* Shanks et al. are suggesting the presence in objects of the same continuity and evolution Viney values in Dion's work, the same continuity we observe in stories of recycled boxes. But the fact that an object might be recovered and recycled—a cardboard box saved from the trash compactor—does not mean that it has not reached a terminus of sorts; or more precisely, that it does not reach *several termini* in the course of a lifetime.

The points of contention between Viney and Shanks suggest a tendency among theorists to present arguments surrounding waste in terms of absolutes, which, given the ambiguity and unstable nature of objects, is understandable. There is a need to pin things down. For the purposes of this chapter, however, I would like to suggest in later sections that both arguments—the existence of terminal points as well as continuity—are at work concurrently, running parallel to one another in our theorizing about the recycling of objects.

* * *

So far, the working definition of the word *recycle* falls more along the lines of a traditional dictionary definition than the one many of us might immediately conjure up when thinking of something such as a recycling center, recycling cans and bottles, recycled paper/plastic, etc. That kind of recycling breaks down the object into a form where it is no longer recognizable as itself, after which it is processed into a new object (possibly similar to the original, though not necessarily). The child's-cardboard-box-kind-of-recycling is the one we will concern ourselves with here—recycling as reuse,

recovering, reclamation, salvaging, or reconditioning—an object *used again* as *something else*.

For me that distinction is crucial from an individual and cultural perspective, and it also serves to highlight what I will refer to as a third world/developing world attitude to recycling compared to that of the developed world. One particular memory involving salvaged and reused objects stands out as emblematic of the distinction in terms and the difference between attitudes across cultures.

It is July 2014 and I am helping my aunt build an enclosure for a mother hen and a dozen or so chicks that are several weeks old. Up until then they had been kept indoors, in the kitchen, with an old cardboard box serving as shelter during the night. As the chicks grew they needed to be moved outdoors, and it was necessary to build them a larger enclosure where they would have access to more space, sun, and grass. I walk with my aunt to the back of the garden, to a spot that resembles a miniature junkyard complete with rusted pipes, broken doors, planks of wood, glass panes, plastic crates, and much more. This is where everything goes once it is no longer in use, either because it has broken or because it has been replaced with another. Everything has been exposed to the elements, sometimes for years, and some things are barely covered by a piece of corrugated metal. We rummage through the pile for what we need: a drawer without any handles, four lengths of rebar, wire meshing, and a sheet of linoleum.

The drawer will serve, standing up, as the back wall for the makeshift chicken pen, but it needs a more stable foundation, and the roof will be extended using other planks of wood that we pull out of the wreckage. For that we need nails. My aunt points to a metal cabinet with more odds and ends and an assortment of containers with nuts and bolts, ball bearings, and nails. The only nails I see are in an old wooden dominos box, sans lid, and all of the nails inside are rusted and bent. I still remember the time it took sifting through those nails, looking for the ones in the best condition, and then kneeling down on the pavement and trying to pound them as straight as possible with a hammer. Whether it was the nails themselves or the act of manual labor, that moment is inseparable for me from the memories it brought to the surface of my grandfather and the tool shed he kept when I was a child. As a young boy I was fascinated by all of the curious objects he kept in there and would spend a good amount of time picking through boxes and containers that seemed to hold nothing but old and broken parts of things. What I can still recall to this day is the smell of the place—of rust and metal—which working the bent nails rekindled for me. And I know that some of the objects we recycled into the chicken pen were once handled by

The Afterlife of Discarded Objects

him, functioning in their new lives as a link to the past—suggestive of what they are no longer, and also that we have changed as well.

Figure 35: Makeshift chicken coop, linoleum table cover and recycled wood paneling from old dresser, Hagiești, Romania (Photo by the authors)

This anecdote supports Viney's claim of the continuity and ambiguity of the future of objects while simultaneously lending support to the notion that all items reach a terminal state of waste. What is crucial to this understanding is to consider the word terminal not as *The End* with a capital T, but as multiple stages in the life of an object, each with a recognizable end (regardless of how fluid it might appear at times). This is not far from the way we think about our own lives when we use language such as terminal degree, bus terminal, the end of a book, the end of the season, opening up a new chapter, etc. None of those terms or phrases imply that nothing will happen after, but that a stage or phase has been completed—a stage with a recognizable identity, a set of distinct coordinates and terms of use. What happens after, of course, is seldom predictable (ask any graduating college senior or a tourist getting off at the last stop in an unknown country). Each of the items that made their way into the chicken pen we cobbled together had been considered by all intents and purposes to be waste. Each object had reached its end use and was relegated to a single point, as Shanks et al. argued. Even Dion's drawer runners and fabric had to be replaced, their use in the display effectively being terminated (Viney does not explain what, if anything, happened to the old ones, or if they were tossed out with the

trash). But the objects also waited, continually decomposing, for the moment when they could be recycled. Some might remain in that stage forever, simply as waste, and some might be repurposed many times over, each time reaching a terminal stage of end use and reclaiming the status of waste.

Recycling then requires that we think of objects as existing at any moment within distinct spatial and temporal points along a continuum that extends (as we established previously) into the past, present, and future. That continuity is not without elements of demarcation—beginnings and ends—however porous and indistinct the borders; otherwise we would lose any sense of time and space. It is this quality of recyclable objects that helps us shape our narratives and further requires that we keep revising them each time objects enter new stages of use.

* * *

My grandfather's tool shed and the miniature junkyard in my aunt's garden complicate conventional notions of waste and the phases objects pass through from use to neglect. They are also examples, as I mentioned earlier, of attitudes toward recycling in the developing world as compared to what we might find in developing countries. More than a quarter century after the fall of communism, Romania is still the poorest country in the European Union, and for a significant number of its citizens in rural, farming regions, life is still a matter of surviving with the bare minimum. This reality forces us to acknowledge that to recycle in such places means a completely different thing than it does for you and me as we sort our used containers into paper, plastic, and metal to be picked up by the curb once a week. While we might be tempted to think of our actions as environmentally conscious or done with the best of intentions, we seldom consider that it is a luxury to even contemplate environmental concerns or where a tuna can might end up if we don't place it in the correct recycling stream.

Hine focuses much of *The Total Package* on consumerist culture and the production of an endless supply of attractive packaging that entices us to buy, consume, and discard. By invoking consumerism, he is implicitly directing his observations to an audience that can indulge the time to ponder their shopping habits *as habits* and the aesthetic value of the packaging they take home with them. "Why yes, now that you mention it, that is a particularly striking design for a can of sardines," is not typically the kind of reaction you might expect from someone who possibly spent the last coin in their pocket to purchase a bare-bones meal. It is also more likely that the empty can will be destined to be repurposed (if at all) as a repository of buttons or safety pins or burnt matches that still have some life left in them, much more than to be recycled into another tin or aluminum product.

What Hine was partially getting at in 1995 are the effects of "cultural capitalism" (a term coined by economic theorist Jeremy Rifkin), which Slavoj Žižek takes up once more in 2014 in a column for *The Guardian*, "Fat-free chocolate and absolutely no smoking: why our guilt about consumption is all-consuming." In cultural capitalism consumption and morality/ethics go hand in hand so that consumers feel good about themselves (helping the poor, saving the environment) in the act of purchasing a product. The product's strict functionality is replaced by the experience it provides: I am *being* eco-friendly, I am *being* eco-conscious, as if the condition of the product confers the same condition on the person upon purchase/consumption. "[T]he very ecological protest against the ruthless capitalist exploitation of natural resources is already caught in the commodification of experiences," writes Žižek. "[A]lthough ecology perceives itself as the protest against the virtualisation of our daily lives and advocates a return to the direct experience of sensual material reality, ecology itself is branded as a new lifestyle. What we are effectively buying when we are buying 'organic food' etc is already a certain cultural experience, the experience of a 'healthy ecological lifestyle.'"

Recycling in this sense is a lifestyle brand, one that confers status by its very practice. Žižek provides an example of cultural capitalism through a Starbucks ad campaign that reads: "It's not just what you're buying. It's what you're buying into." And later, "But, when you buy Starbucks, whether you realise it or not, you're buying into something bigger than a cup of coffee. You're buying into a coffee ethic." For Žižek, "buying into" the coffee ethic is problematic because while it has the ability to empower you personally, to assuage your guilt and provide one with a sense of belonging to a group or cultural movement, ultimately it does little to change the status quo. An awareness of our "carbon footprint" and a desire to buy sustainable product, to compost and to recycle more are the ways we buy into or purchase our daily dose of ethics. Žižek is typically scathing in his admonishment:

> There is something deceptively reassuring in our readiness to assume guilt for the threats to our environment: We like to be guilty since, if we are guilty, it all depends on us. We pull the strings of the catastrophe, so we can also save ourselves simply by changing our lives. What is really hard for us (at least in the West) to accept is that we are reduced to the role of a passive observer who sits and watches what our fate will be. To avoid this impotence, we engage in frantic, obsessive activities. We recycle old paper, we buy organic food, we install long-lasting light bulbs—whatever—just so we can be sure that we are doing something. We make our individual contribution like the soc-

cer fan who supports his team in front of a TV screen at home, shouting and jumping from his seat, in the belief that this will somehow influence the game's outcome.

Figure 36: Makeshift outdoor sink fashioned from old sink bowl, barrel, and plastic buckets, Hagieşti, Romania. (Photo by the authors)

Take for example the "I'm Not a Plastic Bag" bag phenomenon of 2007 (originally designed for the charity campaign We Are What We Do), where a celebrity-endorsed cloth bag sold out within hours after being released in London and subsequently sold for hundreds of dollars on

eBay. When "eco" goes trendy, someone is sure to raise the price for carrying around a guilty conscience. Such a conspicuous display of eco-chic, advertising your green credentials and environmentally conscious lifestyle (cutting down on plastic bag use), would certainly earn at least a sneer from Rifkin and Žižek. What good does it do in the face of the Great Pacific Garbage Patch, estimated at hundreds of thousands of square kilometers in size, where toxic sludge and disintegrated plastics have begun to enter the food chain?

Cultural capitalism as the conflation of morality and consumerism is a rather recent phenomenon, and in some places in the world just beginning to take hold in the past two to three decades. During the late 1980s when Romania had entered some of its darkest days under the Ceaușescu regime, consumer goods were limited and basic foods rationed. I remember standing for hours in long queues with my parents to pick up our portions of flour, rice, oil, and meat. Nothing came in a pretty package, no elaborately constructed container that we might even consider throwing away or recycling afterward. We showed up with our own bags that would be used over and over until they couldn't hold anything anymore. Milk still came in glass jugs that once empty we would take back to the store to exchange for full ones. What I realized many years later is that such an existence produced very little waste. In fact, as a child I simply do not remember much trash on the streets. While this is certainly due to Ceaușescu's draconian policies and the lack of goods overall, it is also indicative of a cultural mindset that teaches you to "waste nothing," just in case it might be needed or useful later.

This is the difference between recycling as fashion, fad, or lifestyle choice, and recycling based on need. When *lifestyle* is replaced with *living*, everything is reused and repurposed. As a child I remember corners of my grandparents' yard where various objects would make their way over time to what many would call rubbish piles. My aunt's junk pile was an extension of those, a connection to an identity that solidified through years of experience with objects that never quite disappeared. What fascinates me now is that I never considered those piles as garbage, as areas where waste accumulated. They were simply part of the environment of my childhood, possibly play things, curiosities, items that might be cycled back into use someday. Some of what my aunt has kept in her pile I have no doubt is decades old and was kept originally by my grandparents. The house has changed, the waste piles have moved, but the objects remain.

This condition, however, might not last for long as the distinction between recycling as fashion and recycling as need is slowly eroding. After the fall of communism in 1989, Romania, just like many other former Soviet satellites fell under the spell of free-market capitalism and conspic-

uous consumption. Shopping centers and malls advertise their goods with flashy package designs, just as Hine observed in the mid-90s. Romanians no longer need to hold on to everything because mass-produced-everything could be found at a reasonable price. Now trash is everywhere, and there is a tendency to discard entirely, fill up the fields and the dumps where instead of functioning as receptacles for memory objects will haunt the guilty conscience. From an economic and political standpoint, the use and reuse loop is worth paying attention to—little to no waste as a condition of need has given way to excess which has given way to a conscious effort to reduce waste. Wholesale change a la Žižek might be outside our grasp, but just like with objects we can notice the stages of historical development—perpetually terminal—in our relationship to waste. Pretty soon we will reach the point where Romanians, too, will begin to look for the label that says, "Now less packaging!" And while most will argue that's a good thing, the future of children's recycled box stories looks pretty grim—the cardboard box, as all human inventions, eventually relegated to folklore and the glass cabinet of a museum.

Natalia

In the 2008 Canadian documentary *Examined Life: Philosophy is in the Streets*, filmed on the streets of New York City and other metropolises, contemporary philosophers such as Cornel West, Avital Ronell, Peter Singer, Kwame Anthony Appiah, Martha Nussbaum, Michael Hardt, Judith Butler, and Slavoj Žižek offer their thoughts on a wide range of issues facing modern culture. In one particular segment, Žižek offers his own philosophy on garbage while wearing a bright orange safety vest and pacing in front of an expansive London trash heap. In one of his bolder claims, Žižek argues that ecology (by which he means ecologically conscious public discourse) is today starting to take the place of conservative ideology. "Ecology will slowly turn, maybe, into a new opium of the masses . . . the way, as we all know, Marx defined religion," he says. When he defines ideology broadly as an illusory, imposed way of thinking about and perceiving reality, he doesn't allow for much wiggle room in the viewer's interpretation. If we agree then with Žižek's take on ideology—a means of deception and self-deception necessary to control populations—then such a comparison to ecology as public discourse sounds dreary. Substitution of true ecological concern for an ideologically loaded, superficial mindset, Žižek believes, ignores the ecological danger facing the global society.

When he is standing in front of mounds of trash, rotting, decomposing, and by any definition ugly, Žižek invokes the viewer's visceral reaction and repulsion: "This surely is not a reflection of me and my own lifestyle." But Žižek is also banking on such a response, expecting that even in the "middle of a catastrophe," as he would call it, many of us could still sleep at night and feel at ease with our efforts to recycle, reuse, and protect the environment. As part of ecologically conscious discourse, recycling then can be said to have an ideological function, making one feel better about oneself while continuing to contribute to the problem on the larger scale. The developed countries' guilt about overproduction and wasteful lifestyle finds release in the culture of recycling, visible alike in household separation of waste and new lines of consumer goods branded as "green."

Recycling

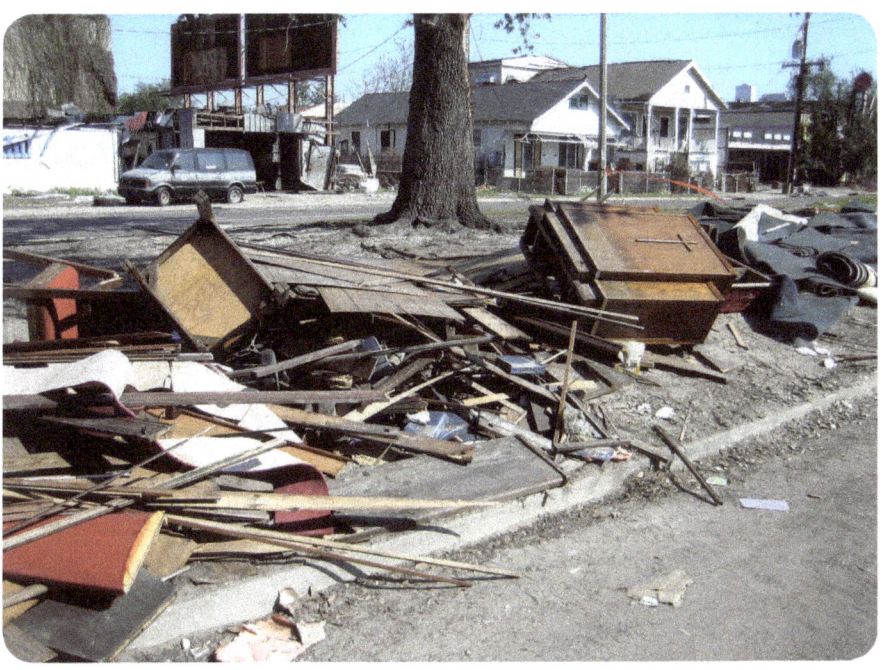

Figure 37: New Orleans after Hurricane Katrina: Damaged pulpit and other items from flood damaged church put on neutral ground to be hauled away as trash in Central City neighborhood. (Photo by Infrogmation / CC BY 2.5, via Wikimedia Commons)

As any ideology, cultural attitudes to recycling are not universal, but differ significantly across different societies, as their underlying rationale is determined by the socio-political context in each case. Writing about representations of waste in African cinema and literature, Connor Ryan cites Kenneth Harrow's concept of "regimes of waste"—a public discourse on waste framed by "a particular relationship between aesthetics and politics" (52). A nation's self-image and perception of its place in the global society, economic conditions of everyday life, and ideal models of individual behaviors of consumption are all factors in formation of a regime of waste: "The regime predetermines how we face up to waste, but as Harrow notes, the notion of waste shifts from one regime to another, making it available for recuperation, adaptation, and recycling" (Ryan 52). Ryan then analyzes postcolonial regimes of waste and the ensuing representations of garbage as a weapon for the politically discontent. As a reaction to the colonial past and its enforced hierarchies of value that organized and disciplined racialized bodies, postcolonial societies' image of waste "confronts the social and material asymmetries between abundance and scarcity, overdeveloped and un-

derdeveloped geographies, sites of production and disposal, access to good health and exposure to death, and so on" (Ryan 53).

In the global south, where a large part of the world's produced electronics end up as a cheap and convenient way for the affluent West to discard its e-waste, recycling must necessarily acquire a different significance. According to the estimations published on the official cite of Greenpeace International in 2009, "In the UK alone, at least 23,000 metric tonnes of undeclared or 'grey' market electronic waste was illegally shipped in 2003 to the Far East, India, Africa and China. In the US, it is estimated that 50–80 percent of the waste collected for recycling is being exported in this way. This practice is legal because the US has not ratified the Basel Convention." While some old electronics are sent as used goods suitable for further exploitation, their life span is short; most of the shipped e-waste is reportedly non-reparable and has to be disposed of, a process that involves disassembling of devices to salvage recyclable parts and metals.

While the United States has in place generally effective and efficient recycling practices, the Basel Convention (an international treaty designed to reduce the movements of hazardous waste between nations, specifically from developed to less developed countries) would have ensured that the same care is in place when dealing with trash that leaves its shores. Recycling hi-tech materials involves hazards that developing countries are often not equipped to handle: "In developed countries, electronics recycling takes place in purpose-built recycling plants under controlled conditions. In many EU states for example, plastics from e-waste are not recycled to avoid brominated furans and dioxins being released into the atmosphere. In developing countries however, there are no such controls. Recycling is done by hand in scrap yards, often by children" (Greenpeace International). To be fair, an average consumer from the West, as she deposits her old laptop at a recycling facility, has no awareness of what might happen to it next and how this will impact other people and the environment. She thinks she is doing the right thing, making the ecologically conscious choice. Whether or not recycling workers themselves are aware of the health hazards of their working conditions, however, their reasons for recycling are more immediate and prosaic than those offered by the Western slogans of "going green." In developing economies, the drive to get as much use of goods and materials as possible is not a choice, but a necessity of life. Under a regime of waste determined by scarcity of means of living, including everyday necessities, public attitudes to material goods turn utilitarian, looking for opportunities presented by waste. Recycling in such contexts can be understood in broader terms, as keeping materials (potentially hazardous or otherwise) in

use with necessary alterations, or reusing them as building blocks to fashion another utilitarian product.

* * *

Similar to post-Ceaușescu's Romania and post-Soviet Eastern Europe in general, Russia itself faced major hurdles during the economy's difficult transition from communism to capitalism. In the early 1990s, as Western goods in plastic packaging appeared on the store shelves, consumers invented a million ways to reuse the packaging: a plastic soda bottle, for one, became an unsung hero of every household. A TV show on prime time called "Skilled Hands" solicited submissions of helpful inventions from across the country and shared the best ideas with the viewers. On screen, following step-by-step instructions, the show hosts cut up plastic bottles and reassembled them into household objects or decorations such as bird feeders, napkin holders, decorative lamps, wind-chimes, hanging flower pots, lifting weights, scarecrows, plastic spoons, protective eye masks, and almost any imaginable objects that could be useful around the house. Today the popularity of such DIY shows and lifehacking segments as "Skilled Hands" has gone viral on social media and YouTube, an indication of just how much we seem to be fascinated with the latent potential of seemingly useless objects.

One of the contributors to *The Afterlife of Discarded Objects*, Alena from Astrakhan, Russia, writing about her childhood in the 1990s, recalls a tennis table in their yard that, during one especially cold winter, "was split up to make wood for heating." Another contributor, Nadia Fedorva from Kurgan, Russia, observes in a similar memory about that time:

> "Everything that would immediately go to garbage now was carefully collected or reused back then. [. . .] We tried to collect and conserve everything; we could not bring ourselves to throw away cups from yoghurt, instead we used them to keep little things inside such as beads and stickers. Boxes from juice did not go to waste either: we did not buy juice that often, and the boxes were so pretty. [. . .] Now, there is no end to all this garbage, but back then there was a deficit of everything and we thought these things were so beautiful, rare and precious. Now it is not even funny to remember these things; it is actually quite sad."

Such testimonials accomplish more than merely presenting retrospective accounts of personal histories: they also record an evolving understanding of the paradoxes of value in the consumerist society. If the resourcefulness of the 1990s in Eastern Europe emerged out of poverty, the

next decade brought relatively better economic conditions and an exaggerated contempt towards everything old and used. In the Russian language there is a proverb that sums up the culture's deprecating attitude towards poverty: Poverty is not a sin, the proverb goes, but it is a piggery. The word piggery here means several things at once: beastliness, disgrace, a dirty act, a rotten, miserable state. In the 2000s, resentment against the hardships and poverty of the post-communist years took an extreme turn: that time saw the beginning of the so-called Putin glamour, which glorified a flashy, swaggering lifestyle. Everything had to be new: clothes, furniture, accessories, which meant that everything old was ruthlessly discarded if the owner had the slightest opportunity to replace the old thing with something freshly bought, even if it was cheaply made (not unlike the transition from the late 1980s into the early 1990s in the former GDR, as depicted in *Goodbye, Lenin!* when people threw out furniture and other goods made in East Germany and replaced them with ones imported from the West). People were in a hurry to discard the past, hastily replacing the old self associated with poverty and stagnation with a new, shiny façade. Attitudes to waste under this new representational regime shifted drastically, making recycling de facto non-existent or, at the very least, looked down upon. The old was simply trash, to be discarded and forgotten, without much regard for how and where it ended up.

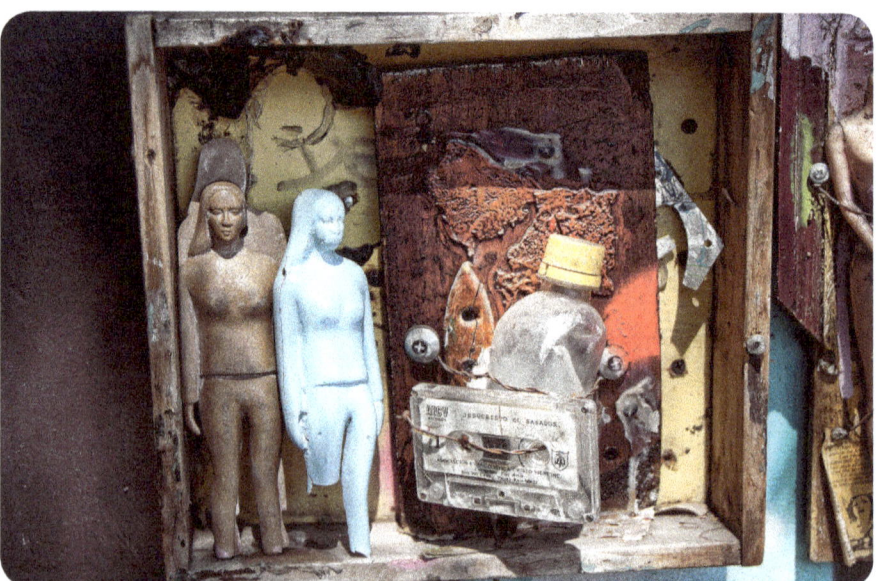

Figure 38: Recycled art in Santiago, Chile. (Photo by She Paused 4 Thought / CC BY 2.0, via Wikimedia Commons)

To regard recycling as symptomatic of the conditions of poverty, however, would be one-dimensional and not entirely accurate. Acknowledging the negative connotations of recycling as dictated by need, it still bears reason to consider the positive implications—and underlying meanings—of the drive to reuse and reinvent objects. It shows, above all, a careful attention to the affordances of materials, a redemptive engagement with discarded objects that is respectful of the interconnection between the human and nonhuman world. As Neville and Villeneuve point out in *Wastesite Stories*, "Nature, to begin with, has always shown a proclivity to recycle, combining what it produces each day with what it decomposes" (6). Connor Ryan, too, emphasizes the productive dimension of waste, as he evokes George Bataille's idea of formlessness (Bataille, *Visions of Excess* 31, 46–50). Ryan explains: "As opposed to a trajectory from creation to destruction, Bataille seeks a renewed cycle of creation in the very site of destruction. He posits formlessness as the point at which a material loses its identity as a recognizable object, which also marks the point at which the material is freed to be transformed into something radically new" (63). Recycling, then, is meant to actualize the creative potential of garbage, to tap into the endless possibilities of the formlessness that can be and will be transformed into a new entity. Recycling—re-cycling—is ultimately a way to bring an object to a new cycle of life, a process through which things that act as participants in a complex interrelational network are redistributed, ready to fulfill a new function as part of a different system.

* * *

Recycling, while performing a role in the feel-good ecological narrative as Žižek argues, also plays a potentially redeeming role through its influence on memory. Russian culture has now caught up with the West and its much more nuanced understanding of the value of old things. As fashion and public taste gradually turned away from the glamour of the new and towards appreciation of antique, weather-beaten things, the concept of *vintage* became central for the newly emerging cultural aesthetic. Soviet-era paraphernalia that only recently functioned as an extension of the old, despised self that the culture denounced and strived to erase have suddenly acquired nostalgic overtones. Keeping in mind the strong ties of memory and material culture, such a radical shift in determining the value of material artifacts is indicative of the country's returning appreciation of its history. Every culture needs its past: as a frame of reference to understand its present and the possible directions of the future, as basis for national and cultural identity, or simply as a story to tell, which is meaningful on the personal as well as the collective level. Russia's turn from erasure of memory to recycling of

it is essentially a movement from self-effacement to refashioning of identity: a rhetorical, abstract move that runs parallel to a change in material values and priorities. In this emerging paradigm of value, things are more than status symbols and signs of conspicuous consumption: objects, especially old ones, enter a relatively more complicated conceptualization of the country's identity in relationship to its past.

Even while curating this new identity, "old" objects are still deployed by their users and owners as distinct cultural markers and indicators of personal values. In that sense, it is the projection of an object's aura that matters; what often seems to be more important than a "real" antique object is a simulacrum of an imagined old object: an imitation, or, better yet, a new creation that posits itself to possess an aura of something old. As such, it is an imitation that does not fashion itself after any original, but rather, promotes the stylized vintage as a new aesthetic and material value. The process of creation of such artifacts—décor elements, household objects, and collectible toys—often involves upcycling, or using old materials to create a product of a higher value (aesthetic or monetary) than the initial product or material. As an example of upcycled collectibles, Olga Bakhareva, an artist from Yekaterinburg, Russia, designs hand-made teddy bears that look vintage using pieces of old cloth, antique or antique-looking details, accessories such as buttons, and by following old-style blueprints of Soviet-era toys. Her teddy bears are aged on purpose: stitches are made to look worn out; there is some patching and special treatment to elements such as brooches and collar bells to make them appear older. Essentially, artificially aged things are "fake authentic," appealing to the allure of mystery that surrounds old things. Combined with these are "real" antique materials: most of Bakhareva's teddy bears are made of old Soviet plush, a popular material that used to be found in every household: curtains, furniture covers, and even clothes were made from it. During the Soviet era, it was not uncommon for apartments throughout the country to be furnished and decorated with similar items that created a common look with little to no variety: an apartment in Moscow could look nearly identical to one in Vladivostok or in a remote Siberian town. Many of these items can still be found in antique shops and even some old apartments and are now readily recognizable by Russians as belonging to that era. Use of these materials, then, is a rhetorically significant choice that creates nostalgic connotations. A teddy bear by definition is a comforting, soothing object; these feel-good associations get applied to the vintage materials and by extension the Soviet past in general. These toys abound with visual cues that help refashion the past and endow it with sentimental meaning; they are aesthetically pleasing as they create a welcoming enchantment, an invitation to remember what possibly never

happened in the first place, a chance to construct a story and a history behind an item.

Figure 39: Teddy bear from upcycled materials designed by Olga Bakhareva, Yekateringburg, Russia. (Photo by Olga Bakhareva)

Similarly, in the West upcycling has become increasingly fashionable, a consumer fetish for taking trash and discarded items and turning them into upscale, often high-priced items of leisure and decoration. Back in Žižek's London at the beginning of *Examined Life: Philosophy is in the Streets*, and alongside the rubbish heap, we might find artist Rupert Blanchard who creates industrial-style furniture from landfill-bound materials that he finds in

the streets of London: discarded drawers, refuse plywood, used doorknobs and other hardware found at flea markets. In the United States, self-taught welder Raymond Guest takes vintage tailgates from Ford and Chevrolet pickup trucks, and along with repurposed wood and metal parts turns them into thousand-dollar benches for the backyard or your very own man-cave.

If you're crafty enough, numerous websites have sprung up within the past decade or so catering to the DIY spirit and offering endless suggestions on how to turn old into new. One such site, *Upcycle That: Upcycling Ideas and Inspiration* (www.upcyclethat.com), has been around since 2012 and bills itself as "a resource for people interested in reusing items in innovative ways." Among the hundreds of ideas you can find out how to make your own beer bottle lamp, drum kit lamp, egg carton flower lights, bottle cap portraits, and a slew of suggestions for turning wooden pallets into tables, chairs, storage containers, and more. What such sites geared to the everyday craftsman have in common with artists such as Blanchard and Guest is the assumption that one has either the time or money (or often both) to undertake such projects or afford them.

As post-communist countries are catching up to the West with its patterns of consumption and disposal of material goods, the move from recycling as necessity towards recycling and upcycling as a rhetorical statement is taking place. A culture where things are easily replaceable loses sight of the value of things and what they can do in our lives. We do not hold on to objects in the same way as before and we no longer recycle for the same reasons. Fueled in part by the feeling of responsibility for our ecological footprint, in part by a desire to justify our lifestyle, our efforts to recycle objects reflect our egos more than they do the objects themselves, or the productive potential of used materials. Upcycling, in its strive to turn exhausted material into a valuable commodity, foregrounds and celebrates the creator of the commodity more than the material, whereas recycling out of necessity does not concern itself with the talents of its maker. Consequently, repurposing objects in developing countries does not fit the decisive element in the definition of upcycling, namely, the upward move in the monetary value of the object, focusing instead on the object's presence and its functionality. A woman in Eastern Europe using straps of cloth from old rags to make a floor rug does so without ever knowing that a similar rug would cost upwards of $100 on Etsy.com. On the contrary, upcycling in the West, regardless of its (undoubtedly praiseworthy) power to promote responsible patterns of consumption, is still bound by its cultural status as a fetish.

Recycling

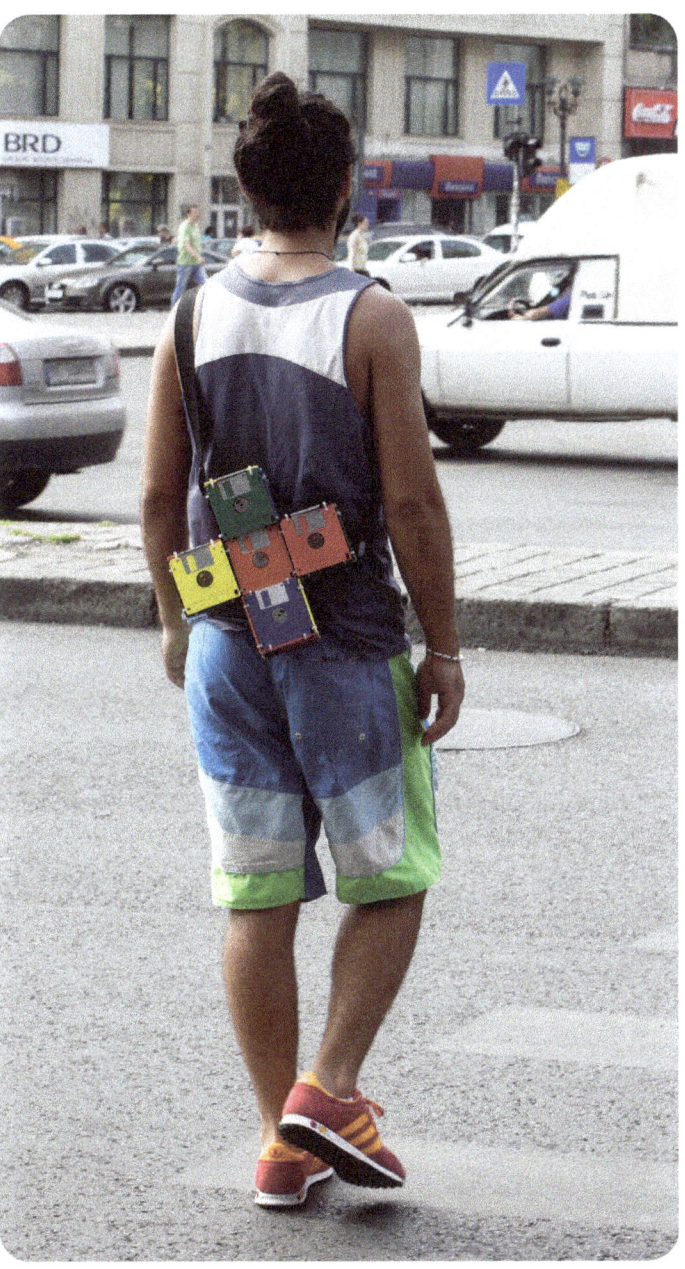

Figure 40: Upcycled backpack made from old computer floppy disks, Bucharest, Romania. (Photo by the authors)

Ultimately, the ability to upcycle is a sign of privilege, of a freedom to choose a certain aesthetic that makes an ecologically correct statement. It

is that same freedom that allows one to recycle a smartphone every two years, letting go of a perfectly functioning machine to switch to a faster, more advanced device. Somewhere in there, hidden behind the politically correct surface of green intent, an element of brandishing is faintly detectable. For example, an Instagram user demonstrating his improved vase construction of several $40 Patron tequila bottles tied together and hung from the ceiling as a decorative installment is declaring his taste in recycled items and simultaneously declaring an economic status that enables him to afford expensive consumer goods. Certainly, financial well-being is not a cause for blame in any way, but nevertheless a reason to honestly assess and acknowledge the rhetorical mechanisms in the upcycling movement that make it part of the ideological machine that Žižek warns about.

However, not everything in the end is a hopeless ideological trap. While Žižek's doom-and-gloom philosophy certainly serves as a wake-up call, forcing us to face our own personal philosophies on reuse and disposal of things, it need not be the only way to think about the fashion of upcycling. Even though upcycling and the notion of the "fake authentic" present us with difficult ideological choices, the simple fact that a deliberate choice is made toward the preservation of objects allows us to view the practice in a redeeming light, especially as it pertains to memory and preservation of the past. Despite being associated with notions of privilege and leisure, production of a new thing out of used materials elevates the practice from a mechanical sorting to the realm of creation and attunement to things and their materiality as they embark on yet another journey of aging and decay. While inclinations might suggest otherwise, at the core of upcycling and the "fake authentic" impulse lies an emphasis on engagement with objects, and, as we have seen, objects are crucial as markers, containers, and indicators of memory. Even if the "fake authentic" is not the true preservation of the past but a version of it, the process of inscribing memories in objects still finds place in the production of a new product, redeeming the past by sheer recognition of its importance.

7 The Ludic Potential of Found Artifacts

Andrei

> *I'm going to build a rocket ship out of a trash can and some wood and a bubble that never pops, and then I'm going to test it out to see if it goes somewhere, and if it goes somewhere, I'll go to outer space and see things that people never even saw before.*
>
> —Humans of New York

For the young girl photographed and quoted by *Humans of New York*'s founder Brian Stanton, the future of exploration lies in the nearest trash bin and possibly some fallen branches and twigs in her backyard. She's not exactly certain if her garbage spaceship will actually work or even make it off the ground, but she's also not counting out the possibility. What allows her to see the potential in what many would call absurd (and unsanitary) is an uninhibited imagination. When she looks at a trashcan or a pile of wood she sees not only what *is* but what *could be*, which is just about anything.

The girl in Stanton's photograph looks no older than seven, maybe eight years old. At that age and even a couple years older I, too, had no problems imagining the potential in trash, going so far as to collect it and play with it. Maybe in my case it was more necessity than anything else, having to use my imagination to fill in the blanks or missing pieces. To this day, my memories of childhood in Romania tend to be dominated by a mute color palate, more often than not entirely monochrome, and a landscape dominated by fields, a cityscape of gray concrete apartment blocks that smelled of yet-to-fully-cure concrete. Memory might indeed be selective, and the exact reason for those images imprinted in my mind is elusive; I attribute some of it to the fact that during the 1980s Romania was still a communist country, largely disconnected from the rest of Europe and the rest of the world. Commercialism had not yet taken a foothold in the country as it would in the wake of the revolution of 1989.

The following year marks a schism in my imagination when everything seems to have suddenly turned bright and colorful. As soon as the Ceaușescus were overthrown and communism had fallen, so did the country's borders, giving way to an influx of consumer goods from other countries. What stands out most to me about these products is how colorful they were compared to what for me had appeared mostly bland and dull (in retrospect and in comparison). Along with colors, logos, and name

brands, another side effect of the arrival of consumerist culture during the early 1990s was trash. The eye-catching packaging for all of these goods that we now had the chance to purchase and consume ended up, unfortunately, by the side of the road.

Again, it is difficult to recall for certain if before the revolution there was simply less trash on the street or if I just did not pay attention to it (as with the monochrome memories of my childhood), but I remember quite vividly how the trash suddenly appeared as though it came out of nowhere. Among the discarded items, the things that caught my eye the most were used cigarette packs along with soda and beer cans. They looked cheerful, designed to attract, and were decorated with lettering that seemed special (some might say exotic) to me simply for the sheer fact that I did not understand the language they were written it. And I wasn't the only one. My friends and I, ranging from about seven to ten years old, started collections of empty cigarette packs and aluminum beer cans. We traded them the way you would trade baseball cards in America. If someone had a double of one particular brand they would trade it for a box or can that they did not have. I remember that Marlboro and Kent cigarette boxes were pretty common, so it became pretty difficult to trade those. And as with baseball cards the condition mattered. A crushed box or a dented can clearly was not as valuable as one in pristine condition.

Figure 41: Empty Heineken beer bottles used as decoration in a restaurant, Old City, Bucharest, Romania. (Photo by the authors)

Because these items had now become our new favorite toys, of course we kept all of these treasures in our rooms, never thinking twice that we were actually collecting garbage. Part of that could be because we did not

have a definitive concept of waste/trash as something that dominated the imagination. Even before 1989 I remember playing in construction sites with leftover building materials, or picking up whatever I pleased off the ground. Post-1989 Romania was just an extension of what we were already accustomed to in a country where trash was never really *trash*. I realize now that we simply did not know the difference; we were part of a society still feeling its way through what we could roughly refer to as Western culture. Additionally, having been closed off from much of it for so long, as children we also had little knowledge of the dangers associated with playing with such things. Playing with whatever we could find outside often satisfied our curiosity, and since we found these items technically outside, they seemed fair game. So did something else we had come across during those years, which, looking back now was not as innocuous as the discarded boxes and cans we scavenged from the trash.

During the violent revolution in 1989, or right after (details were never established), Romania received aid from the international community in terms of medical supplies. For reasons that are yet again elusive, many of those supplies never made it to their destinations, such as hospitals or clinics, the places that needed them most. Boxes of these supplies, specifically syringes and needles, ended up being dumped right outside of the capital, Bucharest, not far from the commune where my grandparents lived at the time. I remember that, along with some friends, we came across mounds of these supplies and realized that something about these items made them special, even more so than the cigarette boxes and cans. I also especially recall not being afraid, or worried, just excited at the good fortune to have found such toys. I can still remember how fascinated we were by those syringes and needles. We divvied up the loot and kept it next to the other treasures. Sometimes I played doctor, but more often I played with the syringes as miniature water pistols.

To some extent we were lucky that what we had stumbled across had not been used, and as far as I could tell they were still sealed. But in *The Afterlife of Discarded Objects*, contributors shared similar stories of playing with found medical supplies, their condition far from certain or safe. Below are just two examples from Russia and Ukraine:

> We lived next to a children's hospital, and once I found a big glass syringe next to the hospital dump. The tip and plunger of the syringe were metal; it was fun to play with. I brought it home. When my father saw it, he asked me where I got it from, and then gently suggested to throw it away, promising to buy me a new one. (Maria Bochegova, Kurgan, Russia, 1980s)

~

> Once my friend and I (we were 5 years old) found a surgeon's toolbox in a dump. There were so many treasures in it! Syringes, scalpels, only not sharp, and a whole lot of different clips and what not. We played doctors for a whole month before our parents found out and confiscated the box. (Olesya, Sevastopol, Ukraine, 1990s)

* * *

I realize now how potentially dangerous it was to play with those medical supplies. We did not think about such issues as cleanliness, sterility, disease, or danger. The cigarette boxes and cans were certainly dirty. The syringes could have been much worse. In a way we were fortunate that our experiences with such items was temporary. But around the world too many children play in environments where they cannot avoid encounters with waste products, where sanitary conditions mean that a plaything could very well be the source of disease. For someone such as myself, now living in the United States, waste is a byproduct; trash is something used and discarded, and I have the choice and luxury to avoid it if I want to—for others, that choice is not entirely in their hands.

While the perils of playing with trash, however exciting it might be, should certainly not be overlooked, the ludic potential of trash poses other dangers to the function of modern society as we know it. In *Anti-Oedipus: Capitalism and Schizophrenia*, Gilles Deleuze and Félix Guattari write that, "Capitalism institutes or restores all sorts of residual and artificial, imaginary, symbolic territorialities, thereby attempting, as best it can, to recode, to rechannel persons who have been defined in terms of abstract quantities. [. . .] The real is not impossible; it is simply more and more artificial" (37). Playing with trash pushes the boundaries of capitalism, it tests the limits capitalism itself has set up. Trash, as we have seen in chapter six, is disruptive, it creates chaos out of order, it threatens from the margins. In this way, capitalism's functioning state of purchase-consume-discard-repeat comes under direct threat from the waste site. "[T]hrough its process of production," Deleuze and Guattari argue, "[capitalism] produces an awesome schizophrenic accumulation of energy or charge, against which it brings all its vast powers of repression to bear, but which nonetheless continues to act as capitalism's limit. For capitalism constantly counteracts, constantly inhibits this inherent tendency while at the same time allowing it free rein; it continually seeks to avoid reaching its limit while simultaneously tending toward that limit" (37). As a society we celebrate eccentrics and rule break-

ers, those who show us the possibilities of pushing boundaries and standing apart from the crowd. We give such individuals "free rein" (and praise ourselves for doing so), only to find infinite ways to counteract and inhibit the full expression of such freedom.

Deleuze and Guattari expand their argument on capitalism's inherent tendency to impose limits later on in their book in the section "Savages, Barbarians, Civilized Men," an appropriate title to establish the perceived difference between those who look *from* the waste site and those who look *at* the waste site. The former are savages, outsiders, infected, and marginalized; the latter are civilized, clean, proper, and most importantly *right*. Take for example the child who can fill up his or her entire day tinkering with a trashcan and some pieces of discarded wood—she does not need the latest redesigned, reinvented limited edition (until the next one) Barbie or Disney-sponsored Lego set. Such individuals, according to Deleuze and Guattari, are defined by terms outside of the established social order and therefore challenge capitalism's stranglehold on the imagination. In these cases, capitalism reigns in and even recodes (makes in its own image) what is perceived as a threat to the symbolic territories and institutions it has set up—namely in this case childhood and playtime. In a situation where a group of children are playing together and everyone has the newest, latest, voice-activated, Bluetooth connected G. I. Joe action figure, the one child playing make-believe with an empty soup can and some pebbles will be made to feel inadequate and, given the nature of young children, will be subjected to various degrees of ridicule. Whether that child truly wants the new toy doesn't matter; he will ask for it and he will feel that his makeshift toy is not good enough until he has what everyone else has.

* * *

At this point some will argue, quite rightly, that children always covet what others have and that the above example is a natural part of growing up. While that is true to some extent, what is also true is that in the new toy vs. discarded item scenario, few if any children would opt for the discarded. It is trash, stigmatized, laughed at, abjected. The new toy, however, with its attractive packaging, molded lines, and predetermined, recognizable storyline has claimed significant real estate in a child's life. For Roland Barthes the effect of such toys is nearly catastrophic to the mind, forcing the imagination to grow (if at all) on artificial turf. In his essay "Toys," Barthes dismantles any illusion one might have about the effects of modern toys in a child's life, and while he addresses his charges to French toys in particular, his arguments hold universal sway. "Toys" appeared in Barthes's 1984 book *Mythologies*, a critique of popular culture and consumerism through the lens of modern

myth and mythmaking (tourism, advertising, film, toys, and more), a kind of socially sanctioned propaganda that tells us how to act, what to feel, how to think. Specifically what worries Barthes in this essay is that the propaganda begins early on at a young age, so early in fact that the child is nearly powerless to resist: "The fact that French toys *literally* prefigure the world of adult functions obviously cannot but prepare the child to accept them all, by constituting for him, even before he can think about it, the alibi of a Nature which has at all times created soldiers, postmen and Vespas" (53). For a young child the toys he plays with "constitute" a world, his reality, which he accepts as truth when it comes from the seat of authority—a parent or older adult. What's worse, he accepts without questioning, without "thinking," substituting for thought what has already been provided as fact. Barthes explains that, "French toys *always mean something*, and this something is always entirely socialized, constituted by the myths or the techniques of modern adult life: the Army, Broadcasting, the Post Office, Medicine (miniature instrument-cases, operating theaters for dolls), School, Hair-Styling (driers for permanent-waving), the Air Force (Parachutists), Transport (trains, Citroens, Vedettes, Vespas, petrol-stations), Science (Martian toys)" (53).

Figure 42: A boy plays on a playground of recycled tires, Guelph, Canada. (Photo by M. Rehemtulla / CC BY 2.0, via Wikimedia Commons)

With meaning already inscribed in the design and function of such toys, is there room for the imagination to flourish, for *play* to occur, or does

the process reduce interaction with such objects to copying and imitation? For Barthes, the answer to that two-part question is a resounding *No* followed by a more emphatic *Yes*, but more than imitation (which is a natural part of growing up and learning), he is worried about what exactly it is that we are imitating:

> It is not so much, in fact, the imitation which is the sign of an abdication, as its literalness: French toys are like a Jivaro head, in which one recognizes, shrunken to the size of an apple, the wrinkles and hair of an adult. There exist, for instance, dolls which urinate; they have an oesophagus, one gives them a bottle, they wet their nappies; soon, no doubt, milk will turn to water in their stomachs. This is meant to prepare the little girl for the causality of house-keeping, to "condition" her to her future role as mother. However, faced with this world of faithful and complicated objects, the child can only identify himself as owner, as user, never as creator; he does not invent the world, he uses it: there are, prepared for him, actions without adventure, without wonder, without joy. (54)

What Barthes would prefer is for the child to play with objects that are not precursors to the adult world, or at least not ones explicitly labeled as such. He calls these preferred objects "invented forms," such as wooden blocks, "which appeal to the spirit of do-it-yourself." Blocks for Barthes are "dynamic" because they can take any shape, mean anything to the child, but also because of the material they are made from: wood. Barthes refers to wood as "[. . .] a familiar and poetic substance, which does not sever the child from close contact with the tree, the table, the floor. Wood does not wound or break down; it does not shatter, it wears out, it can last a long time, live with the child, alter little by little the relations between the object and the hand. If it dies, it is in dwindling, not in swelling out like those mechanical toys which disappear behind the hernia of a broken spring." Jean Baudrillard offers similar praise for wood as a substance in *The System of Objects*:

> Wood draws its substance from the earth, it lives and breathes and 'labours.' It has its latent warmth; it does not merely reflect, like glass, but burns from within. Time is embedded in its very fibers, which makes it the perfect container, because every content is something we want to rescue from time. Wood has its own odour, it ages, it even has parasites, and so on. In short, it is a material that has *being*. (38)

What Barthes and Baudrillard are attributing specifically to wood is more broadly conceived to be an organic and naturally changing relationship between person and object, one that evolves through the wearing out (dwindling) over time, much in the same way that discarded objects do not "sever" us from the world but provide invaluable links to the past and to others. In this kind of a relationship the child is not merely imitating and regurgitating roles, but becomes an inventor: "He creates forms which walk, which roll, he creates life, not property: objects now act by themselves, they are no longer an inert and complicated material in the palm of his hand" (Barthes, *Mythologies* 54).

Figure 43: A gee-haw whammy diddle or gee haw whimmy diddle toy with spinning propeller on a notched stick which is made to spin in either direction by stroking the notches with the second stick. The propeller can be made to turn in either direction. The sticks are 8 inches long, made in Beech Creek, North Carolina in the 1960s. (Photo by Pathh / Public domain, via Wikimedia Commons)

I think we could say with some degree of certainty that Barthes would have supported the move by The Toy Hall of Fame in 2008 to honor the "Stick." He might have something to say, however, about the honor coming ten years after the Hall was founded in 1998, the year when it lost out to Barbie and Monopoly, among others. (Personally, I'm holding out hope that those in charge at The Toy Hall of Fame will make the right decision soon and add the tin can telephone, sheet of paper, and mud to their growing list of celebrated toys.) Still, the dedication to the "Stick" is very

much in line with Barthes's values, and to the ludic potential that discarded, unusual, nonconformist objects offer to children (as well as adults):

> The stick may be the world's oldest toy. Animals play with sticks, and we use them to play fetch with our dogs. Children find sticks an endless source of make-believe fun. Sticks can turn into swords, magic wands, majorette batons, fishing poles, and light sabers. When children pretend with sticks, they cultivate their creativity and develop their imaginations. They explore as they search outdoors for just the right one. Children build with sticks, bat balls with them, and walk with them. They are the original building blocks for creative play. Sticks also promote free play—the freedom to invent and discover. They encourage playing outside instead of inside. Sticks are all around us; they are natural and free. And playing with sticks isn't just for children and animals. Adult artists, crafters, decorators, and architects all make use of sticks in sculptures, wreaths, furniture, and building design. Few adults or children can resist simple play with sticks—from drawing in the sand on the beach, to building a campfire and then toasting marshmallows. Sticks are not only possibly the oldest toys, they're possibly the best! (*National Toy Hall of Fame website*)

With such promotional material it is hard to argue against the use value benefits to the imagination of sticks. But part of the problem and the reason why plain wooden toys are becoming a rare commodity lies in the language of the sales pitch itself: while sticks promote free play, they are also free. A stick costs nothing to manufacture, costs nothing to pick up off the ground. Toy stores do not have a "used stick" aisle; they cannot make money from something you find in your back yard or by the side of the road. As Deleuze and Guattari would put it, sticks (and those who play with them) are "abstract quantities" because they allow for the freedom to invent and discover on one's own terms, *outside* the constraints of commercialism.

Barthes would also prefer the "abstract" over the fixed and pre-defined, but he is not very optimistic about the future of childhood toys. Today, he laments, "toys are made of a graceless material, the product of chemistry, not of nature. Many are now molded from complicated mixtures; the plastic material of which they are made has an appearance at once gross and hygienic, it destroys all the pleasure, the sweetness, the humanity of touch" (54). In his final indictment, he writes, "These toys die in fact very quickly, and once dead, they have no posthumous life for the child." While he might be faulted there for making a sweeping claim about all modern, plastic toys (some indeed have meant quite a bit to children over the years and still do today), it is his use of the term *posthumous life* that bears some attention. Sim-

ply put, at least according to Barthes, there is no "afterlife" for such toys. They are dead, and what's more they also die rather quickly (which typically means a replacement is soon to come as few parents are willing to incur the wrath of a child whose favorite toy has been broken).

In this sense it becomes clear that the value of objects from a capitalistic standpoint lies not in the quality or function of the objects themselves but in their disposable nature—their affinity for being discarded and replaced. One term for this is built-in obsolescence, whereby objects have a limited lifespan requiring a replacement after X number of weeks, months, or years. To the producer, the object's value exists via its many reincarnations (versions), its envisioned end as a waste product. When value is discovered in the discarded object itself, however, systemic order is upended and is replaced instead by the unpredictable nature of the imagination. Recall here the cardboard box from chapter six, whose seemingly limitless potential landed it a place in The Toy Hall of Fame along with the stick. A cardboard box is not intended to have value beyond its intended use, which is typically to protect and transport a product meant for consumption. In its posthumous life, however, its value as a discarded object is unpredictable and incalculable because it has (temporarily) escaped the grasp of social order and capitalist methods of inscription; a *tabula rasa* on which the imagination could rewrite the script.

Maybe this is the reason that, for the most part, it is children and artists that gravitate toward waste sites as places where authority is challenged, where limits (and buttons) can be pushed, even broken. "The Transmogrifier" from the comic strip Calvin and Hobbes is a perfect example. According to the Calvin and Hobbes Wiki page, "The Transmogrifier is an invention of Calvin's that would turn one thing into another. Like most of his inventions, it was made originally from a used cardboard box, though a later model was made using a water gun. Calvin used the transmogrifier many times, turning himself and Hobbes into quite a wide array of creatures." Simply put, The Transmogrifier is a piece of junk that *transforms*, it is a machine of possibilities—it contained a dial setting for "Eel," "Baboon," "Bug," and "Worm," and Calvin even wanted to use it to turn his arch nemesis Susie into a bowl of chowder. We know his efforts are futile, silly, even wrong in a childlike-innocence sort of way, but part of us still root for him to buck reality. Part of me, too, must have known even as a child that there was something *wrong* in playing with syringes found by the side of the road; that keeping boxes that smelled of tobacco and cans that reeked of beer in my bedroom was somewhat unusual. And I'm sure that the young girl who wants to build her spaceship out of trash must have some inkling that it's not quite how it's done. But it's better to look at a heap of rubbish and *wonder what if* than hold in your hand a piece of plastic and *know that you can't*.

The Ludic Potential of Found Artifacts

Natalia

As Dutch historian and cultural theorist Johan Huizinga tells us in this 1938 book *Homo Ludens* (Playing Man), human beings never really stop playing. We bring the element of play to all social interactions that we have, trying on different role identities and structuring our lives according to the game rules. These games seem to become more complex the older we get, more tied up in abstract notions and rigid patterns as we let go of the agency to bend and change the rules, looking up instead to whatever authority is in charge of the particular game we are playing. Yet, even in this new, mature, and rule-driven environment, there are still moments when we allow experience the spontaneous wonder of a world that we can explore unchecked, in awe of its raw and unpredictable mystery; much like children still capable of seeing things as they are and could be, not marred by guidelines and expectations of "should" and "must." In such moments, we remember what it's like to truly play and in the spectacular and improbable debris of imagination, forget ourselves; to play and let worlds build themselves up from the dust.

Poets and storytellers are often thought to possess this ability to see the world with unfiltered eyes more so than others. They are considered truth-tellers because they see things for what they are, because they embody both a child's naiveté and a child's unbound curiosity. For them the world is a large playground and blank canvas, its myriad objects the tools of creation. Former US Poet Laureate Charles Simic believes that, "A toy is a trap for dreamers. The true toy is a poetic object" (46). Playing, in other words, is akin to making art. As such, playing involves interaction with the material world, dreaming it up, rearranging and reimagining the building blocks that make up the universe: "these are dreams that a child would know. Dreams in which objects are renamed and invested with imaginary lives. A pebble becomes a human being. Two sticks leaning against each other make a house. In that world one plays a game of being someone else" (Simic 46). At the moment of play, a sincere encounter with the object happens, freeing it from the weight of culturally acquired signification. Nobody—not even poets, who know a thing or two—is capable of such unmediated connection with things as children, who trample on the boundaries of the imaginable to reclaim things, see them again in an unfamiliar light and in the process fundamentally change objects, allowing them to be themselves. Walter Benjamin, too, spoke about children's attunement to things, their ability to "bring together, in the artifact produced in play, materials of widely different kinds in a new, intuitive relationship" ("One Way Street" 69). Specifically referring to children's fascination with the detritus and waste resulting

from various building or construction projects, Benjamin sees children as collectors of found objects, unrivaled masters of collage who need not follow in the steps of some visionary pioneer of art. Unlike the adults who follow with nearly religious zeal the blueprint of a project, children intuit a way of their own, effortlessly coming up with combinations and uses of objects beyond what adults can predict or are even willing to entertain as possible.

Benjamin knew first-hand the secret language that things speak to children: in a memoir about his own childhood, he approaches the past through memories of objects, such as his mother's sewing box, a sock, or a telephone, or of places. Written when he was fleeing Nazi persecution, in a time of loss and personal and cultural upheaval, the memoir must have been an attempt to preserve, through memory and narrative, the time and place of his childhood. Reading *Berlin Childhood around 1900*, one starts doubting that the past is irretrievable—so vivid and powerful is Benjamin's recounting of rooms, streets, household things and decorations, books, and delicacies of his childhood. Adult Benjamin's sympathy to Benjamin the child is the reason why the memoir rings universally true, even though it is safe to say that contemporary readers' experiences are different from those described in *Berlin Childhood*.

Figure 44: Damaged soccer goal without a net inside a school yard, Bucharest, Romania. (Photo by the authors)

Commonality, however, could be found in his focus on the rebellious nature of a child's exploration of the world, the camaraderie that unites children with things against a broadly conceived sense of order. Many chapters in *Berlin Childhood* evoke memories of trying the dangerous and the forbidden: venturing to a "crooked street" that lured young Benjamin with promises of potential peril and excitement, cheap booklets with lewd pictures in the back of an old bookstore, dark corners of the house that were the hiding places of demons. Playing with various objects he picked up—pebbles, dead insects, pieces of foil, wooden bricks—also had to be "masked," hidden from the adults who, no doubt, would not have approved of his choice of playthings. Benjamin's recollections connect with participants' stories in *The Afterlife of Discarded Objects* nearly a century later, testifying to the lasting, stubbornly subversive, and rebellious nature of children's games with found objects. Indeed, children's obsession with dirt, mud, and trash is universal; it points to an affinity with the material world and also means testing the boundaries of parental authority and pushing the borders of what is allowed and, ultimately possible to achieve. Before we abandon the freedom to treat the world as our playground, we defiantly invest our imagination in the darkest objects.

Here is, for example, an excerpt from the memory shared by Summer Copelan (Upstate NY, 1980s). Copelan tells about her childhood search for adventures "away from supervision of adults," with the freedom to explore and conquer all kinds of neighborhood nooks and crannies. Though her recollection is marked by the stamp of the time—urban legends of the 1980s and the Cold War culture with its permanent fear of nuclear disaster—the motif of being in on the secret life of things is timeless:

> Our neighborhood was mostly working class families but was peppered with different social strata and backgrounds; unlikely alliances were formed in search of adventure away from the supervision of adults. I was a rampant reader and shared stories about children like the ones from books in which magical worlds awaited the brave and curious. A deserted metal yard behind the railroad tracks filled with rusting junk became a clubhouse meeting spot (inside large metal tubes). The highway underpass near an exoskeleton of a rotting mill was a tunnel to undiscovered lands that we staked out on maps. A mysterious cement cylinder structure overgrown with weeds next to fetid water became a place where evil spirits roamed (scaring the younger children). Later this site and the river where we sometimes swam were discovered to contain industrial and illegal waste (and resulted in controversy and eventual cleanup). Some of our games reflected

our 1980s fears of nuclear war and perverted kidnappers in white vans that would snatch a child away tempting them with bad drugs. Some games reflected anxieties from domestic problems at home or testing our growing identities. Abandoned by adults, these reclaimed spaces suggested unknown possible dangers, excitement and a susurration of narratives from my imagination.

The rebellious spirit (and the irresistible pull of danger) rings in every sentence of this memory. Many similar stories take place on construction sites or inside abandoned buildings, trespassed without the permission and knowledge of adults. The trespassers seem to derive most pleasure from breaking the rules and handling dangerous items. In a story from Kuwait, a war zone turns into a field for exploration and fantasy:

> After the 1990 invasion was over, Kuwaiti streets and sidewalks became a minefield on legs. At school we sat in classrooms stained with the toxic smoke of burnt oil wells and were warned never to pick unfamiliar objects off the ground. Later, we were warned not to pick even the most familiar objects off the ground. Empty Cola bottles, ball point pens, battery alarm clocks; they were all a potential explosive hazard in disguise. It only made the broken video cassettes all the more alluring; silky black guts spilled out onto the pavement, distorted reflections curled into tangled intestines of ribbon. We ended up collecting as much as we could, dividing it between the few friends who could be trusted to appreciate its significance. Within a few days, the ribbons would emerge reincarnated, an oil slick of VHS tape devouring random artifacts of daily life. Home videos of birthday parties wrapped carefully around tennis rackets. Kite tails flapping at the sun with cartoons recorded over a graduation ceremony. The Godfather and Bruce Lee knotted into an elaborate garland of teddy bears hung across a bedroom ceiling. And braided through bicycle wheel spokes, Edward Scissorhands danced with Kevin Costner's wolves, rippling and howling against the fiery air, if you could pedal fast enough. (Sara Eidi, Kuwait, 1990s)

Children remain explorers even amid the chaos of the adult world, maybe because they can see through it, can reimagine it as fertile ground for creation. Their drive for adventure is life-affirming as it leads to the discovery of beauty in the most unexpected places, a true testament to human resilience.

The Ludic Potential of Found Artifacts

Certainly, many of the games children play serve a much more docile function, that of acculturation into adult life. Many of the stories from *The Afterlife of Discarded Objects* are about mimetic play: "mimesis," or imitation of the real world, essentially means mimicking the socio-cultural reality as it is, creating a representation of life in art, literature, or, in this case, games. Children playing with discarded objects that once belonged to the adult world often do so to "try on" adult lives, inhabiting the vast territory of social structures and relationships that has created and made these objects necessary in the first place. Many stories recall playing pretend grocery shops, families, professional lives, etc. More often than not, as Roland Barthes made clear in "Toys," such mimetic games emphasize gender distinctions as children are socialized in the gender roles and prescribed behaviors that are reinforced through objects. For example, several recollections by men from different countries feature war games of their childhood:

> When I think back to my childhood on the farm in Alabama my mind is drawn back to my brother and I sword fighting in the yard. We had vivid imaginations of war and military strategy, and with a broken tree branch or an old golf club as our swords we were unstoppable. (Austin, Lafayette, AL, 1990s)

~

> [. . .] Some of us used tree branches as automatic guns and played war. To make a good gun, you needed to find a stick with a thick end that looks like a magazine, and then carefully shave the rest of the stick against the fence. The cut off tree branches were also used to make roofs for the snow bunkers that were guarded by kids with those same tree guns. We made bombs and grenades from snow . . . do not confuse with the snowball game: we firmly believed that we were throwing grenades, not snowballs. (Alexander Yakovlev, Magnitogorsk, Russia, 1980s)

Women, on the other hand, shared memories centered on games that mimicked domestic life: cooking, housekeeping, or caring for others:

> We used to go around garbage hunting with my friends and then used it in our games. Though sometimes the process of garbage hunting was interesting by itself. As we were girls we used the things we found as "interior design" and household objects in our makeshift houses. I think regardless of time and place, all girls like this process of setting up home. (Anastasia, Grozny, Chechnya, 1990s)

My dad has parked his work truck in the same place every day for the past twenty years. Because of this, grass simply would not grow in that small spot near the side of the house. Every morning, after he left for work, I would make my way outside. I would dig through the trashcan under the carport and pull out Styrofoam plates covered in maple syrup, forks stained red from spaghetti, and cups with the coffee ring still in the bottom. The bald spot in the yard my dad used for parking was always a gooey mud pit. I would make my way out with my new treasures and use the mud to make food. Until the sun was sinking behind the clouds, I would imagine new recipes of fancy foods or trying to make things my Grandmother did. (Kennedy, Woodland, AL, 1990s)

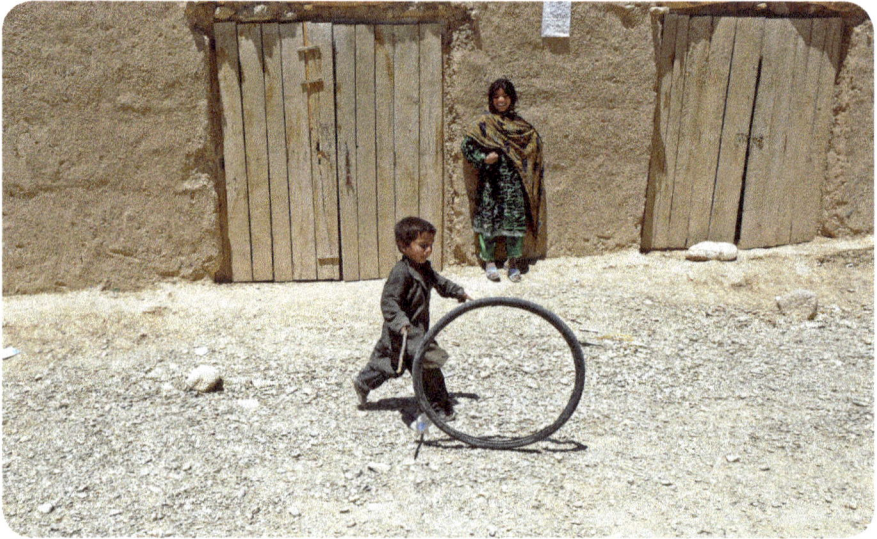

Figure 45: A young Afghan boy uses a stick to push a wheel down the road in the Arghandab Bazaar, May 30, 2011. Members of Provincial Reconstruction Team Zabul, Arghandab detachment, visited the bazaar to meet with shop owners and villagers. (Photo by Staff Sgt. Brian Ferguson, US Air Force / Public Domain, via Wikimedia Commons)

Remarkably, even the choice of materials that arrest the attention of boys and girls often seems to be gender-specific. Men's memories cite playing with sticks, plastic pens, metal parts of disassembled devices, and such, and testify to the more aggressive way of playing with these objects as well.

The Ludic Potential of Found Artifacts

Women, conversely, often choose "softer" materials, whether taken from nature or household objects, and play quieter, slower-paced games:

> A piece of tube . . . aluminum, or maybe copper or steel, 5 to 10 millimeters in diameter. Any boy would give a lot for one of those. I was lucky to have one: it used to be a towel hanger in grandma's bathroom. I sawed it, gave a third to my younger brother, and kept the rest. The guys were jealous: the tube was big enough so a small crab apple would fit inside and you could shoot it from the tube. It would hit far and hard. A weapon! . . . (Ruslan Dautov, Safakulevo, Kurgan region, Russia, 1990s)

~

> Many factories were shut down, and all the equipment that was not sold or stolen was thrown out to become children's property. From the variety of gadgets that we found and played with, I especially remember lamination stacks from electric transformers: base-metal hunters would disassemble transformers, steal the copper parts and throw away the lamination stacks. Each of those stacks contained a huge number of metal flats in the E-shape. You could twist them into new shapes or assemble things from them, and they also flew really far if you threw them. (Enot, Sevastopol, Ukraine, 1990s)

~

> When I was younger I remember using my sister's old baby wipe boxes to build more houses for my Barbies, and to give them a car. I would stack the boxes on top of one another, and arrange different pathways to be the Barbie's room, nursery, kitchen, etc. When Barbie needed to go from point A to point B, all she had to do was hop in her car or baby wipe box and drive there. (Katie, Chelsea, AL, 1990s)

~

> When I was a girl of 6–7, I remember how we played with my girlfriends a game called daughters-and-mothers or something of the kind. People lived rather poorly at that time and if we had dolls we didn't take them out of doors, we cherished them and kept at home. Nevertheless, we had something even better to play with outside in the yards and gardens: earcorns! Do you imagine what they look like? A long body and a mess of real brown hair on the top—Barbies of our childhood! (Galina, Lebyazhje, Kurgan region, Russia, 1960s)

Even though games as described above seem the epitome of conformity, they, too, allow for a self-guided exploration of various roles and models of life. Playing through pretend social situations prepares for a smoother transition into adulthood responsibilities and the many challenges of domestic and public lives. "Trying on" various identities through engagement with material objects facilitates the construction of personality, likes and dislikes, and the building of relationships to both things and people. What's more important, however, is that sometimes it is exactly such trying on of cookie-cutter identities and roles that prompts one to look further, to approach things from a different perspective, to look for alliances in the object world that are better suited to express one's identity. The power of objects is that, while serving as props in our games, they sometimes reveal to us something about ourselves that we did not know before. Leo Racicot's story (Lowell, Massachusetts, 1950s) is one such testimony about a discarded object that, through play, prompted an early self-discovery.

Leo's story features a fox face fur neck warmer that used to belong to his mother. While it was hanging in the dark closet, Leo says, it looked frightening to him: "It always looked as if it was trying to say something to me—or was I imagining it?" Yet, Leo's attitude changed drastically when he one day found the fox fur thrown away in the trashcan behind their house:

> It looked so suddenly there not scary but scared. My mother had deemed it no longer worthy, not useful. Maybe it had hit her how strange it was to wear a dead animal around her shoulders, how apart from the rest of her clothes the fox fur was, misunderstood, somehow "other." I went all sad inside yet didn't know why. After all, hadn't these same eyes scared the hell out of me? Hadn't the mute face refused for so long to tell me what secrets it held? But I hated that the fox had been thrown away as if what it had once meant now needed to be forgotten.

Suddenly moved by the new appeal of a familiar object, perplexed by his own strong feeling towards it, Leo salvaged the fur from the trashcan, of course, then hid it from his mother. There in the safety of the house it remained, until some time later:

> The rare day came when I was alone. Hot, hot day. I put the mink over my shorts and summer shirt, wrapped the fox face fur around it, stuck my too-small feet into a pair of matching pumps and ventured outside.
> The fox and I came alive.

> Parading around the yard in my mother's clothes. Loving the delicious click-clack of her high heels on the sidewalk. Loving the fox against my neck. It smelled like fur and perfume. I sashayed back and forth, back and forth. I was Audrey Hepburn at a movie premiere, Angela Lansbury in Mame. The world fell away. I was invisible in my discovery of "me." The fox felt almost unbearably lush against my face.

The story gets even more dramatic as a neighbor spots young Leo's parade outside the house, calling him "a sex maniac." Regardless of the consequences, though, the newly formed bond between the person and the thing proved to be lasting:

> I saved the fox face fur for years, a talisman of sorts, a protector. It freed me to be myself because it was so very boldly itself, a sly thing, an ugly entity that was, in its essence, a beautiful one. I could not bear to see it relegated to the trash heap of someone's fickle disregard. Once I accepted its oddball charm, I knew what it had been trying to say to me. I gave it back its life and in return, it told me mine.

Faced with the otherness of objects, we become more attuned to otherness per se, more tolerant and open to experiences and sensations. In a world where formation of identity is guarded since the earliest stages, the role of free play is hard to underestimate, and so is the role of objects that act as catalysts of discovery.

I find it significant that in Leo's story, the change of perspective happens once the status of the object is changed: from a treasured decoration to a discarded, lost object rejected by reason but rebelliously and "boldly itself." The fox face fur is a perfect example of a discarded object "in the process of becoming," which comes with an unprecedented freedom: they can be anything, and defiantly so. Broken, in various stages of decay, transformed into an oddly shaped entity that at times does not yield recognition, discarded objects possess what I believe to be an intrinsic ludic quality, exactly what helped young Leo imagine, through play, possibilities of identity.

* * *

Ludic: playful, related to everything that is fun and spontaneous. Huizinga understood this concept as an anthropological constant, meaning that human interactions to some extent invariably involve playing. As defined by Huizinga, the ludic is a feature of subjectivity; however, I would like to presently address the ludic qualities inherent in things. In our games, whatever they are, we need props, and some objects lend themselves to this function better than others. Discarded artifacts can be said to possess ludic qualities

that never fail to capture our imagination: orphaned, misplaced, torn from original context, they are a presence without a name, a pre-language and pre-culture entity that abounds with possible uses and meanings, or simply refuses to be anything—the ultimate rebel universally admired.

Daniel Vella, a Danish digital game theorist, has coined the concept of "ludic sublime," which is applicable to thinking through the inherent ludic qualities of objects. While he uses the term to understand the mechanisms of players' involvement in a computer game, the ludic sublime as defined by Vella refers specifically to digital environments and particularly the image of objects encountered in games. Vella goes back to the Kantian distinction between the beautiful and the sublime in nature: "the Beautiful in nature is connected with the form of the object, which consists in having boundaries. The Sublime, on the other hand, is to be found in the formless object, so far as in it or by occasion of it *boundlessness* is represented, and yet its totality is also present to thought" In other words, Vella explains, the object that engenders the feeling of the sublime "extends beyond the limits of perception, tied as it is to a narrow, situated viewpoint, leaving the faculty of the imagination struggling to represent it as a coherent object of thought determined by a formal order." As it evades perception, such an object at the same time leaves no doubt in its overwhelming material presence. It cannot be overstated then that even in a make-believe world that lacks conventional dimensions of materiality, Vella's focus is overwhelmingly on the material artifacts in games, a tacit acknowledgment of the centrality of objects in a subject's ability to construct and navigate any environment. It is the object, therefore, (playful, mysterious, unavoidable) that drives and underpins Vella's theory of the ludic sublime, more so than any other aspect of gaming. Vella continues his explanation with reference to French philosophers Lyotard and Rancière's corresponding definitions of the sublime:

> For Jean-François Lyotard, "the feeling of powerlessness in the experience of the sublime, is endured by reason" (Rancière, 93), as it is drawn into the "passion" of a direct encounter with the alterity of the material other. In the aesthetics of the beautiful, "the privileging of form protects thinking from any interest in the "material" of the object and consequently from any interest in its real presence" (Lyotard 1994: 78)—however, when the appeal to form breaks down in the sublime aesthetic feeling, reason finds itself forced to account for the sheer, undeniable alterity of the material object standing before it, "approaching presence without recourse to the means of presentation."(Vella)

The ludic sublime, as it follows from the above quote, depends on materiality—more precisely, on the fleeting, unstable materiality that cannot be defined or represented, and that, in its turn, does not serve as a representation of anything.

Vella's ludic sublime is ludic insofar as it clearly refers to and is described in the context of computer games, one among many realms of play and invention. Along those same lines, however, the ludic sublime in discarded objects can be defined as their implicit predisposition to playfulness, the very inclination of such an object to flirt with human subjectivity in several ways: a discarded object is at once captivating and pointless; an invitation to playful projection of subjectivity and a confounding of all pre-existing meaning; a promise of voyeuristic pleasure and a repulsive presence of decay. Furthermore, very contradictory meanings of decay help us understand the ludic sublime as present in our encounter with materiality: subversive in its resistance to order, formless as it creates spontaneous shapes not governed by human will, decomposing just as it partakes in composition—formation of something new. In this way the ludic sublime combines the aesthetic component with the playful, subversive element characteristic of games. As Vella explains, "the sublime has continued to refer to the same aesthetic feeling attendant upon the contemplation of an object that exceeds both the field of perception and the grasp of the mind's faculties, and that opens up, in its various developments, to feelings of awe or terror."

It is here, in the interstices between awe and terror, that the ludic sublime thrives, along with all that it offers to the imagination: sublime, because the materiality and formlessness of the object, its "undeniable alterity" confounds subjectivity and threatens with the specter of the unknown; and ludic, because the object charms and invites the subject to engage with its material presence, suggesting a possibility of control and appropriation, while simultaneously eluding representation. The tension created between the conflicting yet complementary aspects of the ludic sublime is the reason Huizinga's claim rings true—we never stop playing and it is always a complex negotiation between order and chaos, wonder and dread. If we agree that playing with discarded objects allows children to explore both real and imagined territories and to envision alternative scenarios by building new worlds from scratch, then by extension the ludic potential of objects points to the same capacity for meaning-making in adults—a game whose rules are always in the process of being written.

8 Transgressive Art: The Aesthetics of Decay

Andrei

> *Everything that is visible hides something that is invisible.*
>
> —Rene Magritte

All art is the expression of a relationship of power and control; whether that be between artist and model, between artist and the world, or between the artist and himself. The language we use to refer to an artist's work and his purpose underscore this relationship: to capture, to show, to reveal, to document, to remember, to illuminate, to comment on, to critique, to shock, to ask questions/provide answers, to save, to preserve. But I also believe, as art critic John Berger does in his essay "The White Bird," that art is fundamentally an *encounter*; it forces us to face the world on both new and familiar terms, to come to terms with (and either accept or reject) what is being depicted. Berger also posits that, "Art is an organized response to what nature allows us to glimpse occasionally," but because this glimpse or encounter is temporary, "Art sets out to transform the potential recognition into an unceasing one" (10). This is art's tendency toward saving and preserving that which would otherwise disappear from consciousness.

While Berger lays out his claims in "The White Bird," primarily in reference to man's encounter with the natural world (for example a minimally constructed wooden dove created as a symbolic representation of a real dove), his words certainly extend to our encounter with the man-made world, which, despite our best attempts, has proven to be impermanent and vulnerable to the ravages of time. It is perhaps this sense of impermanence, that nothing truly lasts forever (doves are mortal things, roses eventually die, wood decays), that has driven artists to record their world via artistic representations dating back to the oldest cave dwellers who sketched and carved crude representations of daily life into the rock. While we no longer dwell in caves faced with the urge and necessity to document our encounters with wild beasts, we do live in a world of things, which likewise act upon the imagination and find their way into works of art. The same impulse to record and preserve that drove cave artists lies in the works of modern artists who choose to work with found objects, or *objets trouvés*. An *objet trouvé* is any raw material that is used in a work of art in such a way that it calls attention to its real material qualities and inherent aesthetic value. Artists who create from discarded items, readymades, trash/garbage, and

Transgressive Art

other ephemera use techniques and methods of production that include collage, assemblage, bricolage, installation, sculpture, photography, and more. Such works, maybe even more so than figurative art, facilitates both a symbolic/representational and a direct encounter with the real objects used. In these creations, the dynamics of power and control are still present, but through the use of everyday objects, so is a palpable, almost tangible relationship to memory—by incorporating recognizable, even mundane objects in their work, artists recognize and highlight the ability of things to manipulate memory as well as their potential to manipulate what, how much, and the ways in which we remember.

Figure 46: *Perspectives: Praxis* V: Mixed media assemblage by Alexandra Davis using found book cover, wasp nest, bookbinding thread, 8.75 x 6.5 inch. (Photo by Alexandra Davis)

Three of the artists featured in *The Afterlife of Discarded Objects* provide us in the excerpts below with their own motivation and rationale for working with found objects:

Alexandra Davis (Binghamton, NY)
In my mixed media works I reconstruct decomposing objects that are man-made [books] and found in nature. Reflecting back to the wood

and land, the discarded book becomes the matrix for these collages using additive and subtractive methods in printmaking. The natural found objects often in decay are collaged with the annotations left behind as a memory or the exhale of breath and a last attempt at the recognition of existence.

Dina Kelberman (Baltimore, MD)
Much of my work comes out of my natural tendency to spend long hours collecting and organizing imagery from the Internet, television, and other commonplace surroundings of my everyday life. I gravitate towards things that are simple, colorful, industrial, and mundane. I am also interested in using materials that are easily accessible and familiar to the everyday person. My work seeks to elevate the familiar and transform brief moments into infinite stretches of time. In close examination of the simple or the seemingly insignificant the viewer may bring their own limitless associations.

Peg Johnston (Binghamton, NY)
The [. . .] shadow box assemblages were inspired by a box of "orphaned" photographs rescued from the trash. They are not my family, but I created an imaginary family with mementos. Of course, as the creator of these assemblages, I plucked objects from my own childhood. What is interesting about these pieces is the gender binary. In that era, there were very different objects for boys and girls and different roles for men and women. As a child, I lusted after my brothers' adventures—popping cap guns, finding an arrowhead, playing with action figures, and engaging in snowball fights. The little girl's world centers around church—communion cards, pictures, the veil. But there is also the robin's egg, the favorite dog toy and the snapshot of the neighborhood gang and for the adults, dominoes. The war intruded in this family's life, changing the trajectory of the young soldier's life and altering the memories and the importance of objects. In memory, we get to pick and choose what endures and art allows us to create a coherent image of our own history.

In the works of the above artists the encounter that Berger talked about between man and nature takes place through less lofty but no less important means—everyday discarded objects. I say no less important because in contemporary society where man's engagement with the natural world is increasingly limited and in some cases almost nonexistent, the encounters we have with discarded things will hold increasing importance in facilitating valuable conversations, and what Berger refers to as moments of affirma-

tion: "[. . .] what is and what we can see (and by seeing also feel) sometimes meet at a point of affirmation. This point, this coincidence, is two-faced: what has been seen is recognized and affirmed and, at the same time, the seer is affirmed by what he sees" (8). This "double affirmation" is what takes place in works of art constituted from discarded objects. If once we were affirmed when face to face with the danger and beauty of the natural environment on a daily basis, today we are more likely to encounter an overflowing trash bin on city corners or the overwhelming amount of stuff in any given shopping center. If art is a metaphorical mirror onto the world and onto ourselves, the mirror in the case of trash aesthetics is a literal one—we look and we think, *I have this . . . , I used to have this . . . , This looks just like . . . , I remember that . . .* , etc. What it affirms is what we know, what we see and experience daily, and in a cluttered world of stuff where we are often overwhelmed by numbers and accumulations, such work functions to memorialize and to make possible an encounter, arguably the most immediate and significant being an engagement with ourselves. The engagement through creation with discarded objects offers moments of reflections, but also further acts to re-insert us back into a connection to the real, putting the body into a direct relationship with things. The process reinserts us back into temporality, a genuine sense of time that is skewed in digital embodiments and relationships. Participating in the making of works of art that use the "old" as a foundation allows for an evident connection to the past, to the present as it is being curated and created, and to the future as it is designed for later use and consumption.

<p align="center">* * *</p>

In an article for *The New York Times Magazine* titled "Object Lesson," the magazine's photography critic Teju Cole explores photography centered on everyday objects as a powerful tool in the struggle against forgetting. Cole writes about Glenna Gordon's series of photographs on the things left behind by the nearly three hundred Nigerian girls abducted by Boko Haram in Chibok, Nigeria in 2014. One such photograph is of a blue blouse with the name Hauwa Mutah inscribed in dark blue marker on the inside, similar to the way parents write their children's name on belongings while in kindergarten or elementary school. "The faint biographical traces left by this one girl activated my own memories and emotional responses," writes Cole. "[. . .] During the year I spent in a Nigerian boarding school, I wrote my name on my school uniform so that nothing would go missing in the communal wash. The blue blouse restores these fragments to me in a way a portrait of the girl might not have. Photographs of people's things reach us in this way even in the absence of such biographical coincidences because we

recognize their things as being like ours. Our infants wear bodysuits, too. We have favorite coffee mugs, too. There's that lace curtain we have always liked, or have always meant to change."

For Cole the photograph of the abandoned blue shirt does not seem to have a hidden or symbolic meaning (though it certainly can), but instead provides a one-to-one correlation to another object or set of objects that function as bookmarks to a personal memory embedded in a specific moment in time. His encounter with what he terms "object photography," and which we can extend to include all "object art," is primarily of the *I remember . . . , I used to . . . , I, too . . .* , variety whereby he affirms the existence of the shirt and therefore its owner, while the object subsequently affords him with an affirmation of his own similar experience. Cole quotes Marcel Proust who once wrote in a letter that, "We think we no longer love the dead because we don't remember them, but if by chance we come across an old glove we burst into tears." That's because, Cole argues, "Objects, sometimes more powerfully than faces, remind us of what was and no longer is [. . .] objects are reservoirs of specific personal experience, filled with the hours of some person's life. They have been touched, or worn through use. They have frayed, or been placed just so." As with photography, a mixed media collage of cut-ups and trash or a shadowbox containing various personal objects as a memorial to a particular person would have a similar effect. The objects would contain the story of their owner, their own story (and aesthetic value) as objects, as well as our own recollections of times, places, and people either directly or indirectly connected to them.

From the above it is clear that objects in works of art help us preserve memory and restore it as time passes, and give us means to influence and alter events that often seem beyond our control. But what I find perplexing in Cole's article is that while it is clear he recognizes the potential of object photography/art to trigger personal recollections and connections, he seems too easily dismissive of its transgressive power and potential. In his piece, Cole focuses on photography that documents wars, violence, conflict zones, specifically where the images "exclude humans: destroyed buildings, detritus-strewn battlefields, aerial photographs of damaged landscapes. An intriguing subset of that last category depicts domestic objects whose meaning has been altered in the aftermath of a calamity." For example, he explains that it is one thing to portray the Ukrainian conflict via images of riot police, protesters hurling Molotovs, etc., and another is to show the same conflict through photographs of a ruined kitchen. This last domestic image refers to the work of Ukrainian photographer Sergei Ilnitsky, who in 2014 documented an abandoned kitchen in Donetsk that showed "a ta-

ble with a teapot, a bowl full of tomatoes, a can, two mugs, and two paring knives on a little cutting board." In the photograph, Cole narrates,

> Broken glass and dust are everywhere, and one of the mugs is shattered; to the right, across the lace curtain, the shards of glass and the table, is a splatter of red color that could only be one thing. Domestic objects imply use, and Ilnitsky's photograph pulls our minds toward the now lost tranquility of the people who owned these items. How many cups of coffee were made in that kitchen? Who bought those tomatoes? Were there children in this household who did their homework on this table? Whose blood is that? The absence of people in the photograph makes room for these questions.

By the end of the article Cole's questions remain simply that, questions, curious inquiries by a distant observer tossed into the air and aimed at an image. They do no more work than to document a curiosity or induce contemplation, as if the blue blouse of a missing girl holds similar court as Proust's precious madeleine. "Perhaps [this] kind of 'object photography' [. . .] in conflict zones," writes Cole in the final paragraph,

> cannot ever effect the political change we hope for from highly dramatic images. Perhaps they don't make us think of the photographers' bravery, the way other conflict pictures do, or urge us to immediate action. We look at them anyway, for the change that they bring about elsewhere: in the core of the sympathetic self. We look at them for the way they cooperate with the imagination, the way they contain what cannot otherwise be accommodated, and the way they grant us, to however modest a degree, some kind of solace.

If comfort is the only thing achieved by the encounter with the aftermath of broken and trashed lives then we truly have become desensitized. I'd like, however, to believe otherwise, that art that goes "against the grain" of what and how something is represented can offer powerful social commentary and perform redemptive work that has the potential to lead to direct action at the individual and collective level.

Discarded items hold a special attraction to artists' imagination due to their position outside of established meaning, which constitutes their potential to become building blocks of an entirely new world from an aesthetic and practical perspective. We can understand this function better by looking at the way poems or even short stories function—however personal or confes-

sional they might be, when directed inward as a means to explicate a writer's thoughts and emotions, a truly successful piece of writing always externalizes and universalizes its content even if only implicitly; it always points outward from itself, revealing its inward eye as a microcosm of something else, something bigger, something other. In the process, such text others itself unconsciously. However, art of discarded items is *other* by default, marginal in terms of method, content, and mode of consumption.

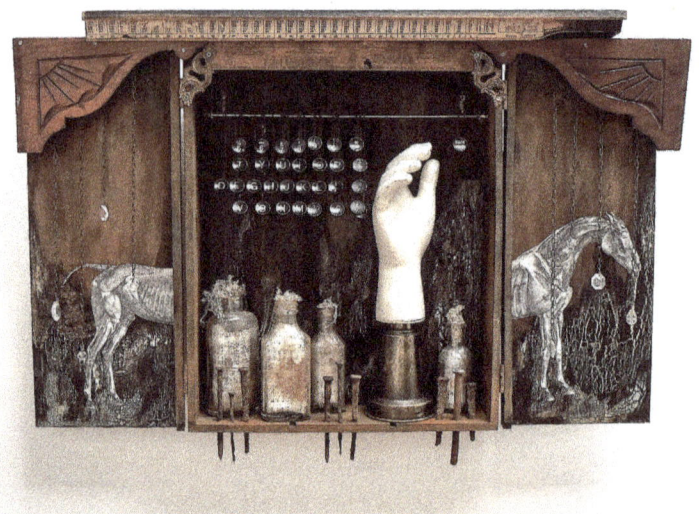

Figure 47: *Backspace*: mixed media assemblage by Dianne Hoffman consisting of a hinged wine crate, cuckoo clock chains, chandelier crystals, antique ruler, keyhole covers, game score block, typewriter keys, mannequin hand, vintage medicine bottles, Japanese sheet music, Spanish moss and railroad nails (15" x 23" x 3"). (Artwork © 2017 by Dianne Hoffman. Photographed by Su Evers. Used by permission.)

In the introduction to *Collage: The Making of Modern Art*, Brandon Taylor addresses the "outsider art" role of collage by defining it "as indecency, paradox and perplexity—as impurity by any other name. Collage as invention. Collage as simple *fact*" (8). By referring to collage as indecent and impure we are reminded of how discarded objects are generally perceived across cultures—trash, rubbish, unwanted, dangerous, and offensive. But when such things are integrated into a display and tagged as works of art, they show us their potential for invention—to invent new forms and new ways of seeing and thinking. They are also simple *facts*, meaning that once

created they exist on their own terms—here is an accumulation of trash. What would have under other circumstances been removed from the public eye and destroyed is now held up to scrutiny (and by the act of double affirmation leads to scrutiny of the object(s) as well as ourselves). We look, we see, we recognize and are recognized by it, and as we ultimately must turn our backs and leave at day's end, the metaphorical eyes of the discarded will follow us as permanent reminders of whatever emotion gripped us during our brief encounter.

Taylor believes that what we might find in this brief encounter is "the expression of modern sensibility: a sensibility attuned to matter in the modern city, matter under the regime of capital," ultimately requiring that we take "a more anthropological interest in the category of the discarded, the unwanted, the overlooked, as marks of modernity" (8). These marks of modernity, Taylor argues, come to us primarily in the guise of fragments (a shattered glass on a kitchen table in Donetsk, a broken or dismembered doll, a blouse without an owner); in other words what we recognize to be our world is a world of bits and pieces, incomplete, torn and reconstituted via memory and imagination. "Modernity's fragments, some collages suggest, *are* its history, its residue," claims Taylor, "they are what is left over when the great feast of consumption has ended for the day and the people have gone home for a rest. Collage in the fine arts allows us to see that it is somewhere in the gulf between the bright optimism of the official world and its degraded material residue, that many of the exemplary, central experiences of modernity exist" (9).

What I suggested earlier exists and functions from the margins, Taylor sees as existing in a gulf, a place of in-betweenness. In either case, the position of collage and other object art is that of outsider; from this vantage point where there is nothing left to lose because there is nothing valuable to begin with, they can destabilize accepted and traditional structures as well as suggest alternatives. This is what Cole is missing in his assessment of object photography—because they make use of commonplace or useless objects, they cannot be as powerful or effective as more dramatic human-centric images. And there is also the sense in Cole's otherwise eloquent evaluation of object art that it never quite transcends the personal—it triggers individual associations, but its purpose in relation to collective memory is secondary, vague, so the best we can hope for is solace.

The Afterlife of Discarded Objects

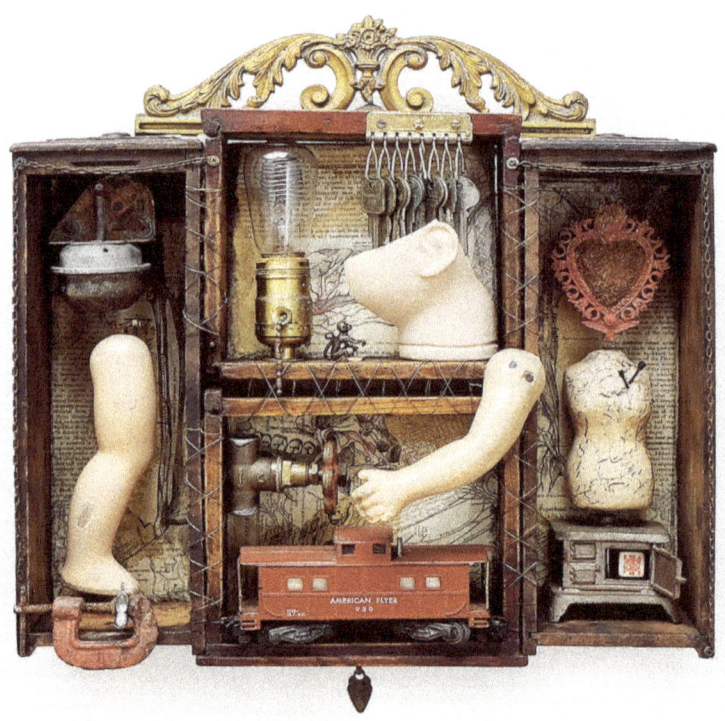

Figure 48: *A Collection of Imperfections Stitched Together With Good Intentions*: Mixed media assemblage by Dianne Hoffman consisting of a vintage sewing machine and jewelry box drawers, wall sconce embellishment, car and doll parts, small vice, monopoly shoe, light bulb with antique switch, keys, pewter monkey, metal Mexican heart, miniature doll house oven, game dice, facet handle, toy train caboose, image clippings from Grey's Anatomy, dictionary text, cuckoo clock chains, brass and rusted metal wire (16" x 16" x 5"). (Artwork © 2017 by Dianne Hoffman. Photographed by Su Evers. Used by permission.)

Solace, however, was far from what the Chinese artist Ai Weiwei had in mind when in February 2016 he wrapped the columns of Berlin's Konzerthaus with fourteen thousand salvaged life vests from refugees that had landed on the Greek Island of Lesbos to try and make their way to mainland Europe. The purpose of the installation made up of the bright orange

vests, further illuminated at night by spotlights, was to draw attention to the thousands of refugees risking their lives and dying while trying to reach Europe. It would be glib to suggest that when looking upon these discarded life vests one would first be reminded of their own life vest that they wore on their first whale-watching trip or on a yacht floating along on the Mediterranean. Ai's art was certainly a memorial to those who've suffered and died, but it was also meant to shock and provoke, a powerful critique of Europe's response to the crisis by exposing the gulf between the powerful and the powerless under current conditions. I do not mean to suggest that Ai's art of discarded life vests was solely responsible for change, but it is worth noting that Germany has since been on the forefront in shaping Europe's response to the refugee crisis.

Other works of art have the potential to suggest change, albeit on slightly less dire terms. Take for example the work of photographer Dan Giannopoulus, who since 2013 has been combing the streets of London looking for and collecting discarded drug baggies. His "Discarded Drug Baggies" project features 420 different baggies featuring an assortment of designs to indicate their contents, and each object is plotted on a map that indicates the location where it was found. Morgan Mandella writing for CNN in "Drug baggies of London: 'Markers of an addiction made public,'" quotes Giannopoulus who explains that, "This is first and foremost a project intended to make something aesthetically engaging from pieces of trash that the general public are mostly unaware of." Indeed, one of the results of the project, according to Mandella, is that it "[makes} the invisible, visible." As for Giannopoulus, he explains that, "There are a number of ways that you can read into these artifacts [. . .] Whether that is questioning where they came from, the journey they took to get where I found them, what was in them, who it was that consumed the contents. What was their story? Are they a casual, social user or is their story one of dependency? And you can also ask bigger questions about public drug use in London." It is those bigger questions that shed light on the transgressive potential of trash art (in this instance while making use of quite literally transgressive and illegal material)—Why are there so many drug baggies in London? Why does London have a drug use problem? What is being done or what can be done about it?

The Afterlife of Discarded Objects

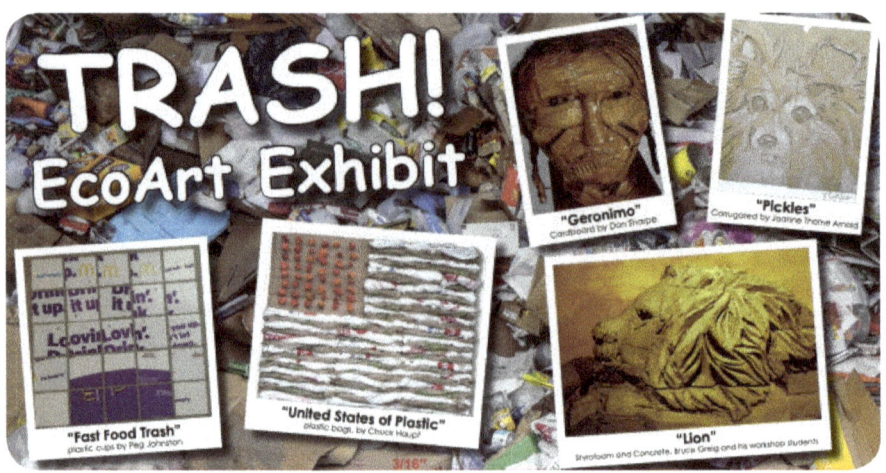

Figure 49: A marketing flyer/postcard for *"Trash!,"* an EcoArt exhibit curated by artist Peg Johnston and shown in 2016 at Cooperative Gallery 213, Binghamton, NY. The exhibit featured the works of more than a dozen artists using discarded materials such as paper and cardboard, plastics, fabrics, scrap metal, Styrofoam, and repurposed pieces of wood. (Postcard design by Peg Johnston)

An exhibit simply titled "Trash!" and curated in June 2016 by Binghamton-based artist Peg Johnston asks similar questions, but from an ecological perspective. The exhibit, shown at the Cooperative Gallery 213, was billed as an EcoArt Exhibit and featured the works of more than a dozen artists using discarded materials such as paper and cardboard, plastics, fabrics, scrap metal, Styrofoam, and repurposed pieces of wood. Representative works included collages and assemblages made out of McDonald's plastic cups and cardboard boxes, photographs of a recycling center, and an American flag made out of plastic bags. More than Johnston's own fascination with creating art from materials that others would consider waste, she hoped that show would bring attention to the relationship between consumer waste and the environment, as well as our role in creating and limiting the damage.

Beyond encounter, the works of Ai Weiwei, Dan Giannopoulus, and those of the artists at the Collaborative Gallery are about confrontation, one that banks on a much more visceral response from the viewer. Ai's and Giannopoulus's displays can cause the viewer to react in horror, disgust, fear, but they cannot be ignored. Similarly, Johnston's use of McDonald's plastic cups might not elicit horror in quite the same way, but it does make one a bit uncomfortable and has the power just like the others to

shift attitudes and behavior—anything from changing one's buying habits to calling for action to protect innocent civilians in a war zone. It might not end the conflict—human or environmental—but it is something, and it took trash to do it. As Brandon Taylor argued, they are the *facts* of modernity, the fragments of individual lives and the detritus of a culture. As facts they resist being entirely discarded, too easily brushed off to the side or passed by the way we do to countless works of art in the halls of a museum. This "degraded material residue" is someone's history, is our history.

Natalia

> When I speak of the aspiration towards the beautiful, of the ideal as the ultimate aim of art, which grows from a yearning for that ideal, I am not for a moment suggesting that art should shun the "dirt" of the world. On the contrary! the artistic image is always a metonym, where one thing is substituted for another, the smaller for the greater. To tell of what is living, the artist uses something dead; to speak of the infinite, he shows the finite. Substitution . . . the infinite cannot be made into matter, but it is possible to create an illusion of the infinite: the image.
>
> — Andrei Tarkovsky, *Sculpting in Time*

"If you could only know from what rubbish poems spring forth, unashamed!" confessed Anna Akhmatova, a famous Russian writer, in one of her poems. Akhmatova was certainly not alone in her recognition of art's ability to turn the insignificant and seemingly worthless into something meaningful and unique. While this is true of all arts, visual artists working with found objects and trash arguably fulfill the transformative function of art most closely, teaching us, as Slavoj Žižek puts it, to love the world. In the documentary *Examined Life*, Žižek proposes an improvised manifesto for the environmentally-conscious, pointing out our most challenging task of today: "to recreate if not beauty, then aesthetic dimension in trash itself—that is the true love of the world. What is love?—Love is not idealization. [. . .] You see perfection in imperfection itself, and this is how we should learn to love the world." Simple and noble as it sounds, the proposition is tricky to interpret, as it embraces several interconnected "calls to action." First, Žižek is pointing his finger at the hypocritical ideology of eco-friendly production of material goods that promotes uninterrupted consumption by erasing from public consciousness the guilt associated with consumption. Secondly, by evoking artistic agency at the center of a socio-political dilemma, Žižek once again makes us question the possibility of art devoid of the political dimension. Last, but not least, the imperative to find an aesthetic dimension in trash certainly necessitates reconsideration, and perhaps, a redefinition, of what we call "aesthetics."

The first of these considerations prompts us to consider the ambiguous role of art itself as a product participating in the socio-cultural assignment of value to objects. Hawkins and Muecke believe that eco-art in particular is also an economic move through which an object that was devoid of monetary worth regains it: "The aesthetization of waste is an economic move, an attempt to invert value, to recuperate the negative" (xi). According to Hawkins and Muecke, waste as a concept is central to understanding the dynamics of cultural production of value: the gap between worth and worth-

less is unpredictably fluctuating. An extreme example of art meddling with value is Michael Landy's piece of performance art titled Break Down, allegedly intended as a protest against Western consumerism. In 2001, Landy scrupulously catalogued and then publicly destroyed all of his belongings, an act that has claimed a place among masterpieces of contemporary British art. By turning perfectly functional items into a pile of fragments, Landy paradoxically drove up the aesthetic value of those items, elevating his mundane possessions to the status of art. Alastair Sooke writing for BBC Culture so describes this provocative experiment: "During the course of two weeks, every single one [of his possessions]—clothes, love letters, artworks, his Saab 900 Turbo car, even his father's sheepskin coat—was stripped, shredded, crushed, dismantled, or otherwise destroyed by Landy and his team of 12 assistants, while listening to David Bowie and Joy Division. When they had finished, the artist owned nothing at all, apart from the blue boiler suit he had been wearing throughout." What was left of the 7,227 items in the artist's possession was a detailed list of every single thing, valuables along with "tedious tallies of mundane objects including matchboxes, wire wool, toilet roll, and plastic bags." Part of the project's appeal was, of course, that it was art that destroyed instead of creating; if it did produce anything, it was trash. Sooke does not specify what exactly happened to the leftovers of the destroyed possessions, only briefly saying that they were "destined for landfill." For a statement on consumerism, this certainly seems a highly wasteful gesture, especially considering the confession Landy makes in his interview with Sooke: "The truth is, it's very difficult to escape consumerism in Western society. In fact, it's almost like breathing: you can't."

Artists working with trash often frame their work as social commentary, combining the aesthetic dimension with potential to shape public opinion through spreading awareness. In a 2012 CNN story "The Eco Artists Turning Trash into Treasure," George Webster interviewed several artists about the hope and intent behind their work, wondering whether they believed that art had any meaningful role to play in the discussions about the environment. The response was enthusiastic. Mandy Barker, one of the interviewed artists whose still-life photographs feature waste debris suspended in water, believes that "art is a form of communication that has the ability to promote the challenges concerning climate change. [. . .] If art has the power to encourage the public to act, to move them emotionally, or at the very least take notice, then this surely must mean art is a vital element in creating impact regarding climate change." Barker's definition of art as a form of communication emphasizes its function to appeal to its audience, and therefore influence public perception and values. One could call this

function of art educational, since it spreads awareness of environmental problems that is a vital precondition to any real change.

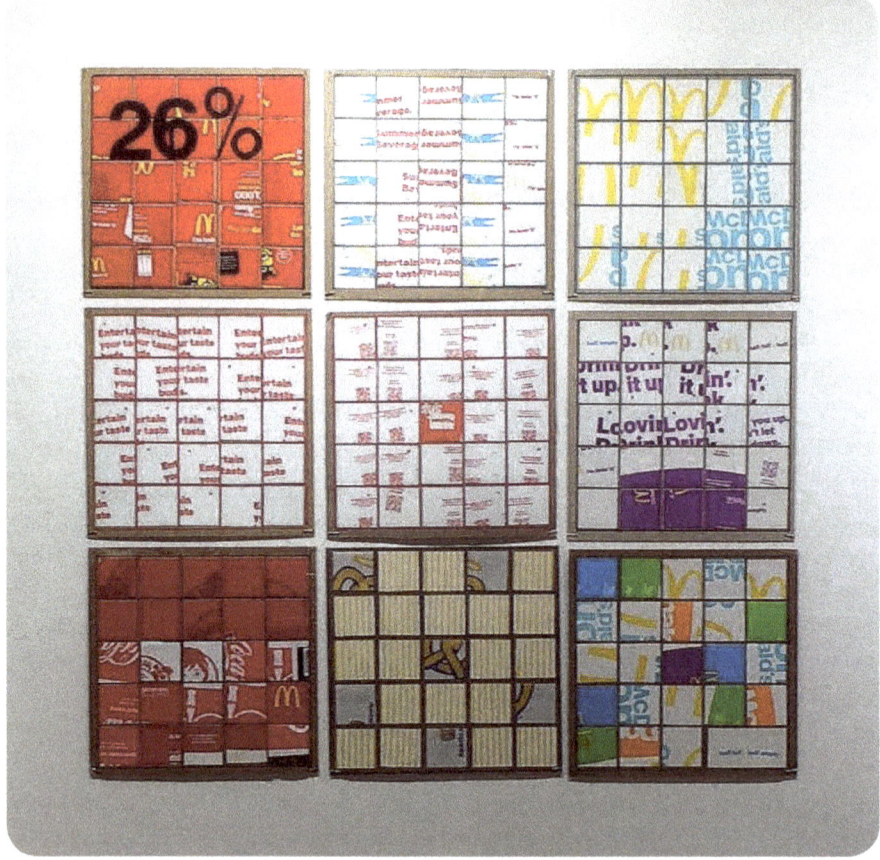

Figure 50: Wall display of nine different McDonald's drink cup and food container assemblages by Peg Johnston shown during a 2016 EcoArt exhibit titled *"Trash!"* at Cooperative Gallery 213, Binghamton, NY. (Photo by Peg Johnston)

In "Beyond the Archive," Aleida Assman so explains the mechanisms of communication that enable transmission of meaning between artist and audience:

> Art, [. . .] having always kept a certain distance from the utilitarian, subscribes to a rather different economy than business, allowing it to take an interest in waste. By incorporating waste into their works and installations, artists achieve two different objectives. They create an

alternate economy and compel the observer to look beyond the external boundaries of his or her sensory world and recognize the cultural system with its mechanisms of (de)valuation and exclusion. This type of art is not mimetic but structural. It does not represent or copy anything, but renders visible what is otherwise inconspicuous—namely, the fundamental structures of cultural value production. (Assman 72)

"Structural" art, according to Assman's definition, busies itself with channeling a certain message to the viewers, a call for action, employing trash as a hefty trope in the rhetoric of persuasion. Such art is reactionary as much as it is visionary: induced by and aimed at present socio-cultural injustice, it is simultaneously directed to the future by suggesting the possibility of change.

* * *

While we explored the socio-cultural and political aspects of object art in the first half of this chapter, it is the third implication of Žižek's proposition that is of the most interest to me presently. Is there a purely aesthetic dimension to trash, independent from the drive to undermine the process of cultural assignment of value? How do we conceptualize and understand "junk aesthetics"? And is there something different—neither mimetic nor structural—about the process of creation that involves found objects?

With the creation of his "readymades," a series of artworks that were essentially unaltered everyday objects merely provided with titles and exhibited as art, Marcel Duchamp famously defied the belief that art should be pleasing to the eye. These exhibits—a bicycle wheel, a snow shovel, a bottle rack, a urinal—are found objects that attracted Duchamp's attention, not because of their aesthetic qualities, but due to their very commonness. They exist on the threshold not only between an everyday object and a work of art, but also between a useful object and an item of trash. *Bottle Rack*, for example, allegedly has an ironic fate: the original 1914 version was thrown away by the artist's sister, who did not realize that the item was intended as art. Creation of another readymade, titled *Unhappy Readymade*, involved exposing a geometry book to the impact of the weather for an extended period of time. As a result, the item's appearance was exactly what one might expect an item of trash to look like: corrupted by the elements, rumpled, and covered by dust.

In his encounter with objects, Duchamp still places the primary emphasis on the artist's will: the act of presenting something as art—as well as on the function of an artwork as a medium to deliver a message to the viewer. Ushering in conceptual art, Duchamp sought to bring art "in the service of the mind" (qtd. in Arnason and Prather 274). His art provokes

The Afterlife of Discarded Objects

the viewers: challenges them to think about the definition and purpose of art, wonder about the meaning intended for the work of art by its creator, etc. One of many artists inspired by Duchamp, the French-American artist Arman, gave objects in his exhibitions more credit, as he is quoted saying, "I have a very simple theory. I have always pretended that objects themselves formed a self-composition. My composition consisted of allowing them to compose themselves" (Lempesis). In his *Poubelles* (assemblages of trash) and *Accumulations* (arrangements of multiple quantities of same objects), Arman explored the endless possibilities created by random repositioning of objects towards one another. Having lost their individual significance and intended function in combination with neighboring items, parts of his trash assemblages become disencumbered from the weight of assigned meaning. What becomes foregrounded instead is their materiality: shape, color, size, and texture, all fancifully altered by the chance adjacency with other elements of the composition. This is not to say that the individual parts of the composition become completely meaningless: rather, the attention shifts from meaning, which is a category of subjectivity, to the object itself and the properties it has besides the meaning that we assign to it.

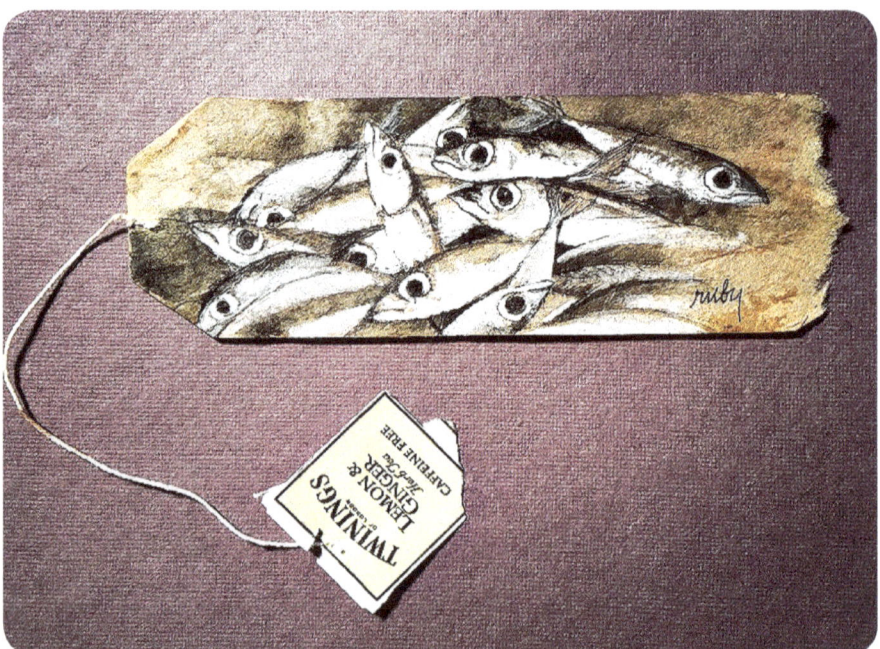

Figure 51: Painting by mixed media recycle artist Ruby Silvious on used, emptied-out tea bag. (Photo by Ruby Silvious)

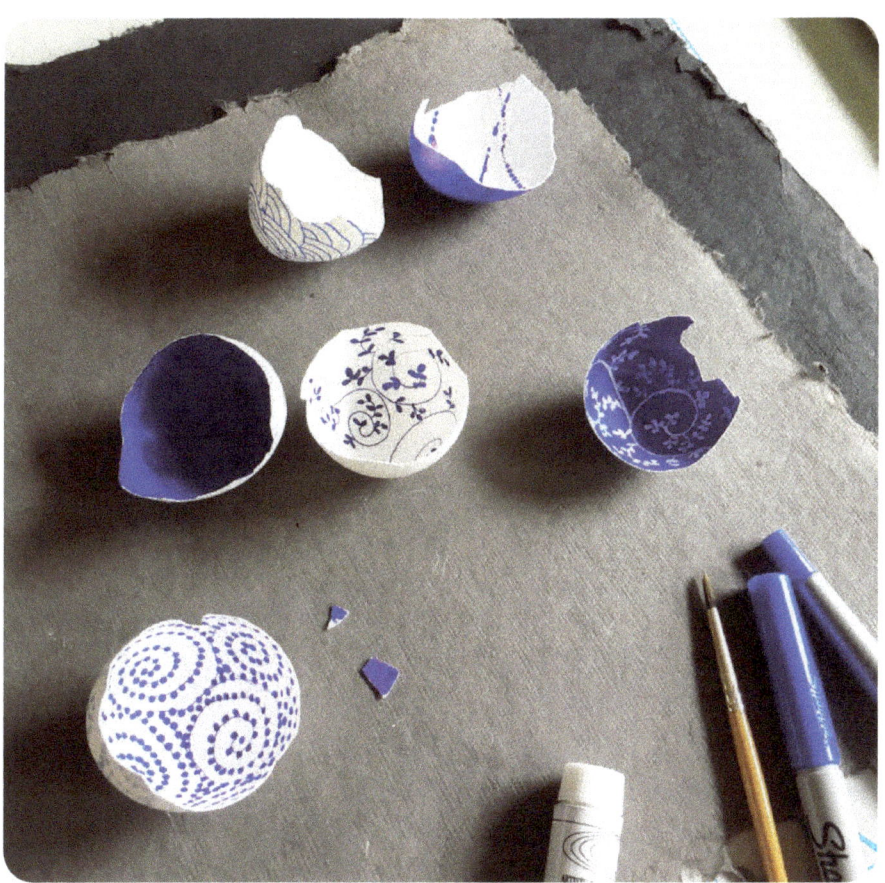

Figure 52: Painting by mixed media recycle artist Ruby Silvious on broken, discarded eggshells. (Photo by Ruby Silvious)

Jane Bennett in *Vibrant Matter* cautions against the temptation of placing human will and subjectivity at the center of an encounter with things, including an artistic encounter. She suggests that, "Found objects . . . can become vibrant things with a certain effectivity of their own, a perhaps small but irreducible degree of independence from the words, images, and feelings they provoke in us" (xvi). She further elaborates on the artistic capacities of things, including garbage, in her inaugural lecture at The New School's Vera List Center for Arts and Politics, "Powers of the Hoard: Artistry and Agency in a World of Vibrant Matter," suggesting that things possess what she describes as "the uncanny agency, the capacity to impress," "positive, creative capacities of things," "active, expressive, calling capacity

of things." Bennett's theory is helpful while considering the aesthetics of trash and found objects assemblages such as those created by Arman and Duchamp. Margaret Iversen in her article "Readymade, Found Object, Photograph" remarks that, "Duchamp's readymades were governed by the zero degree of aesthetics and aimed at a strange new beauty" (48). Such beauty, Iversen explains, is not dictated by the taste of the artist: "the celebrated autonomy of the work of art, it turns out, implies the obliteration of the poet or painter in his or her medium. It is fundamentally about displacement of one's own agency so that something other can surface" (47). She references Barthes's concept of *the death of the author* to demonstrate that the drive to de-subjectivize artistic practices was fundamental for the twentieth century aesthetics. Writing about the pop art of Andy Warhol in his 1980 "That Old Thing, Art," Barthes talks about dissolution of the author: "The Pop artist does not stand behind his work, and he himself has no depth: he is merely the surface of his pictures, no signified, no intention, anywhere" (qtd. in Hal Foster, 128). Absence of signification thus disrupts "referential depth and subjective interiority" of a work of art (Foster 128). Simply put, a work of art is freed from any intended meanings assigned to it by the artist; it is no longer a message, an allegorical reference to some idea, or an attempt at creating likeness of another object or person. It is allowed to be itself—to explore the features and qualities of its material presence, the impact it might make on the viewer's senses that are also freed (however briefly) from the burden of deciphering the meaning behind the work.

Even more so than the effacement of the author/artist, the role of object in the encounter between artist and thing is constitutive for the "strange new beauty" that Iversen observes in Duchamp's work. From this perspective, a work of art is not a coded message intended for an audience; nor is it the artist's exercise in self-expression. Instead, the work of art happens in the moment when an object becomes a thing and reveals itself to the artist, whether in proximity to other things that re-contextualize it and strip it from predictable, habitual meanings, or on its own, by exposing some of its qualities as if for the first time. The question of audience and reception becomes virtually unimportant since the triad—artist, artwork, and audience—does not exist in the same way: the artwork is no longer a medium of expression or a message from artist to audience, but a revelation that springs forth from the thing itself. The artist becomes the audience watching the art object take shape in front of her. Perhaps, art ultimately is a result of a person's ability to notice things—to not really create anything from scratch but instead look at what is already there and see familiar things unveiling something unfamiliar and captivating, something that we have not noticed about them before.

Former US Poet Laureate Charles Simic explains art as the excitement from seeing "the beauty of things before anybody has seen them" (22). This quote appears in *Dimestore Alchemy*, Simic's book about American artist and sculptor Joseph Cornell. Cornell's signature technique that he is most known for is assemblage art, specifically his wooden shadow boxes whose contents included an eclectic array of found objects and paper cutouts that he picked up at thrift shops or on the street. Simic comments on the materials that Cornell collected in his workshop, saving them for his assemblages: "Someone else, not knowing Cornell's method and purpose, would describe what's inside the files as the contents of a trash basket, agreeing, perhaps, that this is the strangest trash imaginable" (37). Living a reclusive life, Cornell was a true flâneur wandering the streets of New York City in search of an authentic encounter with things. Glass flacons, feathers, keys, antique maps, dolls and doll parts, glass cubes, paper bird images—the list of the elements of Cornell's little worlds is inexhaustible. While his assemblages may be seen as encoded messages created by juxtaposition of unrelated objects, they also function as spaces where objects can come into being of their own, independent of the artist's intention.

* * *

So far, I have purposefully referred to found object art, "readymades," surrealist assemblages, and even Pop art side by side, without discussing in detail the many nuanced differences between these separate approaches. Iversen, for example, makes her point to "drive a wedge" between Breton's found objects and Duchamp's readymades, explaining how they actually differ in the extent of their displacement of artist's subjectivity. For the purposes of this book, however, I am interested more generally in the many artistic approaches in those instances when they deal with objects on the verge of their objecthood; objects becoming things; materiality exposed and explored; the various stages of decay and disassemblage that border on the abject. Discarded objects are increasingly vulnerable to decomposition, but it is exactly their inherent liability to decay that becomes one of the most essential material qualities outside of their previous identity. Disintegration and fragmentation paradoxically perform compositional, generative function, thus becoming constitutive features of the creative process. The resulting aesthetic of such works of art, in addition to displacing human agency, foregrounds decay as a captivating, mesmerizing beauty. Duchamp's *Unhappy Readymade*, Arman's *Poubelles*, or Cornell's shadow boxes featuring old broken items all play with boundaries of a physical body and unmask the changing, unpredictable identity of objects that decay makes visible. In doing so, they

exemplify Bennett's point about the uncanny agency of things that is made possible through their very materiality.

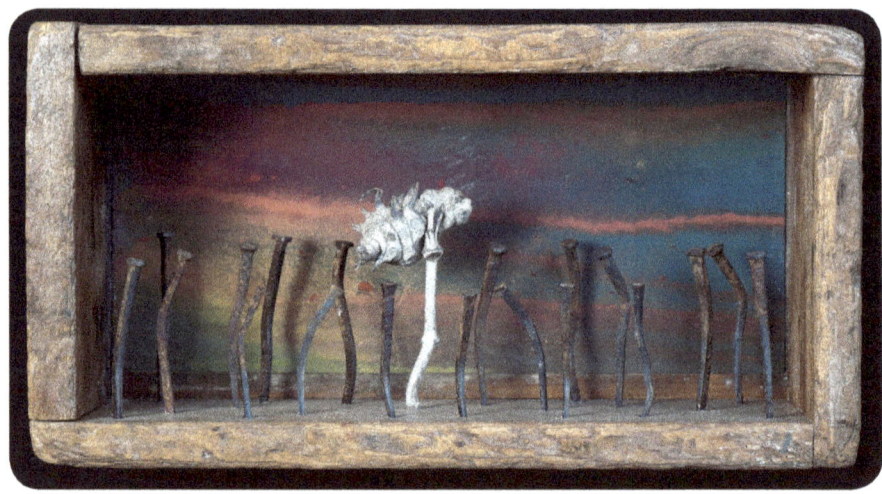

Figure 53: *Desert Dance*: Mixed media assemblage using found drawer, enamel on paper, square head nails, organic matter. (Assemblage © 2007 by Christopher Hynes. Photographed by Eric Beggs. Used by permission.)

The vulnerable, yet inescapable materiality of things, the excess of matter beyond function or meaning, is threatening and deeply affective. Hawkins and Muecke point out the affective dimension of waste, its ability to appeal to our senses: "Waste can touch the most visceral registers of the self—it can trigger responses and affects that remind us of the body's intensities and multiplicities. The qualitative overspill is an excess that escapes the knowable, manageable subject" (xiv). The appeal of a work of art featuring waste is often that of bodily reaction rather than cerebral appreciation; perhaps, it can be explained by what Bennett refers to as "inorganic sympathy." In "Powers of the Hoard" she defines inorganic sympathy as "a distinctive form of relationality, a peculiar associational logic, a subterranian sympathy between bodies that we normally assign to different categories: life, matter." Even though inorganic sympathy, according to Bennett, is neither instrumental nor aesthetic in and of itself, it offers potential for artistic expression that can be explored. Bennett even suggests that hoarding, traditionally viewed as an extreme psychological pathology, can be considered as "exquisite sensitivity to the somatic affectivity of objects" which borders on artistic sensibility. Hoarders, Bennett claims, "participate in the found art assemblages that they live with not by creating them, but by conjoining their sensuous excitable bodies with it." The extreme sensitivity that Bennett

believes hoarders to possess enables one to bring one's body in unison with the surrounding world, becoming attuned to manifestations of its independent existence.

Regardless of whether or not one chooses to expand the definition of art to include hoarding, Bennett's analysis of inorganic sympathy helpfully underscores the affinity, and mutual permeability, of human and non-human bodies, "the extent to which all bodies can intertwine, infuse, ally, or compete with those in its vicinity." Artists often interchangeably explore materiality of the human body and somatic qualities of matter. For example, Louise Bourgeois, a French-American artist who exerted significant influence on contemporary art, created explicitly biomorphic sculptures suggestive of human shapes. Briony Fer in her analysis of Bourgeois's work offers a helpful distinction between anthropomorphic and anthropocentric, pointing out that while the latter presumes superiority—centrality—of the human, anthropomorphism works to erase the rigid boundaries separating life and matter (29). Juxtaposing and often combining elements, textures, and shapes associated with male and female, human and non-human, Bourgeois's sculptures trouble the very existence of these categories.

Fer, writing about the 1966 "Eccentric Abstraction" exhibition featuring work by Bourgeois and several other artists, describes the aesthetics of the exhibition as follows: "If objecthood was a term used to describe the literalness of the object, its mere thing-like status, then this work moved beyond objecthood, not by repairing the rift and returning to the object its aesthetic plenitude, but by taking it even further down the road of literalness itself and into a realm of excessive, bodily materiality" (Fer 25). Admittedly, "Eccentric Abstraction" was an unfortunate title for an exhibition of art whose central concern seems to be far from abstract. Bourgeois's sculptures, made from materials such as cement, plaster, and latex, explored texture, weight, shape, and other physical attributes of her sculptures. While their non-representational character is, indeed, necessarily abstract, this abstraction foregrounds the concrete, palpable presence of the artwork. Fer points out that reviews of Bourgeois have faced the need "to express the heightened sense of the bodily, visceral presence of the objects, to circumvent the problem of likeness they embody and express more-than-likeness, the lack of representation" (29). Her work is simultaneously erotic and repulsive, suggestive of human shape while turning it into disintegrating amorphousness. It displaces subjectivity through fragmentation of the object, repetition of same elements that renders the individual elements meaningless, and, to borrow from Hawkins and Muecke, the qualitative overspill that effaces the knowable subject.

In a series of conversations with Bill Beckley, *On Sunday Afternoons*, Louise Bourgeois reminisces about an early influence on her work:

> When I was a little girl, growing up in France, my mother worked sewing tapestries. Some of the tapestries were exported to America. The only problem was that many of the images on the tapestries were of naked people. My mother's job was to cut out [. . .] the genitals of men and women and replace these parts with flowers so they could be sold to Americans. My mother saved all the pictures of the genitals over the years, and one day she sewed them together as a quilt and then she gave the quilt to me.

The image of discarded pictures of genitals, lumped together in a mass of repeating sameness, is a perfect example of the aesthetics of disintegration and fragmentation. The human shape here loses its humanness, retaining, however, the connotation of physicality. One can only imagine what the quilt must have looked like, but Arman's assemblages of multiple same objects offer a clue. Whatever the individual fragments are—paintbrushes, watches, or cut out images of body parts—their amalgamation overpowers the senses, creating an inadvertent pattern in which composition and decomposition, assemblage and fragmentation, unity and disparity work together to create a "strange new beauty," the aesthetic dimension in trash itself that Žižek is calling for.

Hawkins and Muecke, in their take on the aesthetics of trash, invoke the famous scene with the dancing plastic bag from *American Beauty* where character Ricky Fitts narrates:

> Do you want to see the most beautiful thing I ever filmed? It was one of those days when it's a minute away from snowing and there's this electricity in the air, you can almost hear it. Right? And this bag was just dancing with me. Like a little kid begging me to play with it. For fifteen minutes. That's the day I realized that there was this entire life behind things, and this incredibly benevolent force that wanted me to know there was no reason to be afraid, ever.

Transgressive Art

Figure 54: Plastic bag washed and hung on kitchen wall to dry for reuse, Bucharest, Romania. (Photo by the authors)

Continents and decades apart, Sadaf, a contributor to *The Afterlife of Discarded Objects* from Tehran, Iran, shares a brief and strikingly similar anecdote about plastic bags during his childhood in the 1980s:

> My brother and I used to make some sort of a kite out of plastic bags. We blew into the plastic bags and put a string around them. Sometimes when we were not allowed to leave the house specially during the times of war and missile attacks, we would keep our simple kite out of the window and watch the wind as it was moving it around.

Writing specifically in reference to *American Beauty*, it is impossible not to notice how aptly Hawkins and Muecke's words fit both scenarios as they demonstrate how the affective dimension of waste works as a redemp-

tive force, transforming something ugly and useless into a thing aesthetically pleasing: "Watching this plastic bag we find ourselves unexpectedly affected, caught unawares by the capacity of trash to surprise" (xi). A few pages later, they again quote the element of surprise in aesthetization of garbage, speaking of "elusive qualitative activity—of what Deleuze would call becoming—all those things that break in from the outside, that surprise, that disturb, that introduce unpredictability—a dancing plastic bag for example" (xiv). Whether in Iran or suburban America, it is the plastic bag that speaks, and like Žižek maybe we can learn to listen as it hovers on the wind: "this is how we should learn to love the world."

9 Digital Erasures: New Media and Re-Enchantment With the Material World

Andrei

> *Collective memory is generally understood to entail the narration and representation of the past, while collective forgetting is antithetically thought to be a silencing and muting of the past. It comes as no surprise, therefore, that when nations, collectives or individuals wish to ensure that certain events, eras, people and experiences are remembered, they quite naturally turn to words and images. What can be heard, seen and touched has become the cornerstone of memory . . . While no one can guarantee the mnemonic maintenance and survival of issues that have received textual and narrative representation because memory is unstable, changing and unpredictable, commemoration seems to amount—at least in its beginning stages—to words, narratives and much talk. In other words, speech, narrative and text seem to be perceived as necessary—if not sufficient—for ensuring collective memory."*
>
> <div align="right">—Vered Vinitzky-Seroussi & Chana Teeger,
"Unpacking the Unspoken: Silence in Collective Memory"</div>

With each day we exist increasingly in a world of unthings, a world where by default we interact with digital surrogates, replacements, and virtual simulations more than material objects. This rapid (less than a quarter century) and nearly all-encompassing paradigm shift requires that we think about what it means to live "the digital life": how does it impact the way we assign value to things; how is it affecting our ability for sustained emotional investment in our environment; and how do our notions of time and space change when engaging with digital instead of material objects? Without the felt presence of material objects, and subsequently without the sense of impending decay that attends our physical world, a radical change in our perspective of the world and our own role in it has taken place. In assessing both the positive implications and the limitations of digital embodiments, we come to the conclusion that the digital inadvertently engenders nostalgia for the material and a critical reassessment of our engagement with both people and things.

In a 2015 article for *The New York Times*, "Our (Bare) Shelves, Our Selves," novelist Teddy Wayne mourns the loss of what once used to be ubiquitous across a good number of households, which nonetheless changed over the years: shelves full of books, records, and CDs. Wayne recalls with

a clear sense of nostalgia digging through his parents' stash of Beatles vinyl records when he was thirteen years old during the early 1990s, pointing out particularly how they took up space by being "stacked up next to the record player" and how their more modern digital versions would have rendered them invisible, possibly affecting the way his taste in music developed. The bulk of the records was something that could not be easily ignored in the confines of a household, whereas MP3s do not intrude on our line of vision, and possibly not even on the way we construct even passing thoughts.

While Wayne acknowledges that there are upsides to digital music, such as cost and increased accessibility, ultimately he believes that, "[. . .] in our conversion of media, [. . .] physical objects have been expunged at a cost. Aside from the disappearance of record crates and CD towers, the loss of print books and periodicals can have significant repercussions on children's intellectual development." The rest of the article is a eulogy to books and to the value of material objects in one's life. Wayne is a man who holds in high regard the process of engaging with things, the steps one takes to interact with and make things move, all of which necessitate that one is in contact with them:

> Poking through physical artifacts, as I did with those Beatles records, is archival and curatorial; it forces you to examine each object slowly, perhaps sample it and comes across a serendipitous discovery.
>
> [. . .] Consider the difference between listening to music digitally versus on a record player or CD. On the former, you're more likely to download or stream only the singles you want to hear from an album. The latter requires enough of an investment—of acquiring it, but also the energy in playing it—that you stand a better change of committing and listening to an entire album.
>
> If I'd merely clicked on the first MP3 track of 'Sgt. Pepper's' rather than removed the record from its sleeve, placed it in the phonograph and carefully set the needle over it, I may have become distracted and clicked elsewhere long before the B-side "Lovely Rita" played.

For Wayne, an old record or a well-worn paperback inherently holds more nostalgic value than a Kindle .azw file. "Data files can't replicate the lived-in feel of a piece of beloved art," he argues. To illustrate, he explains that a digital album cover remains unchanged, blemish free over time, whereas a physical book, record, or CD cover would show the marks of use with age. While well-intentioned—he does provide research that shows households with a sizeable library of books result in overall smarter children—Wayne's arguments can come across as overly sentimental, as not being in tune with the incredible potential of the digital era, and thus

easily dismissed by digital natives whose lives we could argue are defined by post-materiality, by what is possible vs. what is.

Figure 55: Discarded records and broken crate following a flood, Binghamton, NY. (Photo by the authors)

To Wayne's rescue comes an article by Sven Birkerts, an outspoken critic of technology, who in 1991 (likely just as Wayne was entering his early teens and just falling in love with his parents' Beatles record collection) penned the essay that would serve as serve as a warning about what was to come. Originally published in the October 1991 issue of *Boston Review*, "Into the Electronic Millennium" goes beyond nostalgia to effectively claim (Wayne hints at this by mentioning "our selves" in the title) that what is at stake in the new electronic order is our humanity. The changes that we are witnessing and experiencing today (though it must be pointed out that Birkerts's arguments come years before personal Internet connections were to become widely available; before cloud computing, Facebook, Twitter, Snapchat; and before even the ancient Instant Messenger and AOL's "You've Got Mail" greeting) manifest across three major "morbid symptoms": **1. Language erosion**—"bite-speak" or "plainspeak" (think text messaging, LOL, and emojis) is replacing more complex speech and writing; **2. The flattening of historical perspectives**—our sense and understanding of the past is being replaced by a sense of living in a perpetual present; **3. The waning of the private self**—the "ideal of the isolated individual" is being re-

placed by "social collectivization" in the digital realm where subjective space is nonexistent.

Like Wayne's ultimate glorification of print matter, Birkerts assesses the three morbid symptoms of the electronic millennium as concurrent with a decline in intimate engagement with the written word. Unlike Wayne's sometimes-sentimental view of libraries, stacks of books, and records, Birkerts is downright frightened at the prospects and sounds an alarm that hits at the core of who we are as individuals and as a society. I especially believe that what Birkerts says about language erosion and the flattening of the historical perspective in our time has prescient parallels to post-materialist discourse. In this chapter, I would therefore like to take Birkerts's claims beyond linguistics to show how the rapid acceleration away from materiality in the past couple of decades risks exacerbating conditions already primed for over a century.

* * *

A common criticism lobbed at Birkerts's text is that he fails to acknowledge the benefits of new media technologies, or that the changes he foresaw (and which we are experiencing) could actually be positive. Such criticism, in my opinion, too easily dismisses Birkerts as a digital immigrant, an old fogey who just can't keep up with the times. He's seen as speaking for an older generation, those who've yet to fully catch up to and transition into the digital era inhabited by writers and thinkers such as Teddy Wayne. In this sense maybe Wayne's NYT article, written from the perspective of a digital (or at least an electronic) native, validates Birkerts more than two decades later. Even Birkerts, in a way, anticipates his detractors when he writes, "I am not suggesting that we are all about to become mindless, soulless robots, or that personality will disappear altogether in an oceanic homogeneity. But certainly, the idea of what it means to be a person living a life will be much changed."

It would be absurd, therefore, to believe that Birkerts is unaware of the possibilities offered by new media, many of which are indeed positive and welcomed. However, we know what those are, and no one really needs a laundry list of ways that technology has improved our lives. What we do not know are the ways in which technology is affecting who we are on a fundamental level—we're getting a sense of it, and many others have sounded the alarm as well, but we are yet to fully grapple with the long-term implications of living plugged in to a digital network. "Transitions like the one from print to electronic media do not take place without rippling," writes Birkerts, "or, more likely *reweaving* the entire social and cultural web." It is

Digital Erasures

this rippling or reweaving that we also are concerned with when we discuss a cultural shift from material objects to their digital surrogates.

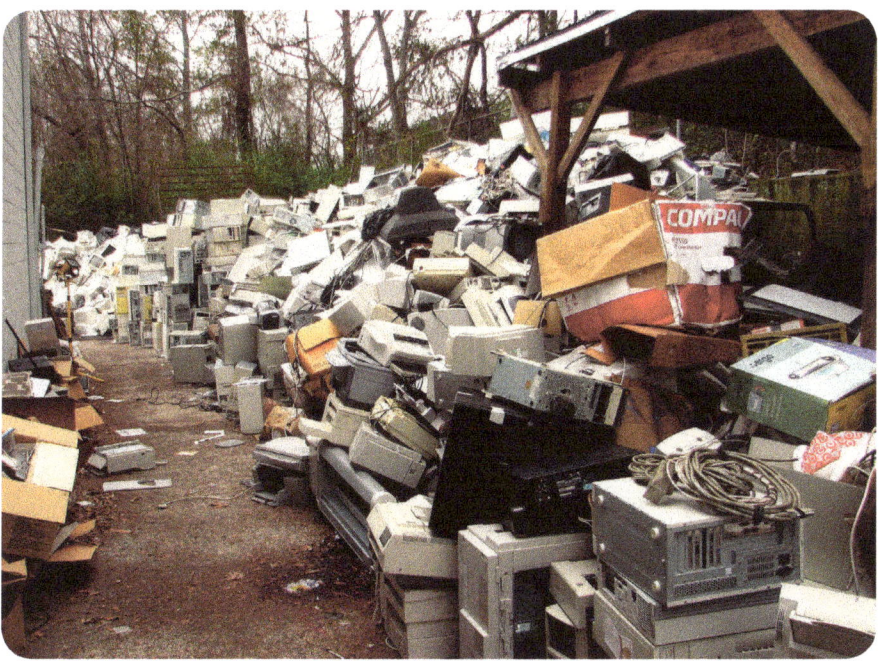

Figure 56: Electronics waste pile, Birmingham, Alabama. (Photo by Curtis Palmer / CC BY 2.0, via Wikimedia Commons).

Let's take as a starting point Birkerts's distinction between how print (books) functions and its digital counterpart (the Internet). First, Birkerts tells us that "reading is fundamentally an act of translation" where "[s]ymbols are turned into their verbal referents and there in turn are interpreted." You read the word "chair" and the mind translates it into a visual referent (what you imagine a chair looks like) that is then processed within the larger context in which it is found/read. The same goes for verbs/actions and phrases. However, changes brought about by electronic and digital eras are affecting the way we process symbols. One thing that technological innovation has done is to effectively eliminate certain objects from our lives—a smart phone today can perform the functions of dozens of clunky and expensive machines (fax, camera, scanner, answering machines, record/tape/CD players, etc.) that we relied on less than two decades ago. What is lost along with the objects themselves is an entire language of engagement, language that placed us into a direct (often physical) relationship with those objects: spinning like a record, like a broken record, dial the number, re-

wind, punch in the numbers, etc. What those phrases have in common is the ability to generate an image of the item itself and of engagement, a visual translation of the words that connect man to objects. As the objects themselves disappear, eventually so will the language we've developed to explain our relationship to the material world.

Of course, it should be noted that this is not something unique to our era. Innovation over centuries has meant that one thing will inevitably replace another (the telegraph gave way to the telephone which gave way to the smart phone and instant messaging), and language has proven resilient in the face of disappearing things that have eventually been replaced with new ones. The significant difference between then and now is that in the past one thing has usually been replaced with another thing, one symbol for another; today, things are replaced with their digital embodiments, all of which function similarly—to return to the smart phone example, all of the functions of gadgets it has replaced can be performed through a tap or swipe. One no longer needs to "remove [. . .] the record from its sleeve, place [. . .] it in the phonograph and carefully set the needle over it" as Wayne so lovingly recalls. Those actions, and therefore that language, is simply no longer necessary, and indeed it would sound strange if while watching a YouTube video someone were to ask, "Can you rewind that tape to the beginning?" No longer is there a tape (the mind will no longer recall that symbol), and nothing needs to be wound (the mind will not generate a visual equivalent for that act). "Dial the number" similarly no longer conjures up the image and action of someone turning the dial on a phone. With ever faster, smaller, and more efficient devices that force us to discard once common objects from our lives and routines, will the erosion of language keep pace as well? If this is the case, and the current trajectory seems to suggest as much, not only does language suffer, impoverished from its prior complexity, but so does overall meaning and memory, which as we have seen is very much dependent on material vessels or referents. When the sign/thing is missing, so are the memories once embedded in it. The chapter's epigraph by Vered Vinitzky-Seroussi and Chana Teeger from "Unpacking the Unspoken: Silence in Collective Memory" makes clear the peril that we face: while "What can be heard, seen and touched has become the cornerstone of memory," what is even more vital to our project is that, "commemoration seems to amount—at least in its beginning stages—to words, narratives and much talk. In other words, speech, narrative and text seem to be perceived as necessary–if not sufficient–for ensuring collective memory" (1103).

Digital creation and expression does, however, come with its own language and syntax, so that one might perhaps argue that language, and therefore memory, is in fact not in danger as long as new words (and old

ones) still exist, albeit as translations of 1's and 0's. But there is a difference, and it is primarily due to the fact that language across the digital realm is often and increasingly divorced from the real world (a natural development as we ourselves disconnect more of the real world and plug into the virtual). What is the cost, then, of tossing out language rooted in the material world and that directed the mind from one space to another, for language that originates in the digital realm and can only point back to itself? Heidegger gives us a hint of the answer in *Building, Dwelling, Thinking* when he writes that, "It is language that tells us about the nature of a thing, provided that we respect language's own nature. In the meantime, to be sure, there rages round the earth an unbridled yet clever talking, writing, and broadcasting of spoken words. Man acts as though *he* were the shaper and master of language, while in fact language remains the master of man. Perhaps it is before all else man's subversion of *this* relation of dominance that drives his nature into alienation" (348); an alienation on multiple levels—from himself, from others, from the nature of things.

Take language that a majority of us would be familiar with, and that we use frequently to describe our interactions online: *I shared something on your wall; Did you like my post?; How many followers do you have? She friended me; Remember to share; Scroll through; Gone viral*. Such words and many others have become part of common vocabulary in less than a decade; some have been formally added to the English dictionary, their impact on our conversations has been that profound. But ultimately we give them little thought, especially to how they might be affecting our thinking. The Facebook wall, despite the reference to a "wall," is not really a wall in the traditional, material sense. That much is obvious, but less obvious is that the mind never has the chance to translate (as Birkerts argues it does with traditional print) the word/symbol into an image of a physical wall. This is a perfect example of self-referential language that was developed by and for the digital world (Facebook's developers called it a "wall"); once processed by the consumer it serves only to refer back to itself. Similarly, we might consider the term *to unfriend*, which while purportedly refers to a real person nevertheless takes one inevitably back to the blue and white infused Facebook page, to an interface of simulated lives. In other words, a term generated by and through digital interaction inevitably functions only within the digital sphere, unable to generate a foothold in materiality. The loss of the object means the loss of a crucial conceptual move where the mind makes connections across contexts and provides a tether between the world and us. As such it is doomed to obsolescence, and our critical thinking alongside it reduced to viral moments, bitespeak, clicks and swipes. Language in this case becomes *partial, incomplete*, or, as Birkerts would say, *eroded* and diminished in its function. And as with

language, so with us. "Maybe we exist as language and when someone dies / they are unworded," writes Bob Hicok in his poem "So I Know" (37). But we may be on our way to erosion, to being unworded even before physical death; which then begs the question, "What remains?"

Figure 57: Broken public telephone, Bucharest, Romania. (Photo by the authors)

* * *

Birkerts's claims about language erosion as a result of technology do not come without criticism. In an age of multimedia, multiple literacies, and multimodality, a dogmatic stance on the value of print seems antiquated and narrow. As a professor of writing preaching to digital natives in the twenty-first century, I had my own initial reservations. But I believe Birkerts begins his list of morbid symptoms with the claim on language specifically because it is, at least on the surface, seemingly the most porous; he opens

himself up to criticism because he knows, and trusts, that once you follow him on to the next point, the flattening of historical perspective, he would have won a convert. He trusts his ordering because this is how print works, how its logic is laid out on the page: "Print [. . .] posits a time axis; the turning of pages, not to mention the vertical descent down the page, is a forward moving succession, with earlier contents at every point serving as a ground for what follows." And what follows is a look at time and history itself, both of which, according to Birkerts, are suffering the onslaught of a digital mindset: "As the circuit supplants the printed page, and as more and more of our communications involve us in network processes—which of their nature plant us in a perpetual present—our perception of history will inevitably alter. Changes in information storage and access are bound to impinge on our historical memory." But again, by invoking the printed page his argument might be swept aside once we consider that with new developments such as eBooks the digital page very much resembles—in appearance and function—print on a piece of paper. What I would like to offer here is that while the printed page for Birkerts is the key ingredient in his theory, for the purposes of our discussion on waste and memory the printed page is only one example among many objects whose functions are not only being eroded but eliminated completely in the digital era. Once the printed page is understood as symbolic of the world of material objects, his thoughts on where we are headed take on renewed significance.

"The depth of field that is our sense of the past is not only a linguistic construct," writes Birkerts, "but is in some essential way represented by books and the physical accumulation of books in library spaces." A principle that underlies our relationship to the material world is that objects take up space and dictate the arrangement of other objects, as well as our selves, within that space. The digital affects our sense of chronology (we have argued previously that the Internet often gives us the feeling of being "lost in time") but also gives everything a sense of "weightless order" where a five-hundred-page book makes no difference in terms of the amount of physical space it takes up when compared to that of a five-hundred-word letter. Christian Horn, Annette Haug, and Gustav Wollentz, in their session at the 2017 Kiel International Open Workshop titled "'Tonight will be a memory too'—Memory and landscapes," postulate that, "Apart from an extension in time, memories have another extension in space, i.e., they had a location. Memorials are frequently constructed in or close to landscapes connected to the memory they attempt to preserve." We have certainly seen how ruins bear this responsibility and how monuments can inspire both memory and forgetting. Birkerts also sees books as taking up space, but more so he would agree that objects help us to "form a picture of time past as a growing

deposit of sediment; we capture a sense of depth and dimensionality." This is precisely what is missing from even the most thorough and well laid out database—a sense of the physical dimension, the accumulation of stuff that has for millennia served a memorial function.

Figure 58: Cable, phone, and Internet wires wrapped around an electrical pole, Bucharest, Romania. (Photo by the authors)

Furthermore, Birkerts argues that a world where materiality is put on the back burner "encourages in the user a heightened and ever-changing awareness of the present." In itself this would not necessarily be problematic but for the fact that what a digital reality encourages is existence in a

perpetual present—everything is *now*—and without a physical dimension of the past provided by material things, our sense of history becomes nothing more than a matter of "repositioning the self within a barrage of onrushing stimuli." Such a world had been embraced by many, even in the early 1990s says Birkerts, including author Mark Leyner whose work was described in a *New York Times* article by Trish Hall as creating a "dissolving, discontinuous world." When everything is dissolving and discontinuous, a world of fragments, Birkerts laments that he has "a great feeling of loss and fear about what habitations will exist for self and soul in the future." Memories can inhabit material objects because they offer a sense of continuity—they extend from the past to the present and into the future. "The printed page is itself a link," says Birkerts, "at least along the imaginative continuum, and when that link is broken, the past can only recede." Yukio Mishima echoes Birkerts's sentiments in the 1959 novel *The Temple of the Golden Pavilion* when he writes that, "The past does not only draw us back to the past. There are certain memories of the past that have strong steel springs and, when we who live in the present touch them, they are suddenly stretched taut and then they propel us into the future" (243).

If we hold fast to the principle that waste is object plus time, then Mishima's claim implies the existence of decay and deterioration in the act of memory; the physical and material conduits for memory age and change over time. And as we are reminded of the language of discarded items when we talk about concepts such as digital debris, link rot, and how knowledge and information are lost in a vast digital sea, to draw an equal sign between objects and their digital surrogates would mean to ignore a crucial distinction between the two. The quality of a digital "item" can be preserved indefinitely, even enhanced, while despite our best efforts at preservation material objects are still countered by the passage of time. When this variable is removed, digital embodiments no longer exists in "a time" or "that time." They are no longer part of history as we know it—linear, sequential, layered, cumulative.

The Internet specifically, by changing the perception of linear time where things exist simultaneously everywhere and at all times, has significantly changed the perception of objects as "embedded in time." They become timeless, endless, perpetually in existence and always in the *present*. Our relationship to things, therefore, is no longer predicated on the knowledge that they are temporary, might disappear, will disappear. By proposing the possibility of preserving things indefinitely, the Internet is rendering our natural relationship to things itself a thing of the past, a non-relationship understood only in terms of its absence. It gives rise to nostalgia as a permanent state of being, a continuous yearning—the digital world as cre-

ator of desire that it can never fully deliver, but which nonetheless aims to satisfy through the preservation and presentation of the very objects of desire themselves. The German word *vorfreude*—which conveys an intense, anticipatory joy from imagining future pleasure—captures this condition quite accurately. *Vorfreude* defines a present that is never happy with itself and is always aware of it, for it is repeatedly duped by the false promise of satisfaction that lies *after*, something just beyond reach. This impossibility manifests itself in the always *better* "approximation" of real things, as well as in our use of language in digital discourse that increasingly approximates more complex speech in the name of efficiency and progress.

* * *

Our own distance from the real world, the alienation Heidegger warned about, can be understood better (made bleaker?) as a modern lack of bodily connection to materiality via digital interfaces. We are bodiless in that interaction and so are the unthings we interact with—the physical body is erased, made moot. As we—and the objects—remain bodiless throughout that interaction; regardless of how many simulacra of the body you choose to present online, it is impossible not to assume that a radical redefinition of self is needed. This definition, however, must have as a foundation the understanding that we live in a time that is profoundly different from what until now we might have referred to as the modern era. The time we live in now is post-historical, soon to be post-human, a world of "post-materiality" simultaneously drowning in an excess of material objects. Or, since the word "post" implies an *after*, maybe a more suitable and eye-opening term would be "the end of history." Unlike Francis Fukuyama's use of the term with respect to politics, in this case the end of history is understood as a digital loop that consists of perpetual nontime and unthings. At the end of history we are a "society that has begun to come loose from its textual moorings." Furthermore, "If we take the etymological tack, history (cognate with "story") is affiliated in complex ways with its texts. Once the materials of the past are unhoused from their pages, they will surely *mean* differently (Birkerts). In chapter four we referred to Derrida's *Archive Fever* lecture, coincidentally delivered the same year as "Into the Electronic Millennium," where he argued that, "What is no longer archived in the same way is no longer lived in the same way." Context shapes perception and reception and shapes both understanding and behavior. By bringing Birkerts and Derrida together we come to realize that when something *means* differently it is *lived* differently (and maybe, we might go out on a limb and argue, in some cases no longer lived at all). Without the text, without the object where the past might dwell, the self moves from being caught in a tug-o-war between mem-

ory and forgetting while navigating constant decay, loss, and erasure, to a state of dynamic stasis—nomads of the now exiled from history, individual and collective, where a *life* has been reduced to an *existence*.

* * *

In defining the differences between print and electronic/digital media, Birkerts explains that with the latter "The pace is rapid, driven by jump-cut increments, and the basic movement is laterally associative rather than vertically cumulative." A digital artifact, unlike its physical counterpart, also revels in "[i]ts combinatory momentum and relentless referencing of the surrounding culture," which "mirror[s] perfectly the associative dynamics of electronic media." The structure of the book you're reading now reflects and embraces this paradigm shift, which we believe was anticipated as early as the twentieth century in Walter Benjamin's *The Arcades Project*. But we also believe that it is necessary even as we embrace and appreciate our current condition that we retain the capacity to evaluate and critique the very changes that define how we live and work.

In the end, however, I am left with more questions about how far our current understanding of the relationship between objects, memory, and forgetting will take us in developing a coherent and practical approach to the future of material studies. I say this because in the face of a new digital reality, "thing theory" might be thought of as a relic of a past when human relationships were predicated and mediated primarily via objects. How then must we recalibrate our understanding of the function of things in a world producing more of them every second and yet consolidating others or replacing them entirely with digital/virtual versions that lack corporeality and subsequently thingness? Can our digital traces be thought of in the same terms as our physical traces? If not, does thing theory need to expand/change in some way to account for "digital materiality"? Yes, our relationship with our digital devices like smartphones or laptops often dominate our time throughout the day, but is this relationship the same as one formed with objects or things? And if it isn't, is it better, worse, or irrelevant?

I do not have answers to all of those questions, but for now I am leaning in one direction—in the face of the unknown and uncertainty, I'd like to put my trust in something old and deceptively sturdy. In "Our (Bare) Shelves, Our Selves," Teddy Wayne recounts the story of one professor S. Craig Watkins who admits that today his family almost exclusively streams music online. But that didn't stop him and his wife from storing away all of their "old CDs in a seldom-used cabinet." The motivation for storing and preserving objects that have been rendered useless has more to do with their daughter than with the things themselves. While to his daughter now "those

CDs are, at best, background matter," Watkins says he hopes that, "when she gets a little bit older, it might become meaningful to her—that those artifacts are a way to connect back to us." The fact that he's not relying on his digital iTunes library to bear that burden is significant. Something there does not say "Watkins," and that could be a pretty good place to begin answering *why*.

Digital Erasures

Natalia

In *Other Things*, Bill Brown addresses what he sees as the perceived threat caused by the shift of social interactions online and the digitization of contemporary reality. He believes that it is precisely the increasing dematerialization of reality that has prompted many to search for a re-engagement with the world of things: "If one can posit a material unconscious that has provoked this thing about things, I suspect it is troubled by "dematerialization" of the world, a proliferation of the newly agential objects, and a recognition that our most familiar object, our planet, has become uncanny" (13). Indeed, contemporary reality bears a shadow of impending technological catastrophe: unmanned drones embody the threat of technology turning against people, our investment of private data to online storage devices makes us vulnerable to surveillance and fraud, and the damage we are doing to ecology is about to bite us at any minute. On top of all this, our everyday activities and interactions; networks of friends and professional connections; mundane acts of shopping, reading, listening to music, or paying the bills; and, indeed, our memory itself—photographs and correspondence—have almost completely moved online, completing the process of dematerialization that Brown talks about. In the words of archaeologist Colin Renfrew, "Physical, palpable material reality is disappearing, leaving nothing but the smile on the face of the Cheshire Cat" (quoted in Brown, *Other Things* 12).

For many people digital embodiments of the material world have become part of their everyday existence. In fact, in an average day some of us might interact more with digital versions of our world than with the material world itself. We are several degrees removed from reality, overwhelmingly connecting to it through somebody else's perspective that is digitally mediated. Instead of experiencing the thing itself, we are often content with its digital replica, a copy of a copy, endlessly detached from the original. What is remarkable is the ability of digital representations to engage human imagination with a promise of the greatness of the "real thing" behind its representation. The real thing often fades in comparison, failing to deliver on the digital promise. If you have never been to Paris, for example, you are as good as if you have, given the proliferation of images of Parisian streets that one comes across almost daily on social media, in advertising, movies, and so on. Chances are that your imagined Paris might be more enchanting to you than the real city, which, as all reality does, has more contradictory features, including some that can be a source of disappointment.

Writing a century ago, Walter Benjamin was concerned with loss of the authentic experience that he saw happening because of mechanical

reproducibility of works of art. In what probably is his most often cited essay, "The Work of Art in the Age of Mechanical Reproduction," Benjamin lamented the loss of significance of the art object when faced with a possibility to multiply its copies:

> The presence of the original is the prerequisite to the concept of authenticity . . . The whole sphere of authenticity is outside technical—and, of course, not only technical—reproducibility . . . In the case of the art object, a most sensitive nucleus—namely, its authenticity—is interfered with whereas no natural object is vulnerable on that score. The authenticity of a thing is the essence of all that is transmissible from its beginning, ranging from its substantive duration to its testimony to the history which it has experienced. Since the historical testimony rests on the authenticity, the former, too, is jeopardized by reproduction when substantive duration ceases to matter. And what is really jeopardized when the historical testimony is affected is the authority of the object. (220)

Writing well in advance of the digital era, Benjamin was critical of representation, which he predominantly discussed in relation to visual art. What he described as the decay of aura of an art object in the age of mechanical reproduction—loss of the elusive essential quality that an original art object possesses—has been seemingly exacerbated by the modern condition of digital isolation. Now more than ever before, we sacrifice essence of an object to the appearance of its likeness, the original to its image, living in the mediated world that shelters us from experience.

In 1991, an American critic and digital artist Douglas Davis wrote, partially in response to Benjamin, his seminal essay "The Work of Art in the Age of Digital Reproduction." In this early enthusiastic response to the dawning of the Internet era, Davis proclaims that the concept of *aura* so treasured by Benjamin did not disappear, but "has stretched far beyond the boundaries of Benjamin's prophecy into the rich realm of reproduction itself. Here in this realm, often mislabeled 'virtual' (it is actually a *realer* reality, or RR), both originality and traditional truth [. . .] are being enhanced, not betrayed" (381). With a bow to the twentieth century disregard of authenticity, evident, for example, in the Pop Art movement, Davis shares his belief in the ability of digital spaces to create an unprecedented feeling of what is real, redefining what authenticity might mean: not the elusive "original" object, but perceived originality recreated anew in potentially endless instances. Digital reproduction, he believes, did not do away with aura; aura persists, and "must now be further transformed, simply to survive the technical assault brought on by the digital age. But transformed

into what?" Davis invites us to consider. "Dematerialized idea? Symbol? Presence?" (384).

His question, in fact, can be extended to the status of digital objects per se, the elusive digital thing that we encounter on the Internet and in our smartphones and laptops. How do we understand digital objects' relationship to the material world? The answer to this question might give a clue about our relationship to the digital, whether we employ completely different mechanisms in our engagement with it, and how it might impact our identities and experiences. Does the digital, indeed, equal a dematerialized idea, the opposite of the material object?

To start with, the way digital environments are structured cannot escape the blueprint of the physical world. The Internet mimics a giant library, or a depository of artifacts and data, a boundless collection that finds itself in the liminal space between order and chaos. We speak of digital archives, collections, and exhibitions; "files" on our computers are kept in "folders" and arranged in "catalogues," etc. etc. The drive to recreate the physical world in a digital manifestation is evident in the smallest details, such as the rustle of paper being discarded into the "trash can" on a computer's "desktop." With the advancement of technology, such as the introduction of high-resolution screens that made images significantly more "life-like," the digital simulacrum of the material world has been infinitely approaching the original.

The opposite of the material and the concrete is an abstraction, an idea or a concept without any material manifestation. Strictly speaking, digital objects are different from pure abstractions almost as much as from material objects: they do have some palpable manifestation that can be felt through human senses. Mainly sight and hearing are employed, but, depending on the complexity of virtual realities created by new media, some digital artifacts are capable of creating a multichannel effect of presence. In their capability to affect the body through its senses, digital artifacts approach what might be called relational materialism. Our relationship with the digital world, therefore, is marked by a tension between embodiment and disembodiment: the asymmetrical affect on the senses that creates fragmentation of experience. The potential of new media art forms to engage multiple sensory channels creates an unprecedented illusion of embodiment; yet it is almost inevitably undermined by the fragmentation and alienation conditioned by digital spaces.

Figure 59: The WEEE Man (designed by Paul Bonomini) is a sculpture in Cornwall, England made from electrical and electronic waste such as washing machines, TVs, microwaves, vacuum cleaners, and mobile phones. He represents the amount of waste electrical and electronic equipment (WEEE) the average British person throws away in their lifetime—over 3 tons per person. (Photo by The Waste Electrical and Electronic Equipment Directive / Free Art License (FAL), via Wikimedia Commons)

By creating digital environments that are meant to connect with and impact the body, we de facto acknowledge the primacy of the physical object capable, without any enhancement, to directly affect the senses. Experiments in virtual reality—what Davis claims is a "realer" reality—not only aim to achieve a perfect likeness to the real world, but also to connect to the body to a greater extent than things ever do. Where physical objects remain impassionate and aloof, digital objects readily offer malleability subservient to human needs, be that entertainment, fascination, or convenience. According to Davis, "[the] most provocative extension" of the work of art in the digital age (and of the digital object generally) "is into the intimate bowels of our body, mind, and spirit" (381). The digital steadily aspires to achieve a greater blend between the material and the abstract: virtual reality game machines require the help of hardware to connect to a human body and stimulate the sensory channels necessary to transport the player to a

virtual world; digital data is stored in physical objects (hard drives, smartphones, servers); multiple digital devices are devoted exclusively to keeping track of the body's functions and turn data about one's personal health or athletic performance into graphs and tables (a phenomenon that is referred to as Quantified Self, a term coined by Kevin Kelly, author of *What Technology Wants*). Digital codes and software are essentially engaged in the engendering of matter, to borrow Erin Manning's concept of *engendering* from her book *Politics of Touch*. "To engender," Manning explains, "is to potentialize matter. Engendering involves potentiality at its most fertile: it calls forth the link between the incorporeal and the material, between the virtual and the actual" (90).

Examples of such engendering can be advanced virtual reality simulation in medical or military contexts, or, on a less specific level, digital tools that allow visualization of data to "translate" something that would otherwise be too enormous for us to perceive as discernible, palpable substance. In their work of engendering matter, digital objects allow the user the ability to willfully manipulate matter: fashion it according to one's taste, delete it without a trace, or bend the limitations of space and distance. Exactly this kind of manipulation, as we have seen, might be the most impossible endeavor when it concerns physical objects. A digital artifact, then, aspires to be a superthing of sorts, a blend of a thing with subjectivity, while the Internet is first and foremost a human dream of things, a love song to materiality in all its unreachable glory. Ironically, emergence of the digital might be a testament to human admiration of things, accompanied by the frustration of being unable to insert human subjectivity in their center: a desire to control matter unconditionally. The epitome of the function of the digital to assert control over things might be what we now call The Internet of Things, a global network of devices linked to the Internet, from coffee makers, to cars, to healthcare support and security systems.

However, success of such endeavors to gain control of the digital mind over matter is not a given. The more complex digital systems become—and the more reliant we as a society become on them—the more we expose ourselves, through our blended co-existence with the digital environments, to erroneous or outright hostile uses of the digital. Computer viruses and malware, state surveillance through access to personal data and social networks, online identity theft, and hacker attacks capable of undermining whole economic and social infrastructures are just some examples of vulnerability caused by overreliance on digital systems.

Figure 60: Shredded bits of the UK's National Identity Register database. (Photo by ukhomeoffice (Flickr: Shredded bits of the database) / CC BY 2.0, via Wikimedia Commons)

Global security issues aside, though, other implications of digital materiality are important to address. Such a rapid and nearly all-encompassing paradigm shift towards the digital requires that we ask ourselves important questions: how does the digital impact the way we assign value to things; how is it affecting our ability for sustained emotional investment in our environment; and how do our notions of time and space change when engaging with digital instead of material objects? Our relationship with our digital devices like smartphones or laptops often dominate our time throughout the day, but is this relationship the same as one formed with objects or things? Digital archives have been a boon to archivists in all fields, and our own personal digital collections (Facebook, Instagram, YouTube, etc.) offer never-before imagined possibilities for the preservation of memories. But can our digital traces be thought of in the same terms as our physical traces? And what happens to memory invested in digital artifacts?

Are the mechanisms of memory formation and preservation in digital environments different from those at play when we engage with physical objects? If we understand memory as a two-way exchange between human subjectivity and the object of memory, then it makes sense to suggest that as one of these elements—the material object—is replaced by a digital object, consequences for memory formation and preservation reflect this change. The crucial conduit in this exchange between mind and matter is the body: the embodied, relational nature of memory ensures formation of recollections through the affect that objects have on our bodies, the imprint that they leave through employing the sensory channels of perception. Even though we must admit that digital does not equal immaterial, digital materiality is fundamentally different from physical matter; therefore, the responses and affects produced on the body by a digital object would also necessarily differ. We do not perceive a digital photograph through the same sensory channels that we do an analogue photo, for example; it would shape and influence our bodily reaction to a lesser extent than a physical photo that you not only see, but touch and smell. A material object's hold on memory is potentially much stronger due to the more direct and multichannel imprint it has on the body.

The ontological status of the object, how we perceive its status and significance for memory—not only personal, but cultural and collective memory as well—must also be reconsidered. Do we assign the same value to digital records and online records of one's social interactions when choosing what information to archive and, consequently, monumentalize in public memory? If Elvis Presley lived in the digital age, would Graceland have a "digital wing"? This question is not all that hypothetical as it might seem: right now, archivists around the world are trying to come to a consensus about the status of online artifacts in memory preservation. An article by Sonia Weiser published on July 5, 2016, in *The Atlantic* and titled "Should Prince's Tweets Be in a Museum?" ponders the pros and cons of archiving online user interactions. Prince's Twitter account that is still followed by thousands of the artist's fans will eventually be scheduled for deletion, and when this happens, Weiser explains, "it won't just be the words of the 740 tweets Prince posted that get lost, but traces of his social-media behavior and routine. Any record of communications he sent or received will vanish. Deleting a known figure's—or anyone's account—erases an extension of themselves, part of what makes up their online footprint." Do tweets, Facebook posts, and emails have the same weight as paper letters and notes that are often carefully collected and archived?

A poem shared with *The Afterlife of Discarded Objects* by Karen Bernardo from Vestal, NY, describes the author's experience of keeping the phone

that used to belong to her son who passed away. Bernardo speaks about her indecision to through the phone away, as it contains "every proof that [he] graced this earth:"

> It sits on the kitchen counter, with its charger,
> next to the toaster. I charged it once
> since you died, and found a video
> of a sixth-grade concert at the mall,
> a bunch of ridiculous selfies,
> some apps I can't identify,
> and an entire Star Wars movie.
> I put it back and now it's lost its charge.

Bernardo's indecision to get rid of the phone reflects the digital object's unclear ontological status and value for memory preservation. The actual physical body of the phone, which, of course, has a direct material presence, is too technological and impersonal to be able to serve as an embodiment of memory, yet it performs the mnemonic function metonymically, insofar as it has been in touch with the remembered person: "The more I touch it, / the more my fingerprints obscure yours, / the more my lived life obscures yours," Bernardo writes. The digital artifacts stored on the phone, on the other hand, are more personal, and potentially contain more information about the remembered person, but their indirect, digital materiality is not immediate and palpable. If the phone is not charged, for example, the digital artifacts are as good as nonexistent, and they clearly do not provide enough substance for memory. Similar to Prince's tweets, the selfies and videos from the orphaned phone are digital traces of a person's life that inhabit a liminal space in the workings of memory.

In addition to diminished affective qualities of digital memory objects and their questionable ontological status in the process of memory formation, digital artifacts' stability is a matter of special concern. Digital things, fashioned after material objects, are similarly vulnerable to impermanence and annihilation. Even though digital data is not subject to decomposition for the same reasons that ensure its reproducibility without loss of quality, digital erasure of information is a real danger. Web resources can become permanently unavailable, leading to the phenomenon of link rot; files on computers can be deleted either by accident or as a result of virus activity; web pages and whole websites often become incompatible with the newer software; finally, political and ideological forces can any moment ban access to information that one previously considered available. Moreover, access to the digital information is dependent on the access to the Internet: anyone familiar with the logistics of international traveling, for

example, knows that it might be difficult or at the very least costly to maintain access to one's records on the Cloud at all times when changing places. In short, both the perceived accessibility of digital artifacts and their lending themselves to our possession are illusory, conditioned by many factors outside of our reach.

Memory invested in digital objects, therefore, is extremely vulnerable to erasure, even more so, one can argue, than memory we invest in analogue objects. While material things are prone to decay, the process of decaying is slow and in itself reflects the passing of time, igniting the nostalgic feeling that often accompanies memory. Digital objects, on the other hand, do not carry signs of the passing time: they either exist or disappear due to link rot and for multiple other reasons. A month after the article about Prince's tweets was published, his Online Museum is no longer accessible; the visitors see a message that explains that it will be offline until an agreement will be reached "on how best to preserve his legacy." Long-term preservation of digital records requires a sustained commitment. Moreover, the authenticity of digital artifacts, as we have seen, is a problematic notion: digital objects are easy to falsify, images can be photo shopped, and the alteration of records is very difficult to trace. Malleability of digital assets results in increased plasticity of memory, making it especially prone to falsification and ideology.

While the Internet can be easily seen as a global dump of ideas where information gets recycled, lost, discarded, and rediscovered, presenting new, often paradoxical, affordances and meanings, the digital object does not allow for perception of passing time. Without the felt presence of material objects, and subsequently, without the sense of impending decay that attends our physical world, a radical change in perspective of the world and our own mortality has taken place. In assessing both the positive implications and the limitations of digital embodiments, we come to the conclusion that the digital necessitates nostalgia for the material and a critical reassessment of our engagement with both people and things.

10 A Guided Tour Through the Museum of Imminent Catastrophe

Andrei

> "The violation of the inner person is the greatest territorial crime of all."
>
> —George Orwell, *Keep the Aspidistra Flying*

We began *The Afterlife of Discarded Objects*—both the digital storytelling project and its print counterpart—with a belief in the power of individual narratives to shape personal identities and broader collective consciousness. We hold firm to that belief, and, if anything, we argue that it is now more imperative than ever that we recognize the cultural value of ordinary stories about ordinary objects, lives, and experiences. We also hold firm to the value of material objects themselves as conduits for memory and for the preservation of our sense of what it means to be human.

More than a quarter century ago, Sven Birkerts warned us of the perils of *language erosion* and the *flattening of historical perspectives*, but the one aspect of contemporary life that pains him the most is the *waning of the private self*. Specifically, what worries Birkerts is that in a world where we are constantly connected and always plugged in to the virtual life—an unreal reality—our memories (and therefore our sense of who we are) as well as our sense of the past itself is becoming unhoused, unmoored, and disembodied. Birkerts's words bear repeating here, as he admits to "a great feeling of loss and fear about what habitations will exist for self and soul in the future." The word he chooses, "habitations," is reminiscent of Heidegger's "dwellings," in other words physical spaces that both function as and contain the instruments of memory. A virtual world, both would argue, fails to provide adequate space for the private self to inhabit and save itself from oblivion. While memory has always been fallible and at best an imprecise science, the material object's impermanence and decay keeps us grounded in experiential moments by facilitating an encounter with reality; on the other hand, digital memory's promise of perfection and perpetuity is by design an illusion, a promise of control that paradoxically requires that we surrender control to something even less perceptible than a cloud of smoke.

But certainly, some would contend, digital technologies do present us with ways to preserve in ways never before imaginable. And for argument's sake, if anything is able to thwart our built-in death drive it is the Internet where nothing ever truly dies (lives on always in some version of it-

self in the ethereal cloud). On the Internet, even the dead do not disappear entirely, an example being the many still-active social media accounts of the recently deceased (in fact an entire industry of firms has sprung up around the promise of keeping one's online presence "alive" after their death). For champions of preservation through digital technologies this is proof of the medium's superiority over the material—the truth is that somewhere out there the digital footprints and detritus of our online presence survives with and without our knowledge (that much Wikileaks, data dumps, and Edward Snowden's NSA papers have made abundantly clear). Yet, the implied peace of mind that comes with the promise of a digital afterlife—of the self and all of our stuff—does not come with a certain sense of unease that manifests itself in acts of cleansing and purging, not unlike moments when we take stock of our possessions and choose what stays and what goes to the dump. But the catharsis we get from discarding digital things, the mimicry of putting files and folders in the trash and then emptying it, is merely symbolic. We seem to want to erase, unfriend, unfollow, eradicate online traces, and clean our digital history, but something that never truly existed in the first place—from the point of view of materiality—does not give us that satisfaction because it was never within our possession. Purging files from your laptop or desktop leaves the device physically intact, as if nothing had changed, whereas tossing away a single jar alters its surroundings. The divide that exists between digital acts and material acts is a sense of discord, a dissonance between what *is happening* and what *appears to be happening*, putting in doubt our sovereignty when it comes to collecting and curating an individual, private identity. Again, this (difficult to acknowledge) lack of control over how we manage our online presence affects, even if only unconsciously at first, our attitudes toward the trust we place in something intangible when it comes to preserving the things we hold dear in our lives.

Ashley Shew, Assistant Professor at Virginia Tech, in her essay "To the Cloud! Loss in the Age of Digital Memory" likens digital embodiments to Plato's forms. Whereas the forms are real reality, "material objects [that] are corruptible and finite," their digital counterparts are "the perfect versions [that] merely cast the shadows that are our material things. All chairs are only cheap imitations of the perfect form of chair that exists in the Realm of the Forms." These cheap imitations are easily accessible, and they promise much; they tantalize with the impression of new and better, but ultimately fall short of assuring us that this is all that, from now on, we will need to bank our memories:

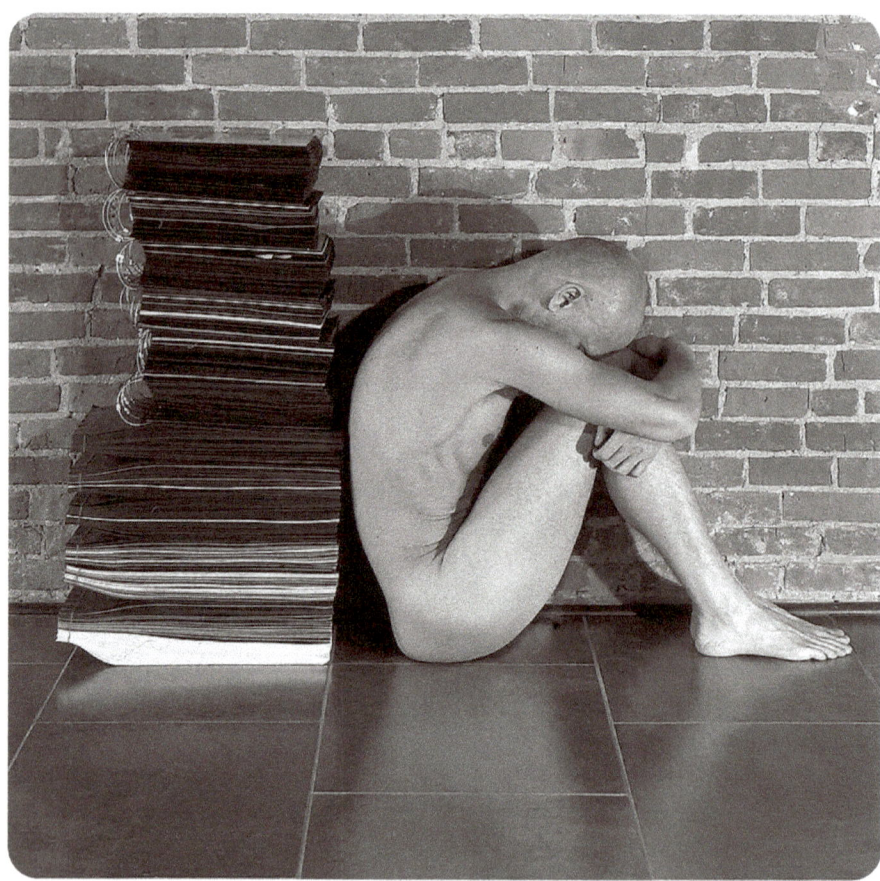

Figure 61: Artist Brent Williamson with a year's worth of hand-sewn journals of written recollections and collected ephemera, 2015, Binghamton, NY. (Photo by Brent Williamson)

The illusion that digital things offer us is that they can be more perfect than the material from which they are derived. Digital memories suggest the lie that memory can replicate experience more perfectly and more durably than that which materiality can provide. Digital memories also let us make moments more perfect by editing video to capture that which we like, and to take out things we don't. We can crop and chop and choose which pictures to keep; we can make remembrances more close to the form of life that we idealize.

When we experience loss of digital memories, the sting is twofold: one for the loss of the digital thing, the other for the loss of the idealization we created. The era of digital memory offers the illusion

that we can have control over our things, over ourselves, but our control still relies on the material. (Shew)

Lest Shew be criticized here for a certain maudlin view of materiality, interviews conducted by William Odom, Abigail Sellen, Richard Harper, and Eno Thereska for the research project titled "Lost in Translation: Understanding the Possession of Digital Things in the Cloud," reveal that many people are ill at ease with the promise of an entirely digital life. In the introduction they write that, "The standard view [. . .] is that, with 'the Cloud,' people will be able to keep their digital assets more securely and, potentially, more cheaply. By moving away from local storage, users can be sure that when their devices crash or get stolen, or when they suffer from the myriad other mishaps of daily life, their data will be safe. There is no doubt that such concerns do motivate people to move the data they care about online." But, as one of the thirteen participating interviewees reveals, ". . . the more I talk about it, the idea of owning something digital seems lost in translation." Our digital things—the thousands of photographs, notes, pictures, songs, videos, and emails—require digital storage spaces, all of which come with a litany of industry lingo for "safe": password protected, encryption, data recovery, backup, etc. Digital storage and retrieval services advertise and tantalize with the promise Shew discussed, and appeal to our inherent desire to collect traces of our lives and the lives of others, and to share them if and when we wish to do so.

But something about the means by which we organize and save all of our "digital stuff" is enough to cause concern among even those who've adopted such practice and want to believe in its potential. One interviewee in Odom et al.'s project reflects on her Facebook content, saying that, "I have this fear that all of a sudden it's going to get shutdown and they're going to wipe [it] and I won't be able to get it back. So it doesn't feel like I'm fully possessing it, I mean I feel like it's my information . . . but it's like I'm not in charge of it fully. Like it's at the mercy of someone else." *They* and the vague *someone else* here suggests an entity or entities outside of the self, mechanisms that although direct and control one's actions are not entirely within the individual's reach. Another interviewee commented on transferring her father's digital photos and documents from his computer to the Cloud, saying that, "I felt like I needed to protect it . . . [put] it in a special place. . . . I did think about putting it online, but it didn't feel right. . . . It probably wouldn't [disappear], but who knows? . . . What if it was accidentally erased? . . . Those are chances I can't take." The interviewers posed this particular respondent with the possibility that even a personal computer might crash and everything could be lost, to which she responded: "I know

my computer could die, but at least it would be on me. . . . it's my responsibility to take care of it. Leaving it up to a website, there's no guarantee it's going to stay around. I can't live with that." Yet, another participant revealed similar hesitation about preserving a deceased friend's photos via DropBox: "My first thought was to put them on DropBox, like if my computer dies, they'll be somewhere else. Then this whole thing came out [about] nothing on DropBox being safe and heaps of people's accounts weren't as private as they thought. . . . I had this wretched feeling, like I was being lazy about him. . . . I took them down immediately. . . . They're backed up on my [computer] hard drive and on a CD. I'm more in command of their destiny." Noteworthy in this response is that while the individual is still reliant on technology for preservation, he has chosen for peace of mind a material, tangible unit of storage. Overall, what these participants in the study have in common in their responses is the fear of a lack of control, that a solely digital means of preservation offers little solace in the face of the unknown.

Aside from questions of powerlessness, the reluctance to "go all in" when it comes to digital storage might be partially attributed to the fact that virtuality is unable at the present time to give objects/events/moments the same kind of emotional resonance as their physical counterparts. The fact that we know physical objects can age, change over time along with us, and even disappear or be destroyed, endows them with a certain aura that is missing from an iCloud, DropBox, or Google Docs folder. Personally, I don't seem to care as much if my library of photos were to meet its digital death than if my family photo album perished in a fire, and the fact that I can't put my finger on the reason doesn't make it any less so. I also look differently upon photographs from childhood that have yellowed and worn at the edges compared to images on my iPhone, no matter how old they might be. I know that I'm not alone, though the psychological rationale might differ among individuals. What it comes down to in the end is that a digital *presence* lacks all of the hallmarks of a material *existence* with distinct spatial and temporal dimensions that forms an identity apart from any other (even when an object is itself a copy of an original, as many of our material possessions tend to be), and which subsequently acts in both predictable and unforeseen ways upon our own identities.

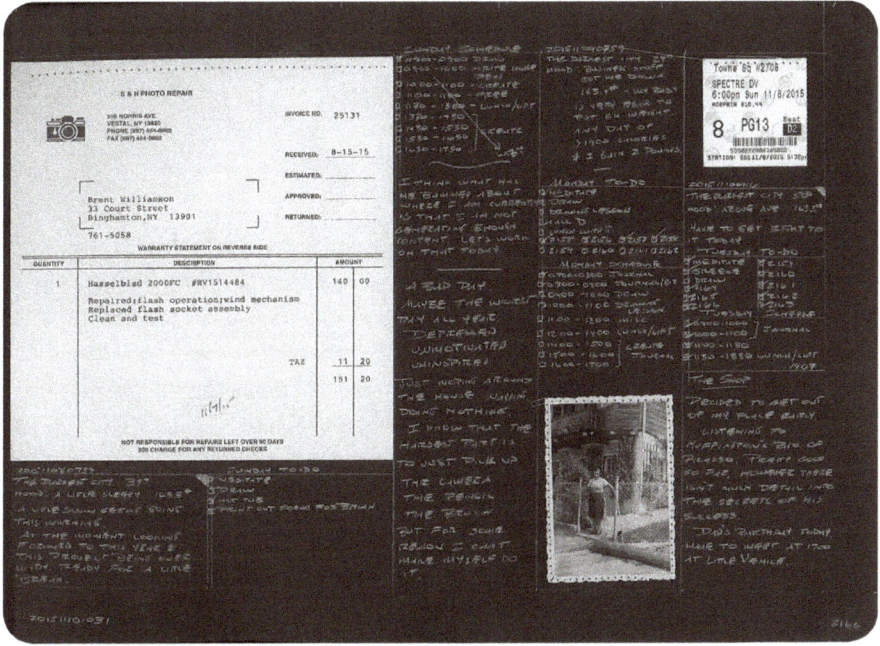

Figure 62: Receipts and photograph sewn on a page from the 2015 journals of artist Brent Williamson, Binghamton, NY. (Photo by Brent Williamson)

As part of their research project, Odom et al. provided a review of relevant literature, focusing on the fields of anthropology and sociology, where the topic of materiality has been especially of interest within the past decade or so. In the area of anthropology, Odom et al. cite the work of Daniel Miller who "[i]nstead of seeing identity as merely a product of social structure, [. . .] shows that identity is partly made in the assemblies of artifacts constitutive of homes in which people live, as well as in their material practices elsewhere (e.g., at work). His study of material displays within homes in South London is a case in point. Here, he argues that 'who you are' is writ large in the things that one possesses and one chooses not to possess; materiality speaks volumes in what it is made up of and what it does not contain."

While accumulations of things, Miller's "assemblies of artifacts," shape and direct our relationship to space, they also constitute forces that determine "who [we] are." As the artifacts change, so do memories and so does our sense of who we are in any given moment in time. We are not static because the material nature of our memories is similarly in flux, subject to the ebb and flow of many objects whose *being* very much parallels our own. Memories therefore forged via such connection are always in the process

of *becoming*—in other words physical/material space is a space of genuine growth; on the other hand virtual space is essentially a space of insecurity, erasure, and *unbecoming*. It is, as Birkerts intuited, not a welcome habitat for the self, much less for the soul.

Not only is the virtual world inherently inhospitable to the self, it is a space where a certain kind of existential violence against the individual is performed on a daily basis. It's no accident that Birkerts used powerful terms such as *erosion*, *flattening*, and *waning* to refer to what he was seeing at the dawn of the virtual millennium. The institutionalized encouragement, incentivizing, and near coercion to shift from an object-oriented existence to a virtual one amounts to nothing less than violence, an erasure and destruction of the private self.

In "Fateful Attachments: On Collecting, Fidelity, and Lao She," which appears in Bill Brown's anthology *Things*, Rey Chow lays out the fight the individual is forced to carry on in the face of authority. What Chow refers to specifically as moments when the self clashes with state mechanisms and cultural ideology (China and the Cultural Revolution) accurately reflects the individual struggle for relevance in a world where virtuality places things increasingly out of his immediate control. Chow quotes Slavoj Žižek from his essay "I," when he writes that, "the point of Marx is that the commodity universe provides the necessary fetishistic supplements to the 'official' spirituality" (377). Chow continues: "Rather than being the moral opposite of the altruistic ideal of class struggle, the loyalty to things—what Žižek calls false idolatry—stands in fact as class struggle's 'fetishistic supplement,' a supplement that rivals the 'official spirituality' of the Cultural Revolution in its demand for the love of the people. The danger posed by this rival 'spirituality,' which is equally if not more capable of exerting a magical hold on the people, is conjured in the perverse collecting behavior" of minor, ordinary individuals (377). Certainly, one would be remiss to claim that the Cultural Revolution is the same as the digital revolution, but from the standpoint of an "official doctrine" the struggle is strikingly similar. We discussed earlier the ways that capitalism has a way of bringing outliers back into the fold, and the same could be argued here for the digital world; for example, breaking the rules that govern social media behavior is tantamount to ensuring cultural exile—what does not fit the mold is either destroyed or reconfigured so as to no longer pose a viable challenge. "This, ultimately, is the reason it is imperative, in the process of class struggle, to put on exaggerated performances of the destruction of things," writes Chow. "The excessive, ritualistic nature of the burning of books and arti-

facts is tantamount to a form of exorcism, the point of which is not simply to dispense with objects but to combat—to tame by mimicry—a competing *illusion* in full potency. Nothing short of a deliberate display of violence, repeated at regular intervals for all to see, is deemed sufficient to ward off this competitor's fierce power." Chow refers to the threat of objects in general in his claims, but we could also argue that discarded objects, trash/waste are that much more of a danger to authority and hegemonic power because they stand outside the flow of accepted and officially sanctioned behavior. By claiming their persistent and resistant materiality they reveal the weakness of the state to dictate all facets of life.

Odom et al. also account for the relationship between materiality and power as they review the work of Elizabeth Shove, Matthew Watson, Martin Hand, and Jack Ingram in *The Design of Everyday Life*. According to Odom et al., Shove argues that, "possession is not only something that can apply to a thing but to spaces, practices, and of course, power. From this view, materiality and possession cannot be examined through the limited lens of the persons being studied, through their own subjectivity, but only through theoretical elaboration: key to this is an analysis of the reflexive ways power is manifest in material practices." Because materiality embodies a sense of power and control, digital erasure is by extension a ritualized attack on the agency afforded to ordinary people through the possession of *things*. If they can be destroyed and replaced with *unthings* or digital surrogates, then not only are the objects tamed but so is the individual, brought under the heel of dominant ideology. "For the party, in other words, things are not realities in themselves but rather symbols," argues Chow. "[T]o destroy them is to destroy the evil idea, ideology, tradition, history behind them; the condemnation of the material is in the end still part of an idealist battle" (377). The existence of a *they* and *someone else* invoked by the participant in Odom et al.'s study no longer seems to indicate a vague sense of foreboding, but instead appears to be a genuine entity that usurps control over material existence—the very sources of tradition and history.

<center>* * *</center>

The profundity of Chow's observation is that official State archives, monuments, and ritualized displays and celebrations are revealed to be nothing less than an ongoing effort to promote and reinforce structures of authority within real space. This is done while limiting the display of similar efforts by the individual, rendering an effective challenge against established power structures that much more difficult to achieve (Baudrillard 191). Ironically, as it works toward its own self-preservation, the State finds itself in the position of condemning and vilifying the very material objects it promotes

through a two-faced ideology—express your individuality by consuming things, but do not become a slave to things. Using advertising as an example, Baudrillard calls it a "two-sided agency": "When advertising tells you, in effect, that 'society adapts itself totally to you, so integrate yourself totally into society,' the reciprocity thus invoked is obviously fake: what adapts to you is an imaginary agency, whereas you are asked in exchange to adapt to an agency that is distinctly real" (191). It is important therefore for the State to retain a monopoly on this real agency while limiting the individual to what Baudrillard would call an "image" or illusion of agency, what Odom et al., claim is revealed when we critically question the meaning of digital things. Consequently, even while the State or the current ideology-in-vogue subsumes and effectively voids the effects of individual preservation of tradition and history (of memory and of a sense of self), it nonetheless recognizes and accepts the necessity of carrying on behind the scenes its own defense against digital oblivion by reinforcing real agency through very real, material structures.

This is as much a well organized and orchestrated effort as it is a reflex of survival. While the former is explained in part by Derrida's ideas on archive fever—"[T]here is no political power without control of the archive, if not memory"—the latter might be thought of as a genuine response in the face of *imminent catastrophe*, a term introduced previously as emblematic of our contemporary condition (11). While it is not necessarily new to the twenty-first century (Cold War rhetoric threatened wholesale destruction on a daily basis), a faster and more connected digital world means that more of us are aware of and consciously think about our impending doom. Whatever the cause—global warming, international and domestic terrorism, nuclear war, etc.—we live today with the knowledge (and unfortunately the proof) that *it could happen*. For the State (and here I include large financial and cultural institutions and corporations), whose existence is dependent on a tight grip on power and control, plans for how to survive imminent catastrophe are an essential component of their operations. While threats have certainly changed over the years, what hasn't changed much is the means of survival and preservation, and when it comes to what truly matters they are distinctly not in the Cloud.

A Guided Tour Through the Museum of Imminent Catastrophe

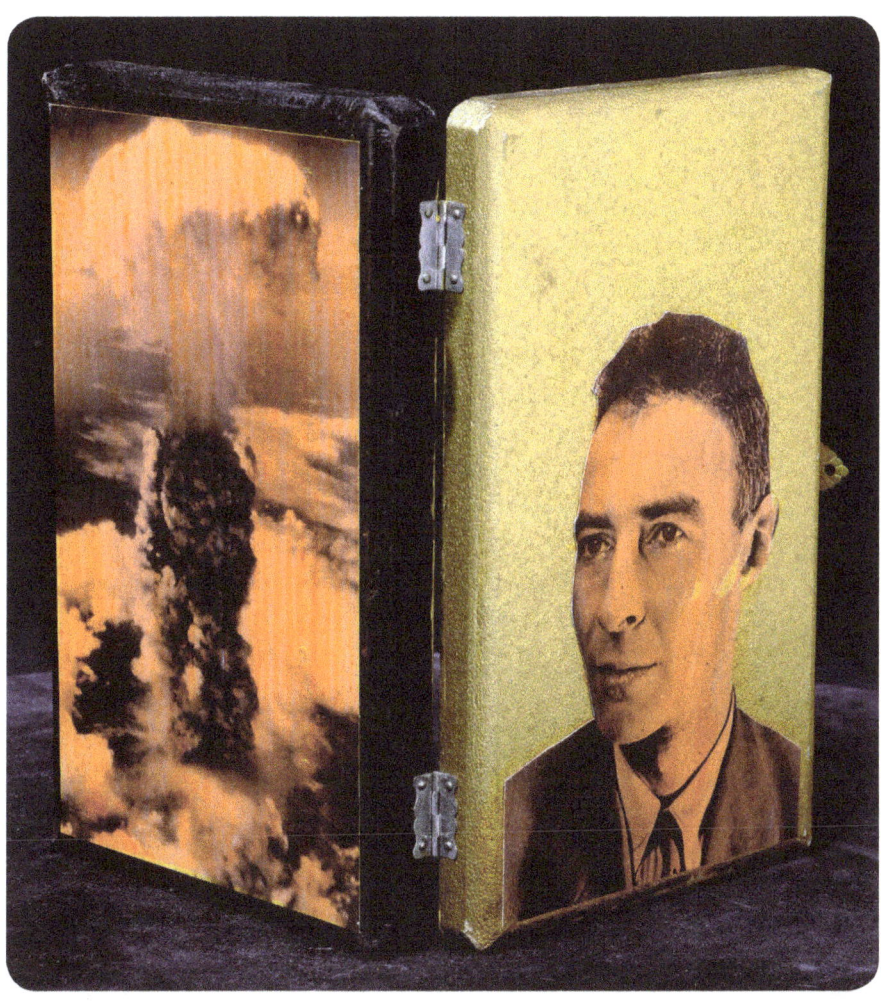

Figure 63: *Oppenheimer Portrait*: Mixed media assemblage. Outside: found jewelry case, gold paint, photo of Oppenheimer and atomic bomb, shellac. (Assemblage © 2012 by Christopher Hynes. Photographed by Eric Beggs. Used by permission.)

The Afterlife of Discarded Objects

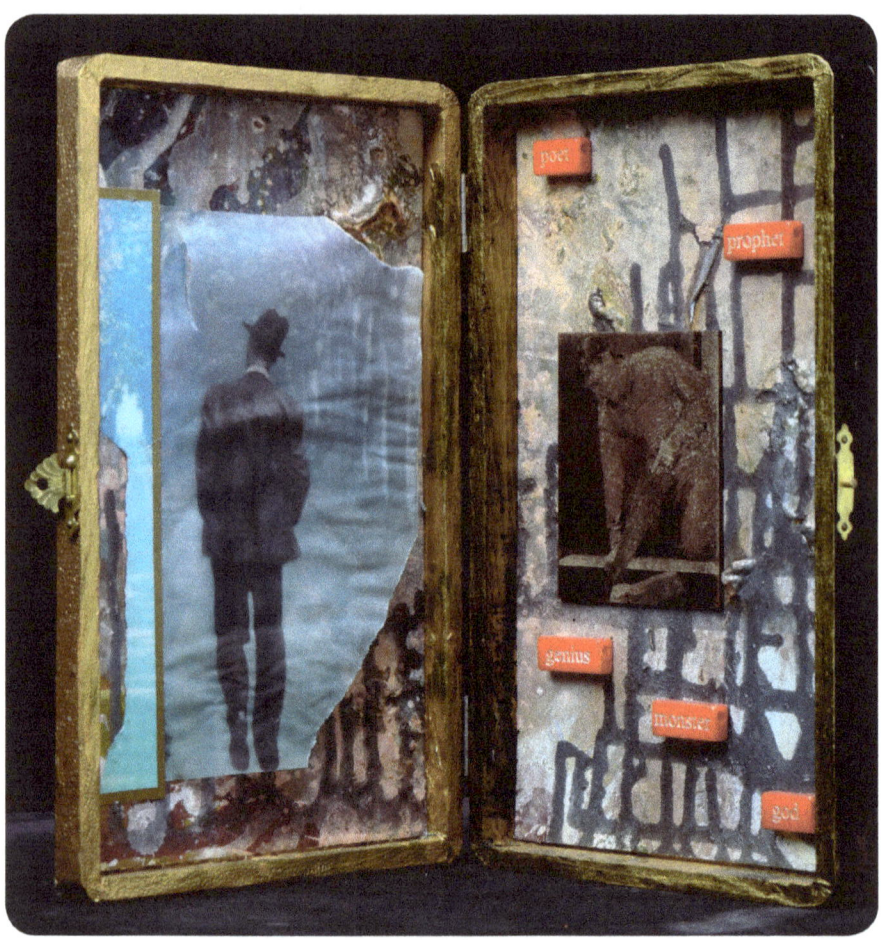

Figure 64: *Oppenheimer Portrait*: Mixed media assemblage. Inside: found jewelry case, hand painted copper plate, photo on glassine, enamel on paper, broken word charm. (Assemblage © 2012 by Christopher Hynes. Photographed by Eric Beggs. Used by permission.)

In "Bomb-proofing the Digital Image: An Archaeology of Media Preservation Infrastructure," Brian Michael Murphy literally goes underground to reveal one place among many in the US and around the world where the survival of some of the most important artifacts of our civilization is ensured. Murphy visits the Corbis Film Preservation Facility (CFPF) deep inside a former limestone mine for US Steel in Boyers, Pennsylvania, which in the 1950s "was converted into a secure, bombproof records storage center by National Underground Storage." The CFPF today "houses tens of millions of paper photographs, film negatives, glass plate negatives, histor-

ical newspapers, and other media in a refrigerated vault, located 220 feet underground." The CFPF, Murphy reveals, is just "one of many vaults within the larger Iron Mountain secure records and data storage" network, comprised of more than one thousand locations that are part of an even larger media preservation infrastructure whose services are ostensibly off limits to most individuals (you can visit, as Murphy did, but you need to get permission). Alongside the CFPF, you will also find "vaults containing Warner Brothers classics, the backup archive of everything HBO has produced, all of Stephen Spielberg's interviews with Holocaust survivors, the records of the U. S. Patent Office," and much more.

Murphy's overall assessment after spending several days exploring the underground facility is this:

> The reliable transmission of digitized imagery relies not only upon fiber-optic cables, servers, and wireless transmitters, but also the stone caverns and reinforced steel-and-concrete vaults in which those networks of hardware are embedded and secured. Thus, the CFPF, and similar facilities, reveal the way in which digital images are emphatically material. This materiality is comprised of hard drives and other recently developed information technologies, and the ruins, remnants, and residual architectures of previous modes of resource extraction, production, and national security regimes that continue to shape media preservation practice today.

What is clear and remains in common between the days of Cold War nuclear disaster hysteria and today's fears of catastrophe is the reliance—to the point of ensuring the survival of civilization—on materiality. Therefore, the larger implication made by Murphy, and the tacit admission of the State and corporate apparatus, is that digital embodiments and their subsequent storage alone is simply not good enough, or at least not as reliable as preserving its material counterpart as well.

But what is even more important than the material nature of digital preservation is what entities such as Iron Mountain tell us about the value of ordinary things and ordinary lives. Iron Mountain, Inc., founded by Herman Knaust and originally called Iron Mountain Atomic Storage Corporation (IMASC), was at first located in upstate New York in the Catskills Mountains and designed to hold "vital records and microfilm duplicates for banks, insurance companies, and other corporations, and also included underground living facilities for executives or large companies like Standard Oil" (Murphy). The facility was supposedly not only bombproof but specifically atomic-bomb-proof—it was located underground, had a reinforced steel and concrete construction and fireproof vaults. Iron Mountain

today, it should be mentioned, has a security rating of 4, a step below the White House and the Pentagon, rated at 5. During the Cold War its function was arguably inseparable from that of the State, serving the needs of corporations who wanted "to preserve their vital records in impervious spaces of preservation to ensure their business continuity—the reconstruction of their business history, the rebuilding of their facilities and equipment, and the resumption of production as soon as possible after nuclear attack." Needless to say, little in Murphy's description of the IMASC assures us that preservation of individual lives, artifacts, and histories was its primary concern.

* * *

When faced with imminent catastrophe, the firmness of a mountain along with steel and concrete containers are known, reliable quantities—they remind us of place, of familiar architectures where we feel safe and secure, where we might live. But we as individuals certainly do not feature on the same scale as multi-billion-dollar corporations, and our things might not matter to civilization as much as the final wills of notables such as Princess Diane, Charles Dickens, or Charles Darwin; or Frank Sinatra's recordings, or the 1959 patent for the red delicious apple (all stored by Iron Mountain). Like it or not, the CFPF will not be digitizing and storing in a climate-controlled bunker copies of your refrigerator art that mother has painstakingly saved and carried with each move. But our things do matter to us, they are integral to our lives, and that should be a good enough reason to find ways to hold on to even the most tattered embroidery, green or pink or yellow Pyrex dish, or a box of old Polaroids where someone still wrote the date and a brief notation in cursive.

Turkish novelist and Nobel laureate Orhan Pamuk believes in the power of things to the point that he devoted an entire novel, a museum, and a book-length museum catalog to the importance of ordinary objects in our lives. In the novel *The Museum of Innocence* (2008), the narrator Kemal collects objects that had belonged to his dead lover as well as objects related to the time he knew her, 1970s Istanbul. Every purchased novel comes with a real ticket good for one entry to the real life Museum of Innocence, which Pamuk curated and opened in 2012 in the Çukurcuma neighborhood of the Beyoğlu district in Istanbul. That same year Pamuk released *The Innocence of Objects*, a book that is essentially a 264-page catalogue with photographs and commentary on the contents—more than one thousand objects—of the museum. Throughout these works, Pamuk suggests ultimately that only our small lives with our small obsessions and possessions make it possible to absorb and counter the violence done to the private self by all of the mech-

anisms that dictate what is and isn't valuable, that would have it be brought under heel and relegated to irrelevance.

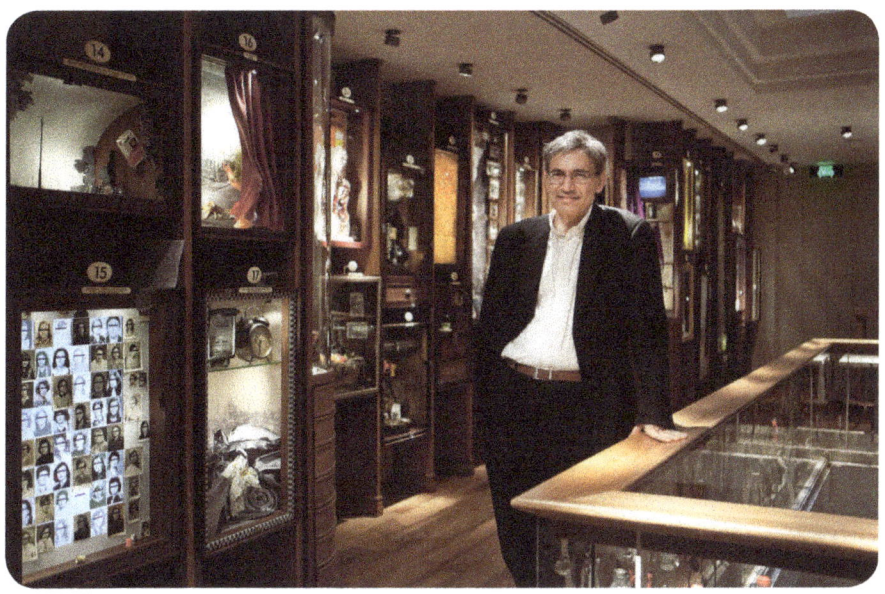

Figure 65: An image of the author Orhan Pamuk in his museum, The Museum of Innocence, in Istanbul, Turkey. (Photo by The Museum of Innocence (Press release) / CC BY-2.5, via Wikimedia Commons)

In her review of *The Innocence of Objects* for *The American Reader*, Presca Ahn explains that, in the novel, while Kemal has dinner with Fusun (his beloved) and her family nearly every night, he mostly keeps his distance; "Meanwhile he amasses thousands of objects that Fusun has touched, or which remind him of Fusun; later in life, these objects become talismans of his sentimental longing." The museum that Pamuk organized purports to present in large glass vitrines all of the objects that Kemal had accumulated over the years: "a single butterfly earring, a petrified glass of *raki*, an array of toy dogs, newspaper clippings, old photos, decorative hair combs vintage watches and clock (a lot of these), women's shoes and clothes," and hundreds more (Ahn).

Ahn chooses to add the brief parenthetical "a lot of these" to her observation of the large number of watches and clocks possibly in acknowledgment of the function of objects in relation to time. At the end of the review she quotes Kemal, who says that, "the greatest happiness a museum can bring [is] to see Time turning into Space." The last twenty pages or so of *The Museum of Innocence* are a testament to Pamuk's own allegiance to this idea,

and to the importance and absolute necessity that we, as Kemal, become "anthropologist[s] of [our] own experience." Certainly, Pamuk would argue, we cannot rely on Iron Mountain to do so. It is up to us to curate our existence, and this existence is made up of thousands of things, useful and useless, but each one endowed with the ability to contain stories and memories. The twenty-first century has presented us in a short period of time with enough encounters with death to suggest that the only things we can be certain of are what we can touch and feel now (Steven Pinker apparently was wrong in claiming in 2005 that violence was on the decline; according to *The New York Times* violent and destructive acts have risen 600-fold since then). But we're also not that naïve to believe that we can dupe time and actually cheat death (the only thing death cannot take away is our stories). By becoming collectors and archivists of our own temporary and provisional lives—hoarders of momentary joys—what we build in our backyard, so to speak, provides only a delicate sense of stability, however tenuous. In any case it is preferable to leaving behind a massive digital trail of glimpsed faces, events, objects—inorganic and inauthentic crumbs of a life.

And, for now at least, living still consists, as Baudrillard put it in reference to the qualities of wood, of things that express *being*. They vibrate when struck, they resonate with their own voice and ours. In another review for *The New York Times* titled "Cultural Artifacts," Edmund de Waal explains that Pamuk's museum presents as genuine artifacts, as items of reverence and relevance, objects such as used "cinema tickets, certificates, the bill from a restaurant, a line of matchbooks, a taxi meter, a stopped clock, a used coffee cup" and "an arrangement of 4,213 cigarette butts" smoked by Fusun. Some of the display cabinets remind de Waal of Joseph Cornell's shadow boxes because they seem to be "part of dreamscapes"—material objects that have the ability to trigger the imagination, to rekindle memories, to help us connect to *then* and *there* through the narratives they tell. Odom et al. came to the same conclusion, writing that "material possessions are essential to the repertoire of identity, we learnt. A sample of the materials used in identity production included photographs of family and friends, mementos from trips, and objects symbolic of personal relationships. All the homes we studied contained family heirlooms, for example, tying identity in the here and now with what it was."

A Guided Tour Through the Museum of Imminent Catastrophe

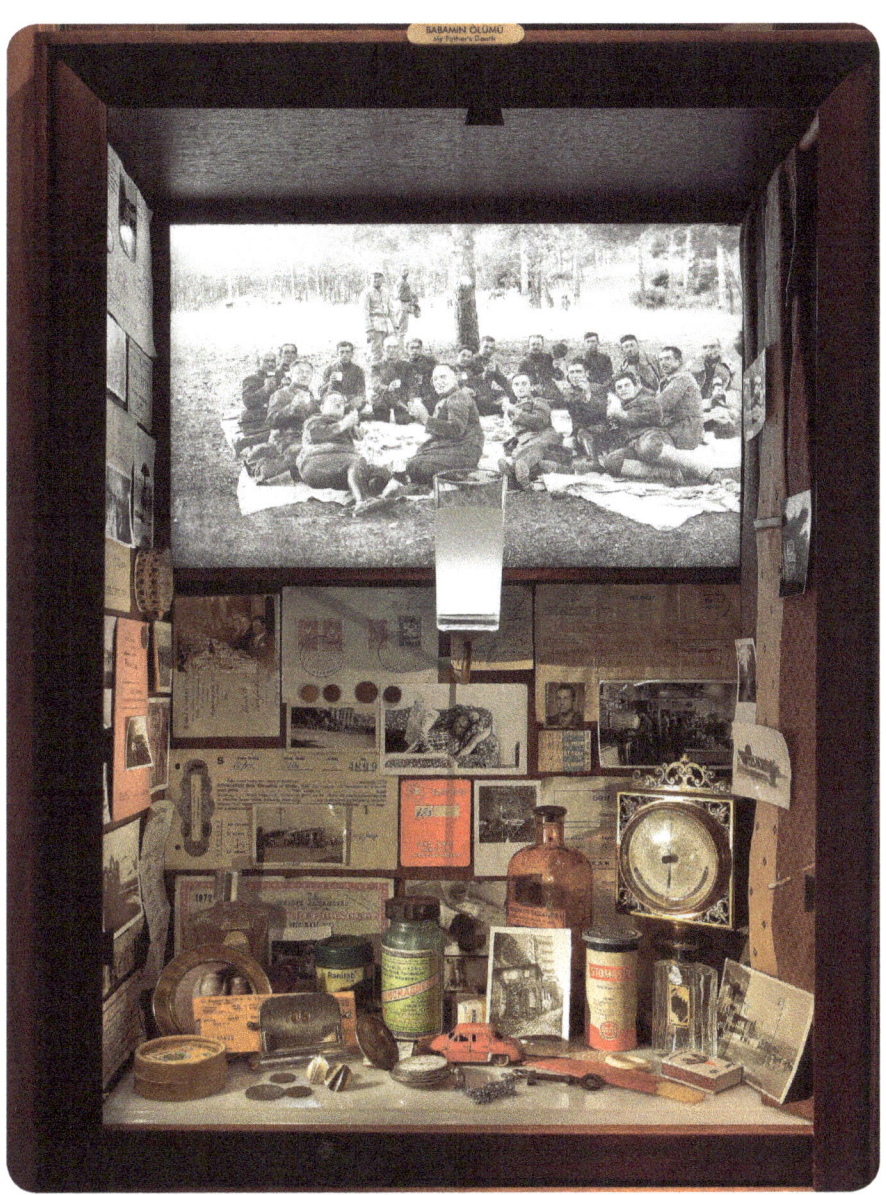

Figure 66: An exhibit from Orhan Pamuk's museum, The Museum of Innocence, in Istanbul, Turkey (Photo by The Museum of Innocence (Press release) / CC BY-2.5, via Wikimedia Commons)

In *The Museum of Innocence*, Kemal, who likes to visit smaller, off-the-beaten-path museums dedicated to the lives of authors, artists, and architects, seems very much aware that the distinction made between ordinary

lives and those of the famous is artificial and imposed: "I would imagine it possible for me to frame my collection with a story, and I would dream happily of a museum where I could display my life [. . .] where I could tell my story through the things that Fusun had left behind, as a lesson to us all. [. . .] Now the only way I could ever hope to make sense of those years was to display all that I had gathered together—the pots and pans, the trinkets, the clothes and the paintings [. . .]" (Pamuk). In the "little museums," the flea markets and the antique shops Kemal frequented in his travels, he came to realize that "the past is preserved within objects as souls are kept in their earthen bodies, and in that awareness [he] found a consoling beauty that bound [him] to life" and which would allow him "to say what it was that gave life meaning" (Pamuk).

Thus, the ordinary, the overlooked—rusty coins, chipped wooden spoons, butterfly hair clips, a pocket watch—bind us to the one life we have to live and make tangible the binds that matter most, our memories and our stories. Pamuk writes in a manifesto for *The Museum of Innocence* that, "If objects are not uprooted from their environs and their streets, but are situated with care and ingenuity in their natural homes, they will already portray their own stories." Pamuk pays great attention to preserving the items *as they were*, which results in the museum's guidebook, de Waal observes, functioning the way our own lives and our own stories do, which is a bit chaotic: "It feels barely edited, a scrapbook of images and ideas, memories, autobiographical interjections on collecting." I realize that this description might very well extend to the very book you are now reading, but such is the nature of the life of things—a bit haphazard, seemingly random, but attuned to the logic of the very materials of which it consists. As such, the book, writes de Waal, "is partly a manifesto for the power of demotic objects to tell grand narratives" where "[f]ictions and objects and place are all intricately and beautifully held together." In a time when so many millions of lives seem disposable and the word meaningless can be attached to scene after scene of destruction, the importance of objects in helping us craft plausible fictions and make sense of it all cannot be understated. They bear the unbearable weight of what we cannot fathom.

* * *

Pamuk believes in the significance of everyday objects so much that if he had his way, institutions such as The Metropolitan Museum of Art, the Louvre, the Hermitage, would give way to personal archivists, collectors, and artists working with everyday discarded items. Objects provide us with a sense of structure and order, but they are also the means by which we can retain some control over who we are and who we become. When faced with the uncer-

tainty posed by digital spaces and the sense of imminent, daily catastrophe, objects are where we find refuge because they are directly experienceable; they bring us back to a known *thing*, to a familiar *location*, to *ourselves* within a personally curated and physically inscribed environment that resists, as best it can, the erasure of memory. Horn et al., in "'Tonight will be a memory too'—Memory and landscapes" write that,

> The attempt to preserve memories by physical means though the landscape is what Paul Connerton has called 'an inscribing practice'[. . .]. A second practice of transferring memories is what Connerton has called an incorporating practice, which is through our bodily habits and routines. Since these habits are carried out in a physical environment filled with residues of previous events, the landscape is crucial for the shaping and structuring of memories. Furthermore, the landscape can serve as a spatial framework giving memories the illusion of permanence and stability.

Understanding the term landscape here to refer also to lived-in spaces, rooms, houses, buildings, etc., I am almost certain Pamuk would take the illusion of permanence and stability provided by them over a digital interface. It is in such landscapes—thingscapes and wastescapes—that his often quoted line, "From tiny experiences we build cathedrals" (The Paris Review, The Art of Fiction No. 187) finds most relevance. While nothing online is ever truly private, the junk in your house can be, and while it seems like an insignificant detail, knowing that something is private and truly in your hands goes a long way toward helping to establish a sense of security and personal identity—a cathedral, or at the very least a small altar to the self. The seemingly insignificant material details of our places of dwelling are the components of our own personal grand narratives; and as with actual cathedrals they are the places where we pray, commune, despair, and hope.

It seems suitable here to end with a few excerpts from Pamuk's "A Modest Manifesto for Museums," a redeeming call for the importance of curation and preservation of the ordinary, for raising the accumulation of simple objects to the status of monuments. The manifesto is available in full via The Museum of Innocence (en.masumiyetmuzesi.org).

- Large national museums such as the Louvre and the Hermitage took shape and turned into essential tourist destinations alongside the opening of royal and imperial palaces to the public. These institutions, now national symbols, present the story of the nation—history, in a word—as being far more important than the stories of

individuals. This is unfortunate because the stories of individuals are much better suited to displaying the depths of our humanity.

- We don't need more museums that try to construct the historical narratives of a society, community, team, nation, state, tribe, company, or species. We all know that the ordinary, everyday stories of individuals are richer, more humane, and much more joyful.

- It is imperative that museums become smaller, more individualistic, and cheaper. This is the only way that they will ever tell stories on a human scale. [. . .]

- The resources that are channeled into monumental, symbolic museums should be diverted to smaller museums that tell the stories of individuals. These resources should also be used to encourage and support people in turning their own small homes and stories into "exhibition" spaces.

- If objects are not uprooted from their environs and their streets, but are situated with care and ingenuity in their natural homes, they will already portray their own stories.

- Monumental buildings that dominate neighborhoods and entire cities do not bring out our humanity; on the contrary, they quash it. Instead, we need modest museums that honor the neighborhoods and streets and the homes and shops nearby, and turn them into elements of their exhibitions.

- The future of museums is inside our own homes.

Or, given today's trends toward micro-apartments, minimalism, and pod-style living, maybe you prefer to rent out a storage unit on the waterfront in Brooklyn where you can visit, at any time and free of cost, your own little museum collection of Beanie Babies and souvenir spoons—if you're into that sort of thing.

Natalia

When, in May 2016, National Public Radio's *Two-Way* segment reported on a finding at Auschwitz—"a mug that held a gold ring and necklace, painstakingly hidden from the Nazis and concealed for 70 years"—reader Sabina Rak Neugebauer recognized similarities to her own story, so she wrote in to share it. That small gesture piqued reporter Camila Domonoske's curiosity, and after further research and interviews turned Sabina's story into the article "Tea, Pride, Mystery: For One Family That Fled The Nazis, A Tin Canister Held It All."

The story begins in 1939 in Warsaw, Poland with Guta and Mayer Rak (Sabina's grandparents), a Jewish couple whose lives would soon be upended following the country's invasion by Nazi Germany. The Raks would spend the next several years on the run from the Nazis only to later end up serving time in a Siberian labor camp after being arrested by the Russians on suspicion of espionage. During all this time, there was one object that traveled with them wherever they went—a tin canister about the size of a coffee can. According to Sabina's story, when the Raks realized what would soon befall them at the hands of the Nazis, they gathered all the small pieces of jewelry that they had and asked a local tinsmith to hide the precious metals in the rim of an ordinary tin canister. It is this can that they then carried with them through occupied Europe, back to Poland after the war, then to Sweden, and eventually to New York where the Raks found their second home. Domonoske quotes Eda Rak, Sabina's mother and the only daughter of the Raks, reminiscing about what the canister had meant to her parents: "It became a symbol of how resilient they were—they were always able to manage. At poverty level sometimes, below it others, but they never needed to extract whatever there was—if there *was* anything under the lid—and use it for their survival."

What further adds to the initial mystery of the object is that the couple was not sure if the tinsmith had been honest with them and hidden the gold in the canister, or whether he had simply pocketed it. The canister that they believed contained the bulk of their valuable possessions might have been nothing more than junk. And possibly it is this status of the object as junk, dull and worthless, that saved it from destruction or from being confiscated by the Nazis (and later the Russians) much the same way they stole numerous other valuables. They saw no harm in letting the Raks keep their bit of tin. Yet, regardless of the actual value of the canister, it became one of the most treasured family possessions, having gone through the many horrors of the war together with its owners: "What was in the tea canister . . . wasn't what was valuable," Sabina says. "It was the fact that it was their com-

panion through all their travels. How is that possible, that you can be locked up in a slave labor camp and still hold onto this little piece of tin?" Whether or not the canister contained any gold, it did without a doubt contain something even more important: a personal narrative of memory of struggle and survival indelibly linked to the Raks's identity then and their identity today.

As Eda and Sabina eventually found out, the canister indeed had three curves of gold hidden behind the rim. With this gold, now that much more precious because of its history, Sabina decided to make wedding rings for herself and her fiancé, a symbolic reminder of hope and strength that her grandparents carried with them through their hardships. As for the canister, it has remained a treasured family artifact, a conduit connecting the living to their ancestors. Chances are it still contains tea bags or serves as the centerpiece of a table or mantle. As her kitchen fills with the aromas of tea, visitors are invited to hear a story about the old rusty canister—a story about times long gone and about resilience in the face of disaster and tyranny—and which would likely have been lost had it not been for an ordinary container.

Just try telling a story without mentioning an object, and you will fail bitterly. Storytelling does not favor abstractions—William Carlos Williams's "No ideas but in things" reverberates strongly here—objects anchor abstract notions in the physical reality, translating them to the senses. Love, hope, struggle, resilience—what have you—are only words that are hard to grasp; solidified in things, however, they are brought to presence and embody human experience better than abstract concepts ever could. Anton Chekhov, a Russian writer and a recognized master of the short story genre, reportedly said that he could write a story about any object: "Would you like to know how I write my stories?" he asked his friend Vladimir Korolenko one day. "'Here, observe.' He glanced at my [Korolenko's] writing desk and picked up the first object that he saw. It was an ashtray. Placing it on the desk right in front of me, he said, 'If you wish, by tomorrow I will write a short story. Its title will be *An Ashtray*'" (Sekirin 39). Checkov recognized the crucial role of things in our lives and narratives: more than merely accessories or stage props, things are centerpieces of our stories, and they have their own stories to tell as well.

A Guided Tour Through the Museum of Imminent Catastrophe

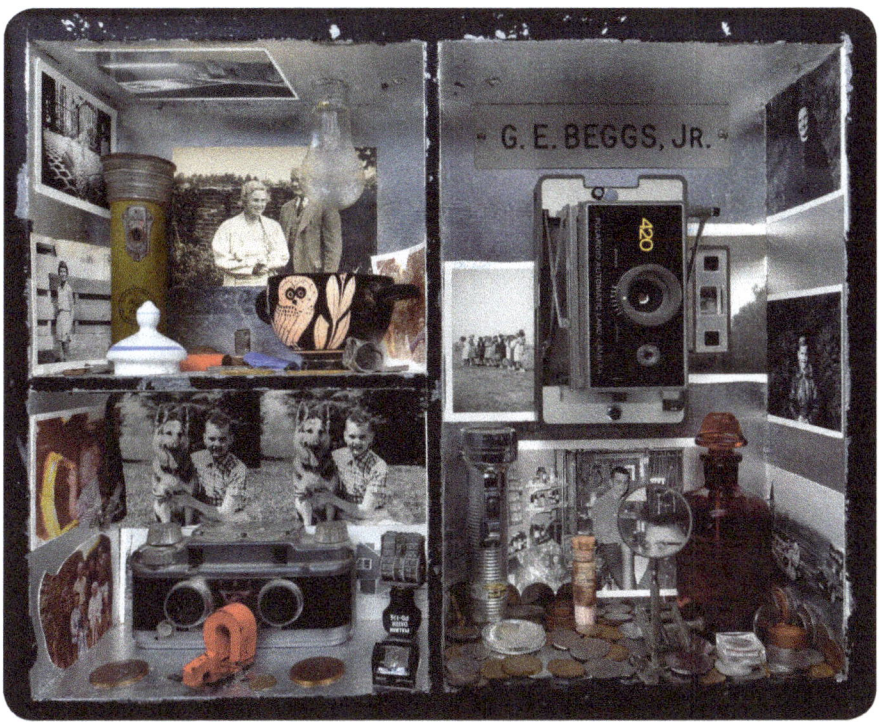

Figure 67: *The Basement Years*: Mixed media assemblage using old desk drawer, acrylic, silver leaf, stereo camera, polaroid land camera, coins, personal photos, flash light, rubber stamp, light bulb, magnet, magnifying glass, litmus paper, antique cup, old sugar bowl lid, various magnifiers, glass jar. One of five commissioned pieces that serve to narrate through objects the life of Eric Beggs. (Assemblage © 2011 by Christopher Hynes. Photographed by Eric Beggs. Used by permission.)

 Storytellers across cultures, following Chekhov's cue, rely on the description of objects, salient details, and settings. From Nikolai Gogol's descriptions of house interiors that Chichikov encounters while visiting serf owners in *Dead Souls*, to Marcel Proust's famous Madeleine cookie that reminds him of his childhood, things propel the plot forward and connect the past and the present. We recognize that things house memory and create it, but things also seemingly act of their own volition and insert themselves in our stories and come to dominate the narrative. If it sounds a bit out of the realm of what is plausible, maybe it is because as we get older we put more and more distance between us and the world of magic, where as children we dwell and in which we believe wholeheartedly. Fairy tales—the oldest form of storytelling—recognize the primacy of things as they grant things with

powerful magic: objects in fairy tales perform a transformative function, exerting their influence to shape and guide the hero. Matters of life and death are linked to objects. In a Russian folktale, for example, a villain's death is contained in a needle, which is hidden in an egg, the egg is inside a duck, the duck is inside a hare, the hare is in a chest, the chest is buried under an oak tree, etc. J. K. Rowling's *Harry Potter* series is another example of the importance of things for the development of narrative: the Harry Potter universe is detailed with objects, whether magic or not, wherein lies the secret of the unmatched credibility of Rowling's fiction. Every object in her books, however insignificant at first glance, is later revealed to be a key to another story embedded in the larger narrative of the book. The architecture of the plot is supported by the material objects and structures that ground the story in the physical world.

The magic of memory, too, depends on things. The function of objects to be vessels for memory explains the appreciation that we are able to experience for things regardless of market or exchange value. We bring back with us a souvenir from a trip to remember the place that we visited; we keep trinkets as mementos to immortalize an event; we pass down heirlooms from generation to generation to keep in touch with our family history. In ritualistic ceremonies across cultures, material objects serve to mark a change of status and identity: wedding rings, medals, memorial signs. In Eastern European memorial services, along with a prepared meal, relatives of the deceased give out plates, spoons, or cups to those who attend the service to keep as reminders of the event and of the departed person. In all of these and other similar instances, a material token is transformed into a note or bookmark for memory, a sign created for the purpose of remembering a person or an event. In some other instances, the function of the thing as an embodiment of memory is less arbitrary and more experiential, directly related to the event or the person we want to remember: a favorite teddy bear that reminds us of our childhood, the wedding dress in the closet that keeps happy memories of the wedding day. All of these objects carry stories that get to be told, or at least thought of, each time we encounter the object of memory. As the Raks's family tin canister, these objects may be indistinguishable from scrap metal, but their stories become that much more significant as they age and accumulate memory through a seemingly endless ability to contain any and all associations we bring to them. They are indeed highly personal, signed with the quirks and idiosyncrasies of the individual, but they are often also commonplace and tinged with hints of the familiar, allowing them to transcend and travel across contexts. I might not share Sabina's story, nor do I possess a similar tin can, but when I handle my father's favorite decorative wooden spoon, the one he's eaten with

for as long as I could remember, I'm holding more than a carved piece of wood—I'm holding an artisan's handiwork, Russian history, the art of food preparation, family tradition, conversation; I'm holding an artifact in my family's museum of oddities, at once strange and sincerely human.

In a short piece titled "Excavation and Memory," written circa 1932, Walter Benjamin spoke about the materiality of memory itself, employing an archaeological trope to explain how memory correlates with and differs from the past:

> Language has unmistakably made plain that memory is not an instrument for exploring the past, but rather a medium. It is the medium of that which is experienced, just as the earth is the medium in which ancient cities lie buried. He who seeks to approach his own buried past must conduct himself like a man digging. Above all, he must not be afraid to return again and again to the same matter; to scatter it as one scatters earth, to turn it over as one turns over soil. For the 'matter itself' is no more than the strata which yields their long-sought secrets only to the most meticulous investigation. (576)

The work of memory, then, is to unearth vestiges of the past from the discarded and the forgotten. Such excavation aims to recover what Benjamin considers the most valuable of human possessions, namely, authenticity of individual experience, the genuine connection of subject and object. It is with the emphasis on experience, as well as presence of multiple voices relating the experience with added layers of meaning, that Benjamin defined storytelling—the ultimate form of memory transmission.

More than a century ago Benjamin lamented that the art of storytelling was approaching a bitter end: "More and more often there is embarrassment all around when the wish to hear a story is expressed. It is as if something that seemed inalienable to us, the securest among our possessions, were taken from us: the ability to exchange experiences" ("The Storyteller" 83). The reason, Benjamin suggests, is our growing disbelief in the authority of experience. Whereas experience used to be the source of wisdom and undeniably came with the right to tell a story, modernity has shaken our faith in the importance of what we witness, live through, and remember. In the world ruled by forces of a much greater scale than an individual life, the private stories that we have to share are no longer deemed important. Anticipating the dawn of globalization, Benjamin deplored the powerlessness of individual experience against the global forces: "never has

experience been contradicted more thoroughly than strategic experience by tactical warfare, economic experience by inflation, bodily experience by mechanical warfare, moral experience by those in power" ("The Storyteller" 84). As a result, we no longer trust our own stories, replacing them with those readily provided by the media, propaganda, and, the most powerful enchanter of all, advertising. And even when we do attempt to put our stories "out there," they are increasingly defined by their ephemeral qualities and limited lifespans; they are essentially set to implode (social medial platforms such as Snapchat and Instagram make sure to encourage that we share stories, but not to preserve them), to disappear so that they can no longer speak, almost as if we no longer trust the validity of our experiences, the importance of a single voice among many.

In place of storytelling, Benjamin believed, came a glut of information and streams of stimuli, which do not concern themselves with experience. Instead, information exists in the here and now; its practical value does not survive the moment and, therefore, plays no part in the formation of memory. News stories are really no stories at all; they are information designed to briefly attract the readers' attention and be almost immediately forgotten: "Every morning brings us the news of the globe, and yet we are poor in noteworthy stories. This is because no event any longer comes to us without already being shot through with explanation. In other words, by now almost nothing that happens benefits storytelling; almost everything benefits information" ("The Storyteller" 89). Rather than representing individual voices, the media claim to speak from an arguably objective perspective that obliterates diverse individual experiences in favor of a falsely universal truth.

In the present day more than ever, "poverty" of experience, as Benjamin put it, is especially of concern. Italian philosopher Giorgio Agamben furthers Benjamin's insight when he asserts that destruction no longer necessitates catastrophe and that the conditions of modern life suffice (Neville and Villeneuve 10). While Agamben refers directly to city life, today's technological development and digital disembodiment have further brought about alienation from immediate surroundings and sensory perception, making experience in contemporary Western culture (though the effects are no longer solely limited to it) significantly less grounded in tangible reality. As society moves everyday interactions online, people's connection with their environment becomes further disembodied. One could say that our relationship with the material world is increasingly a distant one and our attempts to "reconnect" are half-hearted at best. Ironically, even consumerism, which is seemingly centered on material possessions, in fact encourages but a most superficial relationship with things: lured by all things new and

desirable, we easily discard the items that have come to embody our past experiences, effectively getting rid of the singularity and uniqueness of things in favor of the perceived advantage of newer and even more easily replaceable items. As it happens, while the trash heap grows higher it is our memory that disintegrates and flat-lines as individual and collective knowledge is thinning and wasting away. Meanwhile, countless untold stories are going to waste: stories of unique experiences tied to tangible objects that never had the chance to materialize.

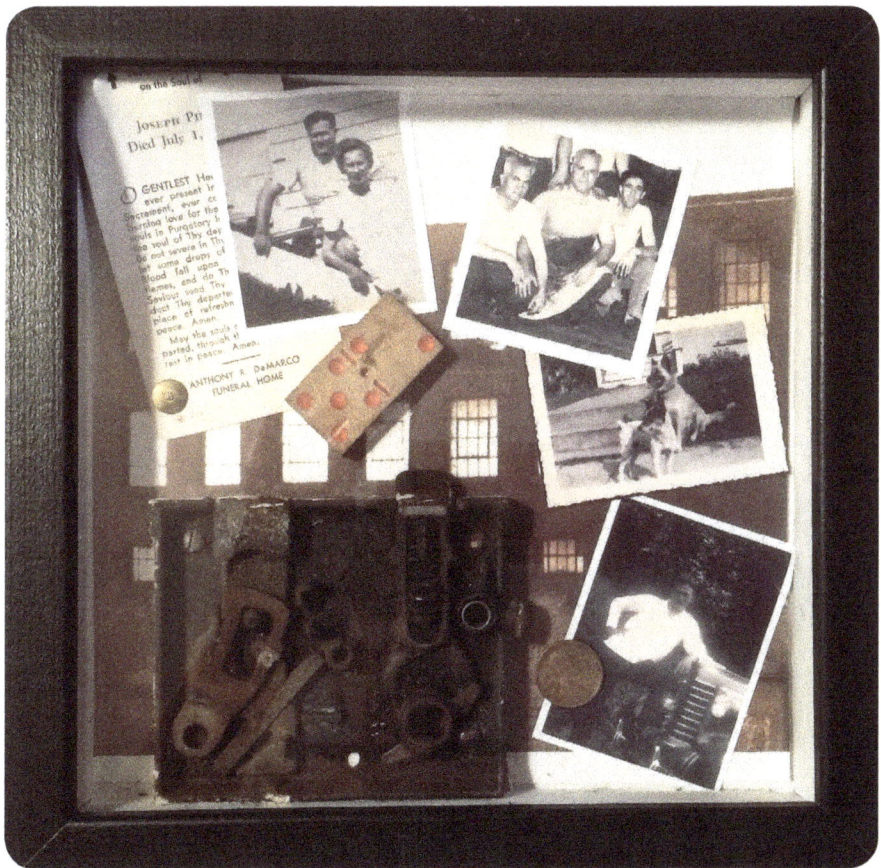

Figure 68: *The Father:* Mixed media assemblage by Peg Johnston using vintage photos, a funeral card, the internal workings of a lock, a domino, a period thumb tack, and a 1940s penny on a background of a photo of an Endicott Johnson factory. (Photo by Peg Johnston)

To counterweight the obtrusive illusory truth maintained by the dominant narrative of culture and media, individual memory must be

moved to the forefront. In light of too much information that amounts to an informational blur, personal stories rooted in experience acquire new significance, acting as an alternative historiographic account of the past and of our own selves. In *Waste-site Stories*, Neville and Villaneuve contrast experience-based storytelling, which they equate to memory, with the official grand narrative of history, commenting on vulnerability of memory:

> Memory is read less than a narrative than as stories culled from the many deposits of experience. If history is a matter of "point of view," memory, we might say, pertains to materiality, which is why for history the question of value amounts to asking what is worth recounting, whereas memory [. . .] resides in the gap between the value and nonvalue of that which was and, as such, remains constantly endangered. (13)

This conception of memory implies both its strong link to material objects and the inherent likeness of memory itself to a material formation, prone to disintegration and decay. Situated, like ruins or objects fallen out of use, on the intersection between value and nonvalue, memory is as fragile as it is effective, offering a return to the origin. Storytelling enters the same dynamic tension seen in all archives—in state-run monolithic bunkers and anointed cultural institutions as well as in Pamuk's cherished but unofficial personal museums—between preservation of experience and realization of the futility of all preservation efforts.

Storytelling, the most ancient form of preservation and dissemination of cultural knowledge, might still be one of our more reliable methods. Storytellers are archivists by nature, collecting objects and experiences and translating them into stories to ensure that ephemeral experiences, moments salvaged by memory, are monumentalized. Nostalgia for authenticity, which is undeniably the driving force behind archiving memory, necessitates reinvention of storytelling, and that is where digitization of modern life turns around to facilitate the democratization of memory. The affordances allowed by digital venues and storytelling tools encourage exploration of alternative forms of memory, such as testimonial narratives, participatory construction of memory, or archives of oral histories and personal recollections. In many ways, it is precisely the fragmented, cursory nature of digital environments that validates the disordered, decentralized, and often random accounts that find a venue and a context online. How to value, nurture, and hold on to such virtual sites of memory is a challenge given what we know about the real challenges posed by digital storage and interaction, but the overwhelming benefits of storytelling necessitate that we find ways to navigate these turbulent waters.

A Guided Tour Through the Museum of Imminent Catastrophe

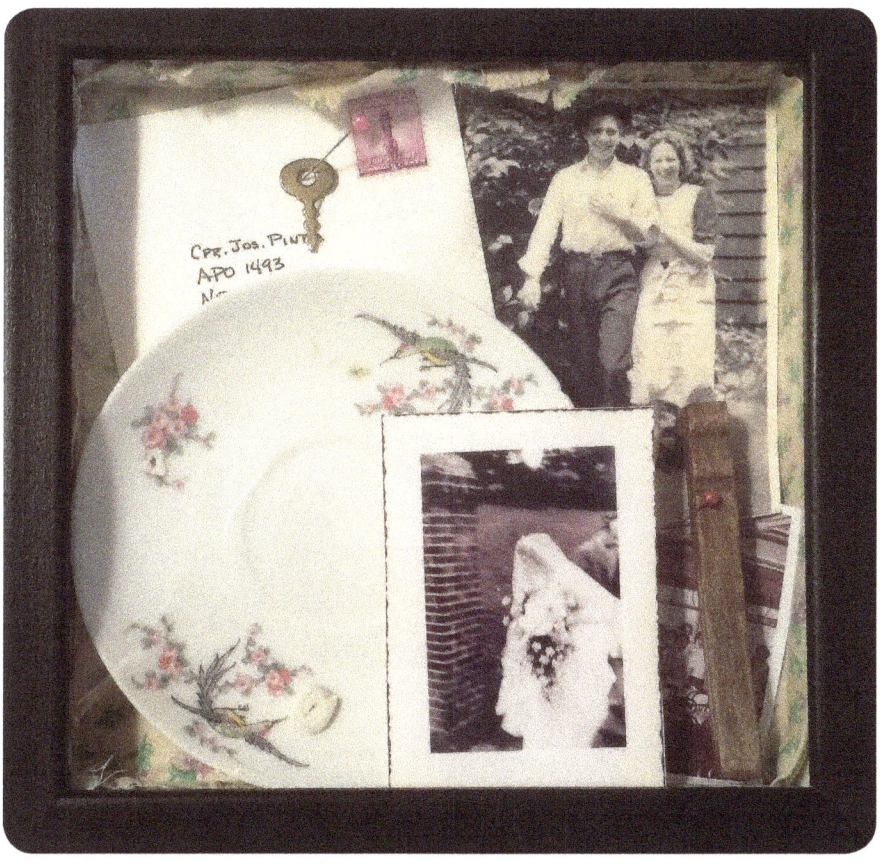

Figure 69: *The Lovers*: Mixed media assemblage by Peg Johnston using vintage photos, handpainted china plate, clothes pin, jewelry box key, created envelope with period stamp, on a background of gingham cloth. (Photo by Peg Johnston)

Neville and Villeneuve's conceptualization of a book of and about waste is helpful for thinking through *The Afterlife of Discarded Objects* and is a good starting point for thinking about a philosophy that might redeem contemporary practices of memory preservation—tangible or otherwise. They describe the waste book "not as ledger for as yet unordered accounts, but as figure for the writing of disordered experiences" (1). More than a description of an isolated collection of essays or stories about waste, this is a substantiation of an epistemology of waste: a practice of knowledge production that is sensitive to the significance of the most insignificant—the unclassified and displaced personal stories of the discarded. Individual voices and previously unrecognized experiences take center stage, as stories "emerge as cer-

tain sites of memory, from the ruins of experience, to explore the material infrastructure of memory, upon which such stories repose. The heterogeneity of memorial practices today recovers the value of the individual witness, site, object, which, relegated to waste, seemed destined for oblivion" (Neville and Villeneuve 13). Following Neville and Villeneuve, in *The Afterlife of Discarded Objects* we read for recovery of debris of memory and experiences that are consciously decentralized and subversive.

Personal stories, regardless of their main focus, are almost by definition subversive, running counter to the generalizing force of prevailing ideology, but always squeezed into that gap between value and nonvalue, meaning and meaninglessness. By daring to put her personal narrative into the public sphere, the storyteller challenges the notion that there is only one defining storyline, one way to live, one definitive set of values. Such totalizing narratives penetrate all dimensions of our lives, acting as a normalizing force—be that consumerist ideology; everyday ideologies of beauty; relationships; religious beliefs; or mainstream ideals of gender, race, class, and sexuality. In doing so, ideology leads to erasure of individual experience. Personal narratives, then, are an act of resistance against the flattening of perspectives, a subversive gesture that champions the individual and private voice.

It is for this reason that telling a story of one's own is among the most empowering experiences we can have. Writing, as French philosopher Hélène Cixous has put it, keeps away death (32): following in the steps of Scheherazade who endlessly postponed her death by telling captivating stories, the storyteller exercises the right to decide what moments from her existence are saved from erasure. American essayist Joan Didion similarly emphasizes the drive for preservation that is inherent in any act of storytelling: "Keepers of private notebooks" Didion remarks, "are a different breed altogether, lonely and resistant rearrangers of things, anxious malcontents, children afflicted apparently at birth with some presentiment of loss." The act of collecting, sorting and compiling personal artifacts—as one would inside a junk drawer, or inside the meticulously arranged vitrine of a personal museum of things—is tantamount to the assemblage of a narrative. Simply by virtue of their existence in our home, the old, worn, nearly forgotten things that constitute and witness our experiences provide us with a narrative that is different from the one we encounter on a daily basis, and might even offer ways to express unfulfilled or incomplete parts of our identity. Time and impermanence of life are not the only entities posing a threat to human existence; more dangerous yet is the omnipresent narrative of history that obliterates memory of individual experiences, rendering any isolated life insignificant. Things, through their loyal presence and seemingly silent

companionship, provide the specter of alterity, and that might be sufficient to allow us to keep our identities intact in the face of the overpowering force of ideology. A fortification for the soul if you will. Only by recounting the fractured memories of ourselves and of the possessions that link us to the past can we make sure that our childhoods, our ancestral homes and our roots survive and remain. To counteract inevitable loss, we need the tools of memory, we need to be able to sift and sort through the strata of daily experience, and we must recognize the value of allowing them to speak—whether from the mantelpiece or from the web.

11 Personal Narratives: Selected Contributions to *The Afterlife of Discarded Objects*

In the beginning of the 1990s, the time of my childhood, many people struggled for money. My parents were among those who struggled: they worked in State organizations and did not make enough to afford most things. At that time, it was fashionable among children to play with these little cheap dolls that everybody had. I also had one of those, but I didn't have any furniture: it was too expensive for my parents. So my girlfriends and I made doll furniture ourselves—from match boxes. If you cut out the longer side from the matchbox, you had yourself a tiny sofa; if you cut out the two shorter sides, you got a bed; if you cut the box in half, it turned into an armchair. We lined the furniture with foam rubber from packaging. Three boxes glued on top of each other made a chest of drawers. . . . We played with these treasures on a big tennis table in our yard (later, in one of especially cold winters, the table was split up to make wood for heating). It was real fun. Later, we made Barbie furniture ourselves as well: the dolls slept in a shoe box, took their bath in tubs for film development, their chairs were made from empty yoghurt cups. . . . Everything that we found in the house was used to play. I think it was a good thing, because having to invent really stimulated our imagination and creativity—even though I was much jealous of the girls who had real doll furniture.

—Alena, Astrakhan, Russia, 1990s

* * *

My childhood playthings were little chips we made ourselves from lead. We invented various board games with them. We also played with details from electric transformers that looked like the letter E: the games we invented with them were endless. It was also the time of cheap plastic dinosaurs, first toy transformers (this masterpiece of Chinese produce was the prerogative of all the cool kids); of water bottles with a hole in the cap to squeeze water from them under pressure (paintball is not even half as much fun!), and of *Kinder-Surprise* collections. I had a great childhood, without computers or cell phones.

—Alexander, Chelyabinsk, Yemanzhelinsk, Russia, 1990s

* * *

Personal Narratives

I remember collecting garbage as a child and playing with it. We used to go around garbage hunting with my friends and then used it in our games. Though sometimes the process of garbage hunting was interesting by itself. As we were girls we used the things we found as "interior design" and household objects in our makeshift houses. I think regardless of time and place, all girls like this process of setting up home. I also remember making "secrets" out of pieces of broken bottle glass and bright pieces of paper or cardboard that we put under the glass. We buried them hoping that in the future someone will find our "secrets."

—Anastasia, Grozny, Chechnya, 1990s

* * *

When I think back to my childhood on the farm in Alabama my mind is drawn back to my brother and I sword fighting in the yard. We had vivid imaginations of war and military strategy, and with a broken tree branch or an old golf club as our swords we were unstoppable. The best weapon we ever had, however, was a spear we got from an old flag holder. The flag pole had been broken during a windstorm and had left the bottom edge very sharp. We were the happiest kids alive when we found that spear. The spear was our pride and joy. We would throw it as far as we could to watch it stick in the ground. Then we'd race to see who could get it first and start all over. We dreamed of being Roman soldiers defending our tree house fortress and we imagined huge armies of men attacking just me and my brother as we swung our swords and threw the spear. We were undefeatable.

—Austin, Lafayette, AL, 1990s

* * *

My grandparents lived in a remote area next to a highway. Behind their house was a big garden, with a little patch of trees next to it. In that tiny forest were trashed items by former residents of the house. Old shoes, pots and pans. I loved it there. I imagined a different world hiding between those trees, and just roaming between them would be wonderful. Today I have made one corner of my garden into something like this little forest. It makes me happy to see rusty tools, pieces of wood, old toys, a discarded watering can lying around there. They tell stories of how we lived here.

—Babygenie, Berkel-Enschot, the Netherlands, 1970s

* * *

Phone

I don't know what to do with it.
It sits on the kitchen counter, with its charger,
next to the toaster. I charged it once
since you died, and found a video
of a sixth-grade concert at the mall,
a bunch of ridiculous selfies,
some apps I can't identify,
and an entire Star Wars movie.
I put it back and now it's lost its charge.
What do I want to do with it?
It's a perfectly good smartphone.
I could take it to Verizon and explain
how I came to have it—how
I want to change the number and get rid
of texts and girlfriends and that stupid film,
but keep the concert and that selfie, there.
The tech rep would get that look
of stricken pity that just shreds my heart,
and finally sputter out "I'm sorry. I'm so sorry."
And I would be undone.
Is that what I want to do with it?
Just set it down! The more I touch it,
the more my fingerprints obscure yours,
the more my lived life obscures yours.
I don't want to delete your awful photos
Or overwrite your number with my own.
I want every proof you graced this earth
much more than I want a smartphone
that might work a year and die.
That's not what I want to do with it.
It's on the kitchen counter, with its charger,
next to the toaster. In the spring
I may get new countertops
and I'll have to decide,
but I don't have to think of it right now.
The phone's dark screen holds secrets
of a son I loved but hardly knew.
Nothing I do today can change that.
There's nothing I can do with it.

—Karen Bernardo, Vestal, NY, 2016

Personal Narratives

* * *

Most people would have thrown it out because it was almost useless. It wasn't even pretty. It was just a plain, old bowl with a big crack in it. Mrs. Jaramillo took it out and patted it before she placed it on the table. She gathered flour, salt, lard and a rolling pin. She was preparing to teach my mom how to make tortillas, and mom was ready to learn; she was already knocking at the door, calling, "Hello! Anyone home?" "Ven. Ven aca. Come in." She was friendly the way the ladies at church are friendly after Mass, smiling and pursing her lips a little. But she warmed up quickly to mom and was soon sloshing coffee over to the table, laughing at mom, who was trying to tell her about the grasshopper that waved to us when we were gathering left-over peanuts from some farmer's field. "I'm telling you the truth! It waved at us! We got down in the dirt and stared real close and it waved one little arm at us when we said 'Hello' to it." Mrs. Jaramillo laughed; her toothless mouth was shiny and pink. "Aye, Joyce, you are one crazy lady, I tell you what."

Her laughter gradually softened and fell quiet like a leaf, falling easy till it rested in her lap. She shook her head, still smiling at the thought of mom, with the four of us kids, lying in the middle of a field, talking to a bug. "OK now, Joyce. Let's make tortillas. Go over to the sink and wash your hands." Mom did as she was told and came back to the table. "You get your flour and fill it to here, where this crack is." Mrs. Jaramillo poured flour into the bowl, up to the crack. Mom said, "But what if I don't have a bowl with a crack in it?" She was still feeling playful and assumed Mrs. Jaramillo was too. But Mrs. Jaramillo stood up straight and looked tall even though she was barely five feet. She picked up her bowl and put it away. "Well, then you will never learn to make tortillas!" Mom thought she must be joking, but she was dead serious and after several very uncomfortable minutes of silence, she said, "Well, I guess I'll go home." The screen door creaked and shut and mom walked back to our house. She never did learn how to make tortillas.

Mom and I love to talk about that story, mainly because we can't figure it out. What was it that upset this friendly old lady so much that she refused to teach what she'd been happy to teach only minutes before? We treasure that story because it makes us laugh because we don't know what to do with it. We hold onto it because it reminds us of a time when grasshoppers enchanted us while we gleaned the fields. We hold on and we talk about it every chance we get, baffled and full of wonder too. I hold my favorite bowl like I'm holding a baby. Not the way a new mother holds a baby, but in that relaxed way that women develop when they realize the baby won't break the way fragile china or porcelain breaks. I get out the flour, salt and olive oil and stand over the empty bowl, looking for that line of cobalt that runs

right through the clay like a river running though the mountains. There is one spot where it looks like it's splashing over its banks. I pour the flour up to there.

—Janice Bisset, New Mexico, 1960s

* * *

We lived next to a children's hospital, and once I found a big glass syringe next to the hospital dump. The tip and plunger of the syringe were metal; it was fun to play with. I brought it home. When my father saw it, he asked me where I got it from, and then gently suggested to throw it away, promising to buy me a new one.

—Maria Bochegova, Kurgan, Russia, 1980s

* * *

My brothers and I always had a curious imagination. When we moved back from California to Maryland the basement storage room was covered with cardboard boxes. We would sit in the basement with our markers and create cars to race, spaceships to travel to the moon with, and secret agent headquarters. For weeks on end we would use our creations for games and competitions. For big projects the three of us would combine boxes to create more exquisite things, like underground tunnels. Along with the boxes covered in marker colorations there were boxes without color that could be interchanged. Although the similarities in boxes, we could always tell the difference between them and remembered which box we had played with the day before. The boxes taught us valuable lessons like heartache, when our parents decided to recycle one of our beloved boxes, and that day tended to be when the recycling truck came, thus there was no way to rescue the box. Nevertheless, that only enforced our creativity as we moved to different boxes, now they were tree houses, animals, and planes. When we played together with our creations there was an unsaid rule that at the beginning of playing everyone says what their box is and then they are not allowed to change it because that was cheating.

—Devon Brake, Rockville, 1990s

* * *

To a dull, unimaginative adult a large, cardboard box is just that—a box. But to my five-year-old self it was so much more. It could be anything I wanted it to be; I could be anything I desired to be. My brother and I could play

for hours at a time coming up with different scenarios in our simple, little minds. Beyond the basic, cardboard box was a pirate ship in search of new land, a house for our imaginative family to eat dinner, and a racecar preparing for the Kentucky Derby. We could paint it different colors with different patterns on each side. We could cut out holes in the side as windows in our quant house or as entrances so we could connect a few boxes to make a fort. The world could be whatever we imagined; we fantasized about everything the world could be through that uncomplicated, cardboard box. Looking back at the humble times, we operated like cats, deeming the packaging of the object more useful than the gift itself. Before long, the illusions faded and the real world began to set in. The cardboard box became that simple- it was just a box. My creative and visionary past self evolved into what I have always dreaded to become—a dull, unimaginative adult. A cardboard box is now an object to store my items in as I move into an apartment in a different state from the one I grew up in and created those memories in. The boxes are no longer twice as tall as me; there is no room for my body or mind to explore the seemingly endless scenarios of my five-year-old perception.

—C.B., Atlanta, GA, 2000s

* * *

I moved a lot as a child, and it taught me a lot about making friends and learning to adjust to my environments. One thing that remained a constant through all the different cities, climates, and accents, was the fact that we always lived in a house. As a child I used to draw my dream house, or simply day dream about what my house would be like when I grew up. The week I moved to Winchester, Virginia was a hard one for me, I guess because I was old enough to understand what was happening. One day me, my little brother, and my little sister got tired of unpacking but hadn't unpacked our toys yet. We walked outside and soon found a pile of old cardboard boxes that we used to move our things. We proceeded to tear apart the boxes and build our own house. We used duct tape to hold it together and we kept it in the garage for years, pulling it out whenever the urge to play "house" came upon us. It is funny how a piece of garbage, like a cardboard box, can mean so much to a child.

—The Cardboard Construction Worker, Winchester, VA, USA, 2000s

* * *

The Afterlife of Discarded Objects

The Road to Hell Was Lined with the Best Intentions

The wealthy families who employed my mom liked to give her all sorts of gently used items. They appreciated that Mom was an excellent housekeeper and babysitter and they knew Mom had four kids to support. Some of the stuff we welcomed, like when their children outgrew their expensive clothes and toys, we got great hand-me-downs. My siblings and I had fun with the five-foot square chalk board we inherited. Mom hung that down in the basement. In between roller-skating on the cement floor, we played endless games of hangman, getting the white chalk dust all over our fingers and faces.

There were other cast-offs we kids definitely didn't want. Once Mom came home with a huge dark-wood sideboard, at least eight feet long; appropriate for a dining room in a much larger house. She was determined to bring it upstairs and somehow with my uncle's help, we got it up the six steps to the front door and then up thirteen more to my shared bedroom. It was an ugly thing.

Then there was the hideous pink brocade sofa. Covered in hard yellowed plastic with odd curved legs, it was quite uncomfortable. Nevertheless, Mom pushed our plaid couch to the side and squeezed both into our tiny living room.

We gradually had to put up with three extra of everything; from telephones, radios and flower vases to dressers, desks and bookshelves. Closets became filled and Mom added boxes of stuff to every room. And then came collections of detritus on every stair—random things like pieces of foam, cans of spray starch and dolls.

I am not sure when I stopped inviting friends over.

—Ann Casapini, Oceanside, NY, 1960s

* * *

Blue Vase

Glazed turquoise blue, a color so intense
you knew it was turned in a place far from water,
under desert skies. My mother brought it home
and unwrapped its blue shape:
Bowl-bottomed, thick-necked, wide-mouthed.
It was unique; but beyond that, nothing special.
Hummingbird blue, gem blue, yet large and coarse,
it coursed through the phosphorescent dreams
of my childhood and those of a family fragmenting.

Once, it held sunflowers in our midst.
Once my sister almost broke it—
playing ball in the hall.
Our eyes filled with it. At day
so bright and lonely it silenced
the sea outside our home; its blues pooled
at night, that's when it shrank like a stone.
It sat on a walnut sideboard that now sits,
I think, in my father's new house.
They left, each one of them, like rivers seeking beds.
I bored a hole into its clay, thinking
it should hold more light to shoo
the darkness from that sun-filled place.
I turned it into a lamp stand, permanently capped.
It glowed artificially all day, all night.
Then I too packed, and moved,
and have packed and moved six times since.
Somewhere I lost its shade.
Or did it loosen and roll
away one day—the bulb, the holder and
the cone of turquoise jute?
Now the blue vase holds
neither flowers nor light.
But air—that drains
through the hole at its base,
and brims
over its open rim.

Author's note: This poem was written almost ten years ago. The vase's various avatars occur even earlier—between the 1970s when I first set eyes on it to the 2000s when I stowed or perhaps deliberately hid it away. Blue Vase was written when my parents were alive, when days would elapse before I thought of them unlike now when I remember them ever day; when the vase was part of my life's breathing fabric, its texture thinning and expanding or growing burnished, depending on the tone of my conversations with my parents, those long separate phone calls to each of them in different cities. After their passing the vase set in amber. As jewel, fossil, as relic better not remembered too well. Quite by chance, a few weeks ago I glimpsed the blue vase in the recess of a closet, hidden behind old backpacks, stacked paintings, yoga mats. As I looked and looked at it, it seemed to open its eyes and awaken for the space around it brightened; from beneath the dust its blue

began to hum. Shall I say it recognized me, and made me do the same—acknowledge stuff I'd hidden away. I decided to retrieve and reuse it. Not as ruined lamp stand, but as vase again, as when we were a family. The only obstacle is the hole above its base. I remember kintsugi or golden joinery, the Japanese art of repairing broken pottery that highlights breakage by filling the cracks with gold or silver dust so that neither its past as shards nor its mending is disguised; rather fragility and resilience are simultaneously on display. This is regarded as truly beautiful; we see our knocks, shattering and the poignancy of transience reflected in a piece of fired clay. Now to find an artisan who, with a play of lacquer and silver leaf, can help recover my past in a uniquely new way. Priya Sarukkai Chabria's Blue Vase was first published in my collection Not Springtime Yet, (HarperCollins (India) Publishers, 2009.

—Priya Sarukkai Chabria, Pune, India, 1970s-2000s

* * *

My parents moved from NYC to the rural Catskills where land was cheap because they wanted to live closer to nature. In the 1980s they relocated our family to a nearby small town that was once part of the railroad and industrial boom. Our neighborhood was mostly working class families but was peppered with different social strata and backgrounds; unlikely alliances were formed in search of adventure away from the supervision of adults. I was a rampant reader and shared stories about children like the ones from books in which magical worlds awaited the brave and curious. A deserted metal yard behind the railroad tracks filled with rusting junk became a club house meeting spot (inside large metal tubes). The highway underpass near an exoskeleton of a rotting mill was a tunnel to undiscovered lands that we staked out on maps. A mysterious cement cylinder structure overgrown with weeds next to fetid water became a place where evil spirits roamed (scaring the younger children). Later this sight and the river where we sometimes swam were discovered to contain industrial and illegal waste (and resulted in controversy and eventual cleanup). Some of our games reflected our 1980s fears of nuclear war and perverted kidnappers in white vans that would snatch a child away tempting them with bad drugs. Some games reflected anxieties from domestic problems at home or testing our growing identities. Abandoned by adults these reclaimed spaces suggested unknown possible dangers, excitement and a susurration of narratives from my imagination.

—Summer Copelan, Upstate NY, 1980s

Patricia's Catalog of Unused Clothing

There is a special corner in my closet reserved for clothes I never wear anymore yet can't bring myself to part with.

A royal blue cardigan. Threadbare and faded from years of wash. Has a boxy cut that would be considered unfashionable by today's standards. My mom bought it for herself during a family road trip to Washington, DC, our first exposure to cold weather. I was 13, and at the end of the trip, the cardigan had become mine. This is a classic example of the ease with which my mother gave up things she loved to pass them down to her children.

A maroon jacket with silver buttons. The interior lining for this hot number is a bright, highlighter green. You can see it when you fold the cuffs. Not unfashionable for a preteen, but too youthful for a woman nearing her thirties. The jacket was a present from my godmother when she found out that my family and I were planning to visit DC. It didn't stand a chance against the wind gusts of the Northeast, the poor thing, but I wore it every single day of our trip.

A pair of navy blue Nike jogging pants. Baggy, straight-cut cotton pants that belonged to my father. Also faded from years of wash and very unfashionable. When I was in high school, my family was going through some lean times financially, and Dad gave me his pants to wear for gym class during the winter months. All I could think of at the time was how much I hated that we didn't have any money to buy a more flattering pair; it never occurred to me that Dad's only other pair of jogging pants were the flimsy, breathable kind, which he wore for all four seasons.

I like the idea that these clothes could have a second life if I donate them. But something tells me I'll need them someday, when nothing in the wardrobe I've collected over the years has the power to make me feel like a better, more confident person. I'll turn to my pile of unused clothes and know they will have more to offer than protection from the cold. In my corner, I'll have no space for embarrassment, judgment, or shame—only love.

—Patricia Cruz, Orlando, FL, 2000s

It was right after the Soviet Union collapsed. Many things we had never seen before broke into the market from the West. Stores began to sell Snickers, Mars, Skittles, M&Ms. Those colorful tasty foreign candies were so unusual to us and so different from what we were used to eating! We collected the

wrappers as something very valuable. The characters we were playing also were from Disney's cartoons extremely popular in Russia that just became available to watch or Latin-American soap operas or American action movies. In my childhood playing Russian characters just was not interesting with all this new information coming from across the ocean. Once we found a discarded torn carton box and used it as a raft to play that dramatic final scene from the Titanic movie.

—Daria, Yurgamysh, Kurgan region, Russia, 1990s

A piece of tube . . . aluminum, or maybe copper or steel, 5 to 10 millimeters in diameter. Any boy would give a lot to have one. I was lucky to have one: it used to be a towel hanger in grandma's bathroom. I sawed it, gave a third to my younger brother, and kept the rest. The guys were jealous: the tube was big enough so a small crab apple would fit inside and you could shoot it from the tube. It would hit far and hard. A weapon!

—Ruslan Dautov, Safakulevo, Kurgan region, 1990s

After the 1990 invasion was over, Kuwaiti streets and sidewalks became a minefield on legs. At school we sat in classrooms stained with the toxic smoke of burnt oil wells and were warned never to pick unfamiliar objects off the ground. Later, we were warned not to pick even the most familiar objects off the ground. Empty Cola bottles, ball point pens, battery alarm clocks; they were all a potential explosive hazard in disguise. It only made the broken video cassettes all the more alluring; silky black guts spilled out onto the pavement, distorted reflections curled into tangled intestines of ribbon. We ended up collecting as much as we could, dividing it between the few friends who could be trusted to appreciate its significance. Within a few days, the ribbons would emerge reincarnated, an oil slick of VHS tape devouring random artifacts of daily life. Home videos of birthday parties wrapped carefully around tennis rackets. Kite tails flapping at the sun with cartoons recorded over a graduation ceremony. The Godfather and Bruce Lee knotted into an elaborate garland of teddy bears hung across a bedroom ceiling. And braided through bicycle wheel spokes, Edward Scissorhands danced with Kevin Costner's wolves, rippling and howling against the fiery air, if you could pedal fast enough.

—Sara Eidi, Kuwait, 1990s

Personal Narratives

* * *

My childhood was back in the 1990s. Ukraine was undergoing some serious changes at that time after the collapse of the USSR. For some people, those years presented endless opportunities, while others had to fight for survival. Nobody had any time to raise kids, so children were left on their own most of the time. Unlike the kids of today, we had no computers to keep us busy, so we would hang out in the streets. Many factories were shut down, and all the equipment that was not sold or stolen was thrown out to become children's property. From the variety of gadgets that we found and played with, I especially remember lamination stacks from electric transformers: base-metal hunters would disassemble transformers, steal the copper parts and throw away the lamination stacks. Each of those stacks contained a huge number of metal flats in the E-shape. You could twist them into new shapes or assemble things from them, and they also flew really far if you threw them.

—Enot, Sevastopol, Ukraine, 1990s

* * *

It was in the 1990s: everything that would immediately go to garbage now was carefully collected or reused back then. We'd play with these things often, too; for example, wrappers from Kukurookoo, not to mention various stickers from chocolate and gum—they were so colorful. You would put the wrapper inside a book to "iron" it. Then we used these colorful papers as pretend money and in other games. In short, we tried to collect and conserve everything; we could not bring ourselves to throw away cups from yoghurt, instead we used them to keep little things inside such as beads and stickers. Boxes from juice did not go to waste either: we did not buy juice that often, and the boxes were so pretty. I would cut off the upper part of the box, wash the inside, and then cut out a window, decorate the box with stickers, and present it to Mom. Now, there is no end to all this garbage, but back then there was a deficit of everything and we thought these things were so beautiful, rare and precious. Now it is not even funny to remember these things; it is actually quite sad.

—Nadia Fedorova, Kurgan, Russia, 1990s

* * *

Flawed

I saved them, even after my tape recorder was long broken. I have tapes of my fiddle lessons, tapes of my friends' concerts, even that tape of Copper-

field playing their final gig. Those tapes are somewhere. In a box in the closet, maybe, the dust from years of cat litter settling on them.

Tapes, what is the word? I want to say congeal, like memories congeal once they've sat in the mind too long. I almost remember what was on them, but more the act of making them: the setting of the levels, the firm click of the button when I hit record. My nervous hovering, hoping that I got it right. Knowing that I wouldn't have a chance to go back and fix it.

You can't just rerecord something the way you'd prefer it to be. You have one shot at it, one shot at getting the details right. The treble. The base. The setting of the levels.

At times, the meter shot into the red. I'd be met with a sharp crack, a quick flash of distortion. The second I saw the needle surge, I'd ache to have that moment back. To replay it like the tape I'd made. But not flawed.

This time, not flawed.

But now, the tapes sit in a box. Somewhere. Maybe in the closet, coated with a layer of fine dust. I can't get rid of them, not after all this time. It would be a failure, really. To admit that those taped minutes are over, maybe didn't matter.

Maybe my memories are flawed. The crash of the beer glasses on the table. The raised voices. The sound of the fire truck, barreling down the street, siren blaring. I know it happened, it had to have happened.

As long as I have those tapes. Congealing.

—Lisa Fusch Krause, Seattle, Washington, May 2016;
cassettes dated mid-1980s to 1990s

When I was a small girl of 6–7, I remember how we played with my girlfriends a game called daughters-and-mothers or something of the kind. People lived rather poorly at that time and if we had dolls we didn't take them out of doors, we cherished them and kept at home. Nevertheless, we had something even better to play with outside in the yards and gardens: earcorns! Do you imagine what they look like? A long body and a mess of real brown hair on the top—Barbies of our childhood! We dressed them, we made them plaits and pony tails, we acted out interesting stories and created fairy tales. Earcorns were among our favorite toys. Those were the years when our country's leader Nikita Khrushchov initiated the national campaign of planting and growing corn. Corn was announced to be the queen of all fields (no matter if the climate was actually good for growing it or not). That was the result of Khrushchov's visit to the USA where he saw many cornfields and the idea gave a start to the new agricultural policy.

Personal Narratives

And thus there appeared a lot of corn fields, and little girls like me got their Barbies of earcorns . . .

—Galina, Lebyazhje, Kurgan region, Russia, 1960s

* * *

When I was younger I remember using my sister's old baby wipe boxes to build more houses for my barbies, and to give them a car. I would stack the boxes on top of one another, and arrange different pathways to be the Barbie's room, nursery, kitchen, etc. When Barbie needed to go from point a to point b, all she had to do was hop in her car or baby wipe box and drive there. Looking back on it now I find it quite fascinating how an object as simple as a plastic box once used to hold baby wipes could, in my toddler eyes, be they way of life for Barbie. Mom saw the boxes only as something to hold wipes in, however in my little world they were a town. As I grew older and no longer played with barbies, I only saw the baby wipe boxes as an object with the sole purpose of holding wipes. However, my seven year old sister has now begun playing with them as well, and I see the joy she gets out of using them to hold her random items. Through her eyes I remember the joy I once got from playing with boxes.

—Katie, Chelsea, Alabama, 1990s

* * *

My dad has parked his work truck in the same place every day for the past twenty years. Because of this, grass simply would not grow in that small spot near the side of the house. Every morning, after he left for work, I would make my way outside. I would dig through the trash can under the carport and pull out Styrofoam plates covered in maple syrup, forks stained red from spaghetti, and cups with the coffee ring still in the bottom. The bald spot in the yard my dad used for parking was always a gooey mud pit. I would make my way out with my new treasures and use the mud to make food. Until the sun was sinking behind the clouds, I would imagine new recipes of fancy foods or trying to make things my Grandmother did. I would ball up mud as cookies or cakes and set the table with my used plastic place settings. I would decorate my cakes with dried grass or leaves, and use different sized rocks for various food items like rolls or beans. My dog Happy and I would prepare food for hundreds of people in my restaurant until my Dad would pull up, honk his horn, and park his tires right on top of table three and my kitchen stove. Closing time meant bath time, and I could only hope to find more "supplies" for my restaurant in the trash the next day.

—Kennedy, Woodland, AL, 1990s

We had a plastic chest, rolling out on wheels along the corridors and into bedrooms, the backyard, prickled with bindis and sticky sunshine. It was piled full of scraps and discarded clothing, found or thrifted even, I suppose, long before we were born—our favourites were gold and purple satin, the indigo and star-spun gossamer sheet sliding over the top. My brother, my small doll-child, following behind and shrieking ahead, turning into mother and monster and memory with each shed and pulled-over layer of fabric. They were fields and night skies, rivers and deserts on the grass, cool even in the heat and the buzz of cicadas. In the end, we fit ourselves for gods, carved circles out of the centre of each treasured piece, then, caped and draped, played the nativity into the dwindling twilight.

—Kennedy, Grafton, Australia, 1990s

I was six years old at that time, maybe five. My parents had financial problems. In fact, saying 'financial problems' is a euphemism. Many times my father came back late at night, drunk, while mother remained at home with us (four children). My mom was a cleaning lady; she had no education and came from the extreme south of Italy. Her dream was to become a secretary, but she could not. His father told her that only bitches aspired to be a secretary. The 1960s . . . in Italy. We children had no toys. My parents could not even buy a new TV since the old one had been confiscated by the bailiff. My dad did not pay his debts, nor taxes, so they came and took the TV and other stuff. So toys . . . I remember when one day my mom came back from job. As I said I was six or seven years old. She came back with a big bag packed with old toys (and other stuff) recycled by the sons of the rich family she worked for. I did not realize that those were second hand toys. I did not care, I was simply happy because I got them. After more than 25 years I can still remember many of them. Some years later I did understand from where I came from. I understood my social class. We were poor, that's why I did not have new toys like the others had. It helped me to know that, and thinking about it probably changed my whole life. It pushed me to know more about social justice, inequalities, and so on. However, some second-hand toys and other stuff recycled by 'the rich' made my happiness, which lasted, at least, for a few days.

—Lauros, Rome (suburbs), Italy, 1980s

Personal Narratives

From my early childhood, I remember spending a lot of time looking through old newspapers and magazines. My grandfather had a huge collection of printed materials. Some of it was stored in special closets, and the rest was in the attic and really all around the house. The journals were kept in piles tied with twine. I couldn't read yet, but I loved flipping the fragile old papers and look at the illustrations and photos. I loved the various things that my grandfather collected: he never threw anything away, and had in his possession various old calendars, postcards, old money, coins, wrappers, papers—stuff that only meant something to him, but was useless for everybody else. I also remember the full collection of works by Lenin, bright red volumes that took up several shelves. Nobody read them: the books just stood there in even rows, collecting dust. I once took them down and made a staircase of sorts to get to the upper shelf, where my grandfather kept bullets for the air rifle.

—Marina, Tomsk, Russia, 1980s

I was about 8 years old, living in a small village with my mother and grandmother in South India when my cousin got married. Family member from everywhere arrived and I was proud to show off the village attractions like the mountain that looked like Stalin's profile, the Kennedy canal built with American aid, and the deep pond beside the canal that acted as a catchment area for water. One day I took my cousin from Bombay, a city girl, to the pond so we could play in the shallow end of the water. I did not know swimming and neither did my cousin. Going near the canal or the pond without adult supervision was expressly forbidden but we broke that rule and sneaked away. Around the banks of the pond were teenage boys playing cricket. All seemed peaceful at three in the afternoon when most people in the village were enjoying the siesta. We were both dressed in customary frocks, our long black hair neatly braided in bright colored ribbons—mine in green and hers in red. As we walked down the stone steps to the deep pond we noticed something that looked like a small ball bouncing off the water and I suggested to my cousin we should retrieve it. After all who knew what delight it might bring? Holding each other's hand we slowly descended into the dark, green water not realizing that in the middle was a deep well. Quickly I started slipping away into the water and was inside the water struggling to breathe, but my cousin's hand still held me firmly although she too was struggling as the water started enveloping her. Just then there was a lot of noise and somebody jumped into the water and lifted me out and spun me around so I would expel water from my lungs. It was one of the boys

playing cricket and he was alerted by a young mother who had brought her day's laundry to wash in the pond when she noticed a red ribbon floating in the water. Thinking she would help herself to the bright colored ribbon she tried to grab it when she realized that she was holding a drowning child's head! My cousin, this child, informed the lady that I was deep inside the pond. She knew then that she would not be able to jump in and save us so shouted to the boys to come quickly and pull us out of water. The boys, who were all excellent swimmers, jumped in and saved us. Now if the lady had not wanted to take my cousin's red ribbons for her own little girl at home we may not be alive. Village life necessitates reuse and recycle, and since lives are connected intimately in rural areas in India one person's garbage is somebody's treasure. Needless to say that the ball which we coveted was a broken rubber one and floated away.

—Meera, The South Indian village of Pattamadai,
in Tamil Nadu, India, 1968

* * *

When I was a kid in upstate NY in the 1960s and 1970s, we played outside a lot—as in "most of the time." I was interested in art, but don't remember having more than a few sketch books to my name, and not until about 3rd or 4th grade. SO . . . I made a lot of stuff out of leaves, sticks, rocks, flowers, pine needles with leftover wood and shellac from my father's garage. I also built a lot of impermanent structures out of natural material: walls of rock, "rooms" with benches or tables of dirt or snow, wood/branches for carpets, roofs . . . little altars with flowers, either religious or in honor of some buried frog, tadpole, or salamander. However, if any neighbor bought a new appliance, the box was a free-for-all. It would be turned into a house, a puppet show, or a lemonade stand.

—Nancy, Upstate NY, 1960–70s

* * *

The Haunted Chair rests, motionless for now, on the back screened porch. I can tell it is glaring at the dark sky and unwelcomed April snow storm by the way she has positioned herself—body slightly bent towards the cold, arms seemingly crossed in disapproval, the ripple of her back threatening action. She has seen worse days I'm sure, but I know she spent most of her years by the ocean in a sunny house in Hyannis, Massachusetts. I feel exactly the same way about today's weather, and about my Cape Cod summers. I acquired this old knitting chair (MY chair now) by accident—but still, un-

der the same summer sun—in a town at least six hours from Hyannis. I was drawn to a garage sale for some persistent and inexplicable reason, my four sweaty children strapped safely into car seats behind me. I pulled over, ran straight to a dark corner of the garage, and there she was, waiting for me I like to think. I had no money, so gave my watch as a promissory note, and returned post-game for pick-up. She was a rocker, but one leg was snapped and strapped together. She seemed crippled, but hopeful when I finally paid my debt. "Do you know the story of this chair?" said the owner, reluctantly loading his treasure into my now-empty van. "Nope! I just felt I should have it. I never stop at garage sales and didn't see the chair from the road either. But I knew something was here for me." He is smiling—and not like he thinks I'm crazy, which is exactly how I sound—but like he believes me. "What's the deal?" I ask. "The chair came from the home of the people who owned the now-famous Kennedy Compound in Hyannis. Barton? Barlow? Something like that. When they sold the house to the Kennedy's, they put some of their furniture in storage, and the rest they gave to neighbors for safe-keeping. My mother was one of those neighbors. They never came back, but this chair has quite a history." He proceeds to show me all the things I missed—the hand-made, irregular nails, the straw or hair stuffing, the finely carved lines of the wood frame. He was vetting me for ownership and I must have passed muster, for eventually he let her go, closed the hatch, and patted the roof of my vehicle—a sendoff much like a father relinquishing his daughter at the altar: not exactly sure it's okay, but the decision made at any rate. Although I AM sure this chair is mine by the rights of the universe, at the time I felt compelled to make a case for ownership. I thought I had the perfect spot for her, in front of our fireplace, until she told me differently. My daughter Meg was probably seven. She was afraid of this chair. We both sat on the couch, watching her adjust to our home. She didn't seem at peace there at all and each of us fully expected her to do something about it. "What are we watching for?" asked Meg. "I think she might be haunted; let's see if she rocks." That Meg waited for motion was a sign that she felt it too. The Chair was miserable, and so were we. "Honestly? I think she needs the sun, even though she's supposed to be an inside-chair; the women who originally used this chair would sit by the fire and knit and rock and maybe they would sing, or worry. There is a heavy feel about her, low to the ground, rocking . . . did she just rock?" "I think she did! Mommy!" "Let's put her in the sun—she grew up by the ocean, like you." And out to the back porch she went, scaring no one with her history, content to live out her days with the quiet and sure dignity of knowing she will live past all of us.

—NBR, Hyannis, MA, 1800s–present

* * *

We found a pile of old vinyl records in a dump and for some reason decided that there was a criminal's confession recorded on them. We had to investigate the case. We made my father to take us to grandma who still had a working record player. When we realized it was a bunch of recordings of fairy-tales, we were so disappointed that we never returned to that dump.

—Olesya, Sevastopol, Ukraine, 1990s

* * *

Once my friend and I (we were 5 years old) found a surgeon's toolbox in a dump. There were so many treasures in it! Syringes, scalpels, only not sharp, and a whole lot of different clips and what not. We played doctors for a whole month before our parents found out and confiscated the box.

—Olesya, Sevastopol, Ukraine, 1990s

* * *

I remember playing with a number of discarded objects as a child. A strangely-shaped cap or knob made of white, opaque plastic became a water bottle for dolls, until my mother took it away (old water being dangerous to her mind, even in such a tiny amount). The lid of cardboard box from a colorful jigsaw puzzle became an open-air restaurant on a small tower, where the townsfolk of Littleton, the doll town I built, came to eat and be seen. Served as food in the restaurant, as bread in a tiny bakery, as the wedding cake built for Dawn doll's remarriage (her first husband broke into bits, she was a widow), and as anything requiring a doughy texture were pieces cut out of soft, dimpled, thin, off-white squares of a type of latex acoustic tile or flooring. This significant craft supply came to me as discarded flooring or tiles from a place called the "Ozite" factory. Ozite was a manufacturer of flooring in Orange County, California, where my stepfather had been an occasional security guard at night as a second job. I made that soft, rubbery tile last a long time as doll food and accessories. Sweets and doughy pretend food were important in my play world because food didn't often taste good to me. Cheap canned food, unflavored boiled cabbage, and hard, damaged apples and potatoes, unless your mother is a cooking genius, and she wasn't, means a child dreams of sweet, better-tasting food.

I was an only child, so making dolls also meant making companions. Sometimes my doll companions expressed attitudes I couldn't in daily life. A scrap of maroon yarn leftover from the art supplies cabinet in the

fourth grade classroom of Leo Carillo Elementary School, Garden Grove, CA, became "Smedley," a small fuzzy creature. I'd made a rough pompon out of the small bit of yarn, left one end of the tie in the middle long, to be his tail, and tied a minuscule scrap of cotton ball fiber to the end of the tail as a bow. The low quality of the rough yarn made Smedley less plump, less round than a normal pompon. He sat in a grouchy slump, which I thought lent him character. I still have him, in fact. The secret of very small things is that, while they might easily be lost, they can just as easily be saved, carefully tucked away, to provide you with a pleasant, more whimsical link to your past.

My mother once was getting ready to throw away a small plastic item passed on to her by her in-laws that looked like a fake grandfather clock. It didn't work. It could have originally been placed on a kitchen table or hung on a wall. It was also pretty ugly. My mother wondered why I wanted it. For a house, I said. My stepfather took the mechanical innards out for me, which left two "floors" and an angled "attic." The empty clock became home to three leprechauns/fairies I'd made out of felt. It was an interesting home, but eventually I rejected it because the furniture I'd made for the dolls couldn't quite stay put and would fall out of the house (no backing to the clock.) All of these and many more scraps and bits went to build a world of my own. Dolls and stuffed animals were lent magic, glamour, and necessities of life by the cast-offs I used. I had to be quick to intercept a throwaway item, because once in the garbage, my mother generally wouldn't let me use it. We were low income, but she had a fear of germs and contaminants. The little world was my solace as a child. The world "ended" when my mother, who somehow resented this retreat of mine, destroyed the town, threw away everything except the three tin toy kitchen appliances that formed the town's under-structure. I wanted to weep, but her one warning look meant I could not. I mourned the loss of the town silently for a long time. Of my garbage-rescued toys, I most miss the tiny white vinyl leather sofa I made from my mother's discarded purse. The sofa, about the length of my thumb, was inside a small cardboard jewelry box containing two of the fairy dolls. The box was stolen by burglars from my first apartment, along with these two last dolls and their pets and belongings. The end of a world.

Not all was lost, not in the end. The skills and eye for small things I gained then assist me now in repairing old dolls and making dolls for my renewed pleasure as a grown up and to give pleasure to children and adults whose dolls I fix. I AM grateful that I did not lose my ability to appreciate overlooked objects.

—Omnidoll, Garden Grove, California, USA, 1970s

Fox Face Fur

I would forget it was there, lurking in the dark, waiting to startle me. I'd open the door and jump back in alarm, its glassy, unblinking eyes popping out at me from the pitch black closet. One of those fox face fur neck warmers chic ladies wore in the 1950s, the mouth acted as a clasp for the tail, holding the muffler in place around the neck. It always looked as if it was trying to say something to me—or was I imagining it? No matter which way I turned to avoid its gaze, it stared me down; I could hear its lifeless little scissored teeth snarl my way.

My mother actually wore this, capping off her ocelot skin coat that had the peacock-y shine to it, like a rainbow or Mother-of-Pearl. There was also an alternate fake mink for "special days."

I chalked these outfits up to "Mother stuff" until one day, lolling behind the house, I spied the fox fur in a trash can. It looked so suddenly there not scary but scared. My mother had deemed it no longer worthy, not useful. Maybe it had hit her how strange it was to wear a dead animal around her shoulders, how apart from the rest of her clothes the fox fur was, misunderstood, somehow "other." I went all sad inside yet didn't know why. After all, hadn't these same eyes scared the hell out of me? Hadn't the mute face refused for so long to tell me what secrets it held? But I hated that the fox had been thrown away as if what it had once meant now needed to be forgotten.

I looked in all directions, scooped it up, jammed it fast inside my jacket and spirited it back into the house. I rescued it.

The rare day came when I was alone. Hot, hot day. I put the mink over my shorts and summer shirt, wrapped the fox face fur around it, stuck my too-small feet into a pair of matching pumps and ventured outside.

The fox and I came alive.

Parading around the yard in my mother's clothes. Loving the delicious click-clack of her high heels on the sidewalk. Loving the fox against my neck. It smelled like fur and perfume. I sashayed back and forth, back and forth. I was Audrey Hepburn at a movie premiere, Angela Lansbury in Mame. The world fell away. I was invisible in my discovery of "me." The fox felt almost unbearably lush against my face. The fox, once so scary, turned out to be kind, utterly kind –

I was feeling quite self-pleased until our old lady neighbor, Alice Achin, came flying off her porch. Her head and face became a witch's broom. Her black Oxford shoes grew to the size of elephant apocalypse as

Personal Narratives

she charged at me with a screeching squeal that knocked me over like a bowling pin. I was "a wicked, wicked child!!," "a SEX MANIAC"!!

If I could have, I would have crawled under a shrub and stayed there, or run out into the road. I hightailed it into the house, tripping and skinning my knee as I did. My face a tidal wave of tears, I got the dictionary out and frantically looked up "sex maniac." Finding nothing, I looked up the word "sex"—NO!! then "maniac." Oh, NO!!!! I was filled with fear and then, after a nameless period of time—and I don't know how to explain this—but gradually, gradually as I lay there on the bed, my head nuzzling against my dear fox face fur, a comfort came over me and I fell peacefully asleep.

I saved the fox face fur for years, a talisman of sorts, a protector. It freed me to be myself because it was so very boldly itself, a sly thing, an ugly entity that was, in its essence, a beautiful one. I could not bear to see it relegated to the trash heap of someone's fickle disregard. Once I accepted its oddball charm, I knew what it had been trying to say to me. I gave it back its life and in return, it told me mine.

—Leo Racicot, Lowell, Massachusetts, 1950s

* * *

When my grandparents died we had to clean out their house, and we could keep things we wanted. Everything we did not keep would be thrown away. My grandfather was my biggest inspiration, and the source of all my interests. He had his own library, he was a freelance journalist, a good teacher, an artist, a collector, and he played chess. He taught me chess, how to draw and paint, how to enjoy writing, and how to appreciate art. Of course, as we cleaned out the house, I requested one of his chessboards to be my own, and I was given one of them. It was my strongest relationship with him, in an object that is. I also chose plenty of books, but only one of my cousins would too. Boxes and boxes of books were thrown out, and it broke my heart. To see books being treated that way makes me emotional, and I felt as though my grandfather was there feeling it too, through me. My dad and his siblings had tried to ask he local library if they wanted any, but most of the books were too old. To me they are treasures nonetheless. Now, a series of old books of his are in my room, as a reminder and a memory of him and our shared love for literature.

—Amanda Red, Orsta, Norway, 2013

* * *

Peeling paint has attracted me since childhood. The west side of my uncle's rural house on the Rosebud Sioux Indian Reservation was sided in rough wood shingles. It had been painted white, probably in the 1940s or 50s before I was born. Like reverse shading, the paint was less faded under the eaves where it was sheltered from the relentless extremes of South Dakota weather. The faded shingles ranged from soft gray to espresso with occasional yellow-brown highlights.

It was the stationary deteriorating school bus near his house that thrilled me most. Doubling as a summer bunk-house as well as place to play, the rust red bus had been long into the process of shedding it's bright gold paint like snake skin. The driver's seat and steering wheel was intact and though one had to pry the doors open to get in, play could quickly ensue if one had enough muscle and wherewithal to endure the scraping and grating protests of the rusted mechanism as it opened and shut.

While we sent boys off to Vietnam, a place we'd never heard of, we reservation children played happily with discarded things. An old chicken coop furnished with empty cans and bottles became a store. A shelled car with the backseat intact became our house.

We swam in mucky stock tanks and ponds, drug old tires and empty boxes into the brush to build castles and forts. In winter we warmed ourselves around neighborhood burning barrels after playing long games of tag in the snow. We burned newspapers, catalogs, cereal boxes, school papers and rags, and only when our families decided there was no use left in them.

I never felt deprived.

—CL Prater, Rural South Dakota, 1960s and 1970s

* * *

My brother and I used to make some sort of a kite out of plastic bags. We blew into the plastic bags and put a string around them. Sometimes when we were not allowed to leave the house, especially during the times of missile attacks, we would keep our simple kite out of the window and watch the wind as it was moving it around.

—Sadaf, Tehran, Iran, 1980s

* * *

It was my fault that this item had to be thrown away. It was a kid's plate with the bunny from the Soviet cartoon, *Nu Pogodi*! (a cartoon about a bunny and a wolf, loosely based on Disney's *Tom and Jerry*). I only wanted to eat from that plate, not because of the famous bunny, but because it was different from

Personal Narratives

all other plates in the house. Being unique did not save it from a bitter end though; it broke as did the other plates that were drying in a tub on the table. I do not remember how this happened, but I dropped the tub on the floor. Oh no, not my plate, I thought, looking for it in the pile of chips. I found it broken in half. And while my mother was bustling about, taking care of the mess, I kept asking if the plate could be glued back together. Mom looked at it briefly and said that it couldn't. I tried anyway, but quickly realized that the plate was not functional anymore. So in a day, I buried my bunny plate in the garden, and even went to visit its grave for a while . . . My parents bought me another plate with a picture of the same bunny, but I did not like it. I still cannot understand why I liked that plate so much: I AM not even a fan of that cartoon! I guess its image was ingrained in my imagination though, for each epoch stamps people's subconscious with different visual images and characters.

—Sara, Yerevan, Armenia, 1980s

* * *

The Recycling Angel

The Christmas I was five, I was laid up with chicken pox. Much fuss was made over me. Two of my mother's fellow nurses from the provincial psychiatric hospital, a married couple, brought me a gift. I don't remember what it was, but decorating the parcel were two tiny angels, a boy and a girl. Each was made from two white pipe-cleaners twisted together for their bodies, scraps of white nylon stockings—probably recycled nurse's stockings—for celestial robes, and wrapped around a third pipe-cleaner for wings. Gold foil from cigarette packages was folded into hymnbooks and glued into their pipe-cleaner hands. More foil made gold halos glued to their embroidery-floss curls. Closed, long-lashed eyelids, pink cheeks, and sweetly singing O mouths were painted on their faces, which must have been glued or Mod-podged or had fabric affixed to make them smooth.

Though at least half-garbage, though intended as ephemera, the angels themselves were not garbage. Recycling—upcycling—*avant les lettres* was big in small-town Saskatchewan in 1971, although an actual recycling program and its apparatus wouldn't come along for another quarter century. The psychiatric hospital, like many in North America until the mania for deinstitutionalization in the 1980s and 90s closed them down, was a substantial property encompassing a working farm, a well-equipped carpentry shop, a greenhouse, a golf course, and a curling rink, all of which were staffed and even sometimes managed by patients. Occupational therapy gave the residents a place to create, to learn, to exchange, to contribute, to form and

maintain friendships and enmities side-by-side, to experience satisfaction and tedium: in short, it gave them what work gives us all. Because the products were offered for sale to the public—the plants, planters, picnic tables, bird feeders, and Adirondack chairs were particularly in demand, whereas the craft items like the angels, teams of clothespin reindeer, bleach-bottle nativity scenes, etc., likely were always bought out of charity—OT also gave them a wage. I have no idea what kind of a wage. Probably only enough to buy cigarettes and chocolate bars at the canteen, those being at least as therapeutic as, say, the Largactil or other antipsychotics whose empty brown jeroboams my mother scooped from the hospital trash and took home to bottle her own, weaker distillations.

Long before I came to know what made other people think my mother had a "weird" job—the hospital was a major employer in our small town, but most women gave up work once they became mothers—my parents would take my older brother and me there for picnics on the pleasant grounds and to dances and socials in the public wards. The angels would have been made by one or more of the soft-bordered ladies who'd stroked my hair as I drifted in and out of the music, on a chair, wrapped in my mother's woolen coat, days before I received them.

Very few of my childhood toys survived my nieces and nephew, but I carted half-way across the continent the angels and the things I'd made for them, packed into the four-roomed, orange crate dollhouse my brother had made for me to house the angels.

For at least five years, Jonathan and Marion Small were my best toy. I played with these throwaway people more than Barbies even. Jonathan Small was a priest because of his robe and a button salesman because two small collar buttons fit into the Barbie's purse, which served as his briefcase. His wife Marion was—unlike *my* mum, whose rotating shifts meant that she was often absent for at least two meals a day, and sometimes even slept while I was awake—a devoted mother who spent each day feeding, weighing, and putting to bed the three identical hard plastic Small infants. The babies, like their bottles, weigh-scale, highchairs, and cribs, were store-bought, as were many of the dollhouse's modern conveniences: a pink and purple toilet; a cerise bed big enough for one of the silk animals, but not both Smalls; state-of-the-art Lego stove and fridge; some other things. Their dishes were lapis Limoges festooned with gilt ladies and flowers; I'm not kidding. From their fancy china the Smalls ate caragana pods, Caramilk squares (picture small, square Rolos), and the odd lentil.

Our own dishes were a hodgepodge of flowery things from the 1930s through 60s, replaced when necessary with the brightest, moddest, Op-art-siest articles Kresge's had on offer that week. Though he loved Jonathan

Small, my father was about as different from that gentleman as he could have been. A catskinner—and please remember that in my mind, my *mother* would be the one with the weird job—he was often gone for weeks straight in the summer working road construction. Then, when my mum was working, I had to go two blocks to the Heathers to get babysat by Mrs. Heather, a psychiatric nurse, and her three teenage daughters. The older girls would let me play with their Barbies, who were ogre-like in comparison to the Smalls, but who had breasts. In the winter, my dad was home to look after us and work on our house. He'd often pick up a contract to maintain a sewer line or some other odd job. I liked winters best. Once he brought back from the town dump a new-looking Barbie airplane, scrubbed it with Lestoil and presented it to me. Though I played with it, I knew better than to tell anyone where it had come from.

The Smalls's finery was very fine indeed. What I really loved, though, was to make things for them. All new things in the 1970s came to us encased in plastic. My parents and brother soon knew not to throw anything away until I'd had a crack at it. (I wouldn't touch anything that had actually been thrown in the garbage can, no matter how much I might crave it. One exception was the soft yellow marshmallows in cigarette butts. They smelled bad but made great mattresses and pillows for the Smalls's matrimonial matchbox bed until my mother found them and threw them out.) A new toothbrush meant a long plastic cylinder, which made, say, a fine knitting basket: poke a hole in the top of the lid so yarn could come through, cut the base off, and fill with tiny balls of yarn and toothpick knitting needles. Tooth*paste* caps: well. Lampshades, stools, trash baskets (into which corners of flecks of colored paper were carefully thrown), fences, stages, stairs. Legs for the matchbox bed. Caps from Pop Shoppe pop bottles and liquor bottles, painted or covered in foil, augmented the Limoges service when the silk animals or other visitors came for supper. The rag-bag furnished rugs, paintings, blankets, replacement robes—saris, really—tents, curtains. The Smalls's interior walls were adorned with bits of broken costume jewelry, my emulation of the life-size OT rooster whose plywood base was covered with broken chains, widowed earrings, bracelet relics, watch parts, and buttons, which hung in my room.

The Smalls's household was in some ways like my family's, and in others—important others—not. It reflected my sense of what the world was and what it should be, which is always a vision ripe for splitting. No one who knows me now would be surprised to learn that my aesthetic is influenced by the work of kindly schizophrenics.

I don't remember the gift that the angels adorned. Four decades and many refurbishments later—in fact, their entire bodies are probably

completely replaced by now, in the same way that my father told me, on my seventh birthday, that our bodies replace themselves, cell by cell, every seven years—the angels survive, now occasionally integrated into my daughter's little worlds. She has plenty of plastic toys, but when her best friend comes over, they head straight to the recycling bin, haul stuff out, and make things.
—Wendy Stewart, North Battleford, Saskatchewan, Canada, 1970s

* * *

Main Street

I live in a city of rust,
where I've learned to love expired things.
The ones that trail motes of dust and desperation
when you rub up against them
leaving orange streaks on your tan shirt
because you forgot
that wearing anything but black
is a bad idea when you're in mourning.
On Main street the poets pimp their wares,
the hookers write poems in sweat and sperm,
while the Johnson City Arch sits,
two of its three globes burned out for months,
looking old enough to make lightning dizzy.
The empty and abandoned factories
scare the living crap out of the local pigeons
as they spread their guano on the Masonic Temple
and giving serious consideration
To that statue of Martin on the Riverwalk.
You see, everything new is old again,
every structurally challenged parking lot,
every burned out skull of a residence
staring back at the empty street.
Every store with a fading sheet of oaktag
thanking customers for their patronage
propped behind glass doors that haven't opened
since shoes they sold were real leather
and came from five miles away.
The time clocks and cash registers
in the back room were built
within rock—throwing distance
of the Susquehanna.

Personal Narratives

Now the pride of IBM, for sale on Clinton Street
between the bars and cavernous steel works
where machines built this town in a roar of industry
and cheering Polish workers.
A thin spring sun watches
as aimless passersby
frequent dollar stores,
if only because the 'five and dimes' are gone.
Churches give away real bread and false hope
forgiving the absent their exodus and
the flock their lack of ambition
bred from collapsing iron and broken windows
where the slow fire of oxidation crackles
beyond the range of human hearing
and the scraping rush of the occasional broom
does nothing to break the silence.
 —J. Barrett Wolf, The Triple Cities, Southern Tier, New York, 30s-60s

<div align="center">* * *</div>

They were building Magnitogorsk back in the 1980s. I remember the New Year vacation, with the old movies all day long on TV. The New Year trees are already thrown away on the curb and so are different New Year decorations. The older guys have made hockey sticks from the thrown away tree trunks (with the help of their fathers: you need to dip the tree branch into boiling water to make it bend well into shapes) and are playing hockey. Some of us use tree branches as automatic guns and are playing war. To make a good gun, you need to find a stick with a thick end that looks like a magazine, and then carefully shave the rest of the stick against the fence. The cut off tree branches were also used to make roofs for the snow bunkers that were guarded by kids with those same tree guns. We made bombs and grenades from snow . . . do not confuse with the snowball game: we firmly believed that we were throwing grenades, not snowballs. Then they would show *The Three Musketeers* on TV and those whose hockey sticks got broken used the remains of the sticks as swords. The younger kids would fall asleep dreaming of a chance to find a good sword made by an older boy.
 —Alexander Yakovlev, Magnitogorsk, Russia, 1980s

Illustrations

INTRODUCTION

Fig. 1: Dismembered doll found in abandoned farmhouse, Naperville, Illinois. (Photo by the authors)

Fig. 2: Processed meat tin can and glass jar repurposed as storage container for nuts and bolts. (Photo by the authors)

Fig. 3: *Aloft on a Rock*: Fiber art by Sandra Hopkins made using scraps and remnants of fabric sewn together to tell a Native legend about a group of children and an abused woman fleeing a bear. According to the legend, in their fear they prayed to the Great Spirit to save them. Hearing their prayers, the Great Spirit made the ground rise up to the heavens and they were protected, high out of reach, from the bear. The marking on the tower walls are said to be the claw marks, but the bear could never reach them again. The name of this tower in Wyoming was mistranslated as "Devil's Tower," but the Kiowa call it "Aloft on a Rock." (Artwork (c) 2014 by Sandra Hopkins. Photographed by Beth Bruno. Used by permission.)

Fig. 4: Macca-Villacrosse passage, Bucharest, Romania. (Photo by tefan Jurcă / CC BY 2.0, via Wikimedia Commons)

CHAPTER ONE

Fig. 5: Cardboard storage boxes during renovation of an art gallery in upstate New York. (Photo by the authors)

Fig. 6: Wooden jewelry/trinket box with traditional Romanian etching. (Photo by the authors)

Fig. 7: Special edition Campbell's soup cans with Andy Warhol's autograph. (Photo by Jonn Leffmann / CC BY 3.0, via Wikimedia Commons)

Fig. 8: A broken and rotting park bench at Ickworth Park, Suffolk, England. (Photo by Karen Roe / CC BY 2.0, via Wikimedia Commons)

Fig. 9: Decorative wooden spoon. (Photo by Skyline at Russian Wikipedia / Public domain, via Wikimedia Commons)

Illustrations

CHAPTER TWO

Fig. 10: A diorama by Stewart that uses dollhouse furniture from the artist's childhood, toys from Christmas crackers and gum machines, candy box letters, magazine titles, and more to bring to life an old American lullaby, "Hush, Little Baby." (Diorama © 2017 by Wendy Stewart. Photo by Kally Schoenfeldt. Used by permission.)

Fig. 11: Handmade International Women's Day plaque. (Photo by the authors)

Fig. 12: Wall clock made from discarded vinyl record, St. Petersburg, Russia. (Photo by the authors)

Fig. 13: Old car and truck tires used to line a well used to draw water for a traditional Russian banya, Yurgamysh, Russia. (Photo by the authors)

CHAPTER THREE

Fig. 14: Abandoned factory, England. (Photo by Copta / CC BY 3.0, via Wikimedia Commons)

Fig. 15: Unfinished and abandoned building in a field, Yurgamysh, Russia. (Photo by the authors)

Fig. 16: A crumbling tile mosaic mural on the side of a former sports complex, Yurgamysh, Russia. (Photo by the authors)

Fig. 17: Row of concrete electrical poles stripped of cables, Hagiești, Romania. (Photo by the authors)

Fig. 18: Statue of Lenin in central square, Yurgamysh, Russia. (Photo by the authors)

Fig. 19: Robert E. Lee statue at Lee Circle New Orleans removed. Block party festive atmosphere of people waiting on Howard Avenue. (Photo by Infrogmation of New Orleans, 19 May, 2017 / CC BY 2.0, via Flickr)

Fig. 20: A pile of sand next to a bas-relief of Lenin, presumably to be used to repair the crumbling base, Yurgamish, Russia. (Photo by the authors)

CHAPTER FOUR

Fig. 21: Damaged book and papers following a flood, Binghamton, NY. (Photo by the authors)

Fig. 22: Former Communist party membership identification card (outside cover) pages), circa 1970s, Romania. (Photo by the authors)

Fig. 23: Former Communist party membership identification card (inside pages), circa 1970s, Romania. (Photo by the authors)

Fig. 24: Used train tickets preserved on a page from the journal of artist Brent Williamson, 2015, Binghamton, NY. (Photo by Brent Williamson)

Fig. 25: Envelopes of black and white film and photographs circa 1970s-1980s, Romania. (Photo by the authors)

CHAPTER FIVE

Fig. 26: Broken and disassembled refrigerator and empty water bottles in an occupied hospital room, Bucharest, Romania. (Photo by the authors)

Fig. 27: Crumbling building under renovation (circa 2014–2015) in Old Town, Bucharest, Romania. (Photo by the authors)

Fig. 28: Section of crumbling building in Old Town, Bucharest, Romania. (Photo by the authors)

Fig. 29: Men scavenging through trash for recyclable materials, Bucharest, Romania. (Photo by the authors)

Fig. 30: Overflowing trash on a sidewalk, Bucharest, Romania. (Photo by the authors)

Fig. 31: Slum shacks and a rubbish-laden river with a child in the middle, Indian Himalayas. (Photo by meg and rahul (Flickr) / CC BY 2.0, via Wikimedia Commons)

Fig. 32: Slums built on swampland near a garbage dump in East Cipinang, Jakarta Indonesia. (Photo by Jonathan McIntosh / CC BY 2.0, via Wikimedia Commons)

CHAPTER SIX

Fig. 33: Paper-cardboard box containing 4 oz. of Plasmon, 'pure, soluble, digestible milk protein powder,' a tonic drink, made by Plasmon Ltd. of London, 1900–1950. 'The great nerve and brain food.' (Photo by Science Museum, London. Wellcome Images / CC BY 4.0, via Wikimedia Commons)

Illustrations

Fig. 34: Grey and white cat in a large cardboard box. (Photo by CelloPics / CC BY 2.0, via Wikimedia Commons)

Fig. 35: Makeshift chicken coop, linoleum table cover and recycled wood paneling from old dresser, Hagiești, Romania. (Photo by the authors)

Fig. 36: Makeshift outdoor sink fashioned from old sink bowl, barrel, and plastic buckets, Hagiești, Romania. (Photo by the authors)

Fig. 37: New Orleans after Hurricane Katrina: Damaged pulpit and other items from flood damaged church put on neutral ground to be hauled away as trash in Central City neighborhood. (Photo by Infrogmation / CC BY 2.5, via Wikimedia Commons)

Fig. 37: Recycled art in Santiago, Chile. (Photo by She Paused 4 Thought / CC BY 2.0, via Wikimedia Commons)

Fig. 39: Upcycled teddy bear designed by Olga Bakhareva, Yekateringburg, Russia. (Photo by Olga Bakhareva)

Fig. 40: Upcycled backpack made from old floppy disks, Bucharest, Romania. (Photo by the authors)

CHAPTER SEVEN

Fig. 41: Empty Heineken beer bottles used as decoration in a restaurant, Old City, Bucharest, Romania. (Photo by the authors)

Fig. 42: A boy plays on a playground of recycled tires. Guelph, Canada. (Photo by M. Rehemtulla / CC BY 2.0, via Wikimedia Commons)

Fig. 43: A gee-haw whammy diddle or gee haw whimmy diddle toy with spinning propeller on a notched stick which is made to spin in either direction by stroking the notches with the second stick. The propeller can be made to turn in either direction. The sticks are 8 inches long, made in Beech Creek, North Carolina in the 1960s. (Photo by Pathh / Public domain, via Wikimedia Commons)

Fig. 44: Damaged soccer goal without a net inside a school yard, Bucharest, Romania. (Photo by the authors)

Fig. 45: A young Afghan boy uses a stick to push a wheel down the road in the Arghandab Bazaar, May 30, 2011. Members of Provincial Reconstruction Team Zabul, Arghandab detachment, visited the bazaar to meet

with shop owners and villagers. (Photo by Staff Sgt. Brian Ferguson, US Air Force / Public domain, via Wikimedia Commons)

CHAPTER EIGHT

Fig. 46: Mixed media assemblage (*Perspectives: Praxis* V) by Alexandra Davis using found book cover, wasp nest, bookbinding thread, 8.75 x 6.5 inch. (Photo by Alexandra Davis)

Fig. 47: *Backspace*: mixed media assemblage by Dianne Hoffman consisting of a hinged wine crate, cuckoo clock chains, chandelier crystals, antique ruler, keyhole covers, game score block, typewriter keys, mannequin hand, vintage medicine bottles, Japanese sheet music, Spanish moss and railroad nails (15" x 23" x 3"). (Artwork © 2017 by Dianne Hoffman. Photographed by Su Evers. Used by permission.)

Fig. 48: *A Collection of Imperfections Stitched Together With Good Intentions*: mixed media assemblage by Dianne Hoffman consisting of a vintage sewing machine and jewelry box drawers, wall sconce embellishment, car and doll parts, small vice, monopoly shoe, light bulb with antique switch, keys, pewter monkey, metal Mexican heart, miniature doll house oven, game dice, facet handle, toy train caboose, image clippings from Grey's Anatomy, dictionary text, cuckoo clock chains, brass and rusted metal wire (16" x 16" x 5"). (Artwork © 2017 by Dianne Hoffman. Photographed by Su Evers. Used by permission.)

Fig. 49: A marketing flyer/postcard for *"Trash!,"* an EcoArt exhibit curated by artist Peg Johnston and shown in 2016 at Cooperative Gallery 213, Binghamton, NY. The exhibit featured the works of more than a dozen artists using discarded materials such as paper and cardboard, plastics, fabrics, scrap metal, Styrofoam, and repurposed pieces of wood. (Postcard design by Peg Johnston)

Fig. 50: Wall display of nine different McDonald's and food container assemblages by Peg Johnston shown during a 2016 EcoArt exhibit titled *"Trash!"* at Cooperative Gallery 213, Binghamton, NY. (Photo by Peg Johnston)

Fig. 51: Painting by mixed media recycle artist Ruby Silvious on used, emptied-out tea bag. (Photo by Ruby Silvious)

Fig. 52: Painting by mixed media recycle artist Ruby Silvious on broken, discarded eggshells. (Photo by Ruby Silvious)

Illustrations

Fig. 53: *Desert Dance*: Mixed media assemblage using found drawer, enamel on paper, square head nails, organic matter. (Assemblage © 2007 by Christopher Hynes. Photographed by Eric Beggs. Used by permission.)

Fig. 54: Plastic bag washed and hung on kitchen wall to dry for reuse, Bucharest, Romania. (Photo by the authors)

CHAPTER NINE

Fig. 55: Discarded records and broken crate following a flood, Binghamton, NY. (Photo by the authors)

Fig. 56: Electronics waste pile, Birmingham, Alabama. (Photo by Curtis Palmer / CC BY 2.0, via Wikimedia Commons).

Fig. 57: Broken public telephone, Bucharest, Romania. (Photo by the authors)

Fig. 58: Cable, phone, and Internet wires wrapped around an electrical pole, Bucharest, Romania. (Photo by the authors)

Fig. 59: The WEEE Man (designed by Paul Bonomini) is a sculpture in Cornwall, England made from electrical and electronic waste such as washing machines, TVs, microwaves, vacuum cleaners, and mobile phones. He represents the amount of waste electrical and electronic equipment (WEEE) the average British person throws away in their lifetime—over 3 tonnes per person. (Photo by The Waste Electrical and Electronic Equipment Directive / Free Art License (FAL), via Wikimedia Commons)

Fig. 60: Shredded bits of the UK's National Identity Register database. (Photo by ukhomeoffice (Flickr: Shredded bits of the database) / CC BY 2.0, via Wikimedia Commons)

CHAPTER TEN

Fig. 61: Artist Brent Williamson with a year's worth of hand-sewn journals of written recollections and collected ephemera, 2015, Binghamton, NY. (Photo by Brent Williamson)

Fig 62: Receipts and photograph sewn on a page from the 2015 journals of artist Brent Williamson, Binghamton, NY. (Photo by Brent Williamson)

Fig. 63: *Oppenheimer Portrait*: Mixed media assemblage. Outside: found jewelry case, gold paint, photo of Oppenheimer and atomic bomb, shellac. (As-

semblage © 2012 by Christopher Hynes. Photographed by Eric Beggs. Used by permission.)

Fig. 64: *Oppenheimer Portrait*: Mixed media assemblage. Inside: found jewelry case, hand painted copper plate, photo on glassine, enamel on paper, broken word charm. (Assemblage © 2012 by Christopher Hynes. Photographed by Eric Beggs. Used by permission.)

Fig. 65: An image of the author Orhan Pamuk in his museum, The Museum of Innocence, in Istanbul, Turkey. (Photo by The Museum of Innocence (Press release) / CC BY 2.5, via Wikimedia Commons)

Fig. 66: An exhibit from Orhan Pamuk's museum, The Museum of Innocence, in Istanbul, Turkey. (Photo by The Museum of Innocence (Press release) / CC BY 2.5, via Wikimedia Commons)

Fig. 67: *The Basement Years*: Mixed media assemblage using old desk drawer, acrylic, silver leaf, stereo camera, polaroid land camera, coins, personal photos, flash light, rubber stamp, light bulb, magnet, magnifying glass, litmus paper, antique cup, old sugar bowl lid, various magnifiers, glass jar. One of five commissioned pieces that serve to narrate through objects the life of Eric Beggs. (Assemblage © 2011 by Christopher Hynes. Photographed by Eric Beggs. Used by permission.)

Fig. 68: *The Father:* Mixed media assemblage by Peg Johnston using vintage photos, a funeral card, the internal workings of a lock, a domino, a period thumb tack, and a 1940s penny on a background of a photo of an Endicott Johnson factory. (Photo by Peg Johnston)

Fig. 69: *The Lovers*: Mixed media assemblage by Peg Johnston using vintage photos, handpainted china plate, clothes pin, jewelry box key, created envelope with period stamp, on a background of gingham cloth. (Photo by Peg Johnston)

Works Cited

Abbas, Niran B. *Mapping Michel Serres*. U of Michigan P, 2008.
Adams, Robert Martin. "Rags, Garbage, and Fantasy." *The Hudson Review*, vol. 29, no. 1, 1976, pp. 54–68.
Adichie, Chimamanda Ngozi. "Transcript of 'The Danger of a Single Story.'" *TED*, July 2009, www.ted.com/talks/chimamanda_adichie_the_danger_of_a_single_story/transcript.
Ahn, Presca. "Review: Orhan Pamuk's 'The Innocence of Objects.'" *The American Reader*, n.d., theamericanreader.com/review-orhan-pamuks-the-innocence-of-objects/.
Alexander, Harriet. "Roma on the Rubbish Dump: British Religious Leaders Call on Romanian Mayor to Reverse Forced Evictions." *The Telegraph*, Telegraph Media Group, 17 Feb. 2014, www.telegraph.co.uk/news/worldnews/europe/romania/10636448/Roma-on-the-rubbish-dump-British-religious-leaders-call-on-Romanian-mayor-to-reverse-forced-evictions.html.
Alsever, Jennifer. "What is Crowdsourcing?" *CBS News*, 7 Mar. 2007, https://www.cbsnews.com/news/what-is-crowdsourcing/
Arnason, Horvard H., and Marla Prather. *History of Modern Art: Painting, Sculpture, Architecture & Photography*. Harry N. Abrams, 1998.
Assman, Aleida. "Beyond the Archive." *Waste-Site Stories: The Recycling of Memory*, edited by Brian Neville and Johanne Villeneuve, SUNY Press, 2002, pp. 71–85.
Augustine, St. *Confessions*. Translated by E. B. Pusey, Oxford, John Henry Parker, F and J Rivington, London, 1853.
Bachelard, Gaston. *The Poetics of Space*. Beacon Press, 1994.
Baker, Mark. "Travel—Bucharest's New Old City." *BBC*, BBC, 16 July 2013, www.bbc.com/travel/story/20130712-bucharests-new-old-city.
Barthes, Roland. "Rhetoric of the Image." *Image Music Text: Essays Selected and Translated by Stephen Heath.*. Fontana Press, 1977, pp. 32–51.
—. "Toys." *Mythologies*. Translated by Annette Lavers, The Noonday Press, 1991, pp. 53–56.
Bataille, George. *Visions of Excess: Selected Writings, 1927–1939*. U of Minnesota P, 2008.
Baudrillard, Jean. *The System of Objects*. London, Verso, 2005.
Becker, Wolfgang, director. *Goodbye, Lenin!* X-Filme Creative Pool, 2003.
Beckley, Bill. "On Sunday Afternoons: Conversations with Louise Bourgeois." *Bill Beckley*, www.billbeckley.com/writings/louise-bourgeois.

Benjamin, Walter. *The Arcades Project*. Cambridge, MA, Belknap Press of Harvard UP, 2002.

—. *Berlin Childhood around 1900*. Cambridge, MA, Belknap Press of Harvard UP, 2006.

—. "Excavation and Memory." *Selected Writings*, vol. 2, part 2, Cambridge, MA, Belknap Press of Harvard UP, 2005.

—. "Ibizan Sequence." *Selected Writings*, edited by Marcus Paul Bullock et al., vol. 2, Part 2, Cambridge, MA, Belknap Press of Harvard UP, 2005.

—. "One-Way Street." *Selected Writings*, edited by Marcus Bullock and Michael Jennings, vol. 1, Cambridge, MA, Belknap Press of Harvard UP, 2004.

—. "The Storyteller." *Illuminations*. New York, NY, Schocken Books, 1969.

—. "The Work of Art in the Age of Mechanical Reproduction." *Illuminations*. New York, NY, Schocken Books, 1969, pp. 217–51.

Bennett, Jane. "Powers of the Hoard: Artistry and Agency in a World of Vibrant Matter." 13 Sept. 2011, New York, NY, The New School.

—. *Vibrant Matter: a Political Ecology of Things*. Durham, Duke University Press, 2010.

Berger, John. "White Bird." *The Sense of Sight*, Vintage, 1993, pp. 5–9.

Birkerts, Sven. "Into the Electronic Millennium." *Boston Review*, Oct. 1991, bostonreview.net/archives/BR16.5/birkerts.html.

Bogost, Ian. *Alien Phenomenology, or What It's like to Be a Thing*. U of Minnesota P, 2012.

Botonogu, Florin. *Hidden Communities: Ferentari*. Bucharest, Editura Expert, 2011.

Boym, Svetlana. *The Future of Nostalgia*. Basic Books, 2008.

—. "Ruinophilia: Appreciation of Ruins." *Atlas of Transformation*, monumenttotransformation.org/atlas-of-transformation/html/r/ruinophilia/ruinophilia-appreciation-of-ruins-svetlana-boym.html.

Brown, Bill. *Other Things*. U of Chicago P, 2016.

—. "Thing Theory." *Critical Inquiry*, vol. 28, no. 1, *Things*, 2001, pp. 1–22.

Butler, Judith. *Bodies That Matter: On the Discursive Limits of "Sex."* Psychology Press, 1993.

"Cardboard Box." *Cardboard Box | National Toy Hall of Fame*, The Strong: National Museum of Play, www.toyhalloffame.org/toys/cardboard-box.

Chow, Rey. "Fateful Attachments: On Collecting, Fidelity, and Lao She." *Things*, edited by Bill Brown, U of Chicago P, 2004.

Cioran, Emile Michel. *On the Heights of Despair*. London, Quartet Books, 1995.

Cixous, Hélène. *Coming to Writing and Other Essays*. Cambridge, MA, Harvard UP, 1991.

Cole, Teju. "Object Lesson." *The New York Times*, The New York Times, 17 Mar. 2015, www.nytimes.com/2015/03/22/magazine/object-lesson.html.

Works Cited

Coole, Diana H., and Samantha Frost. *New Materialisms: Ontology, Agency, and Politics*. Duke UP, 2010.

Craig, Barbara L. "American Archivist." *SAA: American Archivist* (v65:2), 2002, www.archivists.org/periodicals/aa_v65/v65_2/. Accessed 30 June 2017.

Daly, Max. "Bucharest's Drug-Addicted Roma Are Being Left to Rot." *Vice*, 21 July 2015, www.vice.com/en_us/article/kwxzbz/romanias-drug-addicted-roma-are-being-left-to-rot-456.

Davis, Douglas. "The Work of Art in the Age of Digital Reproduction (An Evolving Thesis: 1991–1995)." *Leonardo*, vol. 28, no. 5, 1995, pp. 381–86. *Third Annual New York Digital Salon*.

Debord, Guy. *The Society of the Spectacle*. Zone Books, 1995.

Deleuze, Gilles, et al., *Anti-Oedipus: Capitalism and Schizophrenia*. London, Continuum, 2004.

Derrida, Jacques. "Archive Fever: A Freudian Impression." *Diacritics*, vol. 25, no. 2, 1995, pp. 9–63.

Didion, Joan. "On Keeping a Notebook." *Slouching Towards Bethlehem: Essays*. Farrar, Straus and Giroux, 2008, pp. 131–42.

Dillon, Brian. "Fragments from a History of Ruin." *CABINET // Fragments from a History of Ruin*, 2006, cabinetmagazine.org/issues/20/dillon.php.

Domonoske, Camila. "Tea, Pride, Mystery: For One Family That Fled The Nazis, A Tin Canister Held It All." *NPR*, NPR, 3 June 2016, www.npr.org/sections/thetwo-way/2016/06/03/480176649/tea-pride-mystery-for-one-family-that-fled-the-nazis-a-tin-canister-held-it-all.

Douglas, Mary. *Purity and Danger: An Analysis of Concepts of Pollution and Taboo*. Taylor and Francis, 2003.

Evans, Owen, et al., *Soviet Ghosts: The Soviet Union Abandoned: A Communist Empire in Decay*. Carpet Bombing Culture, 2014.

Felluga, Dino F. "Modules on Kristeva: On the Abject." *Introductory Guide to Critical Theory*, Purdue University, 31 Jan. 2011, www.cla.purdue.edu/english/theory/psychoanalysis/kristevaabject.html.

Fer, Briony. "Objects beyond Objecthood." *Oxford Art Journal*, vol. 22, no. 2, 1999, pp. 27–36.

Foster, Hal. *The Return of the Real: The Avant-Garde at the End of the Century*. MIT Press, 1996.

Freeman, Lindsey A., et al., "Memory / Materiality / Sensuality." *Memory Studies*, vol. 9, no. 1, 2016, pp. 3–12., doi:10.1177/1750698015613969.

Freud, Sigmund, et al., *Beyond the Pleasure Principle*. New York, Norton, 1989.

Fukuyama, Francis. "The End of History?" *The National Interest*, 1989.

"Garage Sale Statistics." *Statistic Brain*, Statistic Brain Research Institute, 1 Apr. 2017, www.statisticbrain.com/garage-sale-statistics/.

Gillet, Kit. "Risky Cities: Red Equals Danger in Bucharest, Europe's Earthquake Capital." *The Guardian*, Guardian News and Media, 25 Mar. 2014, www.theguardian.com/cities/2014/mar/25/risky-cities-red-equals-danger-in-bucharest-europes-earthquake-capital.

Gladdis, Keith. "Life inside the Romanian Gypsy Ghetto That is so Grim the Town Mayor Sealed It off behind a Wall." *Daily Mail Online*, Associated Newspapers, 1 Mar. 2013, www.dailymail.co.uk/news/article-2285796/Romanian-gypsies-living-condemned-ghetto-mayor-built-wall-around.html.

Goldsmith, Kenneth. *Uncreative Writing: Managing Language in the Digital Age*. Columbia UP, 2011.

Guneratne, Anthony R., et al., *Rethinking Third Cinema*. London, Routledge, 2003.

Hall, Trish. "Lifestyle; The Making of a College Cult." *The New York Times*, The New York Times, 9 June 1990, www.nytimes.com/1990/06/10/style/lifestyle-the-making-of-a-college-cult.html?pagewanted=all.

Harrow, Kenneth W. *Trash: African Cinema from Below*. Indiana UP, 2013.

—. "Trash and a New Approach to Cinema Engagé." *Black Camera*. Indiana UP, 4 Mar. 2010, muse.jhu.edu/article/364682.

Hawkins, Gay, and Stephen Muecke. *Culture and Waste: the Creation and Destruction of Value*. Lanham, MD, Rowman & Littlefield, 2003.

Heidegger, Martin. "Building Dwelling Thinking." *Basic Writings*, Harper Collins, 1993, pp. 343–64.

Herwig, Christopher. *Soviet Bus Stops*. Fuel Design & Publishing, 2016.

Heynen, Hilde. "Transitoriness of Modern Architecture." *Modern Movement Heritage*, edited by Allen Cunningham, E&FN Spon, London and New York, 2005, pp. 25–32.

Hicok, Bob. *Words for Empty and Words for Full*. U of Pittsburgh P, 2010.

Hine, Thomas. *The Total Package: The Secret History and Hidden Meanings of Boxes, Bottles, Cans, and Other Persuasive Containers*. Little, Brown and Company, 1997.

—. "The Total Package: The Secret History and Hidden Meanings of Boxes, Bottles, Cans and Other Persuasive Containers." *Thomas Hine*, 29 Nov. 2015, www.thomashine.com/the_total_package_the_secret_history_and_hidden_meanings_of_boxes_bottles_cans_3429.htm.

Hoffman, Eva. *Lost in Translation: a Life in a New Language*. New York, Penguin Books, 1990.

Horn, Christian, et al., "'Tonight Will Be a Memory Too'—Memory and Landscapes." *International Open Workshop 2017*, Kiel University, Mar. 2017, www.workshop-gshdl.uni-kiel.de/workshop-sessions/session-2017-03/.

Works Cited

Huizinga, Johan. *Homo Ludens: A Study of the Play-Element in Culture*. Angelico Press, 2016.

Žižek, Slavoj. "Fat-Free Chocolate and Absolutely No Smoking: Why Our Guilt about Consumption Is All-Consuming." *The Guardian*, Guardian News and Media, 21 May 2014, www.theguardian.com/artanddesign/2014/may/21/prix-pictet-photography-prize-consumption-slavoj-zizek.

Ilnitsky, Sergey. "The World Press Photo Winners 2014—in Pictures." *The Guardian*, Guardian News and Media, 12 Feb. 2015, www.theguardian.com/artanddesign/gallery/2015/feb/12/world-press-photo-winners-2014-in-pictures.

Ishiguro, Kazuo. *Never Let Me Go*. Vintage, 2006.

Iversen, Margaret. "Readymade, Found Object, Photograph." *Art Journal*, vol. 63, no. 2, 2004, pp. 44–57.

Jacobs, Shayna. "EXCLUSIVE: All City Court Records Lost in Brooklyn Blaze." *NY Daily News*, 22 Mar. 2015, www.nydailynews.com/news/politics/exclusive-city-court-records-lost-brooklyn-blaze-article-1.2158374.

Kelly, Kevin. *What Technology Wants*. London, Penguin, 2011.

Kristeva, Julia. *Powers of Horror: An Essay on Abjection*. Columbia UP, 2010.

Last Week Tonight with John Oliver. HBO, 16 Mar. 2016, www.youtube.com/watch?v=zsjZ2r9Ygzw.

Lempesis, Dimitris. "Art Cities: Paris – Arman." *Dream, Idea, Machine*. http://www.dreamideamachine.com/en/?p=10404

Lyotard, Jean-François. *The Inhuman*. Stanford UP, 1991.

Lyotard, Jean-François. *Lessons on the Analytic of the Sublime*. Stanford UP, 1994.

Manella, Morgan. "Drug Baggies: 'An Addiction Made Public.'" *CNN*, Cable News Network, 19 Apr. 2016, www.cnn.com/2016/04/19/health/cnn-photos-drug-baggies/index.html.

Manning, Erin. *Politics of Touch: Sense, Movement, Sovereignty*. U of Minnesota P, 2007.

Marica, Irina. "How Many Roma People Live in Romania?" *Romania Insider*, 3 June 2016, www.romania-insider.com/many-roma-people-romania.

McEwan, Ian. *Atonement: A Novel*. Anchor Books, 2003.

McGrath, Stephen, and Jonn Elledge. "Is Bucharest Ready for the Earthquake That Could Kill Thousands of Its Citizens?" *CityMetric*, 16 Dec. 2015, www.citymetric.com/skylines/bucharest-ready-earthquake-could-kill-thousands-its-citizens-1645.

Mechoulan, Eric. "Parthenon, Nashville: From the Site of History to the Sight of Memory." *Waste-Site Stories: The Recycling of Memory*, edited by Brian Neville and Johanne Villeneuve, SUNY Press, 2002, pp. 143–53.

Mihov, Nikola. "Forget Your Past." *Nikola Mihov*, www.nikolamihov.com/forget-your-past.

Mills, Chris, et al., "How 'Defensive Architecture' Is Ruining Our Cities." *Gizmodo Australia*, 22 Feb. 2015, www.gizmodo.com.au/2015/02/how-defensive-architecture-is-ruining-our-cities/.

Mishima, Yukio. *The Temple of the Golden Pavilion*. London, Vintage Books, 2001.

"A Modest Manifesto for Museums." *The Museum of Innocence*, 2014, en.masumiyetmuzesi.org/page/a-modest-manifesto-for-museums.

Muller, Maria, and Anne Schienberg. "Gender and Urban Waste Management." *Urban Enviornmental Management*, The Global Development Research Center, www.gdrc.org/uem/waste/swm-gender.html.

Murphy, Brian Michael. "Bomb-Proofing the Digital Image: An Archaeology of Media Preservation Infrastructure." *Media-N: Journal of the New Media Caucus*, New Media Caucus, 30 May 2014, median.newmediacaucus.org/art-infrastructures-hardware/bomb-proofing-the-digital-image-an-archaeology-of-media-preservation-infrastructure/.

National Toy Hall of Fame. www.toyhalloffame.org/toys/stick

Navaro-Yashin, Yael. "Affective Spaces, Melancholic Objects: Ruination and the Production of Anthropological Knowledge." *Journal of the Royal Anthropological Institute*, vol. 15, 2009, pp. 1–18.

Nora, Pierre. "Between Memory and History: Les Lieux De Mémoire." *Representations: Memory and Counter-Memory*, no. 26, 1989, pp. 7–24., doi:10.2307/2928520.

Odom, William, et al., "Lost in Translation: Understanding the Possession of Digital Things in the Cloud." *Conference proceedings: SIGCHI Conference on Human Factors in Computing Systems*. ACM, 2012, pp. 781–90.

Olsen, Bjørnar. "Reclaiming Things: An Archaeology of Matter." *How Matter Matters: Objects, Artifacts, and Materiality in Organization Studies*, edited by Paul R Carlile et al., Oxford UP, Oxford, 2013, pp. 171–196.

Ortner, Sherry. "Is Female to Male What Nature Is to Culture?" *Woman, Culture, and Society*, edited by Michelle Zimbalist Rosaldo and Louise Lamphere, Stanford UP, 1974, pp. 67–89.

Orwell, George. *Keep the Aspidistra Flying*. London, Penguin Books, 2014.

Pamuk, Orhan. "The Art of Fiction No. 187." *The Paris Review*, 26 May 2016, theparisreview.tumblr.com/post/144964931804/from-tiny-experiences-we-build-cathedrals.

—. *The Innocence of Objects: The Museum of Innocence, Istanbul*. Abrams, 2012.

—. *The Museum of Innocence: A Novel*. London, Faber and Faber, 2009.

Pinter, Jacob. "Something Old, Something New: Public Service Broadcasting On History And Storytelling." *NPR*, NPR, 5 July 2017, www.npr.org/2017/07/05/535352500/something-old-something-new-public-service-broadcasting-on-history-and-storytell.

Poet: Internet Has Revolutionized Reading. CNN, 2014, edition.cnn.com/videos/business/2014/06/03/spc-reading-for-leading-kenneth-goldsmith.cnn.

Premiyak, Liza. "Looking for Lenin: Hunting down Banned Soviet Statues in Ukraine." *The Calvert Journal*, www.calvertjournal.com/features/show/5790/lenin-soviet-monument-ukraine.

Rancière, Jacques. *Aesthetics and Its Discontents*. Polity, 2009.

Rann, Jamie. "Beauty and the East: Allure and Exploitation in Post-Soviet Ruin Photography." *The Calvert Journal*, www.calvertjournal.com/contributors/show/1798/jamie-rann.

Rifkin, Jeremy. *Age of Access: The New Culture of Hypercapitalism, Where All of Life Is a Paid-for Experience*. Tarcher (J.P.) Inc., 2001.

Rilke, Rainer Maria. *Letters on Life: New Prose Translations*. Modern Library, 2006.

Romanek, Mark, director. *Never Let Me Go*. Fox Searchlight Pictures, 2010.

Rourke, Daniel. "Kipple and Things: How to Hoard and Why Not To Mean." *Daniel Rourke*. Daniel Rourke, 31 July 2011, www.machinemachine.net/portfolio/kipple-and-things/.

Ryan, Connor. "Regimes of Waste: Aesthetics, Politics, and Waste from Kofi Awoonor and Ayi Kwei Armah to Chimamanda Adichie and Zeze Gamboa." *Research in African Literatures*, vol. 44, no. 4, 2013, pp. 51–68.

Schopenhauer, Arthur. *The World as Will and Representation*. Createspace, 2015.

Sekirin, Peter. *Memories of Chekhov: Accounts of the Writer from His Family, Friends and Contemporaries*. Jefferson, NC, McFarland, 2011.

Serres, Michel. *Genesis*. Ann Arbor, The U of Michigan P, 1997.

Shanks, Michael, et al., "The Perfume of Garbage: Modernity and the Archaeological." *Modernism / Modernity*, vol. 11, no. 1, 2004, pp. 61–83.

Shapiro, Michael J. *War Crimes, Atrocity and Justice*. Cambridge, UK, Polity Press, 2015.

Shew, Ashley. "To the Cloud! Loss in the Age of Digital Memory." *The New Everyday: A Media Commons Project*, NYU, 1 Oct. 2013, mediacommons.futureofthebook.org/tne/pieces/cloud-loss-age-digital-memory.

Shipka, Jody. "The Things They Left Behind: The Estate Sale as an Archive." *Provocations: Reconstructing the Archive*. Computers and Composition Digital Press, 2015, ccdigitalpress.org/reconstructingthearchive/shipka.html.

Shockey, Lauren. "In Former East Germany, a Search for Lost Foods." *The Atlantic*, Atlantic Media Company, 14 Apr. 2010, www.theatlantic.com/health/archive/2010/04/in-former-east-germany-a-search-for-lost-foods/38902/.

Shove, Elizabeth, et al., *The Design of Everyday Life*. Berg, 2007.

Simic, Charles. *Dime-Store Alchemy: The Art of Joseph Cornell*. New York Review, 2011.

Sooke, Alastair. "Culture—The Man Who Destroyed All His Belongings." *BBC*. BBC, 14 July 2016, www.bbc.com/culture/story/20160713-michael-landy-the-man-who-destroyed-all-his-belongings.

Stam, Robert. "Beyond Third Cinema: The Aesthetics of Hybridity." *Rethinking Third Cinema*, edited by Anthony R Guneratne and Wimal Dissanayake, Routledge, 2003, pp. 31–49.

Stan, Lavinia. "Inside the Securitate Archives." *Cold War International History Project*, Wilson Center, 4 Mar. 2005, www.wilsoncenter.org/article/inside-the-securitate-archives.

Stanton, Brian. "Humans of New York." *Humans of New York*, 29 May 2016, www.humansofnewyork.com/post/145077658286/im-going-to-build-a-rocket-ship-out-of-a-trash. Accessed 7ADAD.

Swaffield, Bruce Carl. *Rising from the Ruins: Roman Antiquities in Neoclassic Literature*. Cambridge Scholars, 2009.

Tarkovskii, Andrei, and Kitty Hunter-Blair. *Sculpting in Time: Reflections on the Cinema*. U of Texas P, 1987.

—. *Sculpting in Time: Reflections on the Cinema*. U of Texas P, 2014.

Taylor, Astra, director. *Examined Life*. Zeitgeist Films, 2008.

Taylor, Brandon. *Collage: The Making of Modern Art*. London, Thames & Hudson, 2014.

Thill, Brian. *Waste*. New York, London, Oxford, New Delhi, and Sydney, Bloomsbury Academic, 2015.

"Transmogrifier." *The Calvin and Hobbes Wiki | FANDOM Powered by Wikia*, calvinandhobbes.wikia.com/wiki/Transmogrifier.

Trigg, Dylan. *The Memory of Place: A Phenomenology of the Uncanny*. Ohio UP, 2012.

"Upcycle That." *Upcycle That*, www.upcyclethat.com/.

Vella, Daniel. "No Mastery Without Mystery: Dark Souls and the Ludic Sublime." *Game Studies: the International Journal of Computer Game Research*. The Swedish Research Council , July 2015, gamestudies.org/1501/articles/vella.

Vendler, Helen. "'The Voice at 3 AM.'" *The New York Review of Books*, 10 June 1999, www.nybooks.com/articles/1999/06/10/the-voice-at-3-am/.

Vertov, Dziga, director. *Man with the Movie Camera*. VUFKU, 1929.

Viney, William. *Waste: A Philosophy of Things*. London, Bloomsbury, 2015.

Vinitzky-Seroussi, Vered, and Chana Teeger. "Unpacking the Unspoken: Silence in Collective Memory." *Social Forces*, vol. 88, no. 3, Mar. 2010, pp. 1103–122.

waal, Edmund De. "Cultural Artifacts 'The Innocence of Objects,' by Orhan Pamuk." *The New York Times*. The New York Times, 1 Dec. 2012, www.nytimes.com/2012/12/02/books/review/the-innocence-of-objects-by-orhan-pamuk.html.

Works Cited

Wallach, Amei, et al., *Ilya Kabakov: the Man Who Never Threw Anything Away*. Harry N. Abrams, 1996.

Wayne, Teddy. "Our (Bare) Shelves, Our Selves." *The New York Times*. The New York Times, 5 Dec. 2015, www.nytimes.com/2015/12/06/fashion/our-bare-shelves-our-selves.html.

Webster, George. "The Eco Artists Turning Trash into Treasure." *CNN*, Cable News Network, 16 Mar. 2012, www.cnn.com/2012/03/16/world/environmental-green-art/index.html.

Weiser, Sonia. "Should Prince's Tweets Be in a Museum?" *The Atlantic*. Atlantic Media Company, 5 July 2016, www.theatlantic.com/technology/archive/2016/07/should-princes-tweets-be-in-a-museum/489776/.

Weld, Kirsten. *Paper Cadavers: The Archives of Dictatorship in Guatemala*. Duke UP, 2014.

"Where Does e-Waste End up?" *Greenpeace International*, 24 Feb. 2009, www.greenpeace.org/international/en/campaigns/detox/electronics/the-e-waste-problem/where-does-e-waste-end-up/.

Woodruff, Bob, et al., "Life in the Tunnels: Inside the Underground World of Bucharest, Romania's Sewer Kids." *ABC News*. ABC News Network, 28 Nov. 2014, abcnews.go.com/International/life-tunnels-inside-underground-world-bucharest-romanias-sewer/story?id=27200275.

Yee, Vivian. "Fire at a Brooklyn Warehouse Puts Private Lives on Display." *The New York Times*. The New York Times, 1 Feb. 2015, www.nytimes.com/2015/02/02/nyregion/large-warehouse-fire-continues-to-burn-in-brooklyn.html. Accessed 1 July 2017.

Index

abject, the, 98–101, 103–104, 107, 110, 113, 115–116, 119, 187
Adichie, Chimamanda Ngozi, 12
Adorno, Theodor, 59
aesthetics, 56, 59, 85, 90, 131, 137, 141–142, 145, 166–168, 171–173, 180–181, 183, 186–190, 271
affect, 40–42, 51, 90, 115, 188, 191, 209–210, 213–214
archive, 3, 16, 24, 75–79, 81–87, 89, 91, 93–94, 127, 213, 224, 227; digital, 209
art, 3–4, 11, 19–20, 23–24, 26, 37, 47, 49, 70, 79, 87, 91, 127, 140, 142, 157, 161, 168, 170–175, 177–181, 183, 186–189, 194, 208–210, 228, 239, 253–254, 262, 264, 267, 270
artifact, 46–47, 157, 236, 239; cultural, 4; digital, 205, 209, 211–212, 214–215; material, 86, 89–90, 141, 166
Assman, Aleida, 85–87, 182–183
Augustine, St., 6

Bachelard, Gaston, 21, 42, 44, 50–51
Barthes, Roland, 9, 151, 153–155, 161, 186
Baudrillard, Jean, 22, 54–56, 62, 153–154, 223, 230
Benjamin, Walter, 7, 13, 15–17, 31, 62, 157–159, 205, 207–208, 239–240
Bennett, Jane, 27, 29–31, 84, 185, 188–189
Birkerts, Sven, 195–196, 197, 199–202, 204–205, 216, 222

Bogost, Ian, 27, 31, 53, 91
Boym, Svetlana, 56, 60
Breton, Andre, 32, 187
Brown, Bill, 11, 27, 29, 31, 207, 222
Butler, Judith, 113, 136

Cioran, Emil, 63
collecting, 14, 16, 21, 24–26, 35, 38, 46, 55, 59, 75, 85, 86–89, 91, 97, 99, 111, 115–116, 127, 139, 147–148, 160, 170, 177, 195, 209, 217, 219, 222, 232, 234, 242–243, 244, 247, 254, 256–257, 261
conspicuous consumption, 142
consumerism, 3, 13, 20, 131, 134, 151, 181, 240
contamination, 116, 119; social, 117
Coole, Diane, 10
Cornell, Joseph, 187, 230
Craig, Barbara, 5, 205
cultural imaginary, the, 113–114

death drive, 75, 77–78, 82–83, 216
Debord, Guy, 84
decay, 5, 28, 45, 53, 54, 59–60, 63, 67–68, 73, 75, 98, 100, 102–103, 107–109, 121, 127, 146, 165, 167, 170, 187, 193, 203, 205, 208, 215–216, 242
decomposition, 28, 45, 113, 187, 190, 214
Derrida, Jacques, 75–76, 78, 83, 85, 94, 204, 224
Dick, Phillip K., 7, 9
digital erasure, 214, 223

Douglas, Mary, 99, 107, 109, 113, 208
Duchamp, Marcel, 183, 186–187

ecology, 30, 132, 136, 141, 144, 178, 207
embodiment, 6, 33, 45, 87, 113, 209, 214, 238; digital, 17, 171, 193, 198, 203, 207, 215, 217, 227

flâneur, 187
Freeman, Lindsey, 31, 50
Frost, Samantha, 10

garbage, 4, 12, 14, 18, 30, 33, 47, 65, 67, 73–74, 82, 83–86, 89, 99, 106–111, 114–115, 119–120, 126, 134, 136–137, 139, 141, 147–148, 161, 168, 185, 192, 247, 251, 257, 262, 265, 269, 271
gender, 11, 113–114, 161–162, 170, 244
Goldsmith, Kenneth, 13–15, 90

Halbwachs, Maurice, 66–67
Harrow, Kenneth W., 86, 100–101, 109, 137
Heidegger, Martin, 15, 42, 46, 51, 199, 204, 216
Hine, Thomas, 19, 122, 126, 131–132, 135
historiography, alternative, 118, 242
history, 3–6, 17, 20, 25–26, 36, 42, 46–47, 54, 60–63, 68, 70, 80, 85–86, 90, 93–94, 100, 104–105, 123, 141, 143, 170, 175, 179, 201, 203–204, 208, 217, 223–224, 228, 233, 236, 238, 242, 244, 263; collective, 61; personal, 50, 94–95, 139

Huizinga, Johan, 157, 165, 167

imminent catastrophe, 101, 110, 224, 228
Iron Mountain, 227, 228, 230
Ishiguro, Kazuo, 111–112, 116, 120–121

Kabakov, Ilya, 86–87
kipple, 7–10
Kristeva, Julia, 98–100, 103, 110, 113–114

Latour, Bruno, 11, 27
lieu de memoire, 26
ludic, 150, 155, 165–167
Lyotard, Jean-François, 166

mal d'archive, 76
matter, 4, 7, 10–11, 13, 16, 18, 27–32, 35, 45, 51–52, 56, 66, 76, 107, 109, 116, 131, 151, 175, 180, 188–189, 196, 203, 206, 208, 211, 213–214, 220, 228, 232, 239, 242, 258, 266, 271
memory, 3–7, 10, 16, 20, 22–27, 31–33, 36–37, 39, 42, 44–48, 50–52, 57, 59–62, 65–69, 71, 75, 77–78, 83–84, 86–88, 94–98, 110, 118, 121, 129, 135, 139, 141, 146, 158–160, 169–170, 172, 175, 193, 198, 201, 203, 205, 207, 212–216, 218, 224, 233, 236–244, 260, 267; collective, 46, 54, 61, 66–67, 175, 193, 198, 213; embodied, 50; historical, 83, 201; preservation of, 20, 75, 213–214, 243
Mitchell, W.J.T., 31
monuments, 37, 53–54, 57, 61–62, 66, 68, 70–74, 201, 223, 233
mortality, 5, 23, 45, 101, 107, 215

Index

museum, 70–89, 135, 179, 228–232, 234, 239, 244

narrative, 13, 16, 40, 46–47, 59, 66, 75, 77, 84, 91, 98, 118, 128, 141, 158, 193, 198, 236–237, 241–242, 244
narrative agency, 118
Nerval, Gerard de, 15
new materialism, 10, 27
new media, 196, 209
Nora, Pierre, 20–21, 24–25
normativity, 19, 112–113, 117
nostalgia, 3, 13, 17, 35, 38, 42, 46, 59, 65, 76, 88, 98, 141–142, 193–195, 203, 215

object, discarded, 4, 15, 26, 46–47, 61, 75, 100, 116, 141, 154, 156, 161, 164–165, 167, 170, 174, 223, 264
objet trouvé, 168
Odom, William, 219, 221, 223–224, 230
Olsen, Bjornar, 6
Ortner, Sherry, 114
Other, the, 31–32, 110, 116, 165

Pamuk, Orhan, 228–233, 242

recycling, 12, 100, 106, 115, 124, 126, 128–129, 131–132, 134, 136–138, 140–141, 144, 146, 178, 184–185, 250, 262, 269, 272
resistance, 28, 31, 75, 78, 86, 167, 244

resophilia, 17, 42, 48
Rourke, Daniel, 7, 9
ruins, 17, 53–54, 56–57, 59–62, 64, 66, 68, 103, 105, 201, 227, 242, 244

Serres, Michel, 3–6
Shanks, Michael, 47, 50, 85, 127–128, 130
Shipka, Jody, 87, 89, 91
Simic, Charles, 84, 157, 187
Stallybrass, Peter, 50
Stam, Robert, 109–110
storytelling, 3, 47, 91, 94, 216, 237, 239–240, 242, 244

Thill, Brian, 53–54, 57, 82
thing theory, 29, 205
transgressive, 60, 86, 114, 172, 177
Trigg, Dylan, 38

upcycling, 142–146, 269

Vella, Daniel, 166–167
Viney, William, 51, 59, 98, 127–128, 130
voyeurism, 63, 91–92, 167

Warhol, Andy, 24–27, 33, 122, 186
wastescape, 17

Žižek, Slavoj, 132, 134–136, 141, 143, 146, 180, 183, 190, 192, 222

293

About the Authors

Andrei Guruianu is a Senior Language Lecturer in the Expository Writing Program at New York University where he has taught introductory and advanced level composition courses since 2011. His critical and creative works often explore such topics as memory and forgetting, the role of art and of the artist, and the ability of place to shape personal and collective histories. He holds an MA in Journalism from Iona College and a PhD in English from Binghamton University.

Natalia Andrievskikh is a Language Lecturer in the Expository Writing Program at New York University where she works primarily with international students. Her research areas include contemporary British and anglophone literature, digital writing, and media and culture studies. In her creative work she explores the role of myth-making in construction and preservation of memory. She received her MA in English and PhD in Comparative Literature from Binghamton University.

www.ingramcontent.com/pod-product-compliance
Lightning Source LLC
Chambersburg PA
CBHW040110180526
45172CB00010B/1296